The HDRI Handbook

The HDRI Handbook

High Dynamic Range Imaging for Photographers and CG Artists

Christian Bloch

Christian Bloch, www.hdrlabs.com

Contributors:
Uwe Steinmueller, www.outbackphoto.com
Dieter Bethke, www.fotofreaks.de
Bernhard Vogl, www.dativ.at

Editor: Gerhard Rossbach
Copyeditor: Judy Flynn
Layout and Type: Almute Kraus, www.exclam.de
Cover Design: Helmut Kraus, www.exclam.de
Cover Photo: Christian Bloch
Printer: Friesens Corporation, Altona, Canada
Printed in Canada

ISBN 978-1-933952-05-5

1st Edition
© 2007 by Rocky Nook Inc.
26 West Mission Street Ste 3
Santa Barbara, CA 93101

www.rockynook.com

Library of Congress catalog application submitted

Distributed by O'Reilly Media
1005 Gravenstein Highway North
Sebastopol, CA 95472

This book is printed on acid-free paper.

Table of Contents

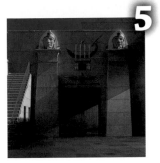

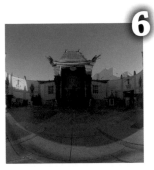

Foreword

Though one could argue that the image is a human invention, high dynamic range is not. Light spans an enormous range, and our eyes can adapt from the dim level of a starlit night to intense daylight, spanning over eight orders of magnitude (100 million to 1). This is comparable to the energy difference between getting going on a bicycle and taking off in a jumbo jet.

With this kind of range in real-world illumination, how have we gotten by so long with image contrast ratios of less than 100 to 1? The answer is deceptively simple. Although the range of light is enormous, our brain cares most about reflectance, and its range is comparatively modest. In fact, it is very difficult to create a surface that reflects less than 1% of the light it receives, and reflectances over 100% are forbidden by conservation of energy. Since the brain is trying to figure out surface reflectances based on what it sees, the huge range of illumination is often more of a hindrance to perception than a help. Therefore, an artist who skillfully removes the excess dynamic range in a painting is actually doing your brain a favor, making it easier for you to see what he (or she) sees. Skill and practice are required to accomplish this feat, for a painter who is inexperienced and does not know how to create the illusion of range within the limited reflectances available will create something more like a cartoon than a rendition. Realistic painting techniques were perfected by the Dutch masters during the Renaissance and are little practiced today.

Photography poses a similar problem in a different context. Here, we have the ability to record an image equivalent to that which lands on your retina. Starting from a negative, skill is once again required to render a positive that captures what matters to the brain within the limited reflectances of a black-and-white or color print. For scenes that contain little dynamic range to begin with, nothing needs to be done and the whole process can be automated. For more challenging subjects, such as storm clouds over mountains or the shadowed face of a child in the sunshine, the darkroom technique of burn-and-dodge is indispensable. With this method, either a round obstructer on a stick is used to "dodge" overexposed regions or a piece of cardboard with a hole cut out is used to "burn" underexposed regions during enlargement. This is an arduous, manual process that requires considerable talent and experience to achieve good results. The move to digital cameras has made such exposure adjustments even more difficult due to their limited dynamic range, which is one reason professional photography has been so slow to migrate from film.

High dynamic range imaging (HDRI) enables the centuries-old practices of renowned artists in a new, digital arena. HDRI permits photographers to apply virtual burn-and-dodge techniques in their image editing process, leaving as little or as much to automation as they wish. Digital artists using HDRI are able to create virtual worlds that are as compelling as the real world since the physics of light can be simulated in their full glory. Using physically based rendering and image-based lighting, HDR photography and virtual scenes and objects may be seamlessly combined. This is common practice for mainstream productions in special effects houses around the world, and even television studios are getting into the act. Enthusiasts, both professional

and amateur, are also pushing the envelope, and commercial software, shareware, and freeware are available to assist the transition from a traditional imaging and rendering pipeline to HDRI.

Of course, not everyone needs HDRI. If the starting point is low dynamic range and the ending point is low dynamic range, there is little need for HDR in between. For example, a graphic artist who creates on a digital canvas and prints his work on paper gains no immediate benefit since reflection prints are inherently low dynamic range. It may be easier using existing tools to simply stick to printable colors and create the desired "look" using a conventional WYSIWYG paradigm. In the long run, even such an artist may enjoy features and effects that HDRI enables, such as lens flare and the like, but these will take time to reach the mainstream. Meanwhile, there is much for the rest of us to explore.

In this book, Christian Bloch introduces the topic of high dynamic range imaging and how it relates to the world of computer graphics, with an emphasis on practical applications. Starting with film photography, Mr. Bloch re-examines the digital image, looking at file formats and software for storing and manipulating HDR images and going on to discuss how such images can be captured using conventional digital cameras. This is followed by a description of tone-mapping operators that can transform HDR images into something viewable and printable on conventional devices. Then, a more complete discussion of HDR image editing introduces color in the larger context of illumination rather than simple reflectance. A chapter covering the specialized topic of HDR panorama capture

and reconstruction then leads into the final chapter on computer graphics imaging and rendering, describing the techniques that have revolutionized the film industry.

Whether you are an artist, a hobbyist, a technician, or some exotic mixture, these pages offer valuable explanations, methods, and advice to get you started or to take you further on the path of high dynamic range imaging.

GREG WARD OF ANYHERE SOFTWARE

Introduction
What you can expect from this book

This book will reveal the many secrets behind high dynamic range imaging (HDRI).

You have heard this term before, and maybe you have even worked with a high dynamic range image before. The simple fact that you are holding this book in your hand shows that HDRI is not all that new to you. But still, you want to know more. You want to know the full story, and I know exactly why.

Currently, there is a lot of talk about high dynamic range imaging in the online photography communities. The topic emerged from discussions about taking better pictures in difficult lighting conditions, and it turned out that HDRI is just the right tool to address this challenge. But HDRI is much more.

To cut a long story short: **High dynamic range imaging is a method to digitally capture, store, and edit the full luminosity range of a scene.** We are talking about all the visible light here, from direct sunlight down to the finest shadow details. Having all that available in one image opens the door for immense opportunities in postprocessing. HDRI is a quantum leap; it is just as revolutionary as the leap from black-and-white to color imaging. Or, for a more suitable analogy, HDRI is to a regular image what Dolby surround sound is to mono tape. If you are serious about photography, you will find that high dynamic range imaging is the final step that puts digital ahead of analog. The old problem of over- and underexposure—in analog photography never fully solved—is elegantly bypassed. HDRI extends the digital development process beyond anything that was ever possible in an analog darkroom. Correct exposure is not an on-site decision anymore; it becomes a flexible parameter that can be dealt with in entirely new ways. An HDR image is like a digital negative on steroids, more like a true representation of the scene than a mere photographic image. You can even take measurements of true world luminance values in an HDR image. For example, you can point at a wall and determine that it reflects sunlight equal to 40,000 cd/m2. Even better, if the HDR image is panoramic, you can apply all the captured light to 3D objects.

High dynamic range imaging is an emerging field, but it is not all that new anymore. It has become a mature technology. It has just been poorly documented. Until now.

Five years ago, HDRI was a huge buzzword in the world of computer graphics (CG). It was considered the holy grail of true photorealism, the magic "make it cool" button that everyone was looking for. Fully digitally generated images were popping up, and even professionals could not tell if they were photographs or not. Hollywood studios were the first to adapt and implement that technology because their daily business is to fool the audience and sell them artificial dream worlds as the real thing. By now, HDRI has become a standard tool, even for the 3D hobbyist at home. Everyone and his dogs know how to use HDR images to make a rendering look photo-realistic. When they watch the **Making Of** feature for the latest blockbuster movie and the art director talks about lighting all the computer graphics with HDRI, everyone is nodding his head, mumbling, "Ah, sure... so that's why it looks so good." But what is really behind this technology? How can an HDR image be used as a light source? It's just an image, isn't it? How does it work? And can you make an HDR image yourself? Exactly how would that be done?

Many questions are still open, even for the 3D folks who have been using HDRI for years. Because **using** something is different from

understanding something. Only if you really understand the nature of HDRI will you be able to develop your own way of working with it. That's why this book digs deeper than a footnote or a single chapter in a software-specific tutorial book. Reading it from cover to cover will build a comprehensive knowledge base that will enable you to become really creative with HDRI. Regardless of whether you are a photographer, a 3D artist, a compositor, or a cinematographer, this book is certain to enlighten you.

About the author and contributors

Your hosts on this journey to new frontiers of Digital Imaging are renowned artists, working professionally in the field for years. They speak your language, and they understand that a hands-on tutorial is a thousand times more valuable to you than scientific formulas.

Christian Bloch is a visual effects artist, who works and lives in Hollywood, California. During the six years of his professional career, he has created effects for the TV shows StarTrek: Enterprise, Smallville, Invasion, Lost, 24, and Studio 60 as well as for several movies and commercials. His work has been rewarded with an Emmy Award as well as a nomination for the Visual Effects Society Award. He has been a pioneer in the practical application of HDRI in postproduction, specifically under the budgetary and time restraints of TV production.

Bloch earned a degree in multimedia technology. Years of research and development went into his diploma thesis about HDRI, which was honored with the achievement award of the University of Applied Sciences

Leipzig. Since his thesis was published online in July 2004, it has been downloaded more than 15,000 times, and it has been established as the primary source of information on HDRI in Germany. This book is the successor to Bloch's diploma thesis, rewritten completely from the ground up in English and heavily expanded and updated.

But this book is not just a one-man-show. There are many specialty applications for high dynamic range imaging. To provide you with the best expert knowledge available, Bloch has invited renowned experts to share their practical experiences and their secret workflow tricks.

Dieter Bethke has more than 17 years of experience in digital media production and does artistic photography, showing his prints at several galleries in Germany. When Bethke discovered HDRI, he turned into a diligent promoter in the photography community, and he believes that the future of digital imaging is high dynamic.

He also works as a consultant for digital fine art printing, prepress, color management, and digital photography. Bethke offers his expert knowledge in training seminars to media companies and individuals. He also contributed to the German localization and manual of Photomatix, which has been a remarkable resource for the photographic community.

Bernhard Vogl is one of Vienna's finest panorama photographers. He has a long history of sharing his knowledge with the community through online tutorials, thus he has given countless photographers a jump start in the art and craft of panoramic photography. His particular interest in HDRI is a natural progression toward capturing even more of

▲ **Christian Bloch**
[PHOTO: TORE SCHMIDT]

▲ **Dieter Bethke**

▲ **Bernhard Vogl**
[PHOTO: MICHAEL WIESAUER]

"The Real Thing". Just as a panorama breaks the framing restrictions of photography, a panoramic HDRI breaks free from exposure restrictions. For Vogl, this is the next step for capturing the moment and preserving it in a digital VR environment.

▲ Uwe Steinmüller

Uwe Steinmüller is known to the photography scene as the owner and chief editor of DigitalOutbackPhoto.com, one of the largest and most valuable resources on digital fine art photography. Originating from Germany, he moved to California in 1997, where he focused on the digital workflow, raw file processing, and fine art printing. He has written a number of books, two of which won the prestigious German Photography Book Award in 2004 and 2005.

Steinmüller's engagement in HDRI evolves out of the never ending journey after the perfect print, and he is fascinated by the new opportunities to take total control over his digital pictures.

I am proud to present this book as a complete guide to high dynamic range imaging. You can read it from front to back, and I highly recommend you do so. However, many chapters are intended for browsing or for situations in which you are working with HDRI and you must quickly look something up. You may need to make a choice about image formats or you may be stuck doing a specific task and want to peek at a tutorial again. Let this book be your crib sheet. It's full of practical hints and tips, software tests, workshops, and tutorials. There's an old German saying that goes "Knowledge means knowing where it's written." Well, it's all written here. That is all you need to know.

Your road map

 Chapter 1 is an in-depth explanation of the ideas and concepts behind high dynamic range imaging. This chapter is the foundation on which everything else is built. To understand the full range of opportunities, we must question some very basic concepts of digital and analog photography. You will be amazed to find out what little progress digital imagery has made until now and how a simple twist on the basic premise of digital—on the bits and bytes— can suddenly push it beyond the boundaries of what has been ever thought to be possible in analog.

 Chapter 2 presents all the tools needed for a high dynamic workflow. Conventional image formats have proven to be insufficient, and conventional software is still quite limited when dealing with HDR images. I will introduce and compare new image formats and programs, rate them, and give advice on how to integrate them into your own workflow. This chapter is also most useful as a quick reference that will come in handy on a million occasions.

 Chapter 3 is all about capturing HDR images. You get to know both: the scientific way and the easy way. I will walk you through different methods and compare the results so you can choose the method that best suits your own situation. Also, we take a peek into some research labs and learn about the future of taking HDR images. It's only a question of time before high dynamic range will be the standard and not the exception. So let's look ahead to be prepared for tomorrow's standard.

 Chapter 4 is dedicated to tone mapping. You'll be introduced to automatic algorithms as well as creative methods to reduce the tonal range of an HDR image while preserving all the details. This chapter is especially designed for all you photographers, because here is where you learn to create superior prints from HDR images. There is no right or wrong here; there is only creative potential to be explored. To inspire you in finding your own ways, Uwe Steinmüller and Dieter Bethke will showcase their personal workflow in practical tutorials.

 Chapter 5 reveals new opportunities for image editing and compositing. You will see a wide variety of workshops that can easily be re-created with the material on the supplied DVD-ROM. The results will be compared to those of traditional methods. Learn how the pros used to work with HDRI to create more lifelike composites for film and television. There is an great wealth of established techniques that can easily be applied to still image editing as well.

 Chapter 6 is dedicated to panoramic HDR photography, which is a cornerstone of this book because this is where the worlds of photography and computer graphics come together. And indeed, Bloch and Vogl contributed equally to this chapter. Together, they show you several different ways of shooting panoramic HDR images; they compare them all and rate them based on the necessary workload, equipment expense, and quality of the results. Chapter 6 is full of practical tips and tricks that will be an invaluable help in the field.

 Chapter 7 finally demonstrates how HDR images can be used in 3D rendering. I will break down the technical background for you so you understand how rendering algorithms work and how you can make them work better for you. Step-by-step, you will find out what the ideal lighting setup looks like. Then I'll take it a step further and present a brand-new lighting toolkit that automates the most common HDRI setup. On top of that, I'll show you some unconventional applications that will encourage creative uses of HDRI.

 All of the methods described in this book are based on readily available software that you can buy in a store or sometimes even find as freeware. They run on standard platforms such as Windows and Mac OS X, preferably both. It is very important to me that you have a chance to follow each workshop step-by-step. That is why proprietary in-house software and command-line programs are not covered here, even if they have proven successful in production for some privileged postproduction companies. The main goal is to make HDR working methods accessible to everyone, so friendly software with a graphical user interface is always preferred over scripting methods.

 # Chapter 1: The Background Story

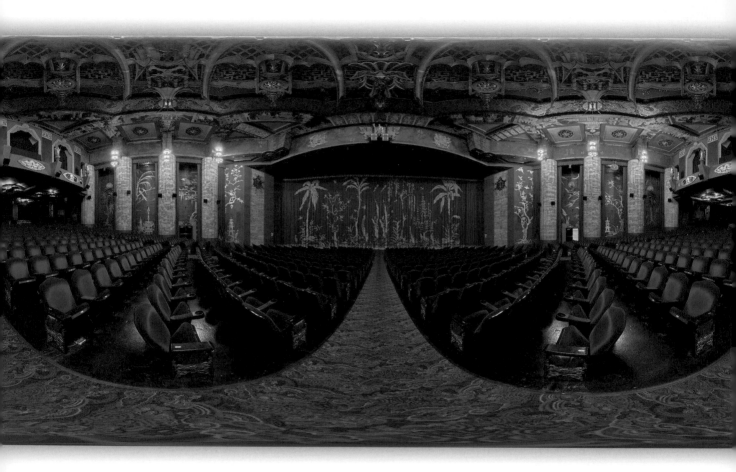

Before we can lift the curtain and present
high dynamic range imagery, we must be on
the same page about some basic terms. These
terms are essential for explaining our topic,
and they are used throughout the book.

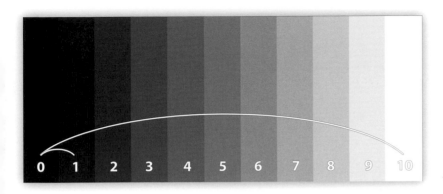

◀ Test image with contrast ratio 10:1

1.1. Basic Questions

What is dynamic range? Dynamic range (DR) is the highest overall contrast that can be found in an image.

It is often also called the contrast ratio, but this name is somewhat less defined and doesn't sound as cool. As with any ratio, it is a proportional value, such as, for example, 500:1. These numbers refer to the difference between the brightest and the darkest color values. Black doesn't count as a value; we cannot compare anything to black. Black is like zero. So 500:1 really means that the maximum contrast in an image is 500 times the smallest, just barely noticeable step in brightness.

Confused? OK. Let's start over: Let's look at the lowest image value first. I painted a very easy test image. If the black bar marks our zero point, the first bar would be the first step up in brightness. This shall be our base contrast of 1. Now, if we want to compare the outer bars, we can say they have a 10 times higher contrast. So the contrast ratio of that image—its dynamic range—is 10:1.

It is important to remember that the DR always depends on two factors: the overall range of brightness and the smallest step. We could enhance the dynamic range of this image if we used smaller steps in brightness or if we could

somehow add an extra bar that is brighter than the paper this is printed on.

This is the basic definition of dynamic range, based on pure logic. We will need that later on when we talk about how a computer sees an image. Photographers and cinematographers prefer to use units that are more grounded in the real world. A photographer would measure the dynamic range on the number of exposure values contained in an image.

What was an exposure value again? Exposure value, or just EV, is a photographic scale for the amount of light that gets through the lens and actually hits the film. This depends on the shutter speed and aperture size, and so the exposure value is a combination of both numbers. Neutral density filters can also be used to vary the amount of light, so they play into this number as well.

In practice, the exposure value is often referred to as **stop**. However, the term **f-stop** applies to the aperture size only, whereas EV can apply to shutter speed as well. To avoid confusion, I will stick to calling it EV throughout the book.

The International Organization for Standardization (ISO) defines EV 0 at an aperture size of 1 and 1 second of exposure time. You get the same exposure with numerous other

	Aperture Size (f-stop)												
Exposure Times (shutter)	f1	f1.4	f2	f2.8	f4	f5.6	f8	f11	f16	f22	f32	f45	f64
15 s	-4	-3	-2	-1	0	1	2	3	4	5	6	7	8
8 s	-3	-2	-1	0	1	2	3	4	5	6	7	8	9
4 s	-2	-1	0	1	2	3	4	5	6	7	8	9	10
2 s	-1	0	1	2	3	4	5	6	7	8	9	10	11
1 s	0	1	2	3	4	5	6	7	8	9	10	11	12
1/2 s	1	2	3	4	5	6	7	8	9	10	11	12	13
1/4 s	2	3	4	5	6	7	8	9	10	11	12	13	14
1/8 s	3	4	5	6	7	8	9	10	11	12	13	14	15
1/15 s	4	5	6	7	8	9	10	11	12	13	14	15	16
1/30 s	5	6	7	8	9	10	11	12	13	14	15	16	17
1/60 s	6	7	8	9	10	11	12	13	14	15	16	17	18
1/125 s	7	8	9	10	11	12	13	14	15	16	17	18	19
1/250 s	8	9	10	11	12	13	14	15	16	17	18	19	20
1/500 s	9	10	11	12	13	14	15	16	17	18	19	20	21
1/1000 s	10	11	12	13	14	15	16	17	18	19	20	21	22
1/2000 s	11	12	13	14	15	16	17	18	19	20	21	22	23
1/4000 s	12	13	14	15	16	17	18	19	20	21	22	23	24

pairs, like f1.4 and 2 seconds. That's because raising the aperture to 1.4 is actually cutting the area of the hole between the aperture blades in half. By doubling the exposure time, you allow the same total amount of light to get through. The following table shows the exposure values as defined at a film sensitivity of ISO 100. This table has been an essential part of the photographer's toolset for ages.

Unfortunately, this table has become unfashionable with the invention of automatic light meters. All that is left on consumer grade cameras is an exposure adjustment, often labeled with "--/-/o/+/++ EV".

Nobody can tell for sure if this changes shutter speed or aperture, and the absolute exposure value is completely neglected. Today, only professional cameras allow you to set a fixed EV and thus reference the amount of captured

▲

On consumer grade cameras the absolute exposure value is completely neglected.

◄

In cinematography and professional photography, people still rely on manual light metering.

light directly. Unfortunately, this sloppy handling has transitioned over to HDRI. It would have been very easy to introduce this absolute exposure scale as a unified measurement base back when HDRI standards were introduced. It would have enabled us to directly access the real-world luminance values right from HDRI pixel values, and since all HDRI software would be calibrated on the same scale, it would be much easier to switch back and forth between them. In fact, the founding father of HDRI, Greg Ward, once defined a nominal EV as that which would be embedded in a crude metadata style in every HDR image. But it has simply been forgotten to implement that feature in most HDR-capable software because the programmers didn't care about this tiny photographic detail.

And even though it doesn't sound like a big deal, there are major shortcomings as a result because in cinematography and professional photography, people still rely on manual light metering. Automatic light meters are attached to the camera, so they never directly measure the light hitting the subject. All they can see is the light that reaches the camera, which can be entirely off, depending on the distance.

On a movie set, for example, you want all cameras to shoot the same range of light intensities. And that exposure has to be perfect, so the director of photography measures the light directly at the subject. He runs over to the actor and puts a manual light meter in front of his face; then he yells the proper exposure value into his walkie-talkie. This is an order every cameraman has to follow, and they must set their cameras accordingly. It ensures that they can cut back and forth in a dialogue scene without having the brightness levels jump around. All cameras are in sync. Now, when you are in charge of taking HDR images on set, you are automatically out of sync. Even though you might capture more light than all cameras together, your image will not automatically be aligned to what ends up on film. Theoretically HDR technology has the potential, but in practice it's not used by most programs. All it takes is calibrating the image values in an HDR to an anchor exposure. So you should listen carefully to your walkie-talkie and make notes. Since your photo camera stores ISO value, exposure time, and aperture size in the metadata, you can use this table to recover the absolute EV again. But there is still

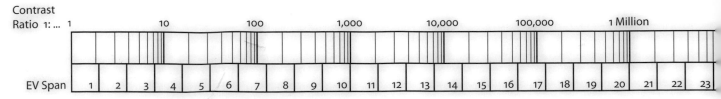

▲ **Conversion Scale:** Dynamic Range measured as Contrast Ratio and EV Span

hope for a unified luminance space that is true to the real world.

How can we use EVs to measure the dynamic range? We talked about contrast ratio as the standard way of measuring the dynamic range. But it's a very abstract system, coming up with numbers like 1:4000 and such, and it is very hard to visualize what that actually means. Exposure values are much easier to understand. When I sat that my HDR image covers in total 12 EVs of the scene light, everything is clear. You have an instant understanding of how far apart the deepest shadow details are from the brightest highlights. And you have a real-world relation to all the shades in between.

So let's take a look at the unit conversion between contrast ratio and EV span.

The contrast ratio directly refers to the difference in light intensity. Double that number means double the light. So you have a linear unit.

Exposure values are in a logarithmic scale. Each increase by 1 doubles the light, meaning it also doubles the ratio number. It's very easy to convert in one direction. It goes like this:

$$2^{\text{exposure values}} = \text{contrast ratio}$$

For example, if you have a dynamic range that spans 12 EVs, that is $2^{12} = 4,096$. So, that DR can also be called a contrast ratio of roughly 4,000:1.

Converting in the other direction is a bit more tricky. You need to calculate the base 2 logarithm, or the binary logarithm as the scientists call it. Chances are your desktop calculator doesn't have a "\log_2" button. Mine doesn't, not even the one on my computer. There is just a regular "log" key, but that refers to \log_{10} instead of \log_2. But luckily, by a happy math coincidence, there is a fixed conversion factor. Well, actually it is a math law that says, There shall be 3.321928 used here. Usually 3.32 is all the precision we need. So, that would be as follows:

$$\text{EV span} \approx \log_{10}(\text{contrast ratio}) * 3.32$$

For example, 4000:1 simply means $\log_{10}(4000) * 3.32 \approx 12$ EVs.

If you don't feel like doing the math at all, you can also use the conversion scale. This scale also shows very clearly how much more sense EV span makes as a measurement unit of dynamic range. EVs just compare so much easier than contrast ratios. For example, the difference between 1:20,000 and 1:30,000 is not even one full EV, no matter how impressive these numbers might sound.

Photographers who are used to Ansel Adams's zone system will instantly recognize that one EV span equals one zone. Essentially, you could substitute these terms for the rest

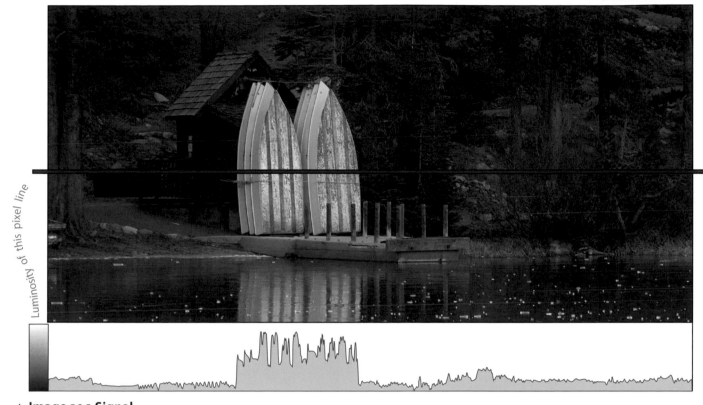

Luminosity of this pixel line

▲ Image as a Signal

For simplicity, I picked a single line of pixels and mapped the luminosity in a graph

of the book. However, since the zone system is strictly aligned to the limitations of film, I will stick to using the open ended scale of EV spans.

Isn't dynamic range an audio unit? Yes, indeed. Well pointed out!

Sound has a dynamic range as well, and it is very closely related to ours. Dynamic range has always been around in the glorious world of engineering, specifically in the signal processing department. For digital imaging engineers, it is an important quality grade of sensor chips.

The technical DR is defined as the logarithmic ratio between the largest readable signal

and the background noise, and the unit is decibel. So it is the big brother of the good old signal-to-noise ratio; the only difference is that it applies to the entire image. That makes sense when you consider an image to be a signal.

Let's try that. Let's look at an image as a signal. For simplicity, I picked a single line of pixels and mapped the luminosity in a graph.

Looks like Beethoven, doesn't it? You can clearly see how the bright underside of the boats show up as towering peaks. And look at the dark brown fence next to the boats: in the graph, it shows up as a small sawtooth pattern. And the bushes on the other side are just

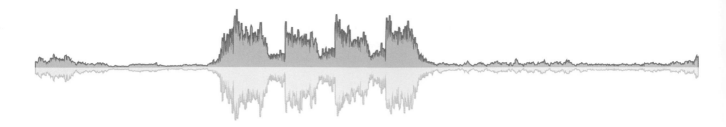

Beethoven ▲
This is the beginning of Beethoven's Symphony no. 7 in A, Opus 92.

a wiggly line. There is a lot of fine detail here, but it is generally dark and low contrast.

For comparison, here is Beethoven. Once again, we have huge towering peaks. This is the part where the volume is pushing you back in your chair. It has to be loud and powerful. You need a good set of speakers to really enjoy this part without distortions. And right after that we have the delicate melody part. An audiophile would insist on a recording in which this is so low in volume that he can barely hear it. But in his soundproof living room he can appreciate the crystal clear quality of the recording, replicating every single nuance the maestro played originally. The difference between the full orchestra playing their hearts out and the subtle sound of a single violin—that's the dynamic range in audio.

Same goes for the image signal. When the recording device has an insufficient dynamic range, you cannot tell the bushes from the noise. You could buy the most expensive output device you could get, but if the image doesn't contain the subtle details in crystal-clear quality as well as the unclipped intensity peaks, it will not look like the real thing.

Admittedly, this signal approach is strange when it comes to images. But from an engineering standpoint, it does not make a difference. Audio, photo, video—it all boils down to signals being processed. Engineers always see the signal curve behind. When an engineer

talks about high frequencies in an image, he's referring to the fine texture details. It's just a special tech lingo that quickly sounds like geek chatter to untrained ears. But engineers are smart, and we rely on them to supply us with all the gadgets we need to get creative. Specifically, they need to build better and stronger imaging sensor chips. And they measure this technical dynamic range in decibels to determine the bit depth that a digital camera is capable of.

Ah… bit depth! So 32-bit images are HDR images, right? Hold on, not so fast. We will get to that later. We haven't even tapped into digital yet.

In the practice of image editing, the dynamic range is often confused with color depth and measured in bits. But that is not entirely correct. It's also not entirely wrong. A digital image with a high dynamic range has to have more than the usual 8 bits, but not every image with higher bit depth also holds a high dynamic range.

You cannot just convert an 8-bit image to 32 bit and expect it to be a true HDR image. That would be the same as zooming into a landscape picture that was taken with a camera phone and expecting to be able to read a license plate. These things only work on TV, but the TV folks have the magic "Enhance" button, which is really a guy sitting in a closet operat-

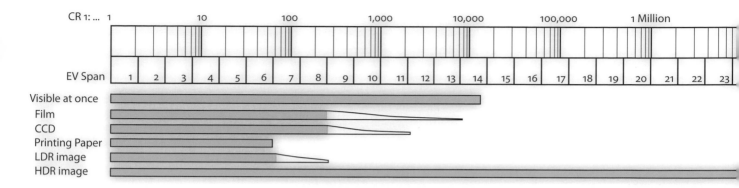

ing the playback controls. If the original data isn't there, it won't ever come back.

The bit depth of an image is a weak indicator of its dynamic range anyway. For example, there are true HDR images that have only 16 bits. It's not just about counting bits. The real innovation is of a much more fundamental nature. You have to clear your mind and try to forget everything you knew about digital images.

Tell me then, what is HDRI? HDRI is a new field, right on the junction where photography, computer graphics, programming, and engineering meet, and it has been researched from all these different perspectives. New toolsets have emerged that provide solutions for basic problems of photography. New methods for dealing with image data have been developed that feel much more like analog procedures than digital image manipulation. New algorithms in 3D programs make virtual camerawork and lighting tasks directly relate to their real-world counterparts. HDRI is the key element that blends everything together. We are steering toward a convergence point that leads to entirely new levels of imaging.

See, the essence of all imaging is light. Photography, cinematography, computer graphics—whatever imaging method you choose,

light is always the central part. And HDRI is the ultimate digital representation of light. It can hold more light than any technology before, and it does it better than any other.

To really understand the revolutionary concept, we have to go back and revisit how we perceive light.

▲
Photography, cinematography, computer graphics —whatever imaging method you choose, light is always the central part.

▲ **Adaptation**

1.2. How We See the World

The human eye is an incredible thing. It can differentiate contrasts up to 1:10,000. That's a dynamic range of about 14 EV. But it goes even further: The eye can adapt to almost any lighting situation, stretching the total perceivable range to approximately 1:1,000.000.000 .

Adaptation: For example, the sun is a million times brighter than candlelight. Still, we can see perfectly when walking in a sunny park, as well as inside of a church. Such extreme contrasts cannot be seen at the same time. When you step into the dark entrance of that church, you experience a short moment of blindness. Within seconds, your eyes begin to work: your pupils widen and your vision brightens up again. This physical reaction is called adaptation.

You can argue that this is not that big of a deal, since the aperture in a camera does exactly the same thing. But the point is, the receptors in your eye are sensitive enough to adapt to much lower light levels than any aperture size can ever allow you. Have you ever tried to digitally photograph an object lit by starlight only? It will drive you nuts because you can clearly see it, sitting right there, but your camera will insist on taking a noisy black image. Human vision knows neither noise nor grain, and if you spend all day in a dimmed environment, you can even adapt to the point where your eyes can detect as little light as 30 photons.

But even when the field of view doesn't change, the perceivable dynamic range can be enormous. Even though the sky is generally a thousand times brighter than the inside of a room, we have no problem seeing all the details in the fluffy clouds **and** the inside of the much darker room at the same time.

This incredible achievement is accomplished by two different mechanisms: nonlinear response and locale adaptation.

Nonlinear Response: First, our eyes don't react to light in a linear manner. Instead, the response roughly follows a logarithmic curve. This is a common trick of nature; all our senses work that way. In acoustics this is a well-known phenomenon: You can double the

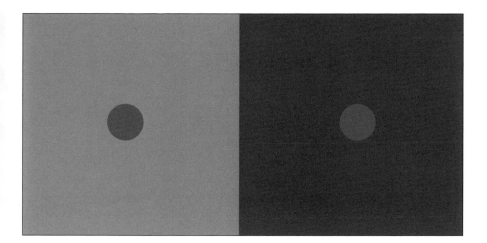

◄ Local Adaptation
Look at the image. Can you believe that the two circles have identical brightness?
I swear, they do.

power that pumps through your speakers, but it won't necessarily sound twice as loud. Instead, you need to increase the power logarithmically. The higher the volume already is, the more power it takes to further increase it by a perceptionally equal amount. That's why you need giant speakers to power a rock concert.

Our visual sense works the same way. When an object is measured as twice as bright, provenly reflecting the double amount of photons, it still doesn't appear twice as bright. Instead, the perceived difference is gradually smaller the brighter it gets. Highlights and luminous light sources that may well be 5,000 times brighter than their surroundings are naturally compressed to fit in our view. This is an important safety mechanism; without it our ancestors would have never left the cave because they would have been blinded all day.

Locale Adaptation: Our eyes are smart enough to apply a different sensitivity to different areas of the field of view. This effect is called locale adaptation. And even though it is a vital part of our vision, locale adaptation is hard to simulate with traditional imaging

systems. This is where the professional photographer has to deal with all kinds of partial lens filters and gradient filters just to get close to a natural-looking image.

We don't even know for sure how exactly this incredible mechanism works because we cannot directly analyze the raw output image that our eye generates. Scientists have collected long lists of empirical data by measuring the tiny currents in those light-sensitive receptors. Some doctors have even picked mouse brains. But the results are impossible to interpret. At best they can map the difference between a healthy and a sick eye. Deciphering the secrets of human vision turned out to be so incredibly difficult that surgeons nowadays are only certain of one fact: The human eye is not just a mechanical apparatus like a camera; rather, it is an integral part of our brain.

The actual perception of contrasts is always accompanied by an interpretation and thus is already an intelligent process. It happens subconsciously; you cannot prevent it. Try it for yourself: Look at the image above. Can

you believe that the two circles have identical brightness? I swear, they do.

You see, the impression of brightness has little in common with the true, physically measured luminosity. How exactly this impression is shaped is impossible to find out. After all, we are talking about a cognitive experience here. Our senses are nothing but a link between the outer and the inner world. We never experience the outer world directly; all we see is the inner world that we reconstruct from our sensual impressions. If our senses were structured differently, we would live in an entirely different world. Have you ever wondered what the world would look like if you could see radio transmissions or cell phone signals? We are surrounded by things we cannot sense, but still we assume that what we see is the real world. This is why the science of cognition operates where physiology, psychology, and philosophy meet.

For our core problem, how the mind makes you see different levels of gray, the cognition expert Robert R. Hoffman offers a superb explanation: First, to construct the grey tone of a specific point, you are not just looking at the brightness level at that point. Furthermore, you are not only using the brightness levels of the immediate surroundings of that point. Instead, you gather large areas of the image and group them together by applying complex rules, which we have not discovered yet. Perceiving a grey tone is part of a coordinated construction process that considers shapes, colors, light sources, and transparent filters.

So that is the situation. Human vision is a complicated beast. We understand some basic principles, like adaptation and nonlinear response. But still, we know little about how we really perceive the world through our eyes.

1.3. How Real Is Analog Photography?

Film has been the primary medium for a century now when it comes to picturing a piece of the real world. In fact, photorealism has set the bar high and is still considered the ultimate goal for 3D renderings. But is film really that good in capturing what a human observer can see? Is it really true to life?

The answer is, not quite. But it is the best we have so far. Let's take a look at the inner workings of film to better understand the advantages and shortcomings.

The chemistry that makes it work: All analog photography is based on the same chemical reaction: the decay of silver halide caused by light. On the microscopic level, film material is covered with millions of silver halide crystals. These crystals are commonly known as film grain. Each of those grain crystals consists of billions of silver ions that carry a positive charge ($Ag+$). Also, it holds about the same amount of halide ions, carrying a negative charge. That can be a chloride ($Cl-$), bromide ($Br-$), or iodide ($J-$). It doesn't really matter which one—all halides have one thing in common: They have one electron to spare, and they are more than happy to get rid of it when light hits them and gets them all excited. That's where the silver ions come in—they catch that electron, so they can turn into pure silver. So, when we are talking about the density of a negative, we are really talking about the chemical density of silver that is on the film. That also explains why shooting on film is so expensive: There might be more silver bound in film than in coins these days.

So, exposure is a photochemical reaction. As such, it progresses in a logarithmic manner. If a certain amount of light has turned half

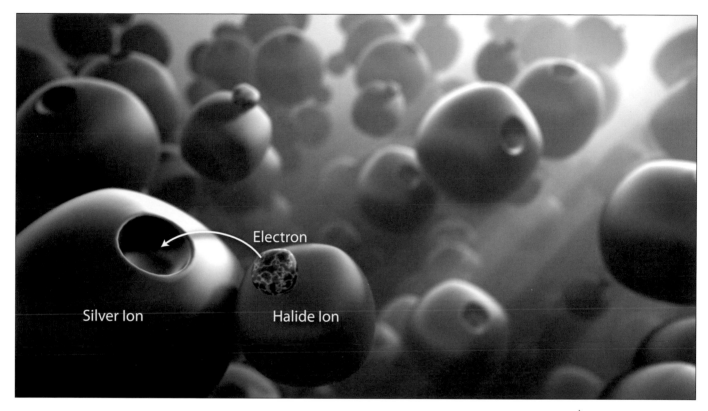

Silver Ion

Electron

Halide Ion

▲

The photochemical
reaction of exposure

of a grain crystal into silver already, the same amount of light will only transform half of the remainder. This is very convenient for us, because it roughly matches the nonlinear response of our eyes. Herein lies the secret, why film appears so natural to us: Film grain reacts to light just as the receptors in our eyes do.

By the way, this chemical reaction is actually very slow. It would take hours to convert an entire piece of grain into pure silver. In practical photography today, much shorter exposure times are used only to plant an exposure seed. Later, when we develop the film, we can grow that seed through a chain reaction and amplify the original exposure a million times. This basic concept hasn't really changed for a century. Color film is just a refinement accomplished by using several layers of film grain divided by chromatic filters.

Where the chemistry is flawed: There is a minimum amount of light required to get this reaction going. On the other side, the film grain reaches a saturation point when hit by a certain amount of light, that is, when all the grain consists of silver. To capture a scene with all its tonal values, the light beam hitting the film has to fit into this interval, the tonal range of the film. If parts of the film get too much or too little light, we end up with entirely saturated or entirely virgin grain crystals, commonly referred to as the evil twin sisters Overexposure and Underexposure. What really ends up on film are the light intensities in between.

▶

The S-shaped curve typically used to map film density to exposure on a graph.

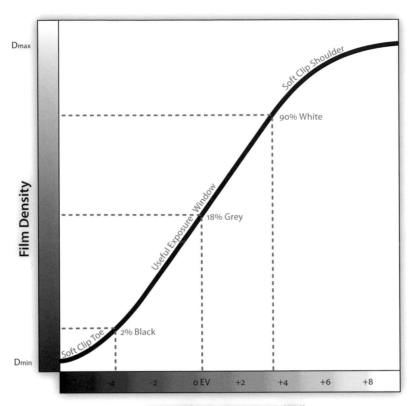

An S-shaped curve is typically used to map film density to exposure on a graph. Note that exposure is measured logarithmically too. Each increase of 1 EV relates to the double amount of light being allowed to shine in the film. A perfectly logarithmic response would show up as a straight line in this diagram. Film does that only in the middle portion of the curve. At the upper and lower end, the curve has a smooth roll-off, called shoulder and toe. These are the spots where the grain pieces are almost saturated, or have received just enough light to start reacting. Even in the most sophisticated film material these thresholds are slightly different for every single grain crystal, so they show up as increasing noise in the toe and the shoulder ends of that curve.

The trick now is to set the exposure right, meaning to tweak the incoming light to fit in that window of useful film response. We can do that with the aperture size or exposure time or by putting filters in front of the lens. This can work well under more or less homogenous lighting conditions, preferably in a studio where the photographer is in control of the light. But a landscape photographer can tell you stories about the pain of having an overcast sky, sparkling reflections, or even the sun itself in the picture. The DR of the real world often exceeds the DR of film by far, and so the photographer has to make a choice. He

can either expose for the darks or expose for the lights. In both cases, the image does not represent what a human observer would see. If the photographer decides for the lights, all details in the shadows get mushed up in one big black stain of unexposed grain. If he exposes for the shadows, he sacrifices all detail of the brighter areas. And the worst is that this on-site decision is irreversible; whatever details get clamped out are gone forever.

How about analog postprocessing? Modern film material can capture a dynamic range of 5 to 8 EVs in the good quality portion of the curve. By comparison human vision easily comprehends about 14 EVs, so only half of the light nuances we can see end up on film. The tonal range of photo paper is usually lower; only premium-quality paper reaches 6 EVs. Obviously, this depends on the lighting conditions when you look at the print, but even under perfect gallery lighting, the limit is set here by the level of darkness that it can reach. Even the darkest black will always reflect some light; you can't get paper as dark as a black hole just by printing it black. So the photographer has to clamp out another part from the light that is caught on film. This is done in postexposure, when the exposure seed is chemically amplified. By choosing just the right chemicals, the photographer can change the gradation curve and shift the exposure about 1½ EVs up or down with no regrets. Obviously, some light information is thrown away here, but the result is still using the full DR of the output media, the photo paper.

That is the great thing about it: The photographer has a bigger range at his disposal than he needs for the output. Within that film range, he can move the smaller window of printable range up and down—the print range will always be fully used. This is analog postprocessing, a method for brightening and darkening that delivers a maximum-quality output. Many professional photographers were resisting the switch to digital for exactly that flexibility. As of right now, a RAW-based workflow is the only digital alternative that comes close. But it's not quite there in terms of quality because digital images start off from a different premise.

What's wrong with digital? Whenever a digital image is brightened or darkened, there is data loss. If you are applying a digital gradation curve to spread out some tonal values, you always crunch together the rest. You can never slide the exposure as you can with the analog post process. You can simulate it, but you won't recover new details in the highlights or shadows. Instead, the more you tweak the tonal values digitally, the more banding and clipping will occur and you end up entirely ruining the quality. And you know why? Because unlike in analog postprocessing, the dynamic range of the source material is identical to the output.

Those are some bold statements. Let me explain a bit deeper how digital imagery works and where it is flawed.

▶

A bit resembles a
simple on/off switch.

1.4. Digital Images

Computers are very different from our good
buddy film. Computers are more like the IRS.
All that matters are numbers, they operate
based on an outdated book of rules, and if you
make a mistake, they respond with cryptic
messages. Everything you tell them has to
be broken down into bite-sized pieces. That's
what happens to images: pixel by pixel they
get digitized into bits.

Let's talk about bits: A bit is the basic infor-
mation unit that every digital data is made
of. It resembles a very simple switch that can
be either on or off, black or white. There is no
grey area in a bit's world. If we want some finer
differentiation, we need to use more bits.

And this is how it works: With a single bit,
we can count from 0 to 1. To count further, we
have to add another bit, which can be either
on or off again. That makes four different com-
binations: 00, 01, 10, 11. In human numbers
that would be 0,1,2,3. We have a slight advan-
tage here because we are not running out of
symbols that fast. Computers have to start
a new bit all the time. For example, it takes

a third bit to write eight different numbers:
0, 1, 10, 11, 100, 101, 110, 111. Whereas we
would just count 0,1,2,3,4,5,6,7,8. What looks
like a 3-bit number to a computer, would still
fit within a single digit in our decimal system.
However, the basic way of constructing higher
counts is not that different at all. When we've
used up all the symbols (0 through 9), we add
a leading digit for the decades and start over
with cycling through the sequence of number
symbols. It's just more tedious in binary num-
bers, because there are only 0 and 1 as sym-
bols. But with every new bit we add, we can
count twice as far. Thus, the formula $2^{(number\ of\ bits)}$ is a shortcut to find out the highest num-
ber that amount of bits can represent.

To sum it up: Bits represent the digits of
computer numbers. The more we have, the
higher the number we can represent and thus
the more unique values we have available.

**Great, that's the math. But how about im-
ages?** Traditionally, 24 bits are used to de-
scribe the color of a pixel. This is the general
practice, laid out in the sRGB standard. All
digital devices, from cameras to monitors and
printers, are aware of it and support it. You

▲
Traditionally, 24 bits
are used to describe
the color of a pixel.

might be tempted to call this a 24-bit image format—but wait! In reality, it's just an 8-bit format. Those 24 bits are broken down into three channels, where 8 bits each are used to describe the intensity of the individual color channels red, green, and blue. Eight bits allow 2^8 = 256 different values. So the darkest color possible is black with the RGB values (0,0,0) and the brightest is (255,255,255). To change the brightness of a pixel, you have to change all three channels simultaneously—otherwise, you also change the color. Effectively, each pixel can have only 256 different brightness levels. This is not even close to what our eye can see.

Ironically, this format is labeled "truecolor", a name that stems from an age when computers had less processing power than a modern cell phone and 256 values per channel were considered high end when compared to a fixed palette of 32 colors total.

Don't get confused with the different counting methods for bits. sRGB is 8 bit, when you look at the individual channels. The other counting method would be adding all channels up, and then you would get 3 * 8 = 24 bit. Some call that cheating, but it makes sense when you want to indicate that an image has more than the three color channels. A common bonus is an alpha channel that describes a transparency mask. The short name for that kind of image would be RGBA, and if you sum up all four channels, you get 32 bits. But it's still 8 bits per channel. Still the same old not-so-true color format. To avoid all this confusing bit counting, I will stick to the per-channel notation and call this format 8-bit for the rest of the book, or low dynamic range (LDR).

Also notice, that there is a limitation built right in: upper and lower limits. Nothing can be brighter than 255 white, and nothing can be darker than 0 black. There is just no way; the scale ends here.

Born to be seen through gamma goggles: Two hundred fifty-six levels are not much to begin with. But it gets even weirder: These levels are not evenly distributed. How come?

Let's see what happens to an image from digital camera capture to display on screen. First of all, digital sensors do not share the logarithmic response of film and our eyes. They just count photons, in a straight linear fashion.

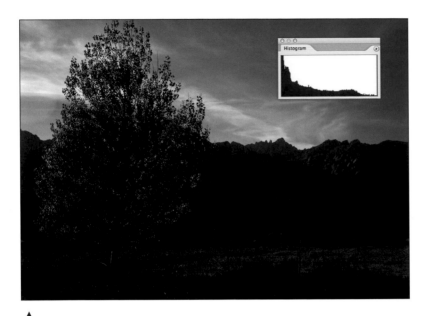

▲

This is what a scene looks like in linear space,
just as an image sensor would see it.

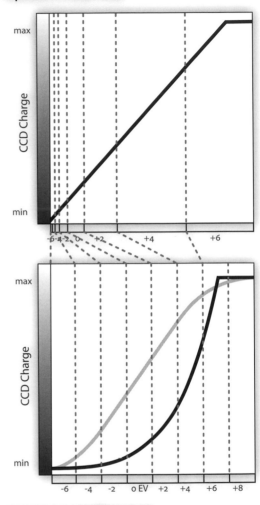

Exposure in Linear Scale

Exposure in Logarithmic Scale

The two diagrams illustrate what
our sensor has just captured ▶

This is what a scene looks like in linear space, just as an image sensor would see it: The image looks very dark and high contrast. In this case, it might have a certain appeal, but we can all agree that it looks far from natural. There are large black areas where we expect to see shadow details and several sudden jumps in brightness. It appears like an evening shot seen through sunglasses. But in my memory, this was a broad daylight scene. What happened?

Here are two diagrams to illustrate what our sensor has just captured. They show the identical curve, but with the scene luminance mapped in two different ways: Linear scale is what the physical luminance really is, with a steady increase of light. However, we like to think in terms of exposure, where each increasing EV is doubling the amount of light.

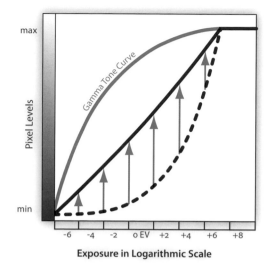

Exposure in Logarithmic Scale

▲ Gamma encoding ▶

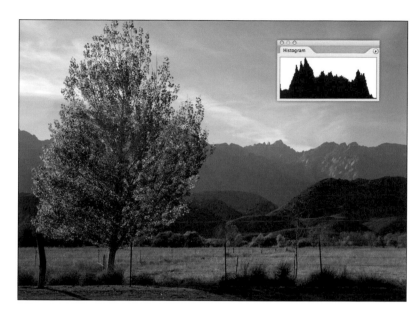

This corresponds better to how we perceive light, and so the second diagram is in logarithmic scale. For comparison, the film curve is overlaid in grey here.

What this tells us is that half of the available values are taken by the brightest EV. The remaining half is divided between the second brightest EV and all the lower ones. If you do that repeatedly for a camera that captures 6 EVs in total, and you try to represent them all with a total of 256 values, you end up with only two levels left for the EV containing the darkest shadow details. Most of the image ends up darker than we would see it, crunched together in fewer and fewer values. It's like cutting half off a birthday cake again and again, until only a tiny crumb is left for the last party guest.

That wouldn't work well, would it?

To the rescue comes a little trick called gamma encoding. And this is where the trouble starts. Mathematically, the gamma is applied as a power law function, but that shouldn't bother us right now. What's important to remember is that gamma encoding has the effect of applying a very steep tone curve. It looks approximately like this: The gamma curve pulls the tonal values up, strongest in the middle tones and weakest in the highlights. The result is a much more natural-looking distribution of tonal values. Most noticeably, the darker EVs are back—hurray. And the middle EVs stretch almost across the entire tonal range available.

Note that this is not a creative process; it is done in the background without you noticing it. Gamma encoding is a built-in property of all LDR imagery, and it is necessary to make better use of our 256 digital values. It is a hack that distorts their allocation to light intensities, born out of the limitations of the digital Bronze Age.

With gamma encoding, our 8-bit image has been cheated to work nicely on a cathode ray tube (CRT) monitor. I don't want to bore you with more technical graphs. Let's just say that

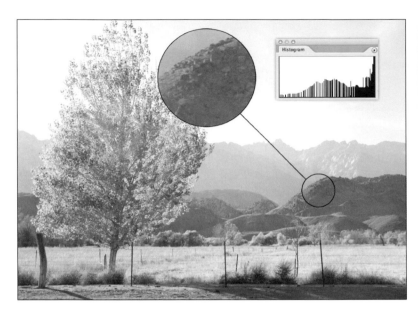

▲

Brightening an 8-bit image with a tone curve introduces artifacts.

they are made for each other. CRT monitors can show all the nuances that 8-bit can deliver, and it's getting as close to human vision as this technology can get. Traditionally, other output devices are calibrated to this gamma value too. Printers, LCD monitors, television sets—they all expect their input feed to come with a gamma distorted level distribution, and it is their own responsibility to turn that into an output that is pleasing to the eye. That is why we call 8-bit imagery an output-referring standard.

Limitations of this output-referring standard: Here comes the catch: As soon as you want to edit a digital image, the pitfalls become quite apparent.

Especially critical are the shadows and middle tones. Brightening an image up will reveal that the gamma encoding has just pretended to preserve detail in those areas, just enough so we don't see the difference on our monitor. The truth is, the lower EVs did not have many different digital values to begin with.

Spreading them out across a larger set of values introduces nasty posterizing effects, most noticeable in the large blue-brown color fills that are supposed to be the shaded side of the mountain. Also, the histogram now looks like it just went through a bar rumble, exposing large gaps all over.

Now this adjustment was done with a very primitive tone curve. Yes, there are more advanced tools, using more sophisticated algorithms to reconstruct the intermediate tonal values. Such specialty tools might be more or less successful in filling the gaps, but in the end all they can do is guesswork. It's very unlikely that they will discover new details that have not been there before. No new pebble or bush will emerge from the shadows.

The next thing to consider is that what were the upper stops before are now stacked up on the right side of the histogram. These tonal values have snapped together. Once again, there is no way to separate them now. We even pushed a lot of them to the maximum value of 255. Remember, this is a hard limit. Almost

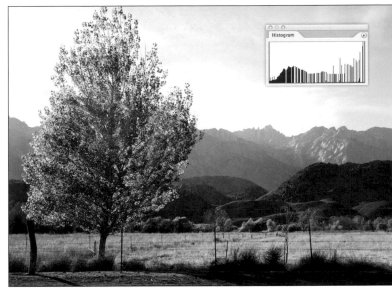

Inverse tone curve applied, in an attempt to bring the image back to where it was.

the entire sky is just white now, and the clouds are gone. Now and forever. We dumped the data.

Any subsequent change has to deal with an even smaller set of distinguishable values. For demonstration purpose, let's try to craft an inverse tone curve to bring the image back to what it was before.

OK, looks like our image can only be declared dead. Bye-bye fluffy clouds. What's left in the sky is just some cyan fade, where the blue channel got clipped off before red and green. The tree looks like an impressionist painting, entirely made of color splotches. And our histogram just screams in pain. Apparently, we could not get the image back to the original that easily.

More bits: Yes, I know what you are thinking. It was very unprofessional to make such harsh adjustments in 8-bit mode. If I am that crazy about histograms, I should have used the higher precision that a 16-bit mode offers.

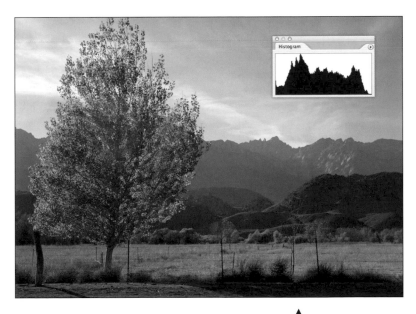

Original image for comparison.

Indeed, here we have more digital values available for each EV, and it helps tremendously when doing such incremental editing steps. Sixteen-bit is actually 15-bit because the first bit is used for something else, but that still leaves us $2^{15} = 32{,}768$ different levels to work with. Wouldn't that be it?

►
Splitting the bit.

And I say no. It doesn't give me back the fluffy clouds. It doesn't even save the sky from getting burned into cyan. Because 16-bit is just more of the same. It has a maximum and a minimum limit, where color values get rudely chopped off. And even if you don't make such hardcore adjustments as I just did, you never know where a sharpening filter or some other fine detail processing step will throw individual channels out of range.

Sixteen-bit is an output-referring format as well. It carries the gamma-encoded nonlinear level distribution, so most of the extra precision gets added in the highlights, where we need it the least. And it uses a fixed number of discrete values. There might be more of them, but that still means our levels get chopped up into a fixed number of slices. The more you tweak, the more rounding errors you'll see and the more unique values you'll lose.

Nondestructive editing: Here is a working solution: Instead of applying multiple editing steps one after another, we could just stack them up and apply them all at once to the original image. That would take out the rounding errors and preserve the best quality possible.

Photoshop's adjustment layers follow this idea, and other image editors use similar concepts. The drawback of this approach is that the flexibility ends at the point where you actually commit all your changes. But you have to commit your changes when you take an image through a chain of multiple programs. An example would be when you develop a RAW file in your favorite RAW converter, tweak the levels in LightZone because you just love the zone system, and then do additional tweaks through dodging and burning in Photoshop. You can dodge and burn all day, but you will not get details back that have been cut out by the RAW converter. The farther down the chain, the more of the original data you'll lose.

Splitting the bit: What we really need to do is reconsider the basic premise that digital imaging is built upon. We need to split the bit. We need to use floating point numbers.

See, the hassle started with our limited set of values, ranging from 0 to 255. Everything would be easier if we would allow fractional numbers. Then we would have access to an infinite amount of in-between values just by placing them after the decimal point. While there is nothing between 25 and 26 in LDR, floating point allows 25.5 as a totally legiti-

mate color value and also 25.2 and 25.3, as well as 25.23652412 if we need it. HDRI is that simple yet that revolutionary!

We need no gamma because we can incrementally get finer levels whenever we need them. Our image data can stay in linear space, aligned to the light intensities of the real world. And most importantly, we get rid of the upper and lower boundaries. If we want to declare a pixel to be 10,000 luminous, we can. No pixel deserves to get thrown out of the value space. They may wander out of our histogram view, but they don't die. We can bring them back at any time because the scale is open on both ends.

We're done with 8-bit anyway. Atari, Amiga, and DOS computers were based on 8-bit. Windows and Mac OS are now making the leap from 32- to 64-bit and so are Intel and AMD processors. Only our images have been stuck in the '80s.

So, HDR workflow is better than RAW workflow? Well, they are closely related.

RAW has extended a photographers capabilities to digitally access the untreated sensor data. Most RAW files are linear by nature and look very much like the first example picture with the tree. By processing such a file yourself, you get manual control over how these linear intensities are mapped to the gamma-distorted color space. There are other hardware-dependent oddities to RAW files, like low-level noise and each pixel representing only one of the primary colors so that the full image has to interpolated. Having control over all these factors is an essential ingredient for squeezing out the maximum image quality.

However, with RAW you are walking a one-way road. The processing is usually done first, and any subsequent editing relies on the data

that is left. Not so with HDR; it preserves everything. You can edit HDR images, take them from one program to another, edit some more. As long as you stick to it, no data will be lost.

RAW is also bound to specific hardware: the capturing sensor. HDRI is not. HDRI is a much more standardized base that is truly hardware independent. You can generate HDR images that exceed what a sensor can capture by far, and you can use them in a much wider field of applications. In the case of CG renderings, there is no physical sensor that would spit out RAW images. Instead, HDR images take the position of RAW files in the CG world.

Think of it like this: HDR imaging is the next generation of a RAW workflow. Right now, they go hand in hand and extend each other. But sooner or later all digital imaging will happen in HDR.

But what is the immediate advantage?
When a RAW image represents what a sensor captures, an HDR image contains the scene itself. It has enough room to preserve all light intensities as they are. You can re-expose this "canned scene" digitally as often as you want. By doing so, you take a snapshot of the HDR and develop an LDR print.

This technique is called tone mapping, and it can be as simple as selecting a focused exposure or as complicated as scrambling up all the tonal levels and emphasizing the details in light **and** shadow areas. You can even simulate the locale adaptation mechanism that our eye is capable of. Or you can go to the extreme and find new, painterly styles. Tone mapping puts you back in control. You choose exactly how the tonal values are supposed to appear in the final output-referring file. None of this slap-on gamma anymore. You decide!

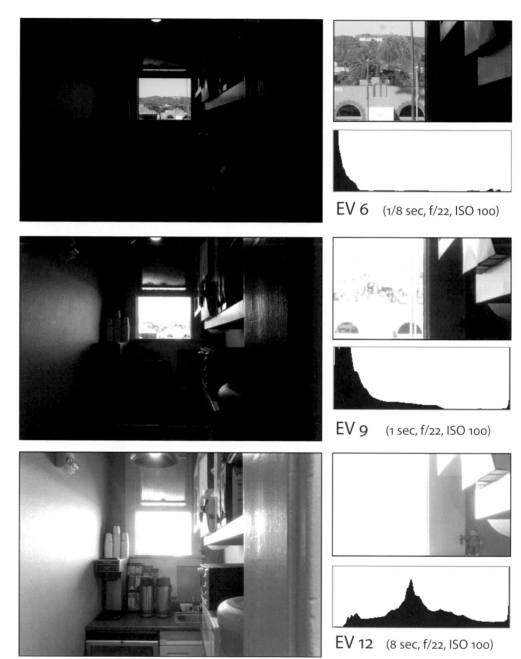

EV 6 (1/8 sec, f/22, ISO 100)

EV 9 (1 sec, f/22, ISO 100)

▶

Kitchen at EdenFX,
at three hopeless
exposures.

EV 12 (8 sec, f/22, ISO 100)

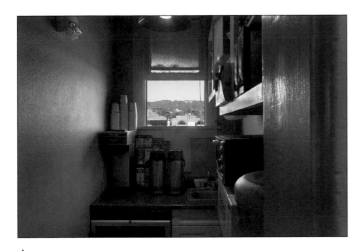

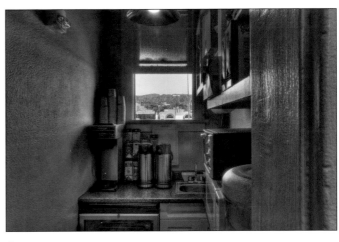

Manually tone-mapped HDR image can show the entire scene

Impressionist interpretation of the HDR image, emphasizing texture details

Let me give you a rather extreme example: A shot of an interior scene that includes a window to the outside, which is a classic case for HDR photography. In conventional imaging, you wouldn't even try this. There is just too much dynamic range within the view; it stretches across 17 EVs. Neither analog nor digital can capture this in one shot.

This scene is a typical kitchen for visual effects artists. It is very important that they see the Hollywood sign while they're pouring fresh coffee.

None of the single-shot exposures can capture this scene entirely. But once they are merged into an HDR image, exposure becomes an adjustable value. You can slide it up and down to produce any of the original exposures or set it somewhere in between to generate new exposures.

Or you can selectively re-expose parts of the image. In this case it was quite simple to draw a rectangular mask in Photoshop and pull the exposure down just for the window.

Other methods are more sophisticated and allow you to squash and stretch the available levels to wrangle out the last bit of detail. The second image was treated twice with the Detail Enhancer in Photomatix and selectively blended in Photoshop.

You see, there is an immense creative potential to be explored here. Tone mapping alone opens a new chapter in digital photography, as well as in this book. There is really no right or wrong—tone mapping is a creative process, and the result is an artistic expression. Exactly that is the beauty of it. Whether you like it or not is a simple matter of personal taste.

So much for the teaser. The thing to remember is that every output device has a specific tonal range it can handle, which can be fully utilized when the HDRI is broken down. Tone mapping takes an image from a scene-referred to an output-referred state. And how far you have to crunch it down depends on the range limitation of the final output.

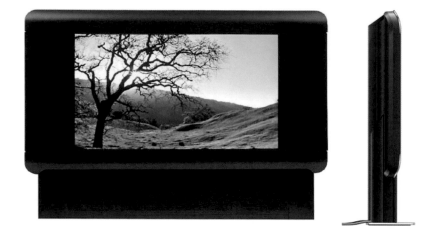

► World's first commercially available HDR display, the legendary DR37-P

1.5. Output Media

For photographers, the final output will often be a print on paper. As mentioned before, only quality photographic paper can hold a dynamic range of 6 EVs (or 100:1). Most papers are even lower. Hence, tone mapping all the way down to an 8-bit output will continue to be a prime goal for photographers. However, our modern world offers plenty of other media options, and they all rely on digital images. And this is where the importance of an HDR workflow comes in. Let me finally prove the bold statement that all digital imaging in the future will happen in high dynamic range.

The death of the cathode ray tube: Let's face it: CRT technology is outdated. Liquid crystal display (LCD) panels have taken the lead now, and nobody regrets this step. Even though they do not necessarily deliver a higher dynamic range, LCDs have to be cheated to work properly with gamma-encoded 8-bit imagery. Unlike CRTs, this is just not native to them. The basement that our house of 8-bit cards is built on has disappeared already.

The next wave in display technology will be HDR displays. A company called BrightSide Inc. has developed the first commercially available display of this type. Yes, they are real. And yes, the difference is huge! When I first saw the prototype at Siggraph 2004, I couldn't believe my eyes. It looks more like an open window than any monitor you have ever seen. Crystal-clear highlights that truly shine. And a black level that is so low your eyes actually have to adapt to shadow details. Remember how you stood in awe watching the first color TV in your life? It's that kind of feeling. You feel somewhat like you have always been betrayed because everything else literally pales in comparison.

And this display is not even that hard to build. Once again, Greg Ward was among the team figuring it out. What they did was replace the LCD backlight with an LED screen. So the backlight now has pixels, too, that can be leveled up and down. Where there are shadows in the image, there is no backlight at all. The screen gets totally black (or as black as the room lighting allows). Only where there is brightness in the image is there light shining off the screen. The LCDs make the color, and

the LEDs the luminance. In full words: It is a liquid crystal display with a light emitting diode screen behind it. Sandwiching them both into one device is the perfect blend of these two technologies.

In numbers, the BrightSide display can show contrasts of up to 1:200,000, which equals almost 18 EV. Compare this to 1:600 (or 9 EV) that the old cathode ray tube can display. At the current stage, it is an ungodly expensive TV to hang on your wall, but there is no doubt that it will trickle down to the mainstream eventually. Just recently Dolby Laboratories bought BrightSide Inc., and given Dolby's track record of high-end sound technology, you can probably imagine where this HDR display technology is heading.

On into a bright future

There are more display technologies coming up. Canon and Toshiba joined forces to create the surface-conduction electron-emitting display (SED). It is expected to hit the shelves in 2008 and has the potential to deliver a contrast of 1:100,000, which roughly equals 17 EV. Then we have laser projection coming up, which might even turn out to be holographic and coming from a device not bigger than a cigarette pack. And there are plenty of new variations to the organic light emitting display (OLED) technology coming on thin flexible screens. The key to all these new inventions is nanotechnology, the miracle science that dives deep into the structure of matter itself.

Any invention that is made in the twenty-first century is so much more sophisticated than the a CRT tube. Really, it sounds quite archaic these days to point a ray gun at the TV viewer and bend the electron beam just by using a magnetic field that pumps at the same rate as the power from the outlet happens to oscillate. The U.S. has a 60 hertz power frequency—fine, give them 60 frames per second. Europe's power grid has 50 hertz—well then let's refresh the screen just 50 times per second. Doesn't that sound like sledgehammer tactics?

Indeed, it is about time for some modern display technology. And believe me, as soon as you have an HDR-capable display at your house, you won't have much fun with your old LDR image archive anymore. The images will look faded and washed out. It will be the visual equivalent to playing back your old mono tapes on a hi-fi stereo.

Learn how to handle HDR images now! Preserve the dynamic range of your photographs instead of tone-mapping everything down. Be prepared for tomorrow's displays. They will pop up at your local electronics market much sooner than you expect.

Chapter 2: New Tools

In this chapter, we'll take a look at all the tools that come with HDRI. In some cases, I'll need to get very technical, but I'll refer to the practical application wherever possible. The main goal here is to give you an overview of the tools that can be incorporated into an HDRI workflow. Whether you adapt the workflow proposed later in this book will be a decision only you can make, but this chapter will provide you with the background knowledge you need to make educated choices.

2.1. File Formats

OK, so 8 bits are clearly not enough. You learned in Chapter 1 that HDR images are made of 32–bit floating–point numbers. This is the image data that sits in the computer memory when an HDR image is edited or displayed. We are talking about huge chunks of data here, much bigger and with a different structure than the regular 8–bit image. So we need new image formats that can store that HDR data.

Each image format has its own way of wrapping all this data into an actual file on disk. Important for us are some key elements: How good do they preserve the dynamic range? How widely are they understood? And most important, how much space do they take?

2.1.1. RAW Formats (.raw/.nef/.crw/.orf/.dng/...)

These formats are used as output for digital cameras, and there are as many variants as there are cameras out there. There is no such thing as one standard RAW format; they are all different from each other. Most variants deliver 10, 12, or 14 bits, which qualifies them as prime examples for a medium dynamic range format. It holds more range than in an LDR image, but it's still far from a true HDR image.

The Good and the Bad: Essentially, RAW is the direct digital equivalent of an unprocessed film negative. The data from the image sensor is dumped on the storage card with minimal alteration. Interestingly, most image sensors react to light in a linear fashion, so a RAW file is already set up in a linear color space, just like HDR images.

▲ **RAW**

Many digital photographers prefer to process this raw image data instead of having the cameras on–board software compress it down to an 8–bit JPEG, just as many traditional photographers prefer to rent out a darkroom and develop the film themselves instead of taking it to the drugstore around the corner. This analogy really holds up because RAW files generally include 1 to 2 EVs more at both ends of the exposure, which simply get clipped by the in–camera JPEG compression. And just like the film negative, a RAW file reveals all the sensor noise that is inherent close to the extremes of light and shadow.

Theoretically, shooting a RAW file would require minimal processing power since it really is just the plain uncompressed sensor data. In real life, the huge file size means it takes longer to save the file to the storage card than it would for the slowest processor to compress it. So the real bottleneck is the storage card—speed and capacity are both maxed out with RAW files.

Camera manufacturers quickly realized these problems, and many of them decided to apply some kind of compression anyway. Some compress in lossless ways; some use

lossy algorithms. Also, the architecture of the sensor chips can be substantially different from camera to camera, so the raw data stream is almost never conforming to the standard format. And just as EXIF data becomes more and more elaborate, there is more and more metadata embedded in RAW files these days. But unlike the JPEG format, there has never been an official standard notation for metadata in a RAW file. So every manufacturer just makes up its own standard.

And the Ugly: The result is a big mess of more than 100 different RAW formats that can drive software developers up the wall. Serious programming effort is needed to support them all; not even Adobe, with an army of coders, can do that. Unless your camera is highly successful in the mass market, like the Canon Digital Rebel line, chances are its RAW files can only be read by the manufacturer's software. This is a serious flaw because it is limiting your software choices, which either limits your creative toolset or sets you up for a complicated multi–conversion workflow. And if your camera manufacturer decides to drop the support for a three–year–old model, or simply happens to go out of business, you are in serious trouble. You might be left with your entire photo collection as unreadable garbage data.

The worst is that most manufacturers treat their own RAW variant as proprietary format, with no public documentation. Software developers have to reverse–engineer these formats, a very time–intensive, expensive, potentially faulty, and entirely boring thing to do. On top of that, some manufacturers even apply encryption to parts of their RAW files—a mean move that can have no other in-

tention than to cripple compatibility to other companies' brands of software.

This is unacceptable from a user's standpoint. That's why a group of concerned photographers came together and formed OpenRAW.org, a public organization whose mission is to convince the industry of the importance of documenting its RAW formats for the public. And it really is in the industry's best interest to listen to them because it has been shown in the past that compatibility and sticking to open standards can get a company much further than proprietary secrets and isolation. What happened to Minolta, whose JPEGs didn't even comply to EXIF standards? What happened to SGI and its proprietary operation system called IRIX? People saw their software choices limited and were voting with their dollars for a competitor that plays well with others.

Where is our savior? Adobe's answer was the introduction of the DNG file format in late 2004. DNG stands for "digital negative", and it's supposed to unify all possible RAW configurations into one format. It still contains the original data stream from the image sensor, which is different each time. But DNG adds some standardized metadata that precisely describes how this data stream is supposed to be deciphered. The file structure itself is very similar to TIFF and is publicly documented. Obviously, it is a format designed to replace all the RAWs on the camera level. But that hasn't happened yet. Only a handful of high–end professional cameras capture DNG directly now, and the support in the software world is just as sparse. Sadly, for a photographer, DNG is yet another RAW variant right now.

And just when it looked hopeless, a man named David Coffin came into the game, saw

the mess, rolled up his sleeves, and created an open source freeware RAW decoder that supports them all. He called it dcraw, and it looks like he really made it. At last count, it supports 266 different variants, and most applications that support RAW these days do it through dcraw. One man took on the burden of an entire industry by untangling that knot. Thank you, David, for this generous gift to the community!

OK, so does it make sense to shoot in RAW format? Absolutely yes, when you want to get the most out of your camera in a single shot. You will see later on that you can get way more out of multiple shots, and in that case, you might be fine with JPEGs.

But does it make sense to archive my RAW pictures? Maybe, but you should not rely solely on it. You must be aware that your camera–specific RAW format will have a life span that does not exceed the life span of your camera. But the purpose of an archive is to give you a chance to safely restore all data at any point in the future. A standard HDR format is much better suited for archiving because these standards are here to stay. The quality of the preserved data would be the same because an HDR image has even more precision and dynamic range built in than any of today's cameras' RAW files.

However, given the complexity of such a task with today's software, DNG would at least be a future–proof alternative. It's quite unlikely that Adobe will disappear anytime soon, and Lightroom, Photoshop, and Bridge already offer convenient ways to do exactly this conversion in a more convenient manner.

▲ **Cineon and DPX**

2.1.2. Cineon and DPX (.cin/.dpx)

Cineon was developed in 1993 by Kodak as the native output format of its film scanners. It quickly became the standard for all visual effects production because it is designed to be a complete digital representation of a film negative. Essentially, it's the RAW format of the movie industry. What's not in the Cineon file hasn't been shot.

One important difference is that Cineon files are meant to be worked with. They start their life on film, then they get digitally sweetened with all kinds of visual effects and color corrections, and then they are written back onto film material. There is no room for anything to slip. Cineon is a so–called Digital Intermediate that is between the film reel that was shot on set and the film reel you see in the theatre.

How to file a film negative: What sets Cineon apart is that it stores color values that correspond directly to film densities. As discussed in Chapter 1, film has a logarithmic response to light. That's why color values in a Cineon are stored logarithmically. It even has a mechanism built in to compress the contrasts at the upper and lower knee, just as in the density curve of film. In many ways a Cineon file is more closely related to HDR images

▶

Cineon pixel values correspond directly to densities on film material, thus sharing film's s-shaped response curve towards captured light intensites. Note that EV is a logarithmic scale, so the linear portion of the curve should be read as "precisely logarithimc".

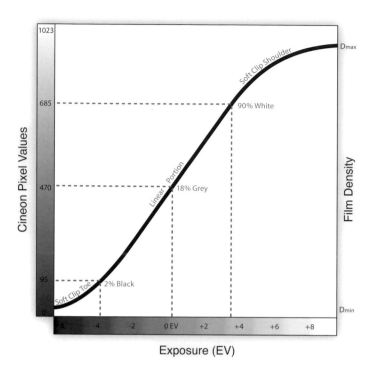

than traditional 8–bit images, even though it uses only 10 bits. That gives it 2^{10} = 1,023 different intensity values, which is not much to cover the whole dynamic range of film. Only the logarithmic distribution makes it possible to have enough of those values available for the middle exposures—the meat of the shot. This "sweet spot" exposure range usually is set between the black point at value 95 and the white point at 685. Lower or higher values are the extra dynamic range, values brighter than white or darker than black.

A Cineon file is not made to be displayed as it is. You have to convert the logarithmic intensities to linear values, ideally with a so–called lookup table, or LUT. A LUT is a tone curve that was generated by measuring the light response of film. It's slightly different for each film stock and usually done by the film manufacturer. Often, a generic conversion curve is good enough, but if you know the film

stock that was used, you should use the LUT specific to the film stock. This way, each value in a Cineon file is precisely tuned to match the density of the film negative, and it also points to a linear RGB value that can be displayed on–screen.

These 10 logarithmic bits expand to roughly 14 bits when you stretch them out to linear space, so it makes a lot of sense to convert into a higher bit depth. In 8–bit, you will inevitably loose a lot of details. A 16–bit format is better in precision but still of limited use here because it does not follow the logic of having über–white or super–black values. You can cheat it by setting a white and black point somewhere within the intensity, but either the image you see on–screen will appear to be low contrast or you clip off the extra exposures. Sixteen-bit images are not made for that. Exposure information beyond the visible

range is clearly the domain of HDR imagery, where there is no explicit upper or lower limit.

Unfortunately uncompressed: There is no compression for Cineon files, so they are always wastefully big. Each pixel on disk even includes 2 entirely unused bits. That's because 10 bits in three channels equals only 30 bits; they have to be rounded up to 32 to fit the next magic computer number. Cineons are hard to work with in a compositing environment since it involves dealing with multiple numbered frame sequences, which become huge in this case. A standard 2K resolution film frame takes up 12 MB. Always. There is no such thing as playing this back directly from disk at 24 frames per second on a desktop machine.

Digital Picture eXchange (DPX) is the predecessor of the Cineon format. It is slightly modernized by allowing a larger variety of metadata information. This makes it less dependent on the specific Kodak film scanner devices and makes it more applicable for general use. However, the basic encoding is still the same: uncompressed 10 bits per channel.

DPX and Cineon both only qualify as medium dynamic range formats. Even though they can hold more range than a traditional image, they are limited to represent what can be captured on film. They do catch up with film but don't exceed to fully use the potential of digital imaging. And as digital sensors start to exceed film, Cineon and DPX will fall back.

2.1.3. Portable Float Map (.pfm/.pbm)
Let's move the focus over to the really high dynamic range formats.

The Portable Float Map is a very simple format that is almost identical to the representation of a 32–bit floating–point image in

▲
Portable Float Map

memory. Essentially, it is a fully fledged RAW for HDR images.

A big dumb space eater: We are talking here about full 32 bits per pixel and color in a constant stream of floating–point numbers without any kind of compression. If you add that up, you need 96 bits, or 12 bytes per pixel; that is almost 4 MB for a simple NTSC frame, or 12 MB for a 1–megapixel image. It's huge! This format will eat its way through your disk space in no time!

The advantage of this format is its simplicity. Each PFM file starts with a little header that states in plain text the pixel dimensions of the image. Even a novice programmer can now design software that reads the image data stream. Every programming language on the planet knows the standard IEEE notation for floating–point numbers, so it really is a piece of cake to read one number for red, one for green, one for blue. And voilà—we have an HDR pixel! Do that for all pixels in a row (the header told you how many there are). And then start the next row. No compression, no math, no confusion. Simple and straightforward.

▲
Floating–Point TIFF

Who knows, it might have been invented before color monitors.

The TIFF format comes in many flavors, and when Adobe bought the format in 1994, it added even more variations. One substandard even applies a JPEG compression to the image data, mixing up the whole concept of different file formats having different characteristics.

Whatever you want it to be: In programmers' terms, TIFF is considered a wrapper—because the image data is wrapped in descriptive tags. It's the tagged file structure that makes a TIFF file so versatile because it allows all kinds of different image data to be included. Color space can be RGB or CMYK or something fancy like CIE L*a*b*, compression can be ZIP or RLE, the bit depth can be anything from 1 bit (black and white) to 32 bits per channel. You name it. As long as the data is labeled with the proper tag, the application knows how to deal with it. TIFF is just an acronym for tagged image file format. Well, that sounds good in theory. In reality, not every application supports every compression method or data format, and so it is quite easy to produce an incompatible TIFF. In fact, some features are supported only by the owner, Adobe.

Consequently, you are likely to see this format in prototyped software. HDRI is a very interesting medium for young computer scientists to develop revolutionary imaging technologies. The programs they write are considered a proof of concept, are often bare bones, and sometimes they perform only a single function. It can be very adventurous and a lot of fun to give them a shot, and in that case, the PFM format will be your buddy. Maybe that single function is a killer feature and you have no idea how you could live without it.

In any other scenario, the Portable Float Map is just a waste of space.

Please note that Photoshop prefers to call this format Portable Bitmap Map and uses the extension .pbm. The file itself is identical to a PFM file; it's just the filename extension that limits portability. So in case a program doesn't accept it, you just have to rename it.

Has all the features, but none of them reliable: However, even the original specification allows a 32–bit floating–point variant, often referred to as FP TIFF, TIFF32, or TIFF Float. This is pretty much the same raw memory dump as the PFM format, and so the file size is just as huge. Compression could technically be used here, but this limits the compatibility again. It doesn't make much sense anyway because old–school compression algorithms like LZW and ZIP are not made for crunching down floating–point data. In fact, the added

2.1.4. Floating–Point TIFF (.tif)
Hold on—aren't we talking about new file formats? Nothing is older than TIFF!

Yes, indeed. Today's TIFF files are still following a specification that dates back to 1992. And that was already revision 6 of the format.

◄

Confusing variety of Floating-Point TIFF options, that are only seen in Adobe Photoshop.

overhead can even cause a compressed TIFF32 file to be slightly bigger than an uncompressed one.

And since all features of TIFF can be combined however you want, a TIFF32 file can also have layers and extra channels, they can be cropped to a specific area, and they can have color profiles embedded. It's just that every program has its own way of reading and writing a TIFF, and so there is no guarantee that a feature will work. In a practical workflow, the plain uncompressed TIFF32 is often the only one that actually works.

For a long time the TIFF32 variant was considered a purely hypothetical, ultimate precision format. In the nineties, you would need a Cray supercomputer to deal with it, and so it was used primarily in scientific applications like astronomical imaging and medical research. Even though our twenty–first century laptops are able to beat these old refrigerator–like monsters with ease, it would be wasteful to use TIFF32 for all our HDR imagery. Especially in compositing, where we deal with image sequences in multiple layers, we would not get anything done because we would spend all day watching a loading progress bar.

What it's good for.: There are occasions, however, when this format comes in handy. In a workflow in which you have to use multiple programs in a row, you can use uncompressed TIFF32 for the intermediate steps. This way you eliminate the possibility of image degrading when the image is handed back and forth. There are other formats that minimize degrading, but nevertheless, even so–called lossless encoding/decoding can introduce tiny numerical differences. Only the straight memory dump method of uncompressed TIFF32 and

▲ **Radiance**

PFM makes sure the file on disk is 100.00% identical to what has been in memory. It is good advice, however, to get rid of these intermediate files when you're done—before you spend all your money on new hard disks.

2.1.5. Radiance (.hdr/.pic)

The Radiance format is the dinosaur among the true high dynamic range formats, introduced in 1987 by Greg Ward.

Accidentally founding HDRI: His original intention was to develop an output format for his 3D rendering software called Radiance, which was so revolutionary itself that it practically founded a new class of render engines: the physically based renderers. Unlike any other renderer before it, the Radiance engine calculates an image by simulating true spectral radiance values that are based on real physical luminance scales. For example, the sun would be defined as 50,000 times brighter than a light bulb, and the color of an object would be defined by a reflectance maxima. Chapter 7 will give you a more elaborate insight on physically based render engines.

However, these light simulations require the precision of floating-point numbers, and they take a long time. They are still expensive today, but back in 1985 there must have been an unbearably long wait for an image. Concerned about retaining all the precious data when the result is finally saved to disk, Greg Ward introduced the Radiance format. Initially, he chose .pic as filename extension, but this extension was already used by at least three entirely different image formats. Paul Debevec later came up with the suffix .hdr, which has been the primary extension ever since. This is how they both laid the foundation for high dynamic range imaging, which turned out to evolve into a field of research that has kept them engaged ever since.

The magical fourth channel: Back to the actual format. Radiance is the most common file format for HDR images, and the filename extension basically leads to the assumption it would be the one and only. And really, it does use a very clever trick to encode floating-point pixel values in a space-saving manner. Instead of saving full 32 bits per channel, it uses only 8 bits for each RGB channel. But it adds an extra 8-bit channel that holds an exponent. In short notation, the Radiance format is called RGBE. What this exponent does is free up the RGB values from the extra burden of carrying the luminance information and multiplies the possible brightness range. The real floating-point value of a pixel is calculated with this formula:

$$\frac{(R,G,B)}{255} * 2^{(E-128)}$$

It's a simple math trick, but very effective. Let's look at an example: A Radiance pixel is saved with the RGBE color values (100,100,130,150). The first three values describe a pale blue. Now, watch the exponent at work:

$$\frac{(100, 100, 130)}{255} * 2^{(150-128)} = (1640000, 1640000, 2140000)$$

Compare this to a pixel with the same RGB values but a different exponent, let's say 115:

$$\frac{(100, 100, 130)}{255} * 2^{(115-128)} = (0.0000479, 0.0000479, 0.0000622)$$

See, the exponent really makes the difference here between blue as a desert sky and blue as the entry of a cave in moonlight. It is a very elegant concept, and a math–minded person can easily see the poetry in its simplicity. Using only 32 bits in total, symmetrically split in RGBE channels, we can store a color value that would have taken 96 bits all together. That's why even an uncompressed Radiance image takes up only a third of the space a floating–point TIFF would take.

More range than we'd ever need: Note that we only changed the exponent by 35. But just as with the 8–bit color channels, we have 256 different exponent levels at our disposal. The full numerical range is more than seven times higher than in our example. Actually, this example was chosen carefully to stay within the numerical range that a human mind can grasp. It literally goes beyond the gazillions and the nanos. The dynamic range that this format is able to hold is truly incredible. Speaking in photographic terms, it's 253 exposure values, much higher than any other format can offer. It's even higher than nature itself. From the surface of the sun to the faintest starlight visible to the naked eye, nature spans about 44 EVs. And it is unlikely we will ever take a picture with both in it. A usual, earthly scene

doesn't exceed 20 EVs, even when it's shot in difficult lightning conditions.

Technically, that much available variable space is a waste. Since we will never need that much range for an image, uncompressed HDR files always contain a whole bunch of bits that are just plain zeros. Instead of having 10 times the range that we could possibly use, the format could have 10 times the precision. That way, the colors we actually use would be even better preserved and we would have even less of a risk to get banding and posterization through subsequent editing steps. However, the precision of the Radiance HDR format is still way beyond any 8– or 16–bit format, and since every image source introduces at least some kind of noise, the Radiance format is more than precise enough for general photographic use. Also, there is a run–length encoding (RLE) compression available for this format, which means that the filled–in zeros get crunched down to almost nothing. It's a lossless compression by nature, so you should definitely use it—you can save roughly 30 to 50 percent disk space with it.

But there is another, more serious caveat to the Radiance format. Since the base color values are set in regular RGB color space, it suffers from a limited color gamut, just like many other traditional RGB formats. It's not exactly

▲ **TIFF LogLuv**

as tight because it can keep color consistent through the whole range of intensities. The available color palette in 8–bit RGB gets very limited close to white and black—simply because all three values are so close to the limit that you have no room left for mixing colors. A Radiance HDR would leave the RGB values alone and make the exponent bigger instead. However, an experienced photographer knows that CMYK is much better in representing printable colors, for example, and if you save an image in RGB, you might have some colors getting clipped off. The same goes for TV production—the NTSC color space is substantially different from sRGB, and you will never know how your final image looks if you don't have a calibrated NTSC control monitor.

Clipping colors is pretty much the opposite of the preservative concept behind HDRI. And even though the Radiance format specifications feature a variant in XYZ color space, that doesn't help us much because this variant is not widely supported.

So when should we use this format, then?
We should use the Radiance format whenever dynamic range is the main concern over

color precision. In image–based lighting, for example, we are aware of the colors getting all scrambled up in our render engine anyway. It's the intensities that we want to feed these algorithms so they can deliver a good lighting solution. We will talk about the details in Chapter 7.

The second major advantage is portability. Radiance HDR is the most common format among the software packages that can work in high dynamic range; in fact, it is the only one that works everywhere. That might be due to its elegant formula and the simplicity of implementation. You would not even need a library or DLL because even a novice can hard–code this conversion. Or it might be due to the historical age of the format or simply the filename extension .hdr that makes it so popular. We don't know. Fact is, Radiance HDR is a well–established standard format, and you are doing good using it when you want to keep all software options open.

2.1.6. TIFF LogLuv (.tif)
Oh no, not another TIFF format!

Yes. TIFF is a 10–headed hydra, and this is yet another head. It's by far the one with the most human–looking face because it stores colors based on human perception.

Greg Ward, once again, developed this format in 1997 when he realized that the popularity of his Radiance format took off in unexpected ways. He was entirely aware of the color and precision limitations that are inherent in the RGBE encoding. So he went back to the drawing board and sketched out the ultimate image format, designed to become the future–safe standard for high dynamic range imaging.

Made to match human perception: And indeed, technically the LogLuv encoding is superior to all others in overall performance: It can represent the entire range of visible colors and stretches over a dynamic range of 16 EV with an accuracy that is just on the borderline of human vision. And it manages to pack all that information in 24 bits per pixel—just the same amount of space that a traditional LDR image takes. It's that efficient.

How is that even possible?

First, instead of the RGB color space, it uses the device–independent LUV color space, the same space that the reference CIE horseshoe diagram is set in. That's how it makes sure that it can really show all visible colors. L represents the luminance, which is logarithmically encoded in 10 bits. That means the smaller the value, the smaller the increments, which is pretty close to the way analog film reacts to light intensities. And as we discussed before, this just happens to be the way the receptors in our eye respond, too.

Now, what it does to the UV color coordinates is so ingenious, it's almost crazy! Instead of picking three primary colors and spanning a triangle of all the representable colors as RGB and CMYK formats do, it simply puts an indexing grid on the entire horseshoe shape of visible colors. It basically assigns each color a number, starting the count from the low purple–bluish corner. The resolution of this grid is set so high that the color differences are just imperceptible to the human eye. Fourteen bits are used for this index, so we are talking about $2^{14} = 16{,}384$ true colors here.

Sounds good, doesn't it? Everything perfectly aligned to the margin of human vision. The perfect image file for a human beholder, but a perfect nightmare for a programmer. This is not a very convenient way of encoding. It is

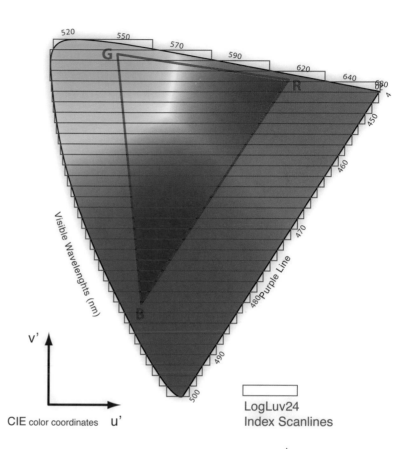

CIE color coordinates u'

LogLuv24
Index Scanlines

▲

TIFF LogLuv's indexed color scheme covers the entire range of visible colors.

super–efficient, but converting RGB to LUV color space first and then using a lookup table to find the color index—all this is somewhat missing the elegance.

There is a variant that uses 32 bits per pixel instead of 24. This one is a little easier, and it's also more precise. Here we have 16 bits instead of 10 for the luminance, and the color values are stored separately in U and V coordinates with 8 bits each. So, it's better suited for images that are not yet in the final stage of editing because there is more room to push pixel values around without having them break through the threshold of human vision.

▲ **OpenEXR**

Using TIFF LogLuv in practice: Even though the overall performance and efficiency of Lo-gLuv encoding is unmatched, it never became the standard that it was designed to be. Only a few programs fully support it. Some applications can load it but don't offer it as a saving option. Some support the 32–bit variant, but not the indexed 24–bit version. Some programs even think they are loading a floating–point TIFF and load it up as pixel garbage. And from a user standpoint, it is a disaster that it shares the common .tif filename extension, because there is no other way of determining the level of support than the old trial–and–error game. The problem lies within the fact that every program uses a different way of reading and writing TIFFs. If they all would just link to Sam Leffler's library, everything would be fine. But then again, they would be missing other TIFF features that are only available in other libraries.

Bottom line: TIFF LogLuv is just too good to be true. You simply can't rely on it as an exchange format unless you run a test.

2.1.7. OpenEXR (.exr)

OpenEXR is the new shooting star among the HDR image formats. It was born in visual effects production and is specifically designed for image editing and compositing purposes.

It's also the only image format that won the Oscar Award.

Florian Kainz developed this format at Industrial Light & Magic (ILM) in 2000 because he saw none of the existing formats fit the needs of the company. For those few readers who have never heard of ILM, it's the visual effects house of George Lucas and primarily responsible for the effects in the Star Wars saga. The first movie ever completed entirely in EXR was "Harry Potter and the Sorcerer's Stone", and since then this format is used exclusively with all the in–house tools at ILM—it seems to serve them well.

ILM released this format to the public in 2003 as open source. It prepared a great package for developers that includes detailed documentation, code pieces from working implementations, and even example pictures that can be used for tests. Obviously, that was a move to encourage software vendors to make their products fit into ILM's production pipeline. And the response was overwhelming—everybody wants to have ILM on their client list. The beauty of it is that this made OpenEXR widely available for the rest of us too.

16 is the new 32: OpenEXR is indeed a beautifully crafted format. The core specification is based on the so called "half" data type. That means it rounds each color channel's 32–bit floating–point numbers down to 16 bits. That might sound like a drastic decrease, but in reality it's all the precision you need. It's certainly much more precision than the Radiance HDR and TIFF LogLuv have to offer because it keeps the color channels separate at all times. So all three RGB channels add up to 48 bits per pixel, 16 in each channel. Don't confuse this with a traditional 16–bit format—those are

all regular integer numbers, but we are talking about floating–point numbers here. They are substantially different!

The 16 bits here are split into 1 sign bit, 10 bits mantissa, and 5 bits for an exponent. Effectively this mantissa allows you to save $2^{10} = 1,024$ different color values for each channel. If you multiply all three channels, you get about 1 billion possible colors—independent from the exposure. So these are 1 billion colors per EV. This is more than any other format can offer (except maybe the space hogs PFM and TIFF32). And in terms of dynamic range, this is what's carried in the exponent; each exponent roughly equals one EV. That means, OpenEXR can hold about $2^5 = 32$ EVs, which is very reasonable for photographic image sources.

For true dynamic range freaks, there is also a full 32–bit floating–point variant. In most applications this is just bloat, though, and all it does is slow you down. It's comparable to the floating–point TIFF again. The 16–bit version is significantly faster to work with. First of all, it loads and saves faster, but more interesting is that it is natively supported by modern graphic cards from NVidia and ATI. If you are shopping for a new graphics card, look for the "CG shader language" feature. The next generation of image editors will be able to use this for doing all kinds of heavy–lifting work on the GPU, and then you won't even notice the difference between editing an HDR or an LDR image anymore. Sixteen-bit floating point is on the fast lane to becoming one of the hottest trends right now. Programs like Fusion5 and ChocoFlop already offer 16–bit FP as color depth to work in, and there are surely more to follow.

Compression and features: OpenEXR also offers some very effective compression methods. Most widely used is the PIZ compression, which is a modern wavelet compressor at heart. It is lossless and specifically designed to crunch scanned film images down to something between 35 to 55 percent. Another common lossless compression is ZIP, which is slightly less effective but faster. Where speed is a concern, like for 3D texture mapping or compositing with many layers, this could be a better alternative. PIZ and ZIP are both widely supported, and you can't go wrong with either one. There are many other compression methods possible in OpenEXR, and the format is prepared to have new ones included.

Sounds good? Wait—here is the real killer feature! OpenEXR is the only HDR format that supports arbitrary channels. So besides a red, green, and blue channel, it can also include an alpha channel. And others, too—like depth, shadow, motion vectors, material—you name it. These channels can have different compression, different precision (16– or 32–bit), and even different pixel resolutions. That makes it the ideal output format for 3D renderings because it gives you the freedom to fine–tune every single aspect of a rendered image in a compositing software.

Another, truly unique feature is the separation of pixel size and viewer window. For example, an image can have a 100–pixel margin all around the actual frame size. These out–of–frame pixels are normally invisible. But whenever a large–scale filter is applied to the image, like a Gaussian blur or a simulated camera shake, this extra bit of information will be invaluable. On the flip side, the pixel space can also be smaller than the actual frame size. That way, you have a predefined placement for the pixel image, which can be convenient

High Dynamic Range JPEG

2.1.8. High Dynamic Range JPEG (.jpg/.fjpg)

All the formats we talked about have one thing in common: They preserve the image in a lossless way. Saving and reloading the file will cause no loss in quality; ideally, the file will be identical down to the bit. This is great for editing and archival, but even the smartest encoding method will produce quite a large file.

But high dynamic range imaging is reaching a state where the applications are appealing to a wider audience. It's inevitable that it will replace traditional imaging in the not–so–distant future. There are already HDR monitors commercially available, and if you have been to a modern movie theatre lately, you might have seen a digital projection that reproduces more DR than traditional images can handle. Digital cameras are tapping into higher ranges too, but the only way to benefit from this is through a jungle of RAW formats. Most people don't really shoot RAW because they prefer demosaicing the sensor data themselves. It's the extra bit of dynamic range, and the ability to fine–tune exposure settings, that attracts 90 percent of the RAW users, according to a survey from OpenRAW.org. And this is just the beginning. Over the next couple of years, both ends of the digital imaging pipeline, input and output devices, will become high-dynamic-range capable.

What we desperately need is a final output format in HDR so we can feed those images efficiently through low–bandwidth channels to all our new gadgets. Common bandwidth constraints are the Internet, wireless networks, and just the limited capacity of a consumer–grade device. We need a format that is comparable to JPEG, providing a compression ratio that might be mathematically lossy but visually acceptable.

for patching a small piece of a 3D rendering that went wrong. Well, at least it works great for ILM artists; but both of these features are sparsely supported in applications on our side of the fence. Currently, Nuke is the only compositing application that can work with it, and all 3D apps have to be patched with plug–ins. It's coming, though. Photosphere, for example, is already using this window property as the default clipping frame for display.

OpenEXR is a true workhorse. It's so powerful and flexible that even Pixar abandoned its own image format, which used to be a logarithmic TIFF variant similar to the Cineon format. Instead, Pixar jumped on the EXR bandwagon and even contributed a new compression scheme called PXR24.

The only reason not to use EXR would be when your favorite software doesn't support it. In that case, you should instantly write a complaint email to the developer and then go on using the Radiance format instead.

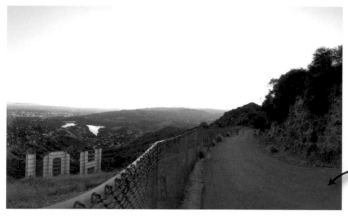

▲ ERI-JPEG: Base image as seen by any regular JPEG viewer. ▲ Residual ERI image, hidden inside the metadata.

The story of ERI: A first attempt was made by Kodak. In 2002, it introduced the ERI–JPEG, which stands for Extended Range Imaging JPEG. What Kodak did was generate a regular JPEG image and use the EXIF metadata as carrier for additional range information. It literally puts a second JPEG inside that holds the additional shadow and highlight details of areas where the regular image is clipped off. The beauty of this is that for an image where the whole range actually fits in, this difference is down to nothing. And so the file is just as big as the primary plain JPEG. When there is additional dynamic range, the file size increases accordingly, which is very reasonable for the amount of extra information. It is at least a million times more efficient than preserving extra dynamic range with RAW files.

The resulting ERI–JPEG is fully compatible to the EXIF2.1 standard. A software that doesn't understand the extra range information can still open the low dynamic range part without any problems.

Unfortunately, this applies to almost every program. After being around for four years, ERI–JPEGs can still only be interpreted by Kodak's own software, like DSC Photo Desk and FFM Photoshop Importer. We're back to the old problem of proprietary RAW formats. We are even dealing with a prime example here because the camera line that this format was originally developed for, the Kodak DCS Pro, has been discontinued after only two years on the market. So if you happen to be the owner of one of these $5,000 to $8,000 cameras, you'd better convert your photo library to OpenEXR soon because support from Kodak will run out in 2008, probably along with the warranty of the last camera sold.

It seems as if Kodak was a bit too far ahead of its time. Apparently, it is not making any effort to implement ERI–JPEGs in its consumer–grade cameras either. Doctor, I think it's safe to declare this patient dead.

The way of FJPEG: FJPEG stands for Floating Point JPEG, which was developed by Helmut Dersch in 2003. Professor Dersch holds a hero status in the panorama community for the creation of his PanoTools software suite, which represents the foundation for most high–quality panoramic stitching software today. We will get back to that later.

In essence, FJPEG follows the same approach of abusing the metadata for dynamic range data. But the range increase is achieved differently. Dersch adopted the RGBE approach from the Radiance format. Remember? The math trick with the exponent? Each of the RGBE channels in itself is just regular 8–bit. So, Dersch simply splits the RGB channels off and makes a regular JPEG out of it. The E channel is used to form a greyscale image and sneaked into the file. If that sounds like a hack, that's because it is.

But it works. To date, FJPEG is the only true HDR format that works on the Internet. That's because it was originally written for Dersch's own PTViewer, a free Java applet. This is a nice little compatibility shortcut because Java applets don't require the installation of anything extra. They can be run off the server that hosts the images. As long as the browser is Java enabled, it can display the HDR image directly. The image is dynamically tone–mapped for display with a very simple exposure+gamma method. You can either set the exposure via shortcuts or pan around in autoexposure mode.

However, the drawback is that the PTViewer applet is the one and only piece of code that reads FJPEG. There is no sign of direct application support anywhere, and if Dersch hadn't made a command–line utility for converting HDR to FJPEG, we couldn't even generate an FJPEG. Also, support by all HDR–capable software might not be the best option because the format itself is seriously flawed.

The RGB part of a Radiance HDR image, and thus the base image of an FJPEG, looks entirely scrambled when seen with a regular JPEG viewer. These channels were never intended to be seen without getting scaled up to their true exposure level by the exponent. Hence, every EV is forming a separate band of hues and shades.

The exponent, on the other hand, is not applied on a per–pixel basis but rather shared across an 8x8 pixel block. This has something to do with the way JPEGs are encoded in general; the geek term for the encoding method is Discrete Cosine Transformation (DCT). We have all seen the effect of it a million times as JPEG blockiness, mostly pronounced as artifacts at low–quality settings. Eight by eight

◄

Tapping through exposures in an FJPEG, directly in Safari via PTViewer

◄

FJPEG as it appears in a regular JPEG viewer

pixel blocks are somewhat like the atomic elements of a JPEG. But it is a very crude assumption; the whole block would be on the same exposure level and thus could share the same exponent. That works fine for smooth gradients and mostly continuous areas, but on hard edges with very strong contrast, this assumption falls entirely flat. Backlit objects and sharp highlights are where the regular JPEG artifacts are getting amplified, until that pixel block is totally wrecked.

This is FJPEG. Far from perfect, but the best we have right now. Actually, these pictures don't really do it justice; the actual sensation of adjustable exposure in a web image

is still a breathtaking experience. Make sure to check out the gallery on www.hdri–handbook. com!

The future of JPEG–HDR: Once again, we have a format that was made by Greg Ward, teaming up this time with Maryann Simmons from Disney. They crafted this format in 2004, so we have a nice constant flow of high dynamic range JPEG formats popping up every year. Except that this time, they got it right.

JPEG–HDR uses the same metadata trick the others use, but it goes one step beyond by adding another level of preparation. The base image is a tone–mapped representation of the

▲ FJPEG
Far from perfect, but the best we have right now

Unlike the ERI format, where the base image shows only the middle exposure window, this one shows all the details across all the exposure levels within. It scales the dynamic range in a smarter way instead of cutting it off.

Smarter applications that can find the hidden ratio image can recover the original HDR image. In Photosphere, for example, I could tap through the exposures and it would look just like the FJPEG in PTViewer—but without the artifacts. I could even go ahead and manually re–tone–map it into exactly what I want for print. Because everything is still there.

JPEG–HDR is an excellent way of handling backward compatibility. And it is an important issue because the legacy of 8–bit imaging is huge. JPEG has an immense installment base; every device or program that has even remotely something to do with digital images can handle JPEGs. And this is not likely to change anytime soon. Having a compatible HDR format like this, one that even takes the limitations of 8–bit imaging into account, allows for a smooth transition. If the new camera model XY can handle internally a higher dynamic range than it can fit into a JPEG, this is a true alternative to inventing yet another RAW format. Over time, JPEG–HDR could become the next standard.

Are we there yet? Unfortunately, not quite. Even though this format is documented well, every implementation had to be licensed by BrightSide Technologies Inc., who owned this format for years. Even though the license has always been free of charge, it still represents a hurdle that has hindered widespread support. Just the word license brings to mind images of a big red neon sign labeled "outside dependency" in management offices. What it takes is a major player to throw the first stone. And

original HDR image and fully complies with the existing JPEG standard. The extra dynamic range is hidden in the EXIF metadata in the form of a ratio image. This ratio image is substantially different from the other formats—it is much smaller while preserving much more dynamic range.

Old–school applications think it is a regular JPEG and show the tone–mapped version instead. That means even an application that is limited to work with 8–bit imagery doesn't show clipped highlights. The image is pre-processed to maintain all color information.

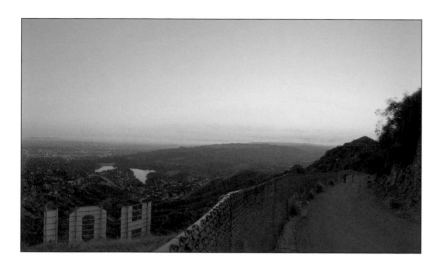

◄

JPEG–HDR in a simple JPEG viewer

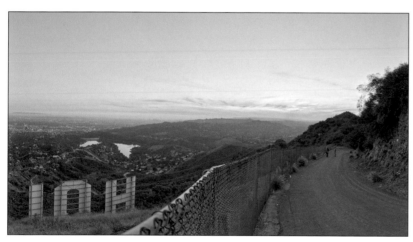

◄

Manually tone–mapped representation

it looks like we have a winner: Dolby bought it, along with the whole BrightSide company. That is a big step forward. We all know how successful Dolby is in marketing and branding its technology. If there is the need to be compatible with someone of that scale, everyone will jump on the bandwagon.

So, what's state of high dynamic range JPEGs? Kodak's ERI–JPEG was a nice try, but it hasn't come very far. FJPEG is a hack, but it works in every browser here and now. JPEG–

HDR is the sleeping princess that will come and claim the throne any moment.

2.1.9. Windows Media Photo (.wdp)
Microsoft has just recently introduced this new image format, which comes along with the highly anticipated Windows Vista. Apparently, it aims at tackling Apple's Mac OS X in the amount of built–in features and out–of–the–box applications. A new photo library and customizable slide shows are integrated on the system level. Windows Media Photo, as the youngest member of the Windows Media

family, is the native format all that is build upon. Even though the logical file extension would be .wmp, this is already used as an acronym for Windows Media Player. To avoid confusion, Microsoft settled on .wdp. Please note that it is considered impolite to call this format "wimp".

WDP is a very flexible standard, and once again it's a TIFF–based format in its basic layout. It is a container that allows all kinds of image data, as long as it's properly labeled and tagged. Most good encoding methods that make other formats unique can be used in a Windows Media Photo file too. It supports the 16–bit floating–point notation known as the half data type from OpenEXR as well as the RGBE Radiance encoding. On top of that, it can have embedded EXIF and XMP metadata, ICC profiles, and alpha channels. Another strong selling point is a novel compression scheme, which is, according to Microsoft, out-performing JPEG in quality and speed. It's a wavelet compression, similar to JPEG2000 or the PIZ compression known from OpenEXR.

It is hard to predict how well this format will perform. Given the track record of WMA for audio and WMV for video, it will have a hard time running up against already well–established standards, especially when these standards deliver equal or better quality and are superior in portability and availability. However, WDP might be able to occupy the slot for HDR imagery on the Internet. With a strong installment base like Windows behind it, which even brings the necessary set of viewing tools with it, the masses could get a taste of HDRI.

2.1.10. Private formats

As numerous programs started working in 32–bit floating point, they added it to their own proprietary file format. These proprietary file types are not standardized at all; some are not even documented. Usually they are intended to work only in the software they come with. Even if a third party claims to support a particular file type, the support is often possible only by reverse–engineering and might stop as soon as the owner changes the specification or adds new features without notice. That happens all the time; that's the whole point about having a private file format.

So be careful! Here is just a quick list:

PSD (.psd)	Photoshop file; a close relative of floating–point TIFF
PSB (.psb)	Photoshop big files; special format that can grow bigger than 2 GB
FLX (.flx)	LightWave's native 32–bit format; can have extra channels embedded
ATX (.atx)	Artizen HDR file; allows layers
ARTI (.arti)	Artizen file; layers and vector support
MAP (.map)	SOFTIMAGE\|XSI texture map; direct memory dump
CT (.ct)	mental ray floating–point image
PFS (.pfs)	Used as intermediate format for data exchange between command-line modules of pfsTools
SPH (.sph)	Raw panorama files captured with a Spheron camera

There might be more; these are just some of the most common ones. The noteworthy point is that none of them makes a good exchange format.

	TGA* (8 bit RGB reference)	PFM	TIFF float	Cineon, DPX*	TIFF LogLuv 24 / 32	Radiance HDR	OpenEXR	JPEG–HDR	Windows WDP
Channels	RGB (+Alpha)	RGB	RGB (+Alpha +...)	RGB	L+Index / Lu'v'	RGBE	RGB (+Alpha +Depth +…)	YCC	RGBE
Total Bits per Pixel	24	96	96	32	24 / 32	24	48	variable	variable
Compression	RLE	–	ZIP, LZW	–	RLE	RLE	PIZ, ZIP, RLE, PXR24, ...	JPEG	Wavelet
Covers All Visible Colors (Gamut)	–	–	✔	–	✔	–	✔	✔	
Colors per EV **	≈2 Million	4.7×10^{21}	4.7×10^{21}	90 Million	1 Million / 33 Million	16 Million	1 Billion	variable	variable
Precision	●○○	●●●	●●●	●●○	●●○	●●○	●●●	●○○	●○○
Dynamic Range (EV)	8	253	253	12	16 / 126	253	30	30	
Application Support Level	●●●	●○○	●●○	●●○	●●○	●●●	●●◐	●○○	○○○

2.2. Comparison of HDR Image Formats

Based on the detailed reviews, I have compiled a comparison table for you. This sums up all the important points, and can be used as a quick guide for setting up a high dynamic range workflow.

Notes:

* Targa and Cineon are not real HDR formats. They have just been included as common reference points so you have some familiar formats to compare with the others.

** Colors per EV is my own scale to quantify the precision of color information independent from the dynamic range performance of a format. Numbers were derived with varying methods. For a format that has a separate exponent, it's simple: Let's say OpenEXR uses 10 bits of mantissa for each color, which makes 2^{10} = 1024 values per channel, which makes $1024^3 \approx 1,000,000,000$ colors. Since each exponent can roughly be seen as one EV, that would be 1 billion unique colors per EV. For 8–bit TGA, it's an entirely different case. Here the I divided all the colors by the stops this format can properly handle, such as $256^3/8$ = 2,000,000. Be aware, though, that this is a very rough estimation since this number is seriously skewed by gamma encoding.

	TGA (8 bit RGB reference)	PFM	TIFF float	Cineon, DPX*	TIFF LogLuv 24 / 32	Radiance HDR	OpenEXR	JPEG–HDR
compared Compression	RLE	–	LZW	–	RLE	RLE	PIZ	JPEG quality "Best"
Full HD (1920x1080)	6.0	23.8	13.2	8.0	5.0	6.2	6.4	0.5
10 MP Photograph (3872x2592)	26.2	115.0	104.1	38.4	22.2	24.5	18.7	1.8
32 MP Panorama (8000x4000)	88.9	366.3	140.2	122.2	58.8	87.8	59.6	4.8

▲ Filesize (in MB) of example images in different formats

▲ 1080 HD Frame

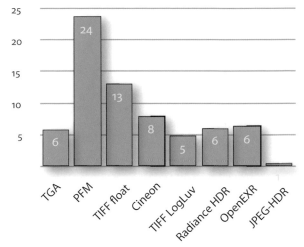

Size matters! But what we really want to know is how big these files are. I have picked three different test images of varying complexity and image size. Each image was saved with the most common compression option. Unfortunately, I couldn't find a single program to work with Windows WDP, so this one falls flat. Also note that the LZW compression in TIFF Float can be a compatibility problem. The safe route is uncompressed TIFF Float, in which case these files are just as big as the PFM files.

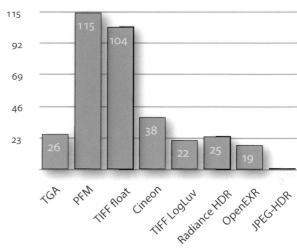

▲ **10 MP Photograph**

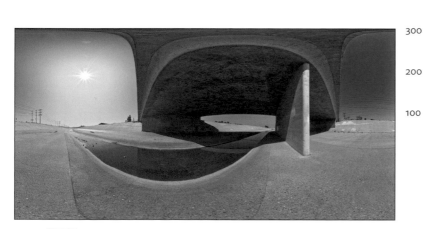

▲ **32 MP Panorama**

Conclusion: OpenEXR offers the best overall performance, with a balanced mix of efficient compression, sufficient range, and superior color precision. Its unique ability to handle arbitrary channels makes it the perfect choice for compositing and postproduction.

Radiance HDR comes in second place, with extreme dynamic range but less accuracy in color preservation. The absence of an alpha channel is one particular drawback that makes it less useful for compositing and image editing. However, it still has the broadest support base and should be preferred when portability is the major concern.

Note that both formats turn out not bigger than a Targa image and certainly much smaller than Cineon or DPX.

Mac OS X:
Setting up a
Finder window
as rudimentary
thumbnail viewer

2.3. HDRI Software

Parallel to these new image formats, new software had to be developed. This was an urgent necessity because traditional applications used to work internally with 8 bits per color channel. Supporting a 32–bit format in such an application requires quite a bit more than just a simple loader plug–in. The entire architecture needs to be updated to work in floating–point precision, which in turn means that literally all image processing functions have to be rewritten. Obviously, this can be a heavy task for big applications that are already loaded with functionality. Photoshop, for example, is having a hard time catching up here.

Other applications that have been designed from the start to work in floating–point precision have it much easier. They might offer less general functionality than Photoshop, but they are definitely ahead when it comes to performing specific tasks that are typical for an high dynamic range workflow.

In the following sections, I will give you an overview. I purposely concentrate on programs with a graphical user interface. There are plenty of command–line–only tools around too. But our main focus is on usability and support and how they would integrate in an artist–friendly workflow.

2.3.1. Small Utilities: HDR Viewer and Browser

OK, first of all we need to get your system up and running.

Mac OS X Tiger 🍎: Mac users have a slight advantage here because Apple's OS X 10.4 (nicknamed Tiger) has support for OpenEXR and Radiance HDR built right in. They show up as thumbnails in a Finder window, just like any other image. In fact, good old Finder does a better job here than 90 percent of the dedicated thumbnail browsers and image library programs. To manage your HDRI collection, you can simply set your Finder to Icon view, and set the icon size to the maximum.

Also, the standard Preview viewer is able to show EXR and HDR files natively. It might not be that obvious because in the standard configuration of OS X, it is not the default application. Surprisingly, it's not even registered as a recommended application – you literally have to force–feed an HDR image into Preview.

Don't worry, you only have to trick the Finder once. If you check the Always Open With box, you are all set. From now on, you

◀

 Forcing a Radiance
HDR to open in
Preview

◀

 Preview's Image
Correction panel...

 ... sports an Expo-
sure slider, that is
surprisingly power-
ful on HDR images.

▼

can see HDR images by double-clicking them in Preview. Here you can call the Image Corrections palette from the Tools menu and you get access to the Exposure control.

Applied to an HDR image, this Exposure slider is much more effective than it used to be. It takes some seconds to initialize when you touch the slider, but then you can scan through all the available dynamic range at blazing speed. And I really mean it; the response of that exposure adjustment is fast

Lobby-Center_3k.hdr Pixel (1670, 948) Color (0.208 0.043 0.016) Scale (1) Stops (−1.3)

Zoom In	
Zoom Out	
Expose Up	+
Expose Down	−
Reset Exposure	
Save As Bitmap…	
About…	

▲ **HDRView**
Note the menu that comes up when right-clicking in the image.

like a bullet train. Truly interactive feedback. That's how we like it.

However, you need to be aware that Preview is … well, just a preview. There is no numerical indication of the exposure level you are looking at, nor is it very accurate in color reproduction. Especially on smooth gradients at low exposures, it tends to show nasty color banding even though the image data itself is clean and smooth.

This basic system–level support is a beautiful thing because it automatically trickles down to many other image and thumbnail organizers. The simple ones are affected, the ones that have no internal image decoder and rely purely on the Cocoa system to get an image from disk to display. Such tiny freeware applications are, for example, VitaminSEE,

ThumbsUp, and shareware like PhotoReviewer and GraphicConverter. However, this coincidental HDRI support is always very basic—they all show HDR images in their naked linearity instead of preprocessing them with a display gamma, and there is of course no exposure adjustment.

HDRView ▦: HDRView is a lightweight image viewer that is essential for quickly looking at an HDR image in Windows. It's free of charge, so just download it to your Programs directory and assign it as the default application for HDR files.

Once you open an image in HDRView, you can change the exposure level in single EV intervals with the + and – keys. Also, you can Shift+click on point in the image and the dis-

▲ **exrdisplay**
The reference viewer, supporting the essential display adjustments for OpenEXR

play gets auto–exposed to that point. There is also a right–click menu, which is not quite so obvious.
www.debevec.org/FiatLux/hdrview

exrdisplay ⊞ 🍎: exrdisplay is another essential little helper that will make it much easier to work with OpenEXR images. Handling is a little different than in HDRView, which can sometimes lead to confusion. Instead of keyboard shortcuts for zapping through the exposure levels, you get a floating window with a slider.

Actually, you get a couple of sliders. Knee Low and Knee High refer to the density curve of film, previously seen in the Cineon format

settings as well as on analog film. Since EXR has a strictly linear brightness curve, you can smooth out the end, making it more look like a film curve. Essentially, this is a basic form of tone mapping, enabling you to see more of the image. There is one thing that spoils it for photographic use. No zoom capabilities! It always shows actual pixels; you cannot zoom out of a 12–megapixel image.

The Windows version is available directly from the download section of www.openexr.com. It's a bit hidden, though—download the archive containing precompiled binaries and look into the bin folder. There you will find exrdisplay.exe. So to speak, it is the Mother–of–all–EXR–viewers, the reference application

▲ JahPlayer
plays back OpenEXR
sequences, but
works with still
images as well.

JahPlayer ⊞ : JahPlayer can load frame sequences in EXR format and play them back from memory at full speed. That's especially useful for compositors and 3D artists who want to check an animation. However, it does work well on stills too. As a photographer, you can just drag and drop EXR images onto the viewport. It generates a little thumbnail bar, called a reel, that it remembers for the next time you launch it. You can even save several reels to disk, so it can be used as a basic image library.

The display quality of the viewer is very clean. It automatically does some kind of tone mapping to show all highlight and shadow details, which is great for a quality evaluation because the highlight and shadow areas are where all the fun is. It does not let you change the exposure level; what you see in the viewport is all you get to see. It's also not quite true to the display in any other application. Think of it more like an overview of the full dynamic range to spot problem areas.

However, the display tone mapping comes at a price. It's slow, and it can get unbearably slow with big images. Eventually, it will even fail displaying a 10 megapixel HDRI and display only a white screen. You can fix that by lowering the display resolution, as shown in the screen shot.

Other features are an A/B split–screen mode, a resize function, the ability to show the individual channels, and a very crude histogram overlay. Even though it is not indicated anywhere in the interface, you can zoom in and out with the mouse wheel and pan holding the spacebar. JahPlayer is a surprisingly feature-rich application that comes at an unbeatable price. It's entirely free.
www.jahshaka.org

from the creators of the format themselves. Oddly enough, it is accompanied by a bunch of other command–line tools that can do panoramic remapping and access the metadata and other unique features of an EXR file.

The Mac version of exrdisplay, called OpenEXR Viewer, is a bit slower than the OS X native Preview application, but it's also much more accurate. It's freeware anyway, so it might be worth a try.
www.mesadynamics.com/openexr.htm
www.openexr.com

◄ **Adobe Bridge**
thumbnails lots of
file formats, but
will only show poor
preview JPEGs.

Adobe Bridge ⊞ : With the latest incarnation of Adobe's Creative Suite comes Bridge, which is a content management system for all file types associated with any Adobe product. You could also call it a generic thumbnail viewer. It's pretty fast and responsive once the thumbnails are generated and stored in some hidden spot.

So, the good news is that it can show a hell of a lot of file types: HDR, EXR, TIFF in all its flavors—you name it. But it doesn't really let you view the image itself. All it will ever display is a preview image that it generated along with the thumbnails. To show the image itself, it defaults to starting up Photoshop, which is not exactly what I would call a lightweight image viewer and certainly overkill for having a quick look.

The problem with that approach is that this preview image is a crude JPEG and doesn't remotely give you any representation of the dynamic range that was in the original HDR image. It pretends to display the HDR image and even displays the original file info. But

IrfanView ▶
Lightweight
thumbnail viewer.

the colors are all wrong and clipped, you can-not tune the viewing exposure, you can't even zoom in. Don't let Bridge fool you; it's playing with hidden cards that are cut down so it can fit more into its sleeves. It's good in pulling them out quickly, but to play the cards it relies on big brother Photoshop.

IrfanView 田: IrfanView is a thumbnail view-er that supports TIFF LogLuv natively and Radiance HDRs through a plug–in. It's quite similar to Adobe Bridge, but it's much smaller and has a more bare–bones style. It does come with a viewer that shows the full resolution image, so you can zoom in and out. But be-hind the scenes IrfanView is working still in 8–bit, so you have no exposure controls.

◄ **XnView**
My personal favorite
thumbnail viewer.

There are many other file formats it can
show, and IrfanView also includes a good se-
lection of general–purpose image tools hidden
in the menu. It can do lossless JPEG transfor-
mations and file conversions and much more.
But the biggest advantage is that it loads
quickly and gets straight to the point. Can't
ask for more when it's freeware.
www.irfanview.com

XnView ⊞ 🍎 △: This one is very similar in
concept and design to IrfanView. In fact, they
are like twins. The interface is a bit more mod-
ernized, and it has some more features when it
comes to managing your images. It can show
crude histograms, lists all metadata, allows
you to set tags and sort by them, and has a
handy batch rename function built right in.
You can even run Photoshop plug–ins directly
from the menu. Very cool!

	OS–X Tiger Preview	HDRView	OpenEXR Viewer	Jahplayer	Adobe Bridge	Irfanview XNView
Platform	🍎	⊞	⊞ 🍎	⊞ 🍎 🐧	⊞ 🍎	⊞ 🍎
HDRI Formats	Radiance, EXR, TIFF Float, TIFF LogLuv	Radiance, PFM, TIFF Float	EXR	EXR	Radiance, EXR, TIFF Float, TIFF LogLuv	Radiance, TIFF LogLuv
Thumbnail View	✔	–	–	✔	✔	✔
Exposure Adjust	✔	✔	✔	–	–	–
Zoom	✔	✔	–	✔	–	✔
Screen Display Accuracy	●●○	●●●	●●●	●●○	○○○	●○○
Interaction Speed	●●●	●●●	●●○	●○○	●●○	●●●
Top Pros	• conveniently built into OSX	• accurate	• very accurate	• plays EXR sequences • display is tonemapped	• thumbnails most formats	• lightweight programs start fast
Top Cons	• slightly inaccurate	• no EXR	• EXR only	• sluggish response	• 8-bit viewer	• 8-bit viewer

However, when it comes to thumbnailing and viewing HDR images, it's just as limited as IrfanView—no viewing exposure adjustments and no OpenEXR support. What's kind of neat, though, is that it also displays text documents. And when it encounters an unknown format, it will open it in HEX mode so you might get an idea of the file type by looking at the header.
www.xnview.com

Comparison Table: We know, you love those test charts, don't you? This one shows you all your options for quickly viewing HDR images at a glance. Note that the programs from the following sections can also be used as a viewer. These are just the plain and simple ones.

What utilities will serve you best really depends on your personal workflow. They all have advantages and disadvantages, and you get the most out of them by combining their strengths.

An example configuration for a Radiance–HDR based workflow on Windows would be to assign HDRView as the default viewer but browse with XnView. If you'd rather work with OpenEXRs, you probably would browse with Adobe Bridge and configure the OpenEXR Viewer as the default file type action. If you have no idea yet, you're better off keeping your options wide open by getting them all.

2.3.2. Specialty Tools: HDR Generator and Tone Mapper

OK, now you are armed with some basic viewers so dealing with HDR images feels a bit more natural. But they don't really do anything. What we need to look at now are some tools that can perform special tasks—in particular, generate HDR images and apply tone–mapping operators. These are the essential cornerstones in a high dynamic range workflow, and both will be explained in detailed workshops later on. Right now, we concentrate on a quick overview that gives you an idea about the toolset available.

HDR Shop ⊞**:** HDR Shop is the granddaddy of high-dynamic-range programs. It emerged in 1997 from the Creative Technology labs at the University of Southern California, where a project group lead by Paul Debevec worked out the principles of image–based lighting. Hence, HDR Shop is specifically tailored to prepare HDR images for exactly that purpose. It includes some special tools that are still hard to find elsewhere, like panoramic transformations and analytical functions to determine diffuse and specular lighting influence. Another powerful yet unique feature is the possibility to apply a white balance adjustment on an HDR image.

In many regards, HDR Shop is still the Swiss Army knife of HDR editing. It can quickly ex-

▲ **HDR Shop**
Still the Swiss Army knife of HDR imaging.

Picturenaut ▶

Picturenaut's unique variety of resampling options for resizing HDR images.

pose an image up or down and do basic resizing and conversion tasks. But, although the name might imply it, it does not sport painting tools, layers, or any of the more advanced features of Photoshop. The menus look very basic and somewhat cryptic. You have to know what you are doing because it doesn't guide you anywhere. It takes some scientific mindset to use it for assembling multiple exposures into an HDR image because it shows you all the inner workings of the algorithms. Some HDRI professionals love it. Some artist types hate it, and most others don't get it at all.

One feature that has been unmatched until this day is widely underestimated. HDR Shop has the power to steal any regular image editor's features. It works like this: You select an area that you want to edit and properly expose for it. HDR Shop can bake out the visible exposure slice as an 8–bit BMP image and send it directly to… let's say Photoshop. Here you can use all the tools you want—you can paint, use layers, clone stuff around, whatever. You just have to make sure you don't push a pixel

into total white or black. When you're done and switch back to HDR Shop, it detects the pixels that have changed. Then it injects those changes back into the HDR image just by sorting in the new pixels at the proper exposure level. It's a crazy hack, but it works. Effectively, it allows editing HDR images with any low dynamic range image editor. It's limited, though, since you can only work in one exposure level at a time. So there are no global image filters allowed, and it fails entirely for edges with a contrast that exceeds the dynamic range that would fit in one exposure view.

Other than that, HDR Shop is clearly showing its age.

Some basic features, like support for RAW and EXR, were added in 2004 in HDR Shop 2, but nothing really revolutionary that would justify the price jump from $0 to $400. The addition that gets the most mileage is a scripting interface to JavaScript. So this update is clearly addressed to companies that have the capabilities and resources to weave it into an in–house set of tools. That's out of our league.

Picturenaut runs
HDR Shop plugins
natively, for example
Banty's motion blur.

The original HDR Shop 1, however, is still freely available for academic and noncommercial use.
www.hdrshop.com

Picturenaut ⊞: Picturenaut is a lightweight freeware utility written by Marc Mehl. It has been developed in close conjunction with the German photographers community, where it was tested under real–world conditions and consistently improved over the course of two years. Now it is finally available in English, bundled with this book.

It is a cute little program that puts image quality first. You can choose high–quality resampling algorithms for resizing HDR images, and more image processing functions are planned. The HDR assembly is state of the art, with automatic image aligning and full control over the camera response curve applied. There is not much whizzbang here, no thumbnails or histogram selections, just basic functionality. Advanced users will appreciate the low–level manual control known from HDR Shop but paired with the automatic helpers that have become standard features in modern HDR programs. The same goes for the tone mappers. Available are two popular algorithms, Adaptive Logarithmic (ala Drago) and Photoreceptor (ala Reinhard), both with plenty of

▲ Photoshere
Unique blend of thumbnail browser/ HDR generator with unrivaled display accuracy.

manual controls. Both are implemented with record performance, running fully in realtime on multicore machines.

Picturenaut is very similar to HDR Shop 1 with its simple user interface and straightforward functionality. And in fact, it even shares the same plug–in API, which means that all the plug–ins ever written for HDR Shop will work in Picturenaut as well. So it can draw from a nice pool of functions like Motion Blur, Median Cut, and convolution filters. The essential plug–ins are included in the standard installation on this book's companion DVD, generously provided by Francesco Banterle. Considering the fact that development on HDR Shop has basically stalled, this is a great way of reviving these plug–ins.

Overall, you cannot go wrong giving Picturenaut a try. It is free for personal and academic use, and a donation to the author is recommended in case you use it in a commercial project. We strongly encourage you to do so anyway, to show your appreciation and encourage Marc to keep delivering updates to this fine piece of software. www.hdrlabs.com/picturenaut

Photosphere ⌘: Greg Ward wrote Photosphere as a thumbnail browser with HDR capabilities. It served as test bed for all his later inventions, which resulted in the addition of so many features that I decided to put it into this category. It would have been a bit inappropriate to compare it to other, much simpler image viewers.

The big advantage is that Photosphere supports every single HDRI format out there, including the rare JPEG–HDR. It also features some advanced tone–mapping operators that are permanently used in the viewer portion of

the program. That doesn't make it the fastest viewer, but it's surely one of the most accurate ones.

Its function for assembling an HDR image from multiple exposures is both easy to use and highly accurate. Only in Photosphere can you make HDR images that you can obtain accurate luminance measurements from, just by picking the pixel values. So for lighting designers and applications in the architectural field, Photosphere is the only option. It can also generate false colored luminance maps, which is very useful for all you professional lighting analysts. Also, a recent addition is a basic panoramic stitching function that works naturally in high dynamic range.

The downside is the user interface, which is somewhat lacking the sophistication we are used to seeing in other thumbnail browsers. It does feel a bit homegrown, less configurable, less dynamic, and less polished. Let's just say it's functional. As soon as you start looking past the interface layer, you will discover a lot of goodies in this program. Considering the fact that it's free, you couldn't ask for more.

The only real downer is that it is still restricted to Mac OS X only. Even though Greg Ward has been trying to get it ported to Windows for years, it hasn't happened yet. www.anyhere.com

Photomatix 🖼 🍎: Geraldine Joffre's Photomatix is the new rising star in the HDRI scene and widely responsible for the recent rise of the popularity of HDRI among photographers. That fame might be grounded in the fact that it did not emerge from a science lab like the others but rather from photographic practice. When it was released in 2003, Photomatix was a tool for merging two or three differently exposed images into one LDR image right

▲ **Photomatix**
The assistent gets you up to speed on the essential steps for photographic applications of HDR imaging.

away, automating a tedious exposure blending workflow that has been used in photography for a long time. Going through the intermediate step of creating an HDR image and then deriving a final LDR image by tone mapping were features added to an already stable and established program. Photomatix was originally not designed as HDRI software, it rather evolved into one.

HDR creation and tone mapping are clearly the focus features now. In both parts of the workflow Photomatix offers a nice balance of automatic algorithms and manual control. For example, if you merge an exposure bracketing series that was shot handheld, you have the choice of three different image aligning methods: fully automatic translation, translation and rotation, and manual picking of control points. Whenever the automatic fails, you still have a chance.

▲ Photomatix
Exposure Loupe and HDR histogram are essential tools for quality inspections.

But the principal advantage of Photomatix is usability. Even if you have never heard of HDRI, you can very quickly get to a result because it guides you through every step of the process. The user interface is very clean and intuitive, everything is explained, and everything works just as expected. Beginners will like the small footnotes that give very specific hints about when a feature is useful and when it might screw up.

For power users, it features a unique batch processing mode that makes it easy to create a whole bunch of HDR images and tone–map them right away—super convenient for those extensive shoots where you come home with 1,000 images and never find the time to pro-

cess them all. Also unique is Photomatix's HDR histogram, but the display of HDR images is kept in linear color space. It's part of the program's philosophy that tone mapping is applied only when HDR images are converted to LDR.

Photomatix is on my list of recommended applications, especially for photographers and HDR beginners. It is available for the Mac and PC for $99. There is a trial version that has no restrictions whatsoever in the HDRI generation department; it only applies watermarks to tone–mapping results.
www.hdrsoft.com

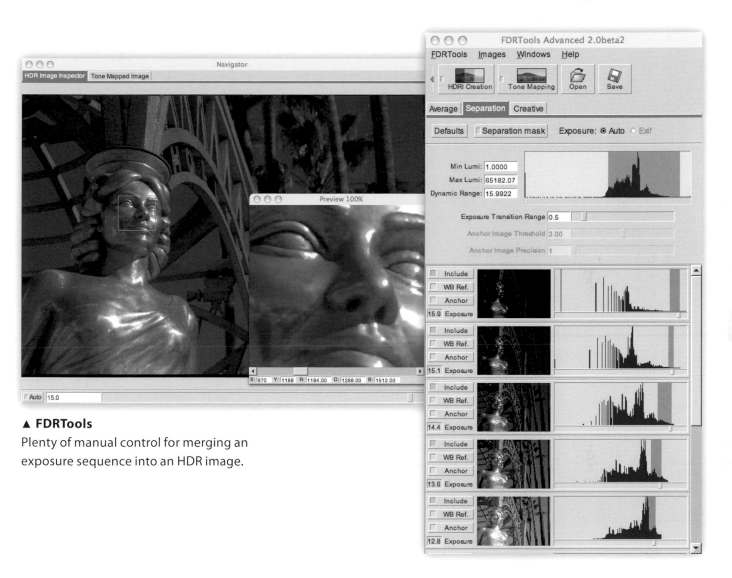

▲ FDRTools

Plenty of manual control for merging an exposure sequence into an HDR image.

FDRTools ⊞ : FDRTools is made by lone warrior Andreas Schömann. (FDR stands for full dynamic range.) It is very similar to Photomatix in its scope of features, and it mainly targets the photographers community. Merging different exposures into an HDR image and enhancing details through tone mapping are the two sole purposes of the software. And just as with Photomatix, there is a free version available, but the power features can only be used in the advanced version, which is still a bargain at (currently) $53.

What makes FDR tools unique is the HDR merging process. You can selectively choose the levels from individual exposures, which are taken into account for the merge. Instead of all images being blended together, each pixel in the final HDR image is coming from the one image where it looked best. This is a bit tedious—and slightly wasteful with the available data. However, it is a working approach

to suppress ghosting, and it offers immense control over the final output.

The overall feel of this software is quite different from all the others. It doesn't try to hide the fact that it is a set of command–line utilities, glued together with an arbitrary Unix–like interface. You can even watch the text output of the underlying commands, which is kind of nice when you are tracking down a mistake. And if you are keen on scripting, it can be easily extended. The interface itself is not as guided as Photomatix's interface—no wizards or assistants here. But now that you have this book, you probably don't need that much guidance anyway. FDRTools still sports a well–written help function, an FAQ, and plenty of rollover tooltips.

There are three tone–mapping operators included, two of them for free. The Advanced edition also offers a local operator called FDR Compressor, which can reveal texture details quite similar to Photomatix Detail Enhancer. And it is available as Photoshop plug–in too. www.fdrtools.com

Comparison Table: Here we go again, another test chart (see next page). This time I focus the comparison on usability and the performance of the common tasks involved in making and processing HDR images. Entries marked with an asterisk indicate that the feature is only fully enabled in the Pro Edition; otherwise, it is either watermarked or completely omitted.

You will have a second glimpse at each of them later when I compare individual disciplines like HDR generation and tone mapping. The screen shots purposely omitted these important points for now because they fill a chapter on their own.

2.3.3. Fully Featured Image Editors

Since those specialty applications all concentrate on a limited feature set, they are often superior in performing those special tasks. However, to get really creative with HDRI, this is often not enough. We want all the image filters we are used to having, we want to be able to use a clone stamp to fix our images, and we want layers and level controls. In short, we want a full–fledged paint application that allows us to edit HDR image the same way we used to edit traditional images.

Photoshop CS3 ⊞ ⌘: No doubt about it: Photoshop is the market's leading paint application. It is so popular that "photoshopping an image" has become a common term for image manipulation, and the only reason it doesn't appear in official English dictionaries is that Adobe wants to protect its trademark.

Photoshop has a long history of inventing useful features that quickly became the standard and got copied by all others. The Magic Wand tool is one of those inventions. Photoshop's layer system is another de facto standard. The list is long. And yet Photoshop always manages to stay ahead of the competition. Since the switch to CS version numbers, there have been plenty of additions that are still unmatched by any other program: Layer Effects, Healing Brush, Liquify, Vanishing Point, Match Color to a reference image—it goes on like that forever.

But here comes the catch: This feature richness is also Photoshop's Achilles' heel. All these features are based on the assumption that digital images have 8 bits and have a gamma encoding built in that needs to be accounted for. Changing this basic premise not only requires a rewiring of the internal data structures, it also means a rethinking of how

	HDRShop (v2)*	Picturenaut	PhotoSphere	Photomatix (Pro)*	FDR Tools (Advanced)*
Platform	⊞	⊞	🍎	⊞ 🍎	⊞ 🍎
Price	free ($400)*	free	free	free ($99)*	free ($53)*
HDR Formats	Radiance, PFM, TIFF Float, (OpenEXR)*, (TIFF LogLuv)*	Radiance, EXR, PFM, TIFF Float, TIFF LogLuv	Radiance, EXR, PFM, TIFF Float, TIFF LogLuv, HDR–JPEG	Radiance, EXR, TIFF Float	Radiance, EXR
Align Source Images	–	✔ Translation	✔ Translation + Rotation	✔ Translation + Rotation + Manual control–points	✔ Translation
Create HDRI directly from RAW images	✔*	–	✔	✔	✔
Ghost Removal	–	–	✔ automatic	✔ automatic	✔ manual
Batch Processing	✔			✔	–
Panoramic Transformations	remaps all standard projections	–	rudimentary panorama stitching	unwrap mirror ball	–
Global Tone-Mapping Operators	via Plugins	• Logarithmic (Drago) • Photoreceptor (Reinhard) • all HDR Shop plugins	permanently tone-mapped display: • Histogram Adjustment	• Photoreceptor	• Logarithmic • Receptor
Local Tone-Mapping Operators	–	–	–	✔*	✔*
Tone-Mapping Plugin for Photoshop CS3	–	–	–	✔	✔
Resize for HDRIs	✔	✔	✔	✔	–
Blur/Sharpen Filter	●○○ (●●○)*	○○○	○○○	○○○	○○○
Usability	●○○	●●●	●●○	●●●	●●○

▲ Photoshop CS3
All the best HDR-related features are exclusively found in the CS3 Extended edition.

each and every single feature is supposed to work. HDRI literally pulls away the carpet that Photoshop stands on. Essentially, it means rewriting the entire application from the ground up. And that's precisely what the Adobe team is doing. When you switch the color depth to 32–bit, you literally switch to an entirely new program.

So this is the current status of HDR in Photoshop: The engineers have done an incredible job in catching up with themselves. They reworked the basic functionality back up to just about the level of pre–CS times. Almost there, but not quite. Many filters are still missing,

but we have layers now, and paint tools, and some of the basic image adjustments. They are exclusive to the Extended edition, though. On the other side, they took care of making the new CS3 features HDR–capable right from the start. That results in some absurd situations: For example, we have the fancy new Quick Selection tool but not a Magic Wand. They both do almost the same; it's just that one is a new breed and the other one is a classic that the team hasn't gotten to yet. Or we can add Smart Filters to a layer; which means that the filters are never really applied but stay accessible in the Layers palette. But we only have a

▲ **Photogenics**
Way ahead of its time
with a fully 32-bit ar-
chitecture and non-
destructive editing.

handful of filters to put in there—excluding
the important Dust&Scratches or any distor-
tion filter. We can use the new Align Content
feature for panorama stitching, but we have
no curves adjustment.

However, it is just a question of time before
Photoshop will be fully HDR capable. The cur-
rent implementation is a huge leap forward,
and it already has one feature that most alter-
natives don't have: stability. You can throw
huge images at it, and it might choke but
won't crash that easily. Also, chances are that
you already use Photoshop, so I will give it
first option in the tutorials. People did amaz-
ing stuff in version 3.0, and with some little

trickery, we can use the few tools we have to
get most things done.

Still, other programs offer a much more
complete feature set in 32–bit mode because
they were designed that way from the start. If
you don't feel like getting your work accom-
plished by cheating your way through, you
should consider giving them a try!

Photogenics ⊞ △: Photogenics was the first
commercial paint program that stepped up
(in 2002) to working internally in full 32–bit
floating point. It took quite a bit of advantage
of that position by matching Photoshop's
price tag of $699, but has been reduced re-

▲ Artizen HDR
Big package for little money, but still a little rough around the edges.

cently to $399. It certainly is an innovative program that is full–featured with a clone stamp tool and all the image filters that you can ask for. Additionally, it has an integrated capturing mode that allows taking HDR images directly from a USB–connected camera. It is also remarkably fast in displaying and manipulating HDR images.

If you are used to Photoshop, you will find that the layer system and menu structure take quite a bit of getting used to. Photogenics works entirely different. It treats every filter and image operator as a new layer, applied through a separate alpha channel. Each parameter of these filter layers can be edited

at any time. For example, you apply a blur by painting over the areas that you want to blur, or you fill the entire alpha if you want to apply it to the whole image. Then you can tint other parts of the image using the same method, add some text, and whatever. At this point, you can still go back to the blur layer and change the intensity or blur radius. You can even change the operator itself, such as making it a motion blur instead of a Gaussian filter. In that way, Photogenics was way ahead of its time in terms of nondestructive image editing.

After you get out of your Photoshop habits, you start to appreciate this nonlinear and

nondestructive workflow. If you want to give it a whirl, you should check out the demo version, which is fully functional for 30 days. www.idruna.com

Artizen HDR ⊞: Artizen is a blend of universal image editor and specialty tool for HDRI. On one hand, it offers the most extensive set of tone–mapping options seen in any software. Eleven different operators come right out of the box, and this number is expected to increase further because they are all implemented as plug–ins. And it even comes with a guide for developers on how to code new tone mappers for Artizen. Especially interesting is the fact that all tone mappers can also be used for display mapping. That means you can edit the HDR image data, but you look at it through a high–quality tone–mapping operator.

On the other hand, Artizen also is a full–featured image editor. It has layers, filters, and brushes, and everything works across all bit depths. Nothing is reinvented here; all features pretty much conform to Photoshop standards, so you feel at home quickly. It even includes things like a screen shot utility, batch processing, image slicing, and a web gallery generator. Really, when you take into account the amount of features, Artizen holds its own with much bigger applications. And all that comes for $50.

Sounds too perfect—there must be a catch somewhere, right? Yes: stability and interaction speed do not really hold up. Let's just say, it still has some rough edges. Not every feature always works as expected, and it starts to slow down to a crawl on large images. If you try opening a 32–megapixel image, it will be gone in an instant. www.supportingcomputers.net

CinePaint ⊞ 🍎 𝛥: CinePaint is an interesting offshoot from the popular GIMP open source image editor. Originally called Film Gimp, it was developed especially for the motion picture industry. Postproduction houses like Rhythm&Hues and Sony Pictures Imageworks used it as in–house software on Linux for years.

That certainly puts CinePaint in a unique position. It is entirely free to use, and it has a tight professional user base that has been working with Cineon and DPX files for years. Those users have the programmers sitting next door, so they are very quick in demanding the features or fixes they need. In–house software like this tends to have very short development cycles and is usually very focused on quick solutions for specific problems. My personal feature highlights are the capability to work in the more economical 16–bit floating–point mode, color–managed display, and a complete set of painting tools. Image filters are somewhat sparse compared to Photoshop.

The downside is that the old–school Linux roots are very dominant. Don't expect the interface to be eye candy. It looks more like a work tool, mundane and simple. The underlying architecture is still identical to the original GIMP, so sliders and check boxes look as ugly as they can. Everything is divided in separate floating windows that clutter around on your screen. This doesn't really help stability, performance, and interaction speed, either. CinePaint tends to lock up or simply disappear when it finds out that you haven't saved for a while.

A new generation of CinePaint, codenamed Glasgow, has been in the works now for two years. It makes the great promise of running natively on Windows, but from what I can see,

▲ CinePaint
The GIMP offspring that became a movie star.

it still has a long way to go before it can be called a usable application.

If you feel adventurous, or just curious how the pros worked on movie effects, you should check out CinePaint for yourself. www.cinepaint.org

Pixel⊞ ⬤ △: In the end, it's all just pixels. That's what Pavel Kanzelsberger must have been thinking when he named his image editor. He has been working on it for almost 10 years now and is finally getting close to the initial release. What makes Pixel unique is that it runs on a lot of different platforms, including rare ones like MorphOS and SkyOS.

Pixel also follows the Photoshop conventions in the way it handles layers and brushes.

It is even identical down to each individual element of the user interface; palettes and toolbars look virtually the same. Obviously, it is missing some of the whizzbang features of Photoshop, but every basic editing function is there—a full set of paint brushes, Bezier curves, vector layers, and layer effects. Not everything works in high dynamic range, though. Also, there doesn't seem to be a display mapping mechanism in Pixel, so unless you burn in a hard gamma adjustment, the HDR image is always shown in plain linear form.

Once again, stability and performance are the major bottlenecks here. In the current state it is therefore still considered beta, and if you can survive a session that lasts longer than an hour, you have been very lucky. If your

image is fairly small, you might have a chance. But anything close to 10 megapixels is killing it right away.
www.kanzelsberger.com

Comparison Table: Let's see how well they compare to each other. Note that this resembles the state of the software as of May 2007, so chances are that some specific features might have changed by the time you are reading this.

For this book, we will concentrate on using Photoshop CS3 Extended. Although many techniques are transferable to other programs on this list, you will have to figure that workflow out yourself.

Forgotten someone?: Just to keep it complete:

- **easyHDR**: At first sight, a very promising candidate to make it in here. Can merge exposures, tonemap, apply filters, and it even has a batch mode. However, for some strange reason it cannot save an HDR image; instead, it uses it for internal processing only. So, it's pretty much useless for our purpose because it does not integrate into an HDR workflow.

- **HCR–Edit**: Has surfaced and disappeared again. It used to have some unique editing capabilities, like HDR histograms and curves.

▲ **Pixel**
Very promising Photoshop clone, hopefully reaching a stable state soon.

	Photogenics	Artizen	Pixel	Photoshop CS3 *(Extended)	Cinepaint
Platform	⊞ 🐧	⊞	⊞ 🍎 🐧	⊞ 🍎	⊞ 🍎 🐧
Price	$399	$50	$99	$649 ($999)*	free
HDR Formats	Radiance, EXR, TIFF LogLuv, TIFF Float	Radiance, EXR, PFM, TIFF LogLuv, PSD	Radiance, EXR, PFM	Radiance, EXR, PFM, TIFF Float, TIFF LogLuv (read only), PSD	Radiance, EXR, PFM, TIFF Float, TIFF LogLuv
Merge to HDRI	✔	✔	–	✔	✔
Align Source Images	–	✔	–	✔	–
Tethered HDR Capture	✔	–			
HDR Paint Brushes	✔	✔	✔	✔*	✔
HDR Clone Stamp	✔	✔	✔	✔*	✔
HDR Color Adjustment Tools	●●○	●●●	●●●	●●●	●○○
Tone-Mapping Operators	Three global	Eight global, three local	–	Three global, one local, + commercial plug-ins	–
HDR Image Layers	–	✔	✔	✔	✔
Adjustment Layers	✔	–	✔	✔	–
HDR Image Filters	●○○	●●●	●○○	●●○	●○○
Thumbnail Browser	–	✔	✔	✔	–
Interaction Speed	●●●	●●○	●○○	●●●	●○○
Usability	●○○	●●○	●●○	●●●	●○○
Stability	●●○	●●○	●○○	●●●	●●○

- **HDRIE**: Open–source project to build a full–featured paint package. It sports paint brushes and a clone stamp brush. Got abandoned before it reached a stable state.
- **FrameCycler**: The professional big brother of JahPlayer, supports playback of EXR sequences properly adjusted with LUTs. It's a standard tool in postproduction, so if you need it, you know it and you have it already. That's why it got omitted from this list.
- **mkhdr**: It's the command–line–only ancestor of all HDR merging tools, even older than HDR Shop. Rumors have it mkhdr would still generate HDR images of un-matched quality.
- **pfstools**: An all–purpose set of command–line utilities. Included are reading, writing, merging, editing, tone–mapping functions. So if you feel like creating your own HDRI application, this should be your first choice. A GUI is currently in heavy development and will certainly get included in the next revision of this book.
- **WebHDR**: A front end for the command–line version of Photosphere, running entirely off a web server. You upload your exposure brackets, and it returns a link to the HDR image in various formats as well as a unique interactive luminance analysis. The coolest part is that it collects the EXIF header of all camera models and makes them open to the public. Please do drop in when you have a new camera and help programmers from all over to support it. http://luminance.londonmet.ac.uk/webhdr/
- **ChocoFlop**: Ultra–light weight image editor for OS X that draws all its functionality from the Cocoa system graphics, which means it is blazingly fast when you have a good OpenGL card. And it can work in the card's native 16–bit half floating–point mode. Definitely an app to keep an eye on: www.chocoflop.com.

2.3.4. Compositing Software

Here is some good news for all you digital compositors: Nowadays, all compositing software is capable of working in high dynamic range to some extent. The reason is that scanned film frames, coming in as Cineon files, have been edited in 16–bit precision for a long time now. They are considered Digital Intermediate, which already incorporates the idea of having extra headroom data beyond white and black point. That's the only way to generate a final output that still has vivid highlights and smooth gradients once it's burned back on film. Stepping up to 32–bit floating–point precision is just the next logical step, and OpenEXR has become the new standard here.

By the way, all these programs don't really care if you work with an image sequence or a still image. There is no reason you couldn't edit a photograph and take advantage of a supreme toolset, enabled for nondestructive editing in full precision.

Here are just some random notes on the different levels of support.

After Effects 🖳 🍎**:** Only After Effects 7 Pro has a 32–bit mode included. A handful of filters are enabled for this mode compared to the hundreds of effects and plug–ins available for other modes. Still, this basic set is completely usable and streamlined, and it has supreme color management built right in. You can choose to tune the viewport to linear or gamma distorted space or any precalibrated profile you might have. Only basic support for

OpenEXR is built in, and alpha is the only extra channel it recognizes.

Digital Fusion ⊞: Nowadays just called Fusion5, it has a long history of 32–bit support, all the way back to version 3. In contrast to After Effects, this is a nodal system, which makes it possible for 8–, 16–, and 32–bit to coexist within one project. A 16–bit floating–point mode is available, which is a great trade–off between precision and speed. Each and every effect can be applied to 32–bit, even those that are not optimized for it or where the math behind it is hitting a wall. This can be quite confusing; sometimes you spend hours hunting down the effect node that breaks everything. Fusion supports 15 extra channels embedded in OpenEXR, which can have different color depths.

Combustion ⊞ : This is often seen as the software–only version of the legendary Flame compositing stations: same interface, similar professional toolset, fully interoperable with any of the Flint/Flame/Fire/Inferno products, just not always in realtime. It has quite a unique blend of layers and nodes: You're stacking up layers that can have different effects wrapped into a single operator via a nodal system. OpenEXR is limited to one alpha channel; the true channel workhorse is here in the Rich Pixel Format (RPF).

Shake : Since Apple owns Shake, it has dropped in price several times. By now it offers the most bang for the bucks, with an incredible wealth of features. As a nodal system, it is also capable of having 8–, 16–, and 32–bit branches within one flow. Optical flow retim-

ing, automatic panorama stitching, even the powerful Primatte keyer—everything comes right out of the box. The downside is that this feature list is unlikely to ever grow because development has stalled entirely with version 4. OpenEXR is supported with only five channels. Usually, that would be RGB + alpha + depth buffer, but you can also reroute these to any channel that is in the file. So it is a common practice to use several loader nodes that suck all channels from an EXR file, always five at a time.

Nuke ⊞ : This used to be the in–house compositing tool at Digital Domain, so it was born and has grown right out of the heavy demands of real–world production. It's a strictly nodal system that is tweakable and customizable in any regard. You get low–level access to managing all kinds of channels. The downside is that you have to manage all channels yourself, so there is quite a steep learning curve, but true mastery is waiting at the top. Nuke leads in OpenEXR support by being the only software that can recognize up to 64 channels, as well as fully supporting every other aspect of this format.

There are many more compositing and color grading systems out there. The more professional they get, the more likely they can juggle all data in floating–point precision at blazing speed. Flame, Toxic, Da Vinci, Inferno—even their names have an aura of power. However, these are beyond the ordinary citizen class. They run on specialized hardware, prized in automotive realms, and instead of just buying them, you have to sign up with blood.

In the workshops to follow in Chapter 5, we will briefly have a look at After Effects 7 and Fusion 5, but the majority of the workshops will be done in Photoshop CS3. This is simply the most common ground.

 # Chapter 3: Capturing HDR Images

Photo: Uwe Steinmüller

We are now all on the same page about the theoretical background of high dynamic range imaging as well as the available tools. But the question remains, "Where do we get the images?"

Basically, there are three ways to generate an HDR image.

First, we can fully create them synthetically with a 3D program. These days, all 3D render engines work internally with 32 floating-point values. So the data is there—up until the point a final image is saved to disk. The general habit of saving out an 8-bit image simply throws away most of the precious rendering. And that's a shame, really, because it couldn't be any easier to maintain the full dynamic range of a rendered image: Just save it as EXR! (That's quite a large topic itself. We'll get into that later when we cover CG rendering in Chapter 7.)

The **second** conceivable way would be to shoot an HDR image directly with a high dynamic range camera. Yes, they do exist. And I know what you're thinking, but no, you can't have one. Not yet. Unless, of course, you have $50,000 to spare. You might also go back to college and sign up for an electronics engineering course. Then you might have a chance to get your hands on a working prototype of a new HDR imaging sensor. It has been worked out already in a handful of research labs, and it really is just a matter of time before it gets thrown into mass production.

The **third** way would be to shoot a series of images with different exposures and merge them digitally into one HDR image. This can be done already with any camera that allows manual exposure settings. It requires a lot of manual labor though, and a huge downside is that it is largely limited to static scenes. Merging a bracketed exposure sequence into a good HDR image is a skill in its own right and will be covered in depth later in this chapter.

If you feel the urge to shoot HDR images right now, you can safely skip to section 3.2 and learn about shooting and merging exposure brackets. But if you're interested in some technical background on how digital cameras will inevitably evolve toward HDR, you should read on.

3.1. Digital Imaging Sensors

Camera manufacturers must consistently deliver innovation. Megapixel counts have reached a level that is more than sufficient; they already surpass the resolution we could get out of film. So **that** war is over. The new battleground is dynamic range (DR). And the battle has begun already. The popular camera testing website Digital Photography Review (www.dpreview.com) has picked up DR as a test criteria, using a designated test setup with a backlit grayscale chart.

Sensor technology is the motor of this innovation, and charge-coupled devices (CCDs) have been dominating this field since the eighties. A consumer-grade CCD can capture a dynamic range from 60 to 70 dB, which is equivalent to 10 to 11.5 EVs. High-end CCD sensors reach 78 dB (13 EV), but that's about the upper limit of CCD technology. By comparison, a sunny outdoor scene can contain 100 to 150 dB (16 to 25 EV).

So, what's the deal—what can be so hard about building an HDR sensor chip?

3.1.1. The Problem
On the hardware side, the problem derives directly from the technical definition of the dynamic range. As mentioned in the introduction, it is defined as the logarithmic ratio between the largest and the smallest readable signal.

Put in a formula, it looks like this:

$$DR = 20 * \log_{10} \frac{Max\ Signal}{Min\ Signal}$$

Yes, I know, I promised no more formulas. I broke my promise, but for a reason: I am trying to explain a technical matter, and it's actually easier to understand by looking at the formula than to read it in a sentence. Don't even worry about the 20. It's just a multiplier that turns the result into a more readable numerical value. The result will be in decibels (dB). Much more interesting are the signal variables.

The maximum signal is the last usable value you can pull off a pixel before it gets saturated. If it got any brighter, it would just clip off. One way to increase the dynamic range would be to increase this maximum by building a very big and tough sensor. The problem with that is that the sturdier a sensor, the more noise it introduces and the more power it needs.

Getting a better minimum signal: The minimum, on the other hand, is the last signal that can be distinguished from noise. So, essentially we are talking about the overall signal-to-noise ratio. Every sensor has some base noise that comes from the electrons in the material zapping around randomly. They are supposed to wait for some light to set them free, but nevertheless, there are always a few electrons that are too excited and break free anyway. There are plenty of reasons for that, and some of them are related to the fact that we need to count them electronically, i.e., by using other electrons. But this is drifting away into the laws of quantum physics—let's just remember the fact that every sensor has some kind of basic noise level. If we somehow lower that noise level, we can read an even smaller signal.

That would work in our favor because our sensor would be much more precise and we would have increased the dynamic range.

And in fact, there is a way to efficiently reduce the noise level in ordinary CCD chips. You can cool them down. Cold electrons get lazy and are less likely to turn AWOL. This technique is used for professional digital backs, and it works great. It's not cheap because it involves a lot of engineering to come up with a quiet and effective cooling system. Those who shoot in digital medium format might not be worried about the money, but the rest of us probably won't see that cooling technology in an affordable camera.

Evolution: Nevertheless, getting a better signal-to-noise ratio out of a sensor is an engineering challenge that has been there from the start. The signal-to-noise ratio has always been a measurement for the grade of quality. At the same time, it has always been an indication of the dynamic range you can capture with that sensor. Right now, we hold the first wave of affordable solutions in our hands. The recent lines of digital single-lens reflex (SLR) cameras already deliver so much dynamic range that they have to pack it in proprietary RAW formats. But that's not the end of the line; true engineers can't just put a problem aside and say it's good enough. Digital imaging is just naturally destined to evolve to higher dynamic ranges.

The next big wave is gathering momentum, and when it hits the shores it will blow everyone away. Everyone but us, because we are prepared for high dynamic range imaging, right?

So let's check out what these engineers are creating in their labs!

◄

A regular CCD sensor works like a field of orange trees.

3.1.2. Time-to-Saturation

We start with a rather unconventional approach to increase the dynamic range. Instead of reading each pixel's current state after a specified exposure time, we could just wait it out and then measure the time it takes for each pixel to become fully saturated. The upper limit of the dynamic range, in capturing the brightest highlights, would be pushed to whatever the reaction time of the circuits can deliver in readout speed. A cutoff would only happen in the darks, where we have to set a threshold for the maximum acceptable exposure time.

The concept sounds nice, but the implementation is difficult. One problem is material wear, since the sensor is running at full saturation quite a lot. Also, designing a radically new readout logic that can register the saturation point and measure the time accordingly has turned out to be next to impossible.

3.1.3. Logarithmic CMOS Sensors

A tale of CCDs and orange trees: A regular CCD sensor works just like a field of orange trees. As a pixel gets hit with light, it grows an orange, or as the scientists call it, a charge. The more light a tree gets, the more oranges it grows. Next to each tree, we place a helper guy. When it's time to harvest, they pluck the oranges into buckets and hand them down the row like a bucket brigade. Down by the road all these bucket brigades join together into a big stream that leads into the farmhouse. At the door we have a supervisor, who counts the oranges in each bucket and writes it down in a table. Since the buckets come in the order in which the trees are planted, this table becomes row by row an accurate representation of the entire field.

On a CCD sensor chip, the supervisor is called an analog-digital converter (ADC). The oranges are the charges collected by the pho-

todiodes, and the helpers are chains of capacitors.

Where CMOS is different: Logarithmic sensors by comparison, are built differently. Their architecture is based on CMOS microprocessor technology—that's why they are often also referred to as CMOS sensors. (CMOS stands for complementary metal oxide semiconductor.) The major difference is that they use additional transistors on each pixel to collect and amplify the charge that builds up during exposure. These transistors can be read directly because they are wired in a grid. Essentially, they are memory chips with a photodiode next to each memory cell. In our analogy, we wouldn't have the helpers form a bucket brigade; they would take their oranges to the farmhouse themselves. They all would have a pager, so we can call them to the door in any order. The farmhouse would also need less space, because in a logarithmic sensor chip we would be growing the orange trees right on the roof of our farmhouse. Essentially, there would be a staircase next to each tree, and the helpers would just walk down a level.

This sensor is highly integrated; some call it a camera-on-a-chip. It can be built in the same manufacturing plant as ordinary memory chips, so it is cheaper to make. Because the readout procedure is so much simpler than with CCDs, it also needs a hundred times less power to operate. All these advantages make it very attractive for use in consumer-grade products.

Unlike the linear response curve typical for CCDs, these chips react logarithmically to light. That's because transistors build up a charge logarithmically. This behavior is very similar to an analog film curve, and so this chip can reach a similar dynamic range. It does, however, suffer the same shortcomings as analog film: The nonlinearity allows a good color reproduction only in the middle part of that curve. On the upper and lower knee, we might cover a lot of range, but it is compressed so tightly that even the smallest amounts of noise can distort the signal tremendously.

It's getting tight in here: Another caveat comes with this technology: We need room on the surface for those transistors. The coverage of the photodiodes, which all together form the actual light-sensitive area, is only around 30 percent. That means only a third of the available light is being used for the image; the rest just hits the transistors and heats them up, which is not too great either because it causes additional noise. So we have a double-trouble situation here: light getting lost and increased noise. The solution is to add a layer on top consisting of millions of tiny lenses. One dedicated micro-lens for each pixel, responsible for catching all the light and focusing it on the photodiode. That is a lot of effort to overcome a design flaw.

Nevertheless, this type of sensor architecture is not only showing great promise, it has hit the mass market already. CMOS sensors needed a little time to reach the quality level and resolution of the more mature CCD technology, but as of right now they have caught up pretty well. Canon's EOS Digital SLR line is using them exclusively, in a design that features four transistors for each pixel. Nikon's new JFET sensors, as seen in the high-end Nikon D2, is another derivative of this technology. JFET is named after the special kind of transistor being used here, a junction-field-effect-transistor, which enables Nikon to get by with only three transistors.

3.1.4. Digital Pixel Sensor/HDRC

The principle of logarithmic CMOS sensors has been taken another step forward by the Programmable Digital Camera project at Stanford University. Under the leadership of Abbas El Gamal, members of the group developed the Digital Pixel Sensor (DPS). They added more transistors to the pixels, up to the point where each pixel has its own analog-digital converter and its own logic circuits. Effectively, that is smartening up the sensor; basic preprocessing steps can already be done in hardware, by the pixels themselves.

In our analogy, we would equip our orange harvesters with a cell phone and a calculator instead of a simple pager. Yes, they may have an iPhone too. They are really smart twenty-first century people now. They don't have to bring the oranges anywhere. They just pick them from the tree, count them, and call in the number.

This is eliminating a major bottleneck. Since all pixels can perform their own A/D conversion (a.k.a. orange counting) at the same time, we have an almost instant digital image. Thus, the prototype at Stanford can shoot at a blazing 10,000 fps. Yes, you read right: ten thousand frames per second! On the speedometer, that's two ticks beyond "Insane Speed".

Now, the trick is to run the sensor at a higher frame rate than the actual image generation. We have plenty of time to shoot several exposures for each capture, and we would still get a smooth video with 30 frames per second. The individual exposures can be combined to an HDR image at the lowest level in each single pixel. Because the chip architecture is based on CMOS microprocessor technology, we already have a lot of experience to make these hardwired calculations. They are the same circuit designs as in a CPU or GPU. Such on-chip preprocessing also has the neat side effect of noise reduction because the resulting pixel values are an average of multiple samples. We could also realize more complex calculations at this preprocessing stage—for example, reducing motion blur or detecting edges and shapes.

Beyond photography: With such processing capabilities, this sensor technology comes very close to imitating what our eyes can do. It is a true smart camera on a chip. The possible applications go way beyond photography; there is, for example, the possibility of an artificial eye. Prototypes of artificial retina implants have already been crafted to give blind people their vision back. From this point on, the imaging research is shifting to deciphering how human vision works, simply through crafting an emulation thereof and improving it incrementally through a game of trial and error. This emerging field of study is called "machine vision", and other prospective fruits of this branch are advanced security systems with facial recognition and fully automatic cars with collision prevention systems. Both exist in a working prototype stage already, and who knows what's beyond.

The Fraunhofer Institute in Germany, inventors of the MP3 audio format, has built a similar CMOS-based sensor with per-pixel readout logic. Its version is called High Dynamic Range CMOS (HDRC®). The registered trademark symbol is referring to its patented architecture, which is layered like a sandwich. All transistor circuitry is buried underneath a seamless thin film surface of photodiodes. That raises the fill factor to almost 100 percent, eliminating the need for micro lenses. The sensor runs at the same incredible speed and can derive each frame from up to four differently

▲

Spatially Varying Exposure interferes with the Bayer RGB filter grid.

would take 185 million transistors, which is about equal to a Pentium 4 processor. So we are talking about the edge of technology, and the manufacturing expense is immense.

In the future, this kind of sensor could potentially set the upper limit—in performance as well as price—for high-end HDR cameras.

3.1.5. Spatially Varying Exposure

A different approach has already been developed in the year 2000 at the Computer Vision Laboratory, dubbed CAVE, at Columbia University. The basic idea is to cover a conventional CCD sensor with a pixel pattern of different neutral density filters. Pixels behind a very dense filter capture the lights, and pixels behind a transparent filter capture the shadows. That way, they combine a 2-by-2 grid of differently exposed pixels on the CCD to expand the dynamic range. It is a very low-cost approach because it builds on existing hardware. The implementation is a mere mechanical challenge: to align the filter pattern to the pixel grid of the sensor.

One big disadvantage is that this exposure grid can only produce high-quality images in a three-chip camera because regular cameras already have a similar pixel pattern in front of the sensor, commonly known as the Bayer pattern. The reason is that all CCDs are actually monochrome. Cameras with only one sensor chip use a grid of red, green, and blue filters to separate colors. The result is a very weird-looking image, where all pixels are just gray but alternating pixels represent either red, green, or blue. To get a full color image, these color values are usually interpolated across; in a RAW workflow this is called demosaicing. Spatially varying exposure, however, interferes with this color pattern. It would further decrease the true color resolution of a sensor,

exposed captures, which results in an effective dynamic range of 120 dB at 50 fps, equivalent to 20 EV.

Prospects: At this time, these sensors are already past the initial prototype stage. The HDRC sensor is available in a 768x496-pixel camera module, which allows tethered capturing from a PC. This is a developer kit, marketed since 2002 by a company called IMS VISION, which is holding the license for that chip technology. From here it is turned into commercial products by international licensees, so far in medical and astronomical imaging. However, IMS VISION was later bought by the Japanese company OMRON. It is the supplier for almost every car manufacturer on the planet, specializing in automotive electronics.

By nature, this sensor technology relies on advancements in processor manufacturing. The amount of pixels we can get on a chip is directly determined by how many transistors we can get on a chip. Miniaturization is the key here. Stanford's Digital Pixel Sensor needs 37 transistors per pixel; that adds up to 14 million transistors for video resolution. If you would want to make a 5-megapixel sensor, it

and much more of the image would need to be computationally recovered, which is always a guessing game.

Another disadvantage is that this method can extend only the upper limit of the dynamic range. It does not help getting more details in the shadows, where we are still bound to the noise restrictions of the CCD sensor. Still, theoretically this method can quadruple the captured dynamic range, boosting a regular CCD up to 200 dB. That's more than 30 EV, enough for even the worst-case lighting conditions.

It's puzzling that this technique has never made it into an actual product. Implementation of an optional HDR capture mode would be straightforward, with a swing down exposure pattern. Considering the fact that even compact cameras nowadays can have more than 10 megapixels, resolution would not be the issue anymore. If the HDR capture mode would capture at half the resolution, we would be more than happy. At least we would not have to deal with blown-out highlights anymore—a notorious problem with those quick from-the-hip snapshots.

3.1.6. SuperCCD SR

But wait, spatially varying exposure has not disappeared altogether: Fujifilm picked up the basic idea, and incorporated it in the design of its very own SuperCCD.

This is a remarkably different sensor: The pixels are arranged in a honeycomb pattern at a 45° angle instead of straight rows and columns. In fact, this is the only sensor where the pixels on the surface of the CCD do not directly translate to the pixels in the final image. The term **photodiode** is more appropriate for these light-sensitive patches. They are not even square, but shaped like an octagon.

Fujifilm claims that this would allow them to be packed tighter together, surpassing the fill factor that is possible with ordinary CCDs and stopping the bleeding of super-bright highlights across the entire CCD column. Critics argue that the true captured number of pixels is only little more than half of the advertised megapixel count; the other half of the image is made up by interpolation. In that regard, it hurt more than benefited Fuji to introduce its first SuperCCD camera with 4.2 megapixels when it had only 2.4 million photodiodes.

New direction: With the third generation of this sensor in 2003, Fuji made a clear effort to regain the trust of its customers. It split its sensor line in two: The Super CCD HR (High Resolution) variant actually crams as many photodiodes on the chip as pixels appear in the final image. But even more interesting is the SR variant, where Fuji added a secondary type of photodiode. It is much smaller than the primary photodiode, so just by design, it has a lower sensitivity. Essentially, this is the hardcore implementation of the spatially varying exposure method. The large primary photodiode captures the regular image, and the smaller one captures the highlight details—both images are combined into one RAW file with a wide dynamic range.

Originally, this secondary photodiode type was piggybacked to the regular one, which officially nominates this sensor for the "World's Strangest Circuitry Design" award. It also did not help dealing with the critics because these photodiodes are paired so close to each other that they form a single pixel again. Fuji quickly abandoned this approach, and in the fourth generation, the low-sensitivity photodiode is located in the empty space between the primary pixels. This design is the **Super**

▲ **Super CCD:** Two different types of photodiodes mixed in one sensor.

CCD SR II; it is much more sane, which helps for using third-party RAW decoders. Fuji claims a dynamic range increase of 400 percent, but that is measured in linear scale and slightly misleading. Technically, the sensor delivers about 80 dB, which roughly equals 13 EV. Not to make light of it—this is a remarkable achievement; it surpasses the exposure latitude of film material as well as the cooled-down high end CCDs, but for a fraction of the budget.

As with the previous method, this design only extends the range upward. Whatever shadow detail (and noise) is captured with the primary sensor is what you'll have in the final image. Only on the highlight end does it gain those 4 EV of extra dynamic range from the secondary pixels. But the key element is that this secondary image is captured at exactly the same time. Unlike the regular combination of multiple exposures, moving objects don't throw it off, which is essential for shooting people, waving wheat fields, or anything other than a still life.

Convincing the market: Fuji made a great commitment here, being the first to pin down and address the dynamic range issue. It was just a bit unfortunate with its market position. At a time when everybody was crazy about counting pixels, it had a hard time convincing the public that dynamic range is a problem at all. When Fuji's top-of-the-line FinePix S3 Pro hit the shelves in February 2004, it was way ahead of its time and did not really get the attention it deserved. Fuji specifically advertises this camera to wedding photographers because they are eventually the first to be convinced. When you shoot a white dress on a regular basis, with no control over lighting, and your client is eager to see every detail of that expensive dress, you are certainly in a tight spot. And there is not much room for mistakes. Wedding photography is a one-shot hit-or-miss adventure. The cake is cut only once.

The predecessor of the S3, the FinePix S5 Pro, contains the same sensor chip and has been out since the first quarter of 2007. The magnesium alloy body of the popular Nikon D200 adds a nice look-and-feel to the S5. It also features a new onboard processing chip that makes better use of the two sensor types. You can now set the sensitivity of the secondary pixel type directly with the ISO value, and it even allows you to choose a film stock that will be emulated through in-camera tone mapping.

Bottom line is that Fujifilm is the first camera maker to have an extended dynamic range camera in the mass market. It doesn't go all the way to HDRI yet, but it certainly is a step in the right direction.

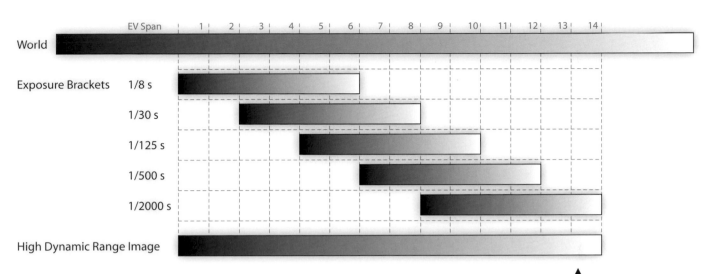

EV Span		1	2	3	4	5	6	7	8	9	10	11	12	13	14	

World

Exposure Brackets 1/8 s

1/30 s

1/125 s

1/500 s

1/2000 s

High Dynamic Range Image

▲

Exposure bracketing captures the dynamic range of a scene in several slices.

3.2. Handiwork

The last section showed that HDR sensors are definitely on the horizon. But even with today's cameras you can capture the full dynamic range of a scene. It might take a bit more effort and time, but with some loving care and the right methods, you can get to very professional results.

3.2.1. Capturing a Bracketed Exposure Series

The basic idea is to shoot a series of different exposures. Each image represents a slice of the scene's dynamic range. That might be 6 to 8 EV in a mediocre camera. Afterward, we digitally merge these slices again and have a fully high dynamic range image.

For a successful recovery of the original dynamic range, these individual exposure slices have to overlap. Otherwise, the combination algorithms can't puzzle them back together. As a nice side effect, we get free noise reduction out of that because each pixel in the resulting HDR represents the average of the most useful parts of each exposure. Really useful are the middle tones primarily. The shadows, where all the image noise tends to get overwhelming, are generally clamped out and replaced with the corresponding color values from the lower exposures.

This sequential capturing method works best for static sceneries. If the scene changes between exposures, the combination algorithms get into trouble. So forget about sports photography in HDR! Pedestrians, cars, animals, even fast-moving clouds or twigs waving in the wind—they all tend to turn into ghosts.

A word on analog: I am not trying to start the old film versus digital flame war. Yes, of course, you can make HDR images from scanned film slides; in fact, this is how it was done in movie production for a long time. The advantages are that the equipment is cheaper, capturing to film is faster than saving to a card, and the individual exposures have a lot of range to begin with. However, a modern digital SLR can beat film in all those disciplines.

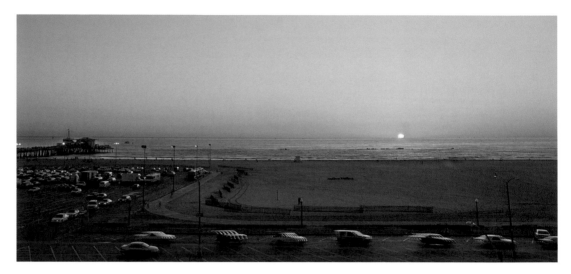

▶
Ghosting:
Beware of moving
objects while
shooting an
exposure-bracketing
sequence.

On the other hand, there are significant disadvantages. Film has to be developed, so you have to wait until the next day to see if your capture was successful. There is no way the exposure brackets come in prealigned because the development and scanning process adds additional movements to the slides. And most importantly, there is no metadata available so you have to remember the exposure data yourself.

At its core, HDRI is a digital imaging technology. Capturing digitally is its native ground. It is possible to go analog, but you're just making it harder for yourself.

What is in your backpack?: The minimum equipment is a digital camera with manual exposure settings. If your camera has nothing but an exposure compensation button labeled with AE --/-/o/+/++, I can assure you that you won't have much fun with it. You're free to give it a shot, but I suggest making HDR your excuse for getting a better camera.

At a minimum, this is what you should have:
A decent digital SLR camera
Whatever lenses you like
A microfiber cloth for lens cleaning
Highly recommended additions are:
A stable tripod
Cable release
Spare batteries
Spare memory card
Very useful, albeit not entirely necessary are:
Laptop computer
A backpack with a pouch for it
USB tethering cable

▲

Disable all in-camera image enhance-ments.

◄

My backpack, fully loaded.

Camera settings: If you are shooting JPEGs, make sure you turn off all in-camera image enhancements. Your camera is not supposed to apply any sharpening, color boosts, or contrast enhancements at this time. It is highly unpredictable what those firmware settings really do to your image. Camera makers optimize them for a single shot; chances are they are not consistent all across the exposure range. If you are shooting RAW, the firmware doesn't touch your image, so those settings don't matter to you anyway.

For varying the exposure, you want to use the shutter speed only. The reason is simple: Aperture size also changes depth of field, ISO value changes the sensors' noise behavior, and ND filters don't get you very far. Shutter speed is the one parameter that leaves everything alone; it changes nothing but exposure. If your camera has an autobracketing feature, make

sure you check the manual to understand what this feature does to vary the exposure. Digital SLRs usually have a menu setting that lets you choose between aperture and shutter speed. Set it to shutter speed; that's very important.

Basically, everything but shutter speed has to be fixed. You don't want your camera to adjust the white balance differently for each exposure, so set it to a fixed value or one of the factory presets. You also don't want the focus to vary. Choose a manual focus mode, and either focus on your subject by hand or use the AF button to fire the autofocus once.

Set the ISO value as low as you can. That's general advice, because all digital sensors show increasing noise as you ramp up the ISO value.

If you are shooting outdoors, it is a good idea to set the aperture to a high f-number. That corresponds to a small aperture size and

minimizes the influence of stray light and depth of field. This is not so much a rule as it is a hint, and you are free to set the aperture lower if you are specifically going for a shallow depth of field look. But a high aperture will help maximize the upper end of the dynamic range you can capture. You want at least one exposure in which the brightest highlights are not blown out, and this will be achieved by a high f-number and a fast shutter speed. However, decide on an aperture and leave it alone from now on.

OK, let's recap. All these settings are fixed:

- ISO value
- White balance
- Aperture
- Focus

Shooting brackets: Now you are ready to shoot the sequence of exposure brackets.

If your camera has a flexible spot metering system, this is a great way to find out which exposures you need. Looking through the viewfinder, you'll see a dot pattern, with one dot marked with a cursor. Move that cursor to the darkest region, just like in figure **1**.

Underneath the image is a display showing you the exposure information. The first two numbers are shutter and aperture, and they are followed by the metering scale. Since we're in manual mode, this metering scale is our advisor now. Right now it shows several bars growing to the right.

Change the shutter speed and watch these bars. Once you have them shrunken in to the zero point, you have successfully found the exposure for the darkest region. Here it is 1/125 second (see **2**). This shall be our slowest shutter speed. Memorize this number!

Now do that again for the brightest region (see **3**). Move the cursor over it and adjust

shutter speed until the bars are gone. I am ending up with 1/800 second. This shall be our fastest shutter speed.

And this is where we start taking pictures. Decrease shutter speed in 2 EV intervals until you reach the upper mark of 1/125. Usually, it's not necessary to shoot every single EV, but it doesn't hurt either. In fact, I personally prefer shooting single EV intervals.

With a little practice, you'll develop an eye for scene contrast, and eventually you don't need to go crazy with all this metering. When in doubt, shoot too many brackets rather than too few. The rule of thumb is that each pixel should at least be fully visible on two images; that means neither under- nor overexposed. Watch the in-camera histogram to make sure of this.

Changing shutter speed manually by fumbling with the shutter wheel is always prone to errors. You will inevitably shake and this will make it harder to stack the images on top of each other. It also takes too much time, and the scene might change in the meantime.

Stability and speed—those two factors are the major bottlenecks of HDR photography. I probably don't have to explain how a tripod helps to maintain stability. Especially when you are forced to do the manual shutter fiddle, a tripod is essential. There is absolutely no way to hold the camera still while changing the shutter with your thumb and pressing the release button several times.

Autobracketing: I mentioned autobracketing before, and it does sound like a good way to get faster and more stable. You just hold the release button, and the camera zaps through the range by itself.

But here's the problem: Autobracketing isn't designed for this kind of stuff. The original

◄ Spot metering for exposure brackets
❶ Moving the cursor to the darkest region

◄ ❷
Determining the slowest shutter speed

◄ ❸
Measuring the brightest region for the fastest shutter speed

Histogram watch:
Make sure each pixel is properly exposed on at least two images.
▼

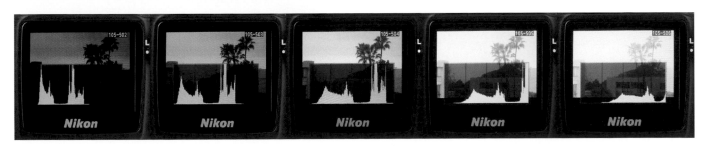

intention was to give you a choice of very similar exposures, for situations in which the lighting changes and you have no time to adjust it. That could be a sports event or a wedding. Most cameras will give you only three images with ±1 EV difference. Well, this is pretty much useless; you get the same in the headroom of a single RAW shot. And even if you're actually shooting three RAWs, the gain is marginal.

Autobracketing should be more than a convenience feature. When you are shopping for a new camera, specifically with HDR photography in mind, consider this a major decision point. At least five images would be ideal, in 2-stop intervals. Unfortunately, not even a handful of cameras allow that setting. Hint, hint, camera makers:- Here is your chance to boost sales with a simple firmware update!

The Pentax K10D is ahead here, with the optimum five brackets in ±2 EV intervals. Nikon has the D2X, D2H, and D200 with nine brackets ±1 EV, which are covering the same ground with more in-betweens. Canons EOS line has a factory setting of 3 images ±2 EV. The one exception is Canon's flagship model, the EOS Mark II-1Ds. This one comes with driver software that lets you tailor your own bracketed shooting mode and transfer it onto the camera as a preset. So if you are the proud owner of this baby, get on your laptop right now! Once you are in the field (and you weren't nerdy enough to take your laptop with you) it will be too late.

Handheld capture: It is absolutely possible to shoot handheld when you have no other option, provided your camera features autobracketing with a burst mode and there is enough light available to keep exposure times on the fast end of the scale. You might need to break last chapter's rule and set the aperture to a smaller f-number, eventually even raise the ISO a notch, to max out shutter speed.

Get a safe stand and hold the camera with both hands, one on the body and one on the lens. Count 1-2-3 to calm yourself down, take a deep breath, and then press and hold the release button. You have to get into some kind of Zen mode for that single second. Try to imagine you're a tree. That helps. JPEGs come in handy here because they don't fill up the camera's internal buffer that fast and the burst mode remains speedy all the way through. A little drift left/right or up/down is usually fine because panning motion is quite easy to align afterward. The thing to watch out for is camera tilt. When your images have to be rotated to align them, you might get into trouble.

This is really just a hint for the emergency—in case you are on a general city tour and a tricky lighting situation catches you entirely unprepared. If you are careful and keep exposure times short, you still have an 80 percent chance of getting a decent HDRI out of it. And if not, you still have the choice of the best exposure, so it was worth a shot anyway.

Still, even a monopod can be a fantastic help, because it eliminates the camera rotation. They are cheap and light and set up in no time. Or try to find some kind of pole, tree, wall—anything that you can press your camera against.

Tripod capture: True professionals, however, don't leave their house without a tripod. It's not only the preferred method, it's also absolutely necessary for indoor HDR images, for shooting at higher zoom levels, and when the subject is close to the camera.

Make sure you set the tripod on safe ground. Soft dirt can take a little stomping as prepara-

tion. There will be vibration, and you don't want the legs to sink in. Find your preferred framing, and fix everything!

Digital SLRs require a special step because the internal mirror can flap up quite forcefully. This causes heavy vibrations going through the entire tripod system, unfortunately right in that millisecond when we need it the least. A human hand holding the camera would easily dampen that out, but a tripod doesn't. So make sure to set your DSLR to mirror lockup mode! This delays the actual exposure for about a second, giving the camera enough time to swing out after the mirror gets smashed on the ceiling of the body.

In fact, you get the best possible result when you don't even touch your camera at all. Even pushing the release button puts enough force on the camera that it can hinder pixel-perfect alignment. With mirror lockup enabled, you can let go right after releasing and have the tripod come to rest. Consider getting a cable remote for your camera! With autobracketing, it doesn't need to be a fancy one; a simple shutter release will do. That will allow you to step back and just let the camera do its thing.

Tethered shooting: If you want to make sure every spectator stops in awe you can even go a step further and remote control your camera from a laptop or PDA. It's most handy in a studio setup, where you have access to a power outlet.

The cool thing about tethered shooting is that you can kill two birds with one stone. At least Canon users can, because there are several remote capture utilities out there that will allow direct HDR capture. Of course, they can't magically remove the sensor limitations, but they combine the individual exposures in the background. You can instantly see if that

HDR image turned out nice and reshoot if it didn't. And taking away the burden of shuffling around all those source files is an immense convenience.

The professional solution under windows comes from Breeze Systems and is called DSLR Remote Pro, paired via plug-in with Photomatix Pro. It's loaded with features and allows detailed control of virtually every setting on Canon EOS cameras. You can get it for $95 from www.breezesys.com (Photomatix Pro not included).

There are also freeware solutions. They are much simpler: fewer features, less to no user interface, and focused on doing nothing but this one thing. You know the deal. If $0 sounds just like your kind of budget, try these:
- AHDRIA by Sean O'Malley: www2.cs.uh.edu/~somalley/hdri_images.html
- CanonCAP by Greg Ward: www.anyhere.com

Dealing with ghosts: Ghosting is the major limiting factor of this exposure-bracketing technique. It seems unavoidable that any motion in the scene will kill the basic premise of shooting one exposure after another. Very annoying.

Photomatix, Photosphere, and FDR Tools—these three tools have some kind of ghost removal on their feature list, and I was originally planning to write a whole chapter on successful ghost removal techniques. The problem is, it hardly ever works out; none of them is reliable in delivering results without any artifacts. I would be lying if I told you anything else. Apparently there is still a good amount of research to be done in this field.

So at this point in time, the best way to avoid ghosts is not to shoot them in the first place. Keep your eyes open and instead shoot

▲ **Ghost bus:**
Better let it pass.

an exposure series again when you see some-
thing move. Avoiding ghosts can be as simple
as waiting for the bus to pass by or picking just
that moment when the wind calms down and
the branches of a nearby tree come to a rest.
Even people are less of a problem when nicely
asked to freeze for a minute.

3.2.2. Calibrating Your System

What? Where is that coming from? I already
shot my brackets, and *now* you're telling me
my system needs calibrating?

All right, OK. If you are one of those photog-
raphers who never care about white balance or
color spaces, you may safely skip ahead. This
one is intended for the curious people, those
who can't resist the temptation of pushing a
button that is clearly labeled "Don't ever push
this button!" You know, the type of guy who
gets told "Go on, nothing to see here", and

stops and asks, "Why? What *exactly* am I not
supposed to see here?"

What the camera response curve is about:
We need to talk about the part again where
the in-camera software takes the linear sensor
data and applies a gamma tone curve to dis-
tribute the levels nicely across those 256 val-
ues we have available. Remember when I told
you that each and every device is calibrated to
a 2.2 gamma? Sorry—that was a lie. (Note to
myself: Stop fooling your readers!)

The reality is much more complicated. Sen-
sors are not always 100 percent linear and
identical. Even the same camera model can
feature different stocks of sensors, which have
slight manufacturing differences in the way
they respond to light. Furthermore, camera
makers tend to slightly distort the tone curves
of individual channels to apply a special
"brand look". That can be the beautiful skin
tones of brand X or a smooth roll-off in the

highlights that makes brand Y look more like film. They all do it to some extent, even if they don't admit it.

What that means is that there is not necessarily just a simple gamma relationship between the true linear world luminance values and the pixel levels as they appear in a JPEG. It might be close, and it gets closer the more professional the camera is. But there is still that bit of uncertainty where we are even uncertain how far it is off.

That's why clever scientists found a way to recover the tone curve that has been applied. It works by analyzing the images themselves and comparing the pixels' appearance across the entire spectrum of exposures. It really isn't as complicated as it sounds: When a pixel is exactly middle gray at one exposure, how much brighter is it 4 EVs up? And does it get a slight blue tint 2 EVs later, just before it clips? That's the kind of questions answered here. The results are drawn as a graph that precisely describes what world luminance is mapped to what pixel level: the camera response curve.

It's exactly the same thing as a lookup table in cinematography—a tool that we can apply from now on to all images for taking out the device-dependent inaccuracies; a color management tool similar to the ICC profiles that sync your screen to your printer, but with the twist that it syncs your HDR images to the world. The curve is the recipe, the source exposures the ingredients, and the HDR image the cake we are going for.

Does that really work from just looking at the final images?: Reverse-engineering that curve from a bunch of images gives you a better chance of success when the analyzed pixels are close to gray to begin with. You know that kind of machinery logic from automatic white balance programs: The average of the image is assumed to be gray, so only what is redder than the average will be registered as red. An algorithm has no sense for the beauty of a sunset and therefore will insist on calling a majority of it gray. Camera curve recovery algorithms are not as picky as white balancing, though. What makes them trip are images in which individual channels clip off earlier than others. For example, when a blue sky is very dominant in the image, then blue will most certainly be the channel that clips off before red and green do, so that sequence would result in a false camera curve. Shooting a primarily neutral scene is the best way to prevent this.

Another problematic case is at hand when the in-camera software is trying to be extra smart and applies a different tone curve to differently exposed images. The intention might be to turn over- and underexposed images into something more pleasing, but to the reverse-engineering algorithms this is fatal. There just is no single curve to extract that would be valid for all exposures.

Gamma or self-calibration or predetermined curve? That is the question!: First of all, a generic gamma is better than a bad camera curve—i.e., one that is derived from images with a dominant color, insufficient range, or a different white balance. A bad curve can screw you up and introduce weird color banding. There is not much sense in redoing that curve for every HDR image because then you will inevitably have that one set with a lot of blue sky in there, which will give you a bad curve. The curve is not dependent on the scene anyway; it's your hard- and software that get measured in here.

For general photography, a standard gamma curve works great. If you are primarily interested in a pleasing image, love the particular look your camera gives you, and plan on tweaking the colors to your taste anyway, then you're getting a very predictable consistency from a generic gamma curve. On modern DSLRs, the response curve is very close to a pure gamma anyway, and the result from a reverse-engineered curve might even be less accurate.

Calibration can be necessary, however, for several reasons. It is a must for lighting designers and architects, or anybody who wants to use the HDR image for deriving precise world luminance values. Capturing the lighting situation on a movie set is a common example of when you would want an accurate light probe as starting point in a CG environment. You also need calibration if you have a couple of cameras, maybe even from different brands, and you would like their output to be in sync. And then there is the case of notorious analog photographers, where there are so many unknown factors between film development and scanning that each film roll needs to be calibrated again.

Here is my advice: Go with a standard gamma first. If you notice weird color shifts or banding in your HDR images, that is a hint that your camera software is doing funky "enhancements", and then you will have to calibrate them away.

It also depends on your choice of software for HDR generation. Photomatix and FDR Tools default to a standard gamma curve, which is usually just fine. But in Photoshop or Photosphere, the curve recovery algorithms are the default behavior. Here it makes a lot of sense to shoot a designated calibration sequence to get a good curve out of it instead of

determining one bad curve after another and having each HDRI merged differently.

Let me illustrate the difference with an example: Both of these images were merged in Photoshop from identical source images. The left image was made with the curve derived from the images themselves. That's Photoshop's default self-calibration. Notice the flat yellow banding around the sun.

In the image on the right, a calibration curve that was generated from a reference sequence was used. Looks much better now; the sky shows a smooth gradient all the way to the disc of the sun.

Shooting a reference sequence: We need a subject that has both neutral colors and a large dynamic range. If you want to go crazy, you can use two MacBeth color charts and put one in the sun and the other inside a shoe box. But the truth is, the calibration algorithms are actually quite robust, and you won't gain a much better curve from this procedure. You might just as well shoot a piece of tarmac or a white wall.

Shoot slightly out of focus! A little blur helps the algorithm because then it doesn't have to deal with pixel alignment of the individual images. Don't defocus all the way, though; that will result in excessive spill and bleeding highlights.

What's much more important is that you really cover all the range that you see through the viewfinder and that you do it in small steps. The maximum here is 1 EV interval. Remember, we want as many good colored pixel samples as possible, so we can keep tabs on how they change throughout the sequence. The darkest picture should not show any overexposed white pixels anymore, and the brightest image shall have no black pixels. Then you have scanned the entire range.

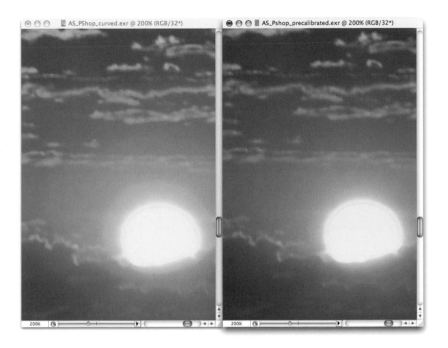

◄ Camera curves compared:
Self-calibration is Photoshop's default (left), but using a pregenerated response curve gives better results (right).

Shooting a reference sequence for calibration
▼

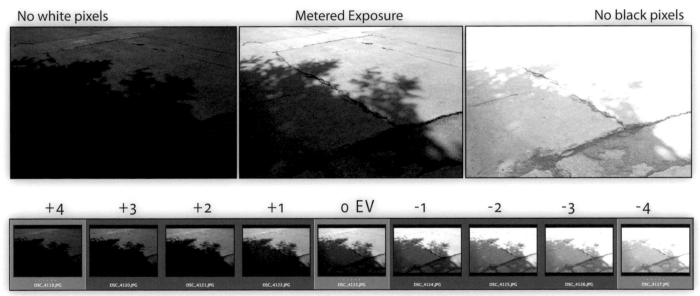

No white pixels Metered Exposure No black pixels

+4 +3 +2 +1 0 EV -1 -2 -3 -4

HDR Shop– grandpa lets you look at his camera curve: Just for demonstration purpose, we will dust off HDR Shop to generate a camera curve.

When calling up that menu point (**1**), it asks for an image sequence. Since HDR Shop is not aware of EXIF data, we manually set it to 1 EV intervals. Then it does something very interesting: HDR Shop is dropping its pants

Generating a camera curve with HDR Shop

❶ Starting the process

❷ ▶
Initial analysis

❸ ▶
Smoothing & Clip-
ping

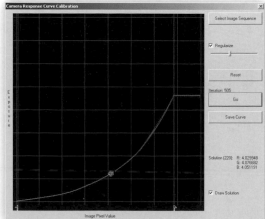

❹ ▶
Resulting curve

and fully exposing the bowels of its algorithm. We get to see a full-fledged response curve estimation utility. It's somewhat semi-manual; you have to actually work it yourself.

First thing is to start the process with the Go button. Then HDR Shop picks more and more samples from the image and looks up how they change. The graph represents the mean value—the Joe Average Pixel, you might say. When it starts, this average curve is very jerky and jumps around, but the longer it runs, the more samples are taken into account, and eventually the curve comes to a rest.

The first graph (figure ❷) shows what the resting pose looks like after 200 iterations. It's still quite bumpy all over, with significant scribbles on the top end of the red channel.

To smooth that curve out, we can switch on the Regularize function. Now the curve turns into a rubber band and the dimples straighten out (❸). This is what a fully automatic curve generation does as well, and it works very efficiently, as you see.

One oddity is left: Look at how the channels shear apart on the top end. That doesn't look right. Those are the near-white pixels, and apparently the pixel values of our images don't

◄ **Calibration today:** Everything happens behind the scenes (here in Photosphere).

give us a good indication of the real world color here. Well, screw "them" pixels; we will just discard them by dragging in that blue clipping guide.

Figure ❹ shows how my curve ends up looking. The overall shape is remarkably similar to a perfect gamma curve except that the red channel still runs a tiny bit above green and blue seems to be always a bit underneath. Well, that is probably my white balance, which is set to Daylight. This is just how my camera makes it look sunny. And we figured that out just by analyzing the images themselves. Amazing, isn't it?

So, I can proudly confirm that my Nikon D200 has a very ordinary gamma response. That means I am pretty well off just using the standard gamma. Still, I hope you enjoyed this little exercise, and I hope it gave you a feel for

what a response curve looks like and how it's made.

Calibration today: In modern programs, all this algorithmic calibration is happening behind the scenes. You just enable a checkbox, and the curve is generated on-the-fly prior to the actual HDR image generation. All you get to see is a progress bar.

But what's really happening behind the scenes is exactly the same process as shown in HDR Shop. Several samples are compared, obvious errors are smoothed out, and the reliable parts of tonal values are determined. And as you have seen with my ad hoc tweak to that curve, there are a lot of rough assumptions made and the entire process is not quite as precise and scientific as a single progress bar might let you think.

	Self-calibrating each set of images on-the-fly	Load and save a pre-generated curve	Use generic gamma response curve
Photoshop	✓ default	✓	–
Photomatix	✓	–	✓ default
Photosphere	✓	✓ default	–
FDR Tools	–	✓	✓ default
Picturenaut	✓ default	✓	✓
HDR Shop	–	✓	✓ default

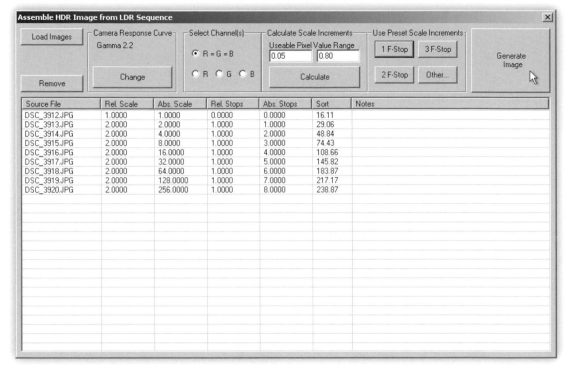

Assemble HDR Image from LDR Sequence

Source File	Rel. Scale	Abs. Scale	Rel. Stops	Abs. Stops	Sort	Notes
DSC_3912.JPG	1.0000	1.0000	0.0000	0.0000	16.11	
DSC_3913.JPG	2.0000	2.0000	1.0000	1.0000	29.06	
DSC_3914.JPG	2.0000	4.0000	1.0000	2.0000	48.84	
DSC_3915.JPG	2.0000	8.0000	1.0000	3.0000	74.43	
DSC_3916.JPG	2.0000	16.0000	1.0000	4.0000	108.66	
DSC_3917.JPG	2.0000	32.0000	1.0000	5.0000	145.82	
DSC_3918.JPG	2.0000	64.0000	1.0000	6.0000	183.87	
DSC_3919.JPG	2.0000	128.0000	1.0000	7.0000	217.17	
DSC_3920.JPG	2.0000	256.0000	1.0000	8.0000	238.87	

► **HDR Shop:**
Merging exposures to an HDR image looks like rocket science here.

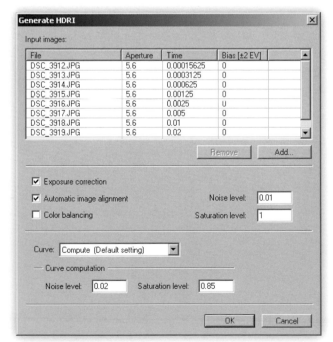

▲ **Picturenaut:**
Balanced blend of manual control and automatic functions.

I mentioned earlier that each HDR generation software handles this curve estimation a bit differently. That is mostly because each programmer has more or less faith in the concept of precalibrating the tonal tweaks introduced by the firmware of a camera (could be different for each exposure), self-calibration of each exposure sequence that is merged into an HDR image (could result in a bad curve, and will be different for each sequence), or using a standard gamma curve (could simply not match at all). Also, there is no standard file format, so the response curves are not interchangeable between software.

3.2.3. Merging to HDRI

You might be wondering, what's all the fuss? Can we finally make some HDR images?

Sure. If you haven't taken your own bracketed exposures yet, this is a good time to pop

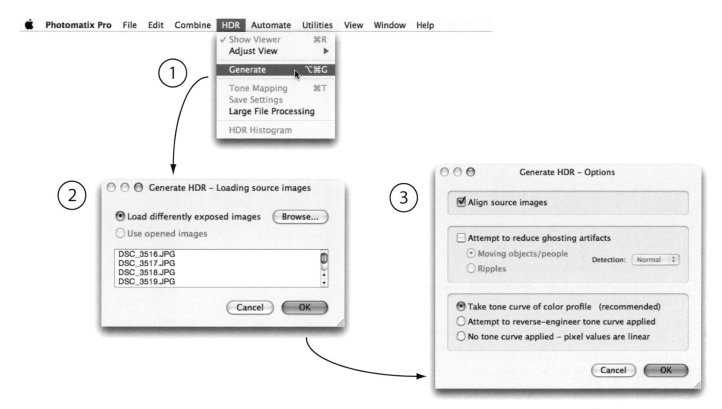

▲ **Photomatix:**
Only 3 easy steps,
with all the tech stuff
behind the curtain.

in the DVD. You will find all the example images used here, so feel free to move right along with me. Merging exposures really is the easy part, as long as you don't do it in **HDR Shop**, because HDR Shop's Image Assembly dialog doesn't look like fun at all. It can't even read the exposure from the EXIF data, so you have to punch in the f-stop increments yourself. But the worst is, there is no image align function. So don't even bother trying to merge your exposures in HDR Shop.

Whenever full manual control is required, you should consider using **Picturenaut** instead.

Just like HDR Shop, it lets you specify the usable pixel range between noise level and saturation level, but it also conforms to modern standards by autodetecting EXIF data and can automatically align the source images. There are quite a few occasions when you want to have all that low-level control. It can help advanced users with problem solving by allowing them to tinker with the merging algorithm a bit. Another scenario would be when you shoot the upper end of the range through stacks of ND filters or any other kind of experimental technique.

However, if you stick to the standard protocol and don't try anything funky, you don't have to care about all this tech stuff. If you want a smooth-sailing workflow, you will like how **Photomatix** makes it as easy as 1-2-3.

When the EXIF data is unknown, it will ask you about exposures after loading the source images. Otherwise, it will just do its job. You can also just drag and drop your exposure

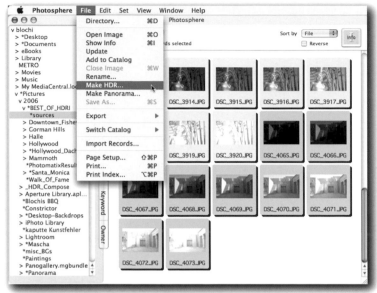

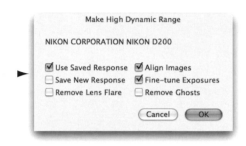

▲ **Photosphere:**
Conveniently select
the source images in
a thumbnail view.

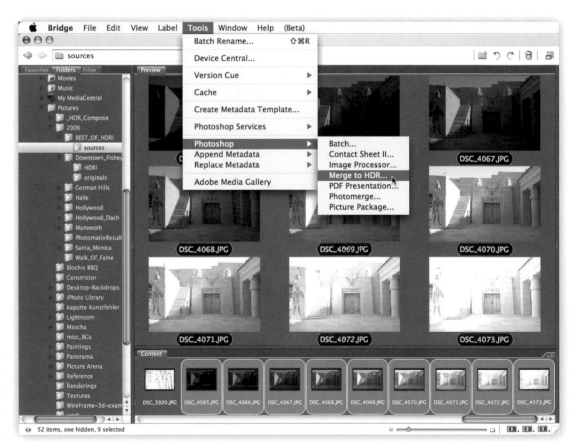

► **Photoshop:**
Merging Preview
allows very limited
control over the HDR
generation process.

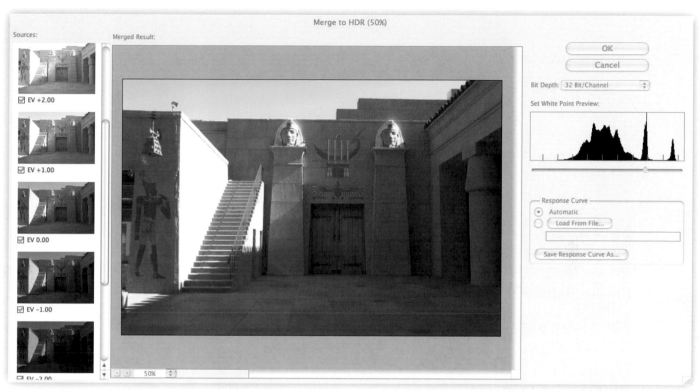

sequence onto the Photomatix icon when you prefer to select images visually in a thumbnail browser. However, in this case each image will be loaded individually first, which takes more time and memory.

Photosphere, being a thumbnail browser itself, makes this part even more convenient. Here you just select the source images and start the HDR generation from the menu.

Quite similar is HDR generation done in **Adobe Bridge**: Select the source thumbnails first and call the Merge function from the menu.

The difference is that Bridge hands the actual workload off to Photoshop. There you will see a script load each image individually, stack the images up in layers, and align them. It looks somewhat like a poltergeist taking con-

trol of your Photoshop. When it's all done, it brings up the dialog shown on top.

This is **Photoshop**'s merging preview. The script did all the preparation, but the HDR image itself is not made yet. At this point you have a chance to set the preferred viewing exposure or exclude individual images from contributing to the merged result. It begs the question, "Why would you want to do that?" Isn't more always better?

OK, let's see what happens during the merge. On the next page you will see is a little mockup of a typical bracketed sequence in 2 EV intervals.

To be honest, the HDR histogram might not really look like that; I just made it up. And in reality the individual histograms' shapes match a lot better because each source image

▲ **Adobe Bridge:** Similar thumbnail-based selection, but for HDR generation it needs big brother Photoshop.

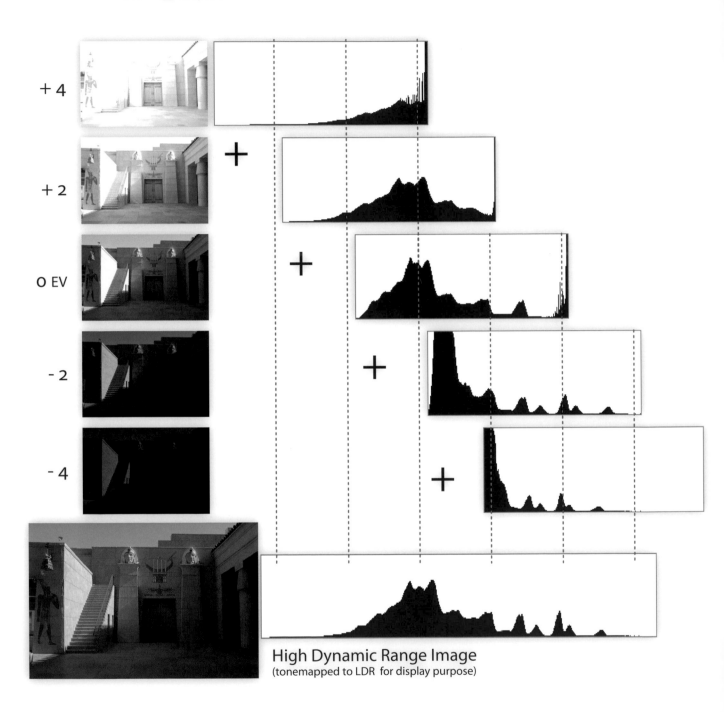

+4

+2

O EV

-2

-4

High Dynamic Range Image
(tonemapped to LDR for display purpose)

will be pretreated with that response curve we talked about. But that's not the point here.

What this chart demonstrates very clearly is how each pixel in the final images represents an average, derived from the exposures that include this particular slice of the scene luminance. Technically, the three middle images would already cover the entire range of the scene, but then there wouldn't be any averaging happening on both extreme ends. And that's a shame, because here is where we need it the most. By purposely overshooting the range, we can get to a much cleaner result, with noise free shadow detail and no color clipping in the highlights. And by using more exposures in between, we can average out noise introduced by higher ISO values or whatever flaws our sources might have.

This averaging also tends to smooth out fine details and small misalignments. Even if you shot on a tripod, there is always a micro-shift that might be smaller than a pixel. The figure on top shows a side-to-side comparison of using these five exposures versus nine exposures.

Admittedly, the difference is small. Look closely at the eye of the Pharaoh and the lines in the brickwork. The blend of all nine images is generally softer and slightly fuzzy, whereas fewer input images result in crisper lines on the brickwork but also reveal a slight misalignment on the eye, rendering a sharp corner where there shouldn't be any.

We can always sharpen the image afterward, so personally I would rather go with the consistent smoothness of the left one. But if crispy detail is your major concern, then you'd probably want to use fewer input images. Specifically, you'd want to exclude the misaligned images explicitly. But which ones could it be?

9 source images, ±1EV intervals 5 source images, ± 2 EV intervals

▲
More input images tend to result in a smoother HDR image

Aligning exposures: I should have told you that the sequence you just saw was shot with a monopod—the tripod alternative when you don't enjoy arguing with security personnel. As mentioned earlier, this is not the best option, but you still have about a 90 percent chance of getting a decent HDR image out of it. Provided your merging software is capable of aligning the exposures.

So, the Pharaoh example was also putting the image alignment function to the test. Basically, there are two substantially different approaches: an MTB image pyramid and a pattern recognition logic.

The latter is the method Photoshop CS3 uses, and in fact it is the very same Align Based on Content subroutine that it uses for stitching panoramas. It crawls through the image, looks for edges and corners, and marks them with a control point. When it has done that for all images, it compares the dot patterns formed by the control point clouds and matches them up. This method can compensate for huge image shifts in translation, rotation, and even distortion, and that is just what is needed for panoramic stitching. But it can

▶

MTB alignment
method

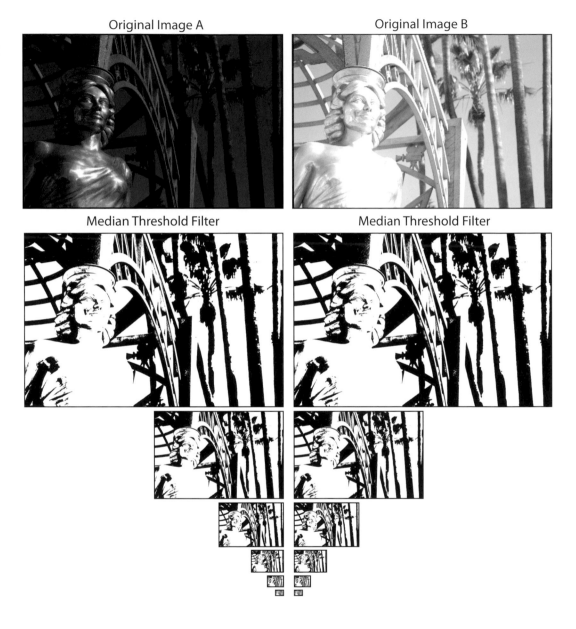

Original Image A

Original Image B

Median Threshold Filter

Median Threshold Filter

easily get confused by regular image patterns and eventually tries to align the wrong things.

The other method is median threshold bitmap (MTB) matching. It was incorporated in Photosphere first and is also used in Photomatix, FDR Tools, and Picturenaut. It is a pretty robust algorithm that can compensate for a wide range of exposure changes.

Let's use a fresh set of example pictures and see how it works!

It starts out by applying a median threshold filter to neighboring exposures. The result is a pure black-and-white bitmap of each image. These get repeatedly scaled down to half their size, forming a pyramid of incrementally smaller resolution.

1) Find the Median Value.

2) Run a Threshold Filter.

Resulting Bitmap for Image A

Resulting Bitmap for Image B

▲
Manual simulation of the Median Threshold Bitmap generation

Then it starts at the smallest zoom level, nudges the images 1 pixel in each direction, and checks each time if they match. This 1-pixel nudge correlates to 32 pixels in the original image. When both small images are identical, it remembers the current pixel nudge and sets it as the starting point for the image pair one step up in resolution. Those are now nudged again 1 pixel each direction until they match up. This way the algorithm works its way up the entire image pyramid, incrementally fine-tuning the pixel nudging distance. And by the end, we have two perfectly matching images in original size.

▲

HDRI made from aligned exposures (Photosphere) and unaligned source images (HDR Shop).

The magic lies in the very first step. You might be wondering, what is that mysterious filter that makes these two images appear the same in the first place? Well, it's simple; you can even do it yourself in Photoshop.

You need to expand the histogram view and show the statistics info. This is where you find the median value. You punch that into the Threshold filter, which can be found under Image→Adjustments→Threshold. And believe it or not, doing that for both images will result in almost identical bitmaps. Greg Ward figured it out, apparently inspired by this party joke where you think of a two-digit number, double it, subtract 15, multiply by 3, and all of a sudden your inquiring buddies know your age. Something like that.

This algorithm works fantastically, and it really is fully automatic! It just needs to be unleashed with the click of a button. Here is a side-by-side comparison of the resulting HDR image, one made in Photosphere and one in HDR Shop, which doesn't have aligning at all.

So now you know the magic behind the Align Images button. Implementations are slightly different in each program; **Photosphere**, for example, is always adding a rotational check to the pixel nudging, which sometimes returns a better match, sometimes just throws it off. In **Photomatix**, the rotational alignment is a separate mode, found under Utilities→Advanced Align→Automatic. **Picturenaut** actually tells you the exact pixel nudge for each image in a console window, so you can see which images were nudged to the wrong place. The notable exception is **Artizen HDR**. Not that the auto-align algorithm would be any different, but it gives you a user interface for manual corrections. Whatever source image you have selected will be semitransparently laid on top of the blending result and can be nudged into place by hand.

That way you can solve the trickiest merges yourself. It stands as a great example for all the other software makers. Because the general method is the same in all these programs, they all fail the same way.

On very dark images, the median threshold filter trick falls apart. When the median value drops somewhere below 10, the threshold bitmaps are not identical anymore. Or, in the extreme example shown on the right, the darker images show a median value of 0. That's not even a real number. We can't pull a threshold with that at all; we would just get a black image.

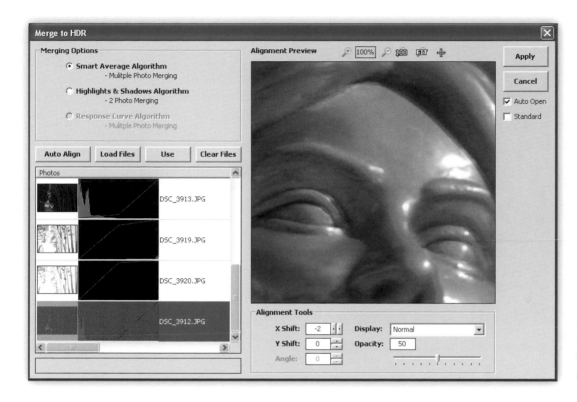

◀

Arizen sports a manual Alignment Tool, that overrides the automatic result.

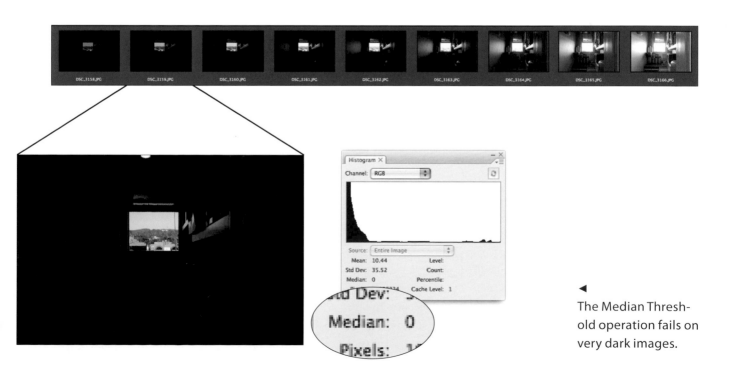

◀

The Median Threshold operation fails on very dark images.

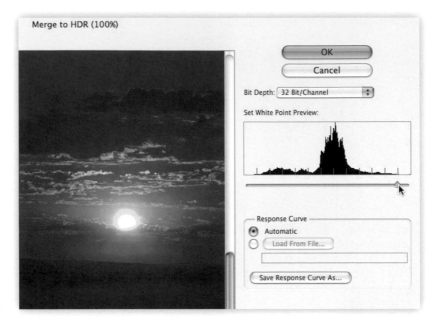

▶
Initial inspection
in Photoshop's
merging preview.

Luckily, I shot this sequence on a tripod, so the images didn't need to be aligned.

About this little peak behind the scenes, you should remember: As long as your images are not too dark, you have a pretty good chance of getting automatic alignment to work. Photoshop CS3, Photomatix, Photosphere, and Picturenaut will work pretty well, although the last three use slightly different variations of the same method. When it fails, this is most certainly the fault of the darkest image, and in the final HDR image, your highlights will be out of place. So make sure to carefully inspect your HDR image for misalignments!

Inspection time: The first thing to do after merging exposures is to inspect the quality of your fresh HDR image. Ideally, you'd have sucked every bit of information from all the source images. Even if you don't really care about the HDR image itself because you want to tonemap it down to an LDR image right away, you should always remember that a

clean HDR image is the base for a good tone-mapping result. Artifacts in the HDR image are more likely to become pronounced than decreased by the tone-mapping process. Yes, it sounds like stating the obvious, but I still see many people skipping this important HDR inspection step.

You need to check for the following:
- Range coverage: Is there anything clipped on either end?
- Noise averaging: Are the shadow details crisp and clear?
- Intensity stepping: Unnaturally sharp edges around the highlights?
- Response curve: Any strange color shifts in smooth gradients?
- Alignment issues: Do high-contrast edges have a double image?
- Moving objects: Any ghost sightings?

What it boils down to is that we have to inspect highlights and shadow regions at a high zoom level. In a clean HDR image, you can dial up and down the exposure and it will always

◄
Setting the nominal
viewing exposure
with the 32-bit
Preview Options.

look as good as the respective source images. In a sparkling HDR image, it will even look better than the source images.

So let's see how the inspection process works in **Photoshop**. Even before actually baking the HDR image, we can do a first checkup in that preview window I mentioned before.

Notice the red tick marks in the histogram. Each tick represents one exposure value. Only about five or six will be visible on-screen at a time—which ones they are can be set with that slider underneath. We can slide it up and down and inspect the range coverage and see if that response curve works out for us. If we don't like how the colors are spread out, or if

the intensity distribution feels unnatural, this is the point where we can plug in our pregenerated response curve. If that image is to be our reference exposure sequence, this is also where we save our calibration curve for later use.

However, the preview has only been made at screen resolution, so we cannot zoom in further. For a closer look, we have to commit to those settings and click OK.

Now watch out: That slider had another function. Whatever you set the preview exposure to will be retained in the file. That means the merged HDR image will come up visually aligned to look the same. It doesn't mess with the actual values in the file; it only remembers

▲

Photoshop's Quick Exposure slider is located at the bottom of the window

it as the preferred viewing exposure. That setting is a bit hidden in the View menu as 32-bit Preview Options.

Note that Photoshop is the only software actually interpreting this setting at this time. It's cool as long as you stay within Photoshop or you're tonemapping the image down anyway. But if the image is intended for use in 3D software, you should reset the 32-bit Preview Options for a more predictable result. Then use Image→Adjustments→Exposure to apply a permanent exposure effect. What's in the Image menu really affects the numerical values of the HDR image; what's in the View menu tweaks just the representation onscreen.

But for quick inspections, you don't always want to change this nominal viewing exposure. Editing and retouching an HDR image can be a bit strange because you're fiddling with more image data than your screen can show you at a time. You will find yourself sliding the visible exposure window up and down quite often just to double-check if your changes have had an effect somewhere else. That's why there is a quick inspection slider right on the bottom frame of the image. It's a very similar concept to panning in an image at a higher zoom level—that isn't really cropping the image either.

It's just that you pan through the dynamic range here.

So this slider is what we will use for all quick inspections. Double-clicking it will always set it back to the center position, which is the nominal exposure defined in the Preview Options.

Got it? We have three levels of exposure control:
- Hard adjustment in the Image menu
- Soft but sticky adjustment in the View menu
- Super-soft quick slider that is just for the moment

Note that Photoshop always does some internal color management. Whatever part of the available exposure data we choose will be adjusted to match the monitor's profile. So even though the HDR values themselves are kept linear, we look at them through gamma goggles just so it looks like a natural image on our monitor.

Photomatix goes an entirely different route. Here the HDR image is displayed in its naked linear form. It looks like a super-high-contrast image because the visible part of the range has not been treated with the gamma distortion that our monitor expects. So the actual HDR image display is pretty much useless for any quality evaluation.

▲
Photosphere auto-exposes the entire view-port as you pan across the HDR image.

▲
Photomatix shows the small area under the cursor auto-exposed in the HDR Viewer

▲
Photosphere can calibrate the HDR pixel values to real world luminances.

Instead, Photomatix added a special inspector window, called the HDR Viewer. It behaves like a loupe that just sits there and shows a 100 percent magnification of the area right underneath your mouse cursor. As you roll over the HDR image, it will auto-expose in realtime for that area under your cursor and bump up the gamma on-the-fly. It takes a bit of practice because as you inspect highlights and shadow portions, you have to keep an eye on that thumbnail-sized viewer and not on your cursor. It's a little bit like operating a periscope or like eating chocolate with knife

and fork. But it works fast, and it's pretty sweet as soon as you get the hang of it.

Photosphere deserves to be mentioned as an excellent HDR inspector. When you flip the Local switch, it does the same kind of auto-exposure for the entire window, no matter what zoom level you set it to. You can pan around holding the Control key and it will constantly readjust the exposure. In addition, you can turn on the Auto and/or Human button and the display will be tonemapped with more complex operators. Those options require a lot of processing, and the bigger you scale the window, the more sluggish the update will feel.

▲ **Comparing HDR images generated in different programs:**
① Initial results.

Photoshop CS3	Photosphere	Photomatix
Picturenaut	HDR Shop	FDR Tools

But the killer feature that makes it unique is the small readout of scene luminance just below those buttons. Whatever object you point to, Photosphere figures out the real-world luminance in cd/m2 (or lux). That trick only works in HDR images generated by Photosphere itself, though, because it has known the absolute EV of the original exposures and

aligns the numerical values of the HDR image to it. If you happen to know the absolute luminance value of an object in your image, you can also calibrate any HDR image to real-world luminance. You draw a selection around the object and then call the secret calibration feature from the Apply menu.

Well, in most cases you wouldn't pick a rusty wreck as reference point; you'd pick the white probe area of a luminance meter.

Once again, it is a question of personal preference. Most certainly you will want to do that checkup in the software you just made the HDR image with. And depending on your findings, it might be worth going back and re-merging with some different settings or trying a different software all together.

Isn't it all the same?: Not quite. I know, you want me to prove it now, but note that the software makers are consistently improving this part, so by the time you're reading this, the actual HDR merging examples might all be different. It's also just a matter of changing the response curve settings or selecting more or fewer images and the result will look better or worse. After reading the last pages, you know everything about those settings, so you can pinpoint the problem and you'll know what to do about it now.

Here we go. In the first row are the results from Photoshop, Photosphere, and Photomatix. In the second row are Picturenaut, HDR Shop, and FDR Tools. Each image is made with the default settings; all except the first image had to be rotated because at the time this test was conducted, only Photoshop could interpret the orientation tag in JPEGs. The latest versions of Photosphere do this as well.

Obviously, the default nominal exposure is a bit different; most notably, FDR Tools is way off.

After visually aligning all exposures with the quick inspection slider, we can have a better look at color and range spread. Photoshop, Photosphere, and HDR Shop start to look very similar (figure ❷). Other contestants still differ quite a lot.

But that shouldn't be much of a concern since we could easily tweak the colors to our taste.

More interesting is a detailed inspection of the upper end of the range (❸). Notice the yellow banding ring in the Photoshop image (upper left). When the response curve is swapped out with a calibrated one, this ring will disappear and it will look identical to the Photosphere result. That's what was demonstrated in section 3.2.2. The same applies to the red halo in the Picturenaut image (bottom left). Photomatix and FDR Tools both show a very smooth gradual falloff around the sun, but red is generally omitted here.

Figure (❹) shows a snapshot of the shadow portions. Picturenaut and Photosphere show a slight blue tint, which in fact was present in this dawn lighting condition. However, there is more visible contrast in Photomatix and HDR Shop, meaning they sorted in the shadow portions much lower, resulting in a virtually wider dynamic range in the HDR image. I say virtually because it really is just more prone to be affected by noise here.

A closer look at the low end of the range (figure ❺) reveals that the higher the contrast is kept, the more noise from the last source image makes it into the HDR image. So even though the numerical DR readout might be different, the true dynamic range inherent in the image is identical.

▲ ❷

After visually matching the exposure they look more similar.

▲ ❸

Highlight inspection.

▲ **4**
Shadow inspection

▲ **5**
Close-up look at the darkest details

Well, once again, don't take this comparison too literally. If anything, it demonstrates that you can sometimes get a cleaner HDR image by stepping away from the default settings or piping it through software that acts differently by default.

Batch me up, Photomatix: If you're coming back from a weekend shoot, baking one HDR image after another can become quite cumbersome. This is especially true when you are shooting panoramas, but also when you become an HDR maniac like me and make it a general habit to shoot autobracketing sequences. There's nothing to lose, but potentially a lot to gain.

In that case, Photomatix Pro comes in very handy. Make sure to collect exposure sequences with identical numbers of frames in separate folders. Then unleash the Batch Processing command from the Automate menu.

Photomatix will alphabetically crawl through that folder, always merging a preset number of images. Take your time to double-check all settings—once the genie is out of the bottle, you will get a longer break anyway.

Once it's all done, proceed to the inspection stage, pick the ones you like, and eventually merge them again with more carefully selected options, or try merging in another software. Same goes for the on-the-fly tone mapping. You can select a previously saved XMP file with settings, but you most certainly will pick the ones you like and tonemap them again more carefully. It's nice as a preview, but honestly, there is so much more we can do with the HDR image. Tonemapping it right away is a bit like peeling an orange and throwing away the inside.

◄

Photomatix can process an entire folder of bracketed exposures into HDR images

Using RAW images instead: As discussed in the file format section (2.1), RAW images already share the linear intensity distribution of HDR images. So in that case, the response curve is not needed at all. The HDR generator just has to puzzle the histograms together—that is, if you merge RAWs directly. It gets a lot more complicated when you use a standard RAW converter prior to that.

RAW converters are naturally trying to take an image from linear to gamma-encoded space. That's part of their purpose, just like the in-camera firmware. You have to manually specify to leave the image in linear space and not apply a tone curve at all. This is not the default setting because it's not generally needed. Also, you have to turn off all image enhancements like sharpening, contrast, and saturation boost—anything that messes with the tonal values. Essentially, all you want the RAW converter to do is perform demosaicing, set white balance, and eventually correct chromatic aberration. If you're not absolutely confident that your RAW converter can do those things better than dcraw, I highly recommend not going that route. You just introduce one more chance for things to go wrong. And you end up with ridiculously large 16-bit TIFF files as the intermediate step, which further delays the process.

Instead, you can merge RAWs directly in Photomatix, FDR Tools, and a command-line version of Photosphere—they all internally use dcraw for demosaicing—and then proceed with merging the original undistorted pixel values directly.

Many people seem to believe they could skip shooting exposure brackets. Instead, they just pull three different exposures from a single RAW file and then merge them into an HDR image. This is a very incestuous practice. There is nothing to gain that wasn't in the RAW file. Noise will not be averaged out; you can be happy if it's not getting amplified. Dynamic range will not increase; it instead can even get lost on the way. When you pour a glass of water into a 1-gallon tank, you don't magically have a gallon full of water. And scooping it over with a shot glass will only result in spillage. If a single RAW is all you have, you might just as well convert it directly in Photomatix. Or simply change the mode from 16- to 32-bit in Photoshop (after doing a straight linear development in ACR).

3.3. Retouching in Photoshop

All right friends, we have our HDR image. What's next?

The case is clear for 3D artists and compositors. They are well aware that the high dynamic range data is the most precious working material they can get and it needs to be protected at all cost.

Most photographers will tell you the next step is tone mapping because an HDR image doesn't fit the limited range of our monitor. Wrong! If you read Chapter 1 carefully and understand the nature of HDRI, you know that this is missing the whole point.

Don't throw it all away yet!: There is nothing super magical about an HDR image. It's all just pixels waiting to be messed with, but better pixels that are much more forgiving when we apply extreme edits. Imagine the HDR image as raw clay that we can form into whatever we want. Why would you burn that raw clay into a hard block now just so you can destructively chisel the final form out of it? Wouldn't it make much more sense to massage the clay into a good model first? And then put it in

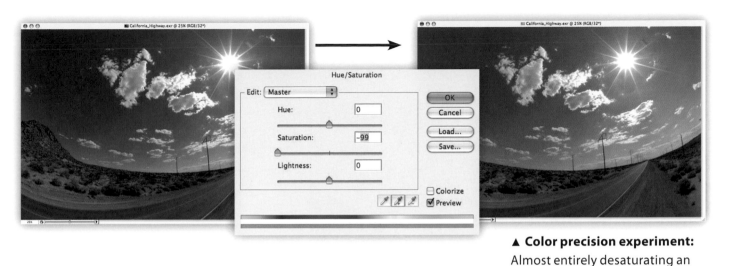

▲ **Color precision experiment:**
Almost entirely desaturating an
EXR image and saving it to disk.

▲ **Part 2:**
Loading the EXR
image from disk
again and boosting
color back up.

the oven to fix that form, and sand and polish afterward?

To speak in more photographic terms: Here we have an image that exceeds the tonal range and qualities of a RAW image. Wouldn't it be great to keep it like that for as long as possible? Well, you can! That's what a true HDR workflow is all about!

Here is a little experiment to illustrate what I'm talking about: I load an HDR image

into Photoshop and pull down the saturation by -99. I do it the destructive way, with a brute force Hue/Saturation from the Image→Adjustment menu. Yes, I'm crazy like that.

Now I can even save that image to disk and open it back up. No trickery, no adjustment layer, just the pure pixel values in the Open-EXR image here. And I can still go back to

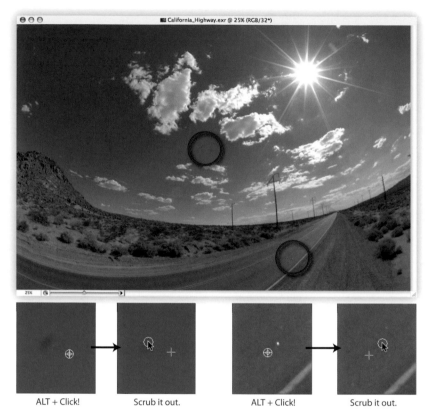

ALT + Click! → Scrub it out. 　 ALT + Click! → Scrub it out.

▲ Basic clone stamp cleanup works just fine in HDR images as well.

Image→Adjustments→Hue/Saturation and pull the saturation back up.

Insane, isn't it?

As long as you stay in 32-bit floating point, the precision will stay the same. Our changes only affect the position of the decimal point, but the information is still there. All pixels still have unique color values, even if they differ by something like 0.0000000000815. OK, the restored result is not quite identical; Thomas Knoll alone might know what a saturation tweak of -99 means for Photoshop. But I promise, bumping it another +25 Photoshop units will bring it precisely back to the original. Try it for yourself; there are plenty of HDR images on the DVD!

So the goal is to do as much as we can right here, right in the HDR image. Admittedly, working in 32-bit mode requires more processing power and memory. But it's worth it—you never know when you might need the precision from the originals again. It might be next month, when there is that new fancy tone mapper out; it might be next year when you buy your very first high dynamic range display! Or it might be a couple of years down the road, when your creative eye has changed and you'd love to revise that image again.

Basic cleanup: For example, we can dust off small mistakes now. That might be dirt particles on the lens or just small things disturbing the image—stuff we don't like at all. The same stuff that an old-school photographer would dust off the negative. There is no reason to leave obvious mistakes in. Get them out right away!

The clone stamp brush works in 32-bit mode since Photoshop CS2, and it does so in a multitude of other programs as well. (See section 2.3.3). I assume you all know how it works: Alt+click on a good spot, then scrub out the bad spot.

So, it's just like in regular images.

Except that you have to watch out for things hidden in the extra range portions. Always remember this: An HDR image is more than meets the eye. You will only spot these hidden mistakes when you do the range inspection we talked about before. And as soon as you see something weird, get it out! It's just too easy to forget about it and carry these dirty spots along all the way to the tone-mapping stage.

White balancing: A very important step. The name is totally misleading because we are really balancing out the colors. White simply

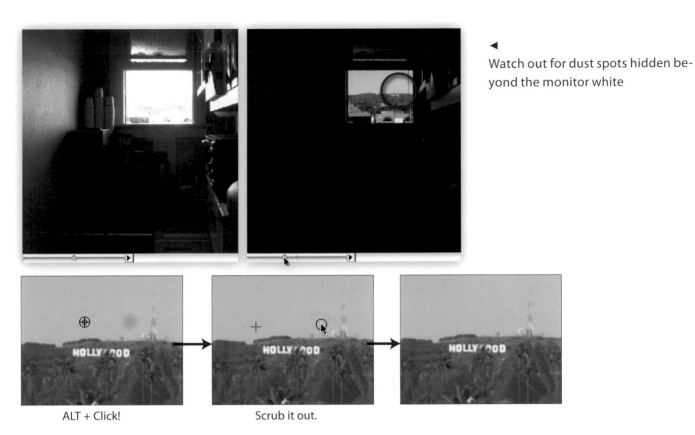

◄ Watch out for dust spots hidden beyond the monitor white

ALT + Click! Scrub it out.

◄ **White balance example:**
There is an annoying blue sheen on the entire image.

▲

Nice dynamic range coverage and some interesting details in high resolution

stands for the most neutral color we can think of. In fact, it's so neutral that it doesn't even count as a color anymore. White is just a very bright gray. Or the opposite of black. It's perfectly colorless.

At least it should be colorless. But in reality, it never is. Before I get into the theories of human perception again, let's look at an example.

The forest image above could be a great generic HDR panorama for all kinds of applications in computer graphics. A bright morning sky spilling through the trees and a band of natural bounce light coming from the frozen waterfall below. There are a lot of great details to show up in reflections as well, and 32 megapixels provide enough resolution for cool virtual camera pans.

Yes, it would be great if there wasn't that cold color temperature, like a blue tint, all over the image. That somewhat kills the green of the trees, and the little patches of sunlight don't appear as golden as they should. So we clearly can't leave it like that.

This is what to do in Photoshop: Bring up the Levels control from the Image→ Adjustments menu. The histogram can't be trusted here—all it shows are the on-screen color values, not the underlying HDR data. We all know that the whites are not really clipped. Just ignore that histogram for now. Instead, activate the little eyedropper icon on the right. This is the color picker for the white point.

Right-click somewhere in the image and a pop-up menu will show up (see figure ❷). Here we can specify where the picker is pulling

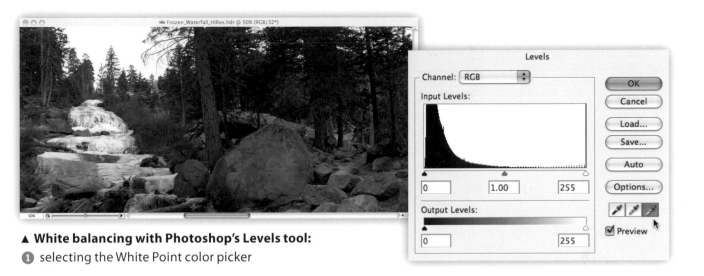

▲ **White balancing with Photoshop's Levels tool:**
❶ selecting the White Point color picker

the color off. You most certainly don't want to pick individual pixels, but rather the average of a small area.

Now we go on a hunt for white in that image. It's tough to see when it's all blown out, so better pull down the quick exposure slider a bit. We're looking for a spot that should be white but currently is not.

It's not quite that easy sometimes. You would think the ice-covered waterfall is white, but it really isn't. In reality, it is reflecting the sky and that gives it a natural blue sheen. Clicking there will just tint the rest of the image with the complementary color, toward the reds (❸). Clicking on the icy spot in the back, the spot that's in direct sunlight, wouldn't work either. Because the sunlight is golden yellow, so the ice is **supposed** to be off-white there too.

Apparently, there is no true white reference in this forest. And that is the case with about 99 percent of all images. Pure white is just hard to find in nature. The appearance of brightness is really caused by the surface

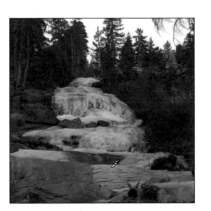

◀ ❷
Right-click in the image to increase the sampling area

◀ ❸
Hunting for white: the ice-covered waterfall doesn't work

❹ ▶

This boulder just got promoted to become my white reference.

▲ **❺**

With the white point set on the boulder, most of the image blows out.

bouncing more light back, and thus the brighter an object, the more its color is affected by its surroundings. That's why white is a very poor scale for defining color neutrality. On top of that, in 8-bit imaging, a white pixel is most certainly just clipped anyway. Makes you wonder how that white balance thing was ever supposed to work at all, right?

Well, it hardly ever worked. That's why most photographers prefer gray as the color neutral standard. For example, that big boulder shown in figure ❹ is supposed to be colorless. If I were there right now and using the white balancing feature of my camera, I would point it at that boulder. You probably have your professional 18 percent gray card, but I don't. I just look for boulders.

Applying that wisdom to HDR image editing, we can just pick the white reference from the boulder. Now watch what happens: The image looks like figure ❺ now.

Pretty wild, huh? In traditional imaging that would have been a fatal move. This poor 8-bit histogram is giving us a taste of it. Huge gaps all over, and half of the image would be clipped, gone to digital nirvana. You'd never do that to an 8-bit image; that's why they have specifically invented the middle pipette icon to pick a gray reference. However, that gray picker isn't working as expected in HDR mode, and we don't need that cheat anyway.

Cameras don't have a dedicated gray balance either. You'd do the white balance on a neutral gray and then step down to your desired exposure. That's precisely what we do in our HDR image. It's just that we do it digitally with the Exposure control from the Image→Adjustment menu.

Now check out figure ❻ : Here is another triplet of eyedropper icons! They look identical to the ones from the Levels window, yet

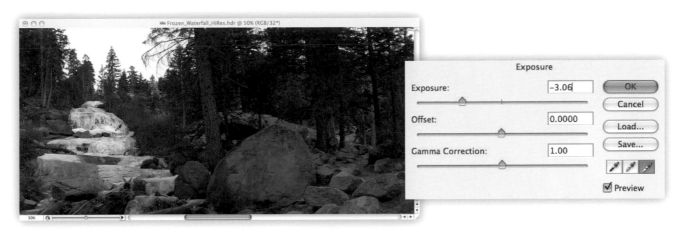

▲ **6**

Compensating with an Exposure Adjustment

they do different things here. In the context of the Exposure control, they are simple spot meters. We can take the white pipette again, click on the waterfall, and it will pull down the exposure accordingly. But it leaves the color balance intact.

Looks much more natural now. Trees appear juicy green, the ground looks dusty, and the sunlight patches have that golden-hour sheen. A good white balance really makes all the difference! So obviously this is an essential step when the HDR image is supposed to be used in 3D rendering.

But even in a photographic workflow it makes a lot of sense to do it now instead of later. You have seen how flexibly I can handle all extreme adjustments without ever losing a bit of quality. And it's simply a great convenience to have it done, out of the way. Now I can go ahead and play with the image some more, and when I finally tonemap it for print, the colors just fit right away.

▲
The grid overlay is a great helper for perspective corrections.

▲
Cropping will reframe the image to concentrate on the important parts.

Perspective correction and framing: This is another basic step we can do at this stage. Having more precise pixel values at hand actually helps the interpolation, so we are less likely to loose sharpness here.

If you don't trust your eyes, turn on the grid overlay. Then hit Ctrl+A for Select All and Ctrl+T to get in transform mode.

The first thing you would do is rotate the image. Move the cursor close to a corner, just outside the image, and as soon as it turns into a small curved arrow, you can swivel it around.

Then hold the Ctrl key and move the corner points. The image will shear out so it always stretches between the corners; nudge them around until vertical and horizontal lines conform to the grid lines. Eventually you will also have to hold Shift to keep these points from snapping to the frame margin. When it looks good, hit Enter and turn off the grid again. Now that image is nice and straight.

After I look at it for a while, something disturbs me about that pillar on the right. It doesn't match the straight architecture, and it's not important for this image anyway. So I reframe the image to focus on the interesting parts, cropping that pillar out.

And while I'm at it, I take care of the modern spotlight that sits on top of that left wall. I don't like that either, so I paint it out with the clone brush.

Sharpening: The final step to a clean HDR image is to add a gentle touch of sharpness. Consider this a first sharpening pass to get rid of the blurriness in the original, not the final sharpening you'd apply just before printing. Remember, we haven't officially tonemapped the image yet.

So here is my workflow: I choose Sharpen→Smart Sharpen from the Filter menu. Personally, I prefer it over the Unsharp Mask filter because it has a cooler name and a bigger preview. It also doesn't have a threshold setting; instead, it seems to grab more lines and edges than flat areas. Take whatever you like; Unsharp Mask works in HDR as well.

Now, the most common problem with sharpening is the chance of oversharpening an image. What that means is that too much sharpening can cause the pixel values to clip to black or white, especially on edges that had a high contrast to begin with. But wait a second—HDR means no clipping ever, right?

Precisely. The pixel values are not clipped off; they just way overshoot into the exposure range that is currently not shown on-screen. When you drag up the quick exposure slider, you can see exactly where the oversharpening is happening.

This is real power. We have a visual clue of where and how badly these sharpening algorithms mess up.

Finding the right settings is now a breeze. Simply pull down the amount and radius slider of that filter until all the false-colored edges disappear. Then they're back to the intensity range where they belong.

Make good use of the quick exposure slider to scan through the entire range, just to make sure. Remember that you can always zoom in the actual image as well, by holding down the spacebar and the Ctrl key or the spacebar and the Alt key while clicking in the image.

▲

Photoshop's Smart Sharpen and Unsharp Mask filters work in 32-bit mode as well.

▲

Dragging up the quick exposure slider reveals the oversharpening artifacts.

► Simply back up the sharpening settings until most artifacts are gone.

Selective color correction: And of course we can flavor the colors to taste. For example, if I don't like how yellow these walls turned out, I can just call up Image→Adjustment→Hue/Saturation, change the pull-down menu from Master to Reds, and shift the Hue setting just a bit more toward the red side.

It's very important here to tune in the display exposure so the area we adjust to is in the middle tones. Don't be fooled by color shifts as they get closer to burning out. That is just caused by the display mapping. Use the eyedroppers to grab just the colors you want to change. And watch the spectrum bars on the bottom of the window; the little indicators between them show you exactly what color will be affected.

In a very subtle tweak like this, changing the hue in full numbers is a bit coarse. That's why in practice this tweak is better done with an adjustment layer. Now the Hue/Saturation slider only sets the rough direction, and I can

use the Opacity setting of that layer to dial in just the right amount of it.

In a nutshell: So those are the basic adjustments commonly used in a photographic workflow: cleanup, white balancing, framing, sharpening, and color correction. They all work equally well on HDR images, some even better, so why wait?

Still, we haven't even tapped the full scope of opportunities yet. I haven't shown you any of the cool new stuff that has no preceding counterpart in LDR image editing. There is so much more to gain when we keep working in floating-point precision that it would cause this chapter to explode. I am talking about hardcore image editing on an entirely new level of control. The big guys in movie post production used to do this for years, and there is a lot to be learned from them. So make sure to check out Chapter 5 on HDR image editing and compositing.

▲

Selective color correction with Photoshop's
Hue/Saturation tool

◄

Real Pros use
Adjustment Layers
for these things.

Chapter 4: Tone Mapping

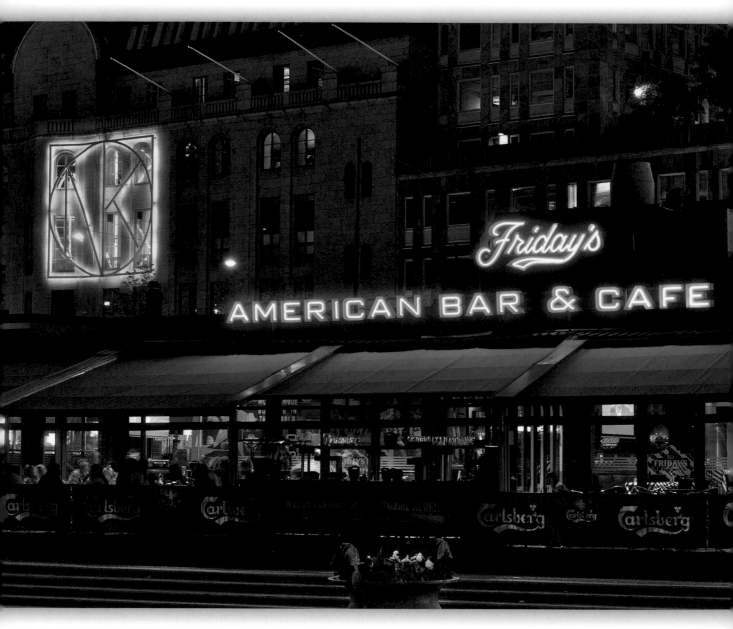

PHOTO: DIETER BETHKE

Tone mapping is a technical necessity as well as a creative challenge.

It's pretty much the opposite of what we did in the Chapter 3: In HDR generation, we expand the dynamic range by assembling it slice by slice from the source images. That's very

straightforward, and the outcome is either right or wrong. In tone mapping, we reduce the dynamic range again so it fits back into a single LDR image. Here the outcome is not so clear, and there are a million ways to do it. Technically, it is impossible anyway. We're try-

ing to squeeze something very big into a tiny container.

There is no ideal result. It just won't fit completely. So we have to make compromises. The whole trick is to make good use of the tonal values available and redistribute them in a way that makes sense. This redistribution is what tone mapping is about. We map the tonal values from an HDR image to an LDR image. How exactly that is done depends on the image content itself and how high the range really is. Sometimes it just takes a little squeeze; sometimes it is like pushing an elephant into a phone booth.

Back to normal: Read this out loud: high-dynamic-range-to-low-dynamic-range conversion! After we're done with tone mapping, we don't have an HDR image anymore. It's completely bogus to point at a JPEG that just happened to be made via tone mapping and call it an HDR image. You don't call a JPEG a RAW image just because you shot it that way. Some may argue that the dynamic range of the scene is still contained in the JPEG, but that is not the case. Applesauce might contain everything that was an apple, but it is not an apple anymore. Maybe there are whole pieces mixed in, maybe it contains all the best of 20 apples, but there is no doubt that the resulting sauce is not an apple. A real apple wouldn't fit in the jar and you couldn't scoop it out and enjoy it as you could a well-done applesauce. Same goes for JPEGs made from an HDR image via tone mapping: They are processed for easy consumption via ordinary devices, and they are low dynamic range by definition. If you read and understood the first chapter of this book, you should know better than to label a tone mapping as an HDR image.

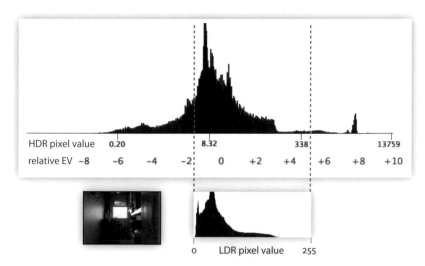

▲ Tone Mapping looks for better ways to map the HDR pixel values into an LDR image.

4.1. Hello Operator?

So we are looking for a tone-mapping method, a general set of rules that describe how the range is stomped together. Some kind of filter or histogram compressor or tone curve adjustment. Everything is allowed as long as it starts out with HDR values and returns some nice LDR representation of it. It's a black box that can do whatever it wants to the image. HDR in, LDR out—that's all we ask.

These are new kinds of functions that cannot be categorized in the traditional way. Instead, they form a tool category of their own: tone-mapping operators (TMOs). There is no real naming convention for TMOs. Some names give you a hint of what's happening inside the black box, some point out a desired result, some are just named after the inventor.

Despite all their differences, there are really just two major strategies involved. This divides the huge variety into two classes: global and local operators. Global operators convert the full image in one fell swoop, whereas local TMOs do different things to different parts of the image.

▲

Photoshop's tone mapping options appear when reducing the color depth of a 32-bit image.

4.1.1. Global Operators

Global operators apply a tone curve to the whole image, squashing different parts of the histogram together. The difference is in what kind of tone curve is used here. It can simply always be the same one, it can be calculated from the histogram itself, and it can even be a different tone curve for each channel.

Simple exposure and gamma

This is what we've always looked at in Photoshop. Technically, it can hardly be called a tone-mapping operator at all. It's just a simple snapshot of our focused exposure. Highlight detail that doesn't fit in the tight bracket of LDR imagery will simply get cut off.

In many ways, this is akin to shooting a regular picture with a regular photo camera. The result looks very similar to the source image of the respective exposure. But it's not quite identical: Our virtual camera has no noise in the darks, and we can choose an arbitrary exposure in between.

A word on Photoshop: All TMOs are hidden in a dialog that comes up when you convert a 32-bit image to 8- or 16-bit.

The first option in that HDR Conversion dialog looks exactly like the first option in the 32-bit Preview Options dialog box. It even comes preloaded with whatever setting you have put in there, so it really is just baking the current display mapping down to LDR. These 2 boxes are connected: The 32-bit Preview Options show you an on-screen representation of your HDR image that looks identical to the result of the HDR Conversion. Makes perfect sense, right? Your monitor is low dynamic range by definition - so what you see is a preview of what you get after the conversion to LDR.

Note that there is still a tone curve applied. Setting the gamma slider to 1 means that in

Let me give you an overview of some common operators. By no means will this be a complete or in-depth description; that would be a book on its own. And in fact it is—a much more precise description of TMO algorithms can be found in the HDRI bible from Reinhard and the other founding fathers (www.hdrbook.com). I hope they forgive me when I pick some selected implementations and group them together with similar types, ignoring a lot of the technical details. My goal is just to give you a feel of what kind of unique approaches there are out there, how you can control them, and how to judge the result. To have a somewhat representative cross section of real-world scenes, I chose four test images:

- **Fat Cloud** - 680:1 / 8.5 EVs. Dusk outdoors scene with interesting details of the clouds.
- **Walk of Fame** - 1,500:1 / 10 EVs. Noon outdoors with badly burned-out highlights.
- **Coffee Shop** - 7,500:1 / 13 EVs. Interior scene with warm colors and deep shadows.
- **Kitchen Window** - 38,000:1 / 15 EVs. The hardest one, with detail inside and outside.

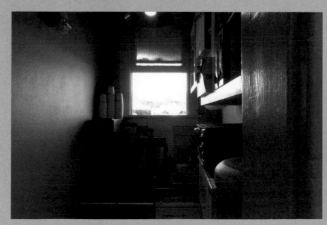

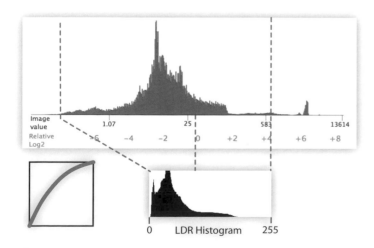

The Exposure and Gamma dialog is just baking down whatever on screen.

this context that the current monitor gamma will be burned in, just as we discussed in section 1.4. The slider here is just an adjustment that can make that gamma curve more or less steep. Visually it behaves like a global contrast, pushing the darks more or less up.

It's a classic conversion that is not smart at all. But it's very predictable; you get precisely what you see. When you go the hard way and massage your HDR values by hand into exactly what you want, this method is a good fixative to get an LDR snapshot. We'll do that later on.

Before/After Histogram of the Kitchen Window example.

◄ Highlight compression supposedly has no options....

▲
... but in reality we can influence the result with all the tools Photoshop has to offer.

Highlight Compression

This is the second option in Photoshop's tone-mapping palette. And it is also available for display mapping in the 32-bit Preview Options dialog box. Instead of clipping, this mode will always protect the highlights. It simply pins down the brightest spot to an LDR value of 255 and converts the rest in a logarithmic manner.

It's fully automatic; there are no options here. That's what the window says. However, you can still influence the result with some dirty tricks. Here is how it works:

• In the 32-bit Preview Options dialog box, set Method to Highlight Compression.

• Choose Image→Adjustments→Exposure and play with the Exposure and Gamma sliders.

• When you're happy with the tonal distribution, you just pin it down by performing the HDR Conversion with the same Method.

This mode works fine when the major concern is to protect the highlights in medium dynamic scenes. The histogram is anchored on the brightest end, and the Exposure slider controls how steep the logarithmic intensity decay is. It can get a bit weird when you are painting in this preview mode because it will try to countercorrect very bright paint strokes.

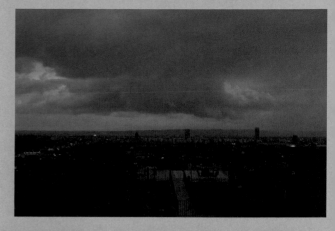

So, even though this mode is listed as having no options, it is actually one of the most versatile and intuitive ones. You have the entire toolkit of Photoshop's image adjustments at your disposal, and you always have a precise full-sized preview.

Highlight Compression is not suited for very high dynamic range scenes. It naturally retains the colors underneath the highlight, which works fine for that statue, it's acceptable for the sugar sprinkler in the coffee shop, but it fails badly on the kitchen window. Here the inside and outside are just too far apart.

A key feature of this TMO is that the HDR pixels get treated with a logarithmic tone curve, which mimics the smooth highlight roll-off known from film better than a simple gamma. Picturenaut's Adaptive Logarithmic option is the same TMO, but it's wrapped in a more traditional user interface with all the relevant parameters in one dialog box. It's actually a very common operator, a true TMO classic. Other programs call it Drago, named after the inventor Frederic Drago.

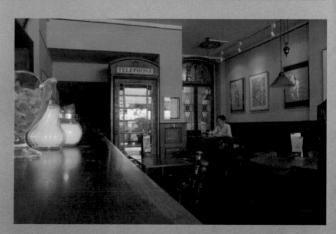

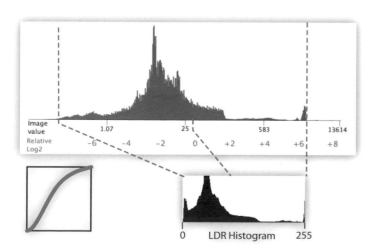

▲
Before/After Histogram of the Kitchen Window example.

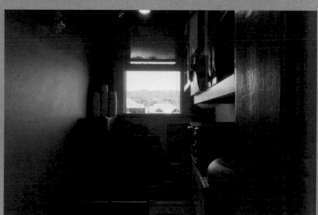

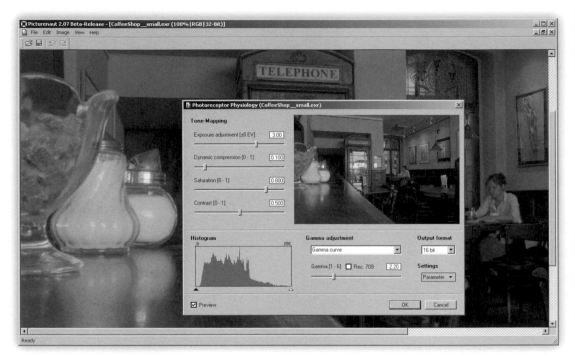

► Picturenaut applies the Photoreceptor TMO to the entire image in realtime.

Picturenaut – Photoreceptor

This one is based on the idea of emulating the receptors in a human eye instead of a film response. It uses an S-shaped tone curve that looks identical to a logarithmic curve in the middle tones. But it behaves differently on both ends. Here the slope of the curve is slightly linear, so the brightest and the darkest parts are not squashed together as much. That means we get better detail in highlights and shadows but sacrifice a bit of contrast in the middle tones.

The most prominent advantage is that it handles colors better as they get closer to white. They get more and more desaturated, which is once again an effect that happens in our eyes too. This prevents false colors, and it works quite well, as you can see in the sugar sprinkler and the kitchen window. Both have a more natural look, and highlights appear crisp

and clean. But when the most interesting colors are just within that highlight end, as in the clouds example, this might be an undesirable effect.

Unlike other parametric tone mappers, Picturenaut is actually tonemapping the original image on-the-fly. So instead of just relying on the small preview, you can zoom into the full image and see your changes take effect right away. Watching the histogram squish and squash in realtime is an incredible way of learning the effects of these controls. The speed of Picturenaut is really breathtaking, and especially when you have a multicore machine, you will just love it!

Most other implementations of this TMO are simply called Reinhard, named after the inventor of the algorithm, Eric Reinhard. Popular sightings are an HDR Shop plug-in (no preview), Artizen, and a whole lot of

command-line utilities. Photomatix's Tone Compressor is the same TMO with fewer controls (and probably less redundancy therein), and it's also slightly less interactive. Despite the name, FDRTool's Receptor acts more like Drago's logarithmic TMO (a.k.a. Photoshop's Highlight Compression). At least it doesn't share the color neutralizing part, which makes a real difference.

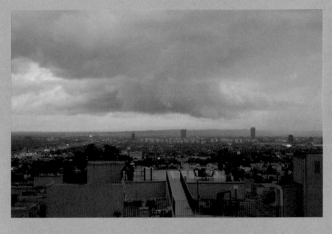

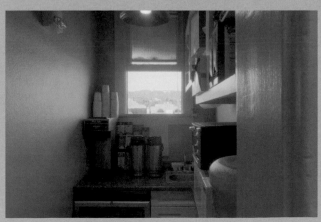

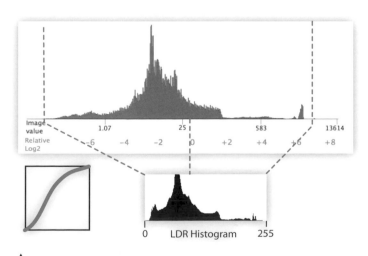

▲
Before/After Histogram of the Kitchen Window example.

► Equalize Histogram is the TMO that powers the viewport in Photosphere.

Photoshop – Equalize Histogram

This is Photoshop's third operator, and this time there are really no options. This one is 100 percent fully automatic. It doesn't apply a fixed-rule tone curve, but rather tries to iron out the histogram directly.

Imagine the histogram suddenly turning into a sand castle. Wherever there is a peak, it crumbles apart. Empty gaps will be filled up, and parts with very few values will be crunched together. That has the effect of maximizing visual contrast in the image. Why? Because peaks in the histogram represent the largest amounts of pixels, and spreading these tones out means that the majority of the pixels of the image will get a contrast boost.

It has basically the same function as the good old Auto Levels, with the exception that it doesn't leave gaps in the histogram. There is always some in-between HDR value to fill in the gap.

Well, that sounds all too fantastic, but in the real world Equalize Histogram isn't working too well. In Photoshop it tends to crunch the range on both ends together, and we end up with deeply blocked shadows and highlights that don't really stand out anymore. The overall contrast boost is incredible, but we lose a lot on the way.

A better implementation of this histogram adjustment can be found in Photosphere, behind the Auto exposure switch. Photosphere has a built-in protection for shadow details; it simply doesn't allow the tonal values to clump together on both ends.

As the name Auto suggests, it's fully automatic as well, but it also works in conjunction with the Local switch. In that case, you can zoom in and pan around and Photosphere will apply this TMO only to the current crop region.

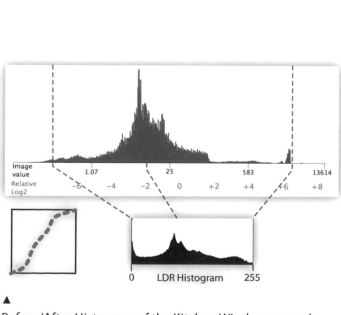

Before/After Histogram of the Kitchen Window example.

▲

Luminance maps like these are used internally by local tone mappers.

In a nutshell

In global operators there is always a trade-off to be made between overall contrast and detail rendition, especially in highlights and shadows. Global operators might works well for scenes containing a medium dynamic range, like the upper two example images. But for the kitchen window, for example, none of the global operators work really efficiently. Photoreceptor comes close to delivering a natural look, but it still doesn't manage to get the most out of the material. This is where local operators shine.

4.1.2. Local Operators

Local TMOs are more sophisticated. Instead of applying the same tone curve to the entire image, they treat each pixel individually—well, not exactly single pixels, but groups of pixels. They can selectively pull the exposure in some areas up and in others, down. The idea is to simulate the locale adaptation mechanism of human vision.

Sounds very mysterious, doesn't it? It's actually quite simple. They generate in the background a mask that is basically just a blurred version of the luminance channel. It looks something like in the examples above..

Once they have a good mask, they can, for example, separate the window from the rest. Then they can pull down the exposure in that area without having to sacrifice contrast anywhere else. They could even make the window view darker than the interior. Also, they could treat each level of grey as a separate zone and boost the contrast locally for each zone. Obviously, the success of a local tone mapper is highly dependent upon the quality of this mask. If the blur crosses the window frame, there is no more separation happening. Then you get halos. If that blur is not wide enough, it will treat each pixel separately and all the details will be mushed together.

How this mask is made, and what is to be done within these zones, is what sets local tone mappers apart from each other. Each one has a different set of controls too. If there are sliders labeled Radius or Smoothing, this refers to the amount of blur and you know that you have a local TMO in front of you.

Photoshop: Local Adaptation

We start off with Photoshop's flagship tone mapper. Option number four: Local Adaptation.

1 At first glance it doesn't look like a local operator at all. But it is one—we have a radius slider that controls the amount of mask blur and a threshold that defines where to blur and where to keep sharp edges. Even at default settings it does a nice job in separating the window from the interior. The mask underneath probably looks more like the leftmost mask example.

The big curve view is normally collapsed—make sure to unfold it by clicking the triangle icon. This is where the party starts. We have a true HDR histogram in the background; the red ticks on the bottom indicate one EV each. So we can now shape a custom tone curve and precisely define how the HDR tonal values are mapped to LDR. One hint: When it all gets too hairy, you can reset everything by holding the Alt key and clicking the Cancel button.

2 The first step is to get to know the histogram. When you hover over the image, your mouse pointer turns into the eyedropper icon. Drag it around holding the mouse button and watch the little indicator circle dance up and down that curve. The horizontal position of that indicator points you to the histogram position that represents this spot of the image. Try to memorize what all the peaks are. Here the last steep peak is the sky, and the alps in the center appear to be the walls. Also, figure out where smooth gradients stretch out, and locate the spots where you want to add some contrast. In this case, I like the wall texture so much that I would like to bring that out a bit more.

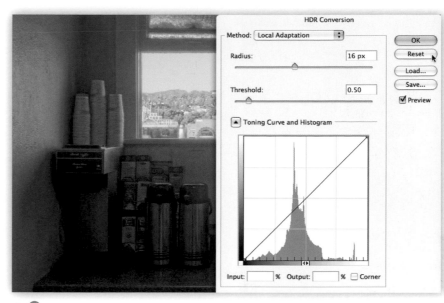

▲ **1**
Local Adaptation is Photoshop's flagship tone-mapping operator.

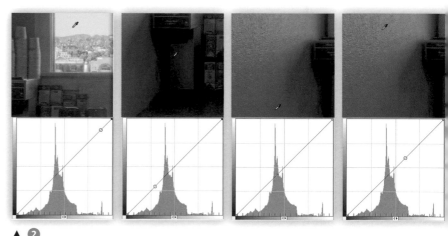

▲ **2**
Get to know the histogram.

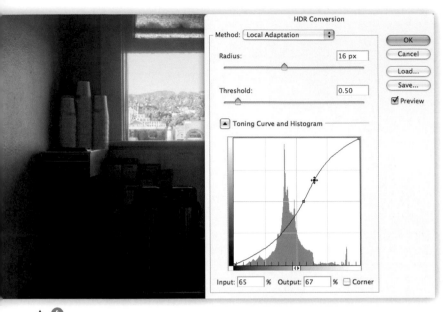

▲ ④

Pulling 2 keyframes apart vertically increases the contrast between them.

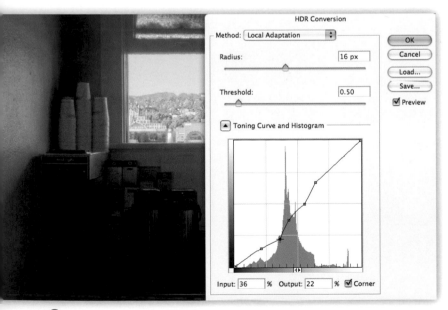

▲ ⑤

The Corner checkbox prevents the curve from shooting off.

❸ The next step is usually to bring in the outer limits of the curve. Bottom left is the black point; top right is the white point. In this case I don't need to do that because they perfectly fit the histogram already. What appears to be a gap behind the sky peak is actually held open by the Hollywood sign—for sure I wouldn't want to clip that off.

❹ OK, now we're ready to rock that curve! Personally, I prefer to work in an inside-out workflow. So I start by setting two points on the curve, around the highlight on the wall, and pull them apart vertically. That makes the slope between them steeper, which is causing a contrast boost there.

It also turns the curve into a wild S shape, pushing the sky up the scale. Quite sensitive, such a curve interface—you always get this whiplash effect when they overshoot.

❺ But this time we have a rescue button. You can mark the selected point as a corner with the little check box underneath. This is a pretty cool way to define several independent zones of high and low contrast.

❻ Let's recap this on the window: Sample first and watch the circle dance. Then go in and tweak the curve. Here I shape a little S curve specifically for that window zone to boost a bit of contrast. It's very subtle, but it shows on the trees and the little architectural checkerboard pattern. To keep the sky from going too far into the baby blue, the last curve point gets cornered off. Pretty crazy curve I am ending up with, isn't it? These corner points are especially unusual; in a regular curve adjustment they would cause some bad color banding. Not so much here.

We have more precision values to scoop from, and even more importantly, this curve adjustment is getting smoothed out by the radius and the threshold value. The invisible blurry-effect mask, remember? It effectively divides the pixels into zones. And the average luminance of each zone is what the curve is getting applied to. Let's have a closer look at how that works.

❼ When the radius is pulled down to 1, each zone is only one pixel plus its direct neighbors. So that curve always affects 5 pixels at a time. That looks just like a regular sharpening filter. If the radius is too large, all pixels outside the window fall into the same zone. They are practically treated as if they all had identical luminance and the window view flattens out entirely. The optimum radius is somewhere around the size of the trees, which is the smallest patch of local detail I want to keep together in a zone.

❽ Threshold has an even more dramatic effect. It defines how far the luminance of two pixels can be apart and be still considered as within the same zone. If it's set too low, each and every pixel is a zone for itself. Then our operator really acts like a global TMO, applying the curve equally to each pixel. But if the threshold is set too high, then even pixels with extreme luminance differences get identical treatment. It's like our effects mask would bleed over sharp edges, and we get the dreaded halo artifacts. The optimum setting here is just below the first visible halo.

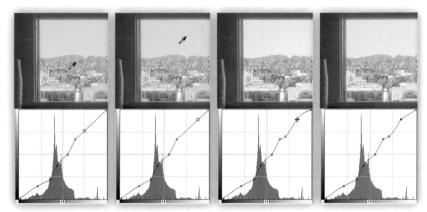

▲ ❻
The workflow recapped: sample/set keyframes/corner off.

▲ ❼
The Radius slider defines the maximum size of the adjustment zones.

▲ ❽
The Threshold value defines the maximum luminance difference within one adjustment zone.

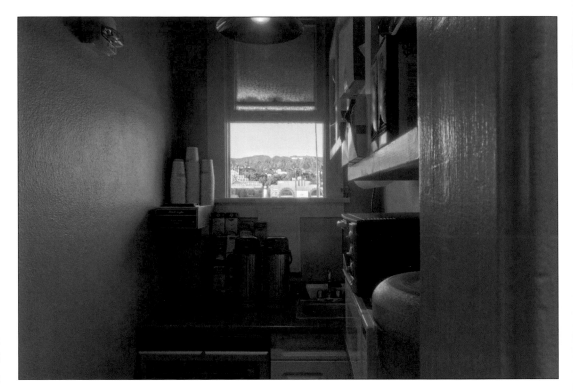

▶

Final Kitchen
Window with Local
Adaptation

As you see, there is a lot of control behind this supposedly simple tone mapper. If you master the curves, the force will be with you. You'll be able to reshape the tonal range just the way you want it. Yes, it can get tedious at times, especially when curves are not your favorite kind of interface. Specifically annoying is the fact that this curve window is locked in size— so the granularity of this control is limited to your pixel-perfect aiming skills. Hardcore gamers clearly have the advantage here.

You might have noticed by now that these example images cannot be compared 1:1 between tone mappers. This is meant more to show you samples so you can inspect the specific aspects mentioned in the text. With this set of examples, it's an invitation to study the curves to see how they affect the image.

For the tech-savvy readers, it should be mentioned that the underlying technology is called bilateral filtering, which directly refers to the way pixels are grouped into zones. Strictly speaking, this is even considered a TMO class of its own, but in a chat among friends, it's safe to call it a local operator.

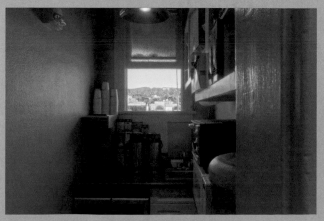

► Photomatix' tone-mapping options

Photomatix – Details Enhancer

This TMO is the shooting star that made Photomatix famous. The photographic community seems to love it. It seems to extract more local contrast with less effort than Photoshop. All controls are clearly labeled sliders and further described in rollover quick tips—a prime example of great usability.

The capabilities of this operator are truly remarkable. It takes a fair bit of experimentation, but its worth the effort to get familiar with it. How to tame Photomatix will be explained in detail by expert photographer Dieter Bethke at the end of this chapter. Right now I'll just give you a quick teaser.

The left column is tonemapped with default settings, straight in and out. On the right side all settings are pulled to the extreme, just to illustrate how much local contrast it can possibly grab. By extreme settings I mean full strength, full micro-contrast, and no smoothing at all. Couldn't resist adjusting to the white and black point, though.

In Photomatix you set all parameters on a smaller-scale preview image. It offers a 100% preview zoom, and in that case it applies the operator only to the region shown in the preview. But you should be aware that the same crop in the final result can look entirely different. This is just the nature of the beast. Local operators have to analyze the whole image at the pixel level. Think back to the blurred effects mask. And imagine the difference between crop-blur and blur-crop.

Photomatix: Details Enhancer

default settings

extreme settings

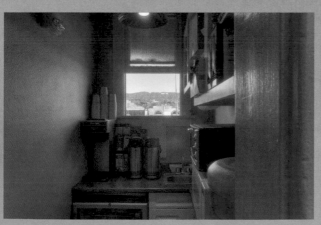
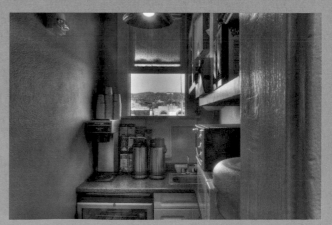

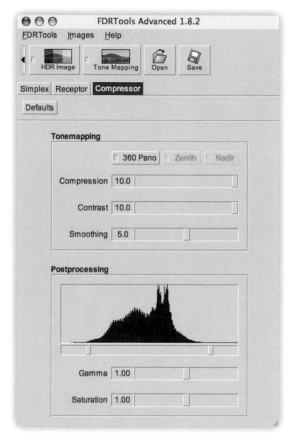

▶
FDR Tools'
tonemapping
options

FDRTools – Compressor

Despite the different interface style, FDR Compressor is very similar to Photomatix Details Enhancer. Detailed rollover tips help you understand the controls, which are trimmed down to the minimum. Setting the white and black point is a bit more intuitive but less precise. Instead of a numerical input field, it has sliders directly underneath the histogram.

Just as in Photomatix, all settings are made just on a small-scale preview. But FDRTools goes even further. There is no OK or Apply button or anything similar. You have to click Save, and then it starts a script that will do the actual work. It will load the image again and apply the tone mapping. Sounds like a strange way to work. Apparently it's made for merging to HDR and tonemapping the images right away while working on preview images all the time in between, which sounds even more strange. But on the flip side, FDRTools can run that process over and over again and automatically change the parameters on each run. It's called compression bracketing or contrast bracketing—pretty helpful for the indecisive.

FDR Tools: Compressor

default settings

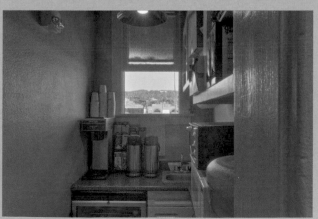
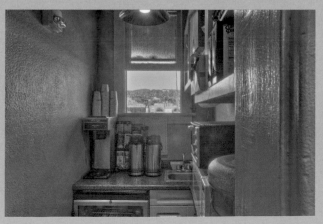

► Artizen's tone-mapping dialog

Artizen HDR – Locko6/Fattal

Artizen HDR deserves to be mentioned as the program with the largest selection of tone mappers. On top of that, it is a full-featured paint package. All global TMOs can be used as display mappers, too, which is precisely where HDRI will be heading in the future.

Unfortunately, the present is not as great as the promise. In this merciless comparison test, this one gave me the most headaches. There was no way to leave the parameters on default settings. While all other programs would always return some kind of acceptable result, I spent most of the time in Artizen fighting nasty tone-mapping artifacts like halos and oversaturation. For example, all Fattal examples were made with a saturation setting

of zero—the low end of the scale. You would think that would return a fully desaturated image, but apparently that is not the case.

So please be aware that these results might just be caused by a particularly buggy version or just plain user error on my part. Maybe the bug was really in front of the keyboard, and you're having more luck taming Artizen than I.

Artizen HDR

Lock06

Fattal

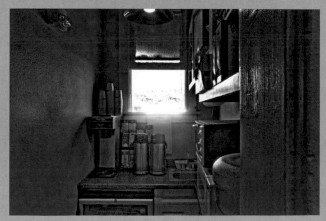

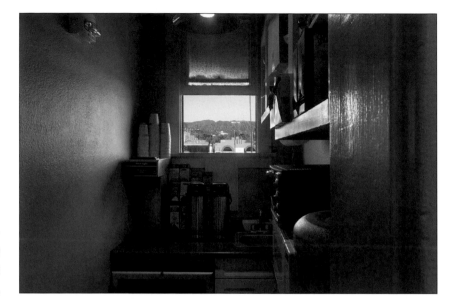

▶

Kitchen Window
tone mapped
manually.

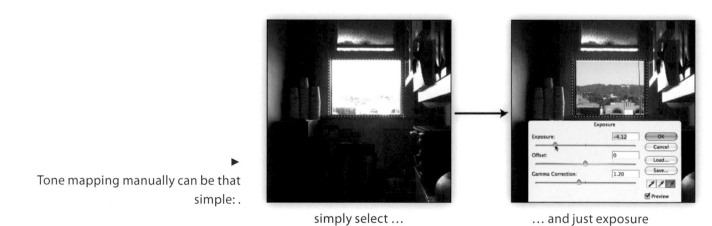

▶

Tone mapping manually can be that
simple: .

simply select … … and just exposure

4.1.3. Human Operator

If you don't trust any of these tools, why don't you take tone mapping into your own hands? You can simply re-expose selective parts of the image yourself and literally massage the range piece by piece until it fits the tonal range of the display. This approach is not new at all; in fact, it is the oldest trick in the book. It's exactly like dodging and burning during the analog development process. Not the digital burn-and-dodge brushes that you used to have in LDR; those were just fakes. They were just pushing around values that had already been developed, but in this technique, you can really re-expose spot by spot.

In the most basic form, you would just make a selection in Photoshop and grab the hard ex-

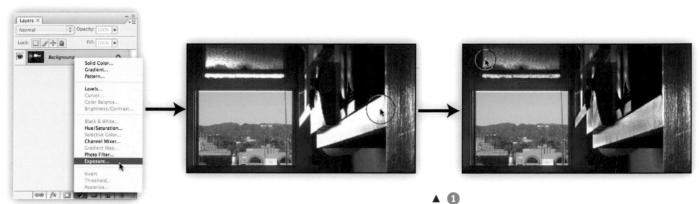

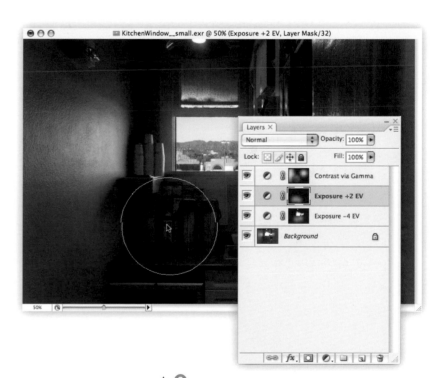

▲ ❶

Using Adjustment Layers and a soft brush to selectively change exposure.

posure control from the Image→Adjustment menu.

There's no magic here. Just manual labor and precise control over the result.

Of course, you are better off using adjustment layers so you can tweak the selection afterward. Figure ❶ shows how this technique really works::

❶ Start off with a rough selection, i.e., the window view.

- Create an exposure adjustment layer with the widget on the bottom of the Layers palette.
- Tune it to taste. Make good use of the Gamma Correction slider to control visual contrast.
- Take a soft brush with a very low flow setting and paint in that exposure to other, similar parts.

Then it's really up to your skill with the brush how well the mask fits. The Smudge and the Blur tools are great helpers here, but your best friend will be a Wacom tablet.

❷ We can stack another adjustment layer on top of that for bringing up the shadows. When you use a very large soft brush and gently touch up whole shadow areas, it blends in as

▲ ❷

Stacking up another Adjustement Layer to brighten the shadows.

all natural. But you'll see the details emerge from the shadows, exactly where and how you want them. It's totally your call.

Once you like what you see, you'd just bake it down. Merge all layers and convert to 8- or 16-bit with the simplest option possible. At this point you really just fix what you see by burning in the current display exposure and gamma. That's it.

The whole technique is very similar to exposure blending, where you just manually merge the original photographs by masking out the best parts. But it's less confusing because you don't have to take care of the layer order or blending modes or anything like that. Instead of handling separate image layers, you have only one. Can't beat the elegance in that. And remember that the noise has already been averaged out when you merged the HDRI— you are already working with nothing but the cream from the original images.

4.2. Tone Mapping Practice

There are lots of different possibilities, with a wide scope of results and more powerful options than ever before in digital imaging. And to quote Uncle Ben, "Remember, with great power comes great responsibility".

True tone mapping: True tone mapping is an invisible art, very much akin to the art of visual effects. The goal is to have the final image appear as natural as possible, natural being defined here in the sense of appearing as if the image had never been touched. It's not about artistic expression. It literally is about creating an image that looks like it was shot with an ordinary camera but incorporates more dynamic

range than a camera could actually handle. Here HDRI and tone mapping are just tools used to get around hardware limitations. The advantage can be highlight recovery, noiseless shadows, or mastering difficult lighting situations. Processing artifacts that draw the attention away from the main subject is avoided at all costs. In tone mapping, the most common artifacts are halos, excessive coloration, and when all the tonal range is spent on details but none on the global contrast.

Excessive digital processing is nothing new. Since the invention of the Saturation slider, it's been very easy to overdo an image. With an HDR image as the starting point, there is just more information to pull from, and especially with local tone mappers there is a huge temptation to go too far. Global tone mappers are generally safe to use for this because they are pretty immune to artifacts. Yet there is more to gain from local TMOs. It is a very thin line between too little and too much, and it's certainly a matter of personal opinion.

True tone mapping is probably the hardest and yet least-appreciated application. Drawing the parallels to visual effects again, it's the invisible effects that require most work and carefulness. Everybody can see the special effects in a space battle. It just has to look cool. But let me tell you from experience that it is much harder to digitally replace a live-action airplane with a CG model, just because the story calls for a 747 instead of an Airbus. It takes immense effort, and you have been successful only when nobody sees that you did anything at all. That's why this kind of tone mapping is not in the public spotlight. It has less of a wow effect. Someone barely ever takes notice. Only when you see a before and after can you appreciate the achievement.

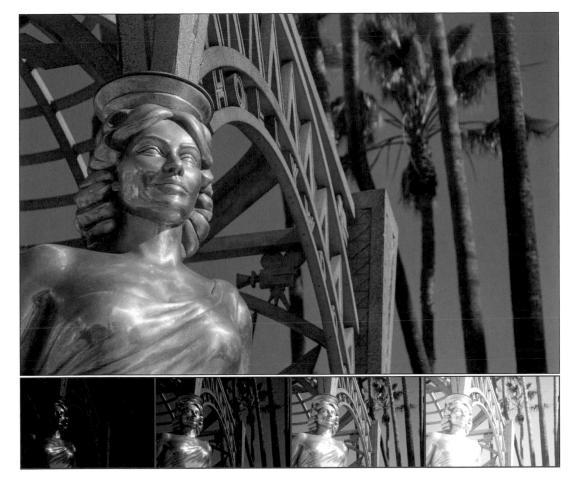

◀ **True tone mapping:** The invisible art to create a natural looking image.

New impressionism: If you don't care about the natural look but rather want to create a piece of art, then you will just love how local TMOs allow you to squeeze every little detail out of an image. Once you completely twist the ratio of detail contrast and overall scene contrast, the image turns into something painterly surreal. We are not used to seeing that in a photograph, but **painterly** is the key word here. Painters cheat the scene contrast all the time; it's part of their artistic arsenal. With advanced local tone-mapping operators, this is finally part of a photographer's toolset as well.

We've discussed before how traditional photography and the sensation of human vision are two different sides of a coin. And when an artist creates an image that matches his personal impression of a scene, there is no point in arguing that it doesn't look real. If you're looking at a Vincent van Gogh painting and saying, "This is crap—sunflowers don't look like that", then you're missing the point of what art is all about. And people would look at you funny. At least now they would; back in the days when painting started to convey these new forms of artistic expression, there was a lot of resistance from the traditionalist

► **Impressionist tone mapping:** An artistic interpretation of a scene.

front, calling it a trend that would fade soon. History repeats itself, but this time it is photography that is evolving away from purely realistic imagery, towards something that is more of an artist's personal impression of a scene.

Local tone mappers are specifically designed to emulate aspects of human vision. It's worth exploring their possibilities and taking photography to the next level of artistic expression. So there you go: start playing, express emotions, find new styles! Just do me one favor: Don't call it HDR anymore. New styles deserve a new name. Call it impressionist photography, or hyper-realism, or anything original. HDRI is a tool, not a particular style.

Texture extraction: When people think about using HDRI for computer graphics, they often overlook the applications of tone mapping for

preparing reference images. The importance of good reference material can not be overstated. Good reference can only be beaten by better reference. Ideally, it should be free from direct illumination—nothing but texture, detail, and shape.

It's not always that easy to shoot. What do you do on a car commercial spot in the middle of the desert? The car doesn't actually run; this is going to be your visual effect. It's noon and there is no shade anywhere. There is a group of people called crew, but they don't listen to you, and they certainly won't push that car around just so it's lit nicely for you. Instead, they give you precisely 15 minutes to do your thing and then they leave for lunch break. What do you do? Well, you take what you can get and shoot brackets like a maniac. Back in the office you have all the time in the world to merge, stitch, and tonemap.

Texture extraction:
Eliminating light and
shadow influence via
tone mapping.

For example you could stitch a 7,000-pixel-wide panoramic strip out of three views, with nine exposures each. Like this one.

The point of tone mapping in this context is to take the lighting out. Once the image is texture-mapped on a 3D object, you will be applying your own light anyway. Shading, shadows, glare, reflections—all these things do not belong in a texture map. So, tonemap like the devil, and use local operators to suck all texture details out.

See you later: At this point I would like to clear the stage and leave you in the capable hands of two professional photographers. From a photographer's standpoint, tone mapping is the creative heart of high dynamic range image processing. You can create or emphasize the message of your images by opting for contrast augmentation, for creating images that look realer than real, or maybe heading for an impressive painterly look. The image data, the "meat", is there—inside your prepared HDR files—sitting and waiting for you to let them shine through.

To give you a taste of what is possible, and how to do it, on the following pages you'll find some inspiring and challenging HDR/tone-mapping projects done by Uwe Steinmüller and Dieter Bethke. Let's find out how HDRI and tone mapping have changed their creative flow and how all these new opportunities are applied to fine art photography and commercial photography.

Ladies and gentlemen, please welcome Uwe Steinmüller and Dieter Bethke!

4.3. HDR for Practical Fine Art Photography

By Uwe and Bettina Steinmueller

Photographers are painting with light. Sounds good, right? But if you listen to them, you will learn that the light is hardly ever right for them. Why are we photographers so picky? We have to deal with three different kinds of contrast range:

- Contrast range of the scene
- Contrast that can be captured in the camera (negative film, slide film, or digital)
- Contrast that can be printed

Most fine art photographers care most to produce photos that can be presented in prints. The first barrier we have to master is to handle the contrast of a scene and capture it with our camera. Studio photographers produce their own light and can create a contrast that can be fully handled by their photographic medium (film, digital). Landscape photographers don't have this luxury and need to hope/wait for the right light. If you listen to them, the right light of course hardly exists. Studio photographers have a hard time producing the "ideal" soft, yet contrast-revealing light (don't forget the coloring of the light). Now imagine being as picky in the outdoors. That's why many landscape photographers get up early (not all of us love this part ☺) or photograph late in the evening.

What happens if the scene has a larger contrast range than the camera can capture in a single shot? There will be clipped light in the highlights and/or the shadows. Somehow, lost highlights are the worst because the highlight details are lost forever and will show in a print as paper white. We try like hell to avoid clipping the highlights. This may sometimes force us to underexpose the main content of the photo. Underexposure leads to blocked and noisy shadows. The most efficient solution to this problem is to wait for a better light. We natural light photographers need to be very patient (and, of course, not all of us are). There are also some techniques used in the field that help to tame the contrast. One of the solutions is a gradient neutral density filter. They work fine, but unfortunately the boundaries between the bright areas and the darker ones are not that often just split by a line.

In the end, many of us photographers don't even start taking photos when we think the light is not right. In California, this is most of the day. Also, low contrast (in the extremes like fog) is challenging, but low-contrast photos can be much better handled than clipped highlights and shadows.

Capturing more dynamic range

The desire to capture more dynamic range is not new. Black-and-white photographers captured quite a bit more dynamic range and also knew how to handle the film to tame the contrast. Slide color photography is more restricted, and most digital cameras today behave like slide film. As said, if the highlights are clipped, you have actually captured an image that will hardly be good enough to be used for any fine art print.

An old classic solution is to capture multiple exposures (film or digital) and blend these images together. Unfortunately, this is both labor intensive and error prone. Here are some of the challenges:

- How to make sure nothing moves (neither the camera nor anything inside the scene)
- How to blend (masking)

It is a classic problem that if you cut something into pieces (here, exposures), it is always hard to get back to the original.

In the digital world, there is some hope that in the future our cameras may be able to capture better dynamic range (Fuji made a first step). Of course, until then we won't stop taking pictures.

Our personal road to HDR

We tried in the past some manual blending of exposures and were hardly impressed by our results:

- Manual registration of the photos was a pain.
- Manual creation of the blending mask was tedious and unpleasing.
- Automatic tools did not make us really happy.

At some point we looked into using the Photomatix tonemapping plug-in (Details Enhancer) for single exposures and we started to like some of the results.

"Light in the Dark" Portfolio –
Sample workflow #1

Our experience with Details Enhancer made us curious how HDR would work in Photomatix and we revisited some photos that we took two years earlier at Fort Point in San Francisco. These were three-shot sequences (unfortunately only shot at -1, 0, +1 EV; today we would do -2, 0, +2 EV instead). Image ❶ shows the exposures we took.

We call this portfolio "Light in the Dark" because the shots have in common a dark scene that is only lit by light through a window or opening. They also have in common that we hardly have to deal with moving objects. Still, a lot of attention has to be paid to camera movement. It sounds actually easier than it is.

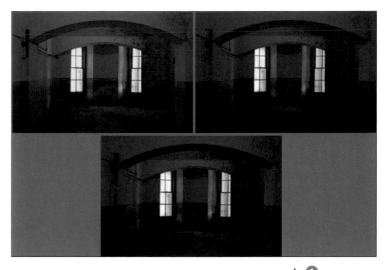

▲ ❶
Three exposures in 1 EV steps.

Even on a sturdy tripod, the camera shake by the mirror (yes, we enable the mirror lockup feature but still it has to go up for each exposure) and the shutter will cause small movements. Be careful if the floor is not sturdy enough. It's less of a problem with medium- to wide-angle lenses, but it can be shocking with telephoto lenses. Don't forget to use a remote release and avoid any contact with your camera during all of these exposures.

If we capture multiple exposures, we only use the camera in manual mode. First we decide on the aperture and then find the medium shutter speed for the exposure. Finally, we either use three (-2, 0, +2 EV) or five (-4, -2, 0, +2, +4 EV) exposures using the camera's autobracketing mode. It's too bad, but using autobracketing mode can sometimes be a problem because some (most?) cameras limit the longest exposure in this mode to 30 seconds and this is easily a limitation for the +4 EV shots. We plan to explore some more advanced programmable remote release for future work.

Once you have your multiple exposures, your fist step is to combine the images. There are two principle ways:

▲ ②
Loading three RAW files into Photomatix.

▲ ③
Dialog after RAW conversion.

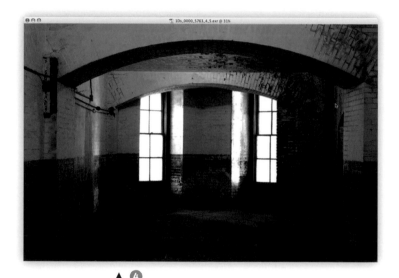

▲ ④
HDR image displayed in Photomatix.

- Exposure blending
- Generating an HDR image

For us, exposure blending is not the solution as it already compresses the tonal range and we plan to do this via a choice of tone-mapping operators. So we first create an HDR image. This can be done in Photoshop, but we are happier using Photomatix Pro. In the following sections, we'll show the steps we use to get our final image.

Generating an HDR image (②): In Photomatix, you can either open the three files directly (we use, of course, RAW files) or convert them in the RAW converter of your choice

(Adobe Camera Raw, LightZone, or other tools). We open the RAW files directly.

Note: The selected files are RAW files even if they have a .tif extension. The Canon 1Ds saved the RAW files using the .tif extension. This was not a good idea and Canon fixed it in later cameras.

Photomatix is quite slow converting the RAW files but it does the job. Once Photomatix finished the conversion, it shows dialog ③ .

We always check the Align Source Images… option. Photomatix does a nice job for minor alignment problems (mainly vertical and horizontal movements). After this step, Photomatix Pro creates an HDR image.

Don't be too shocked if the HDR image looks like this (④)on the screen in Photomatix.

This looks quite horrible on normal monitors, right? Everything is actually fine. Remember that HDR files can store way more dynamic range than your monitor or any printer can handle. The HDR image needs to be tonemapped to fit into the dynamic range that our normal output devices can handle. For now, we save the HDR image in either Radiance RGBE (.hdr) or OpenEXR (.exr). This is only needed if we plan to perform other tone

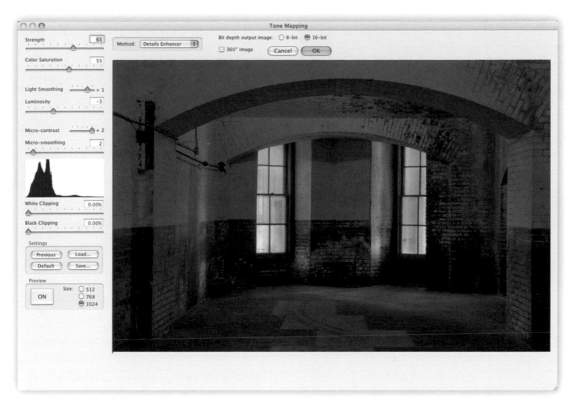

◀ **5**
Tone mapping with
the Details Enhancer

mappings in the future or use different tools
(e.g., Photoshop).

The next step is tone mapping(**5**). Photo-
matix currently supports two different tone-
mapping algorithms:

- Details Enhancer
- Tone Compressor

We almost always use the Details Enhancer
because it is a local operator and helps to cre-
ate better local contrast/detail.

The Details Enhancer in Photomatix is quite
a complex control. Its use requires some expe-
rience as well as some trial and error.

Note: Because Details Enhancer is a local
operator, the result depends a lot on the im-
age. With some images it works great, and
with other images not so great.

Also, with this tool we try to avoid clipping
at nearly any cost. The settings we show can be

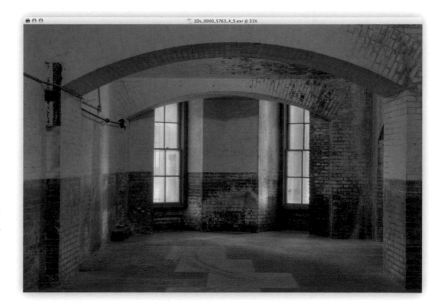

▲ **6**
The resulting image from Photomatix looks
like this.

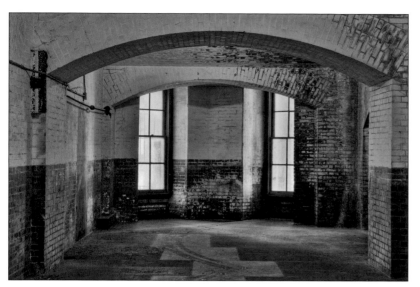

▲ **Final image**
Fort Point in San
Francisco

a good start for your own images. We expect
some more intuitive tone-mapping operators
with future versions of Photomatix.

We save it as 16-bit TIFF file(**6**). You will
find it too soft and you are right. We inten-
tionally want the image to be soft and with the
lowest amount of clipping at this point. We
will enhance the contrast in further editing.
It is very hard to soften files that show too
strong a contrast, and as mentioned earlier,
clipping cannot be undone at all (in 8-/16-bit
files). For the final editing we use LightZone
and Photoshop CS2/CS3. We consider the
result from Photomatix Pro to be like the
result from any RAW converter. We always
want some sort of soft image from the RAW
converter, and then we fine-tune it with Light-
Zone and Photoshop.

Note: While we work in Photomatix, we are
not really working color managed. We try to
get pleasing colors and fine-tune them later.

Here is one possible interpretation we got
from this file (we use a technique we call "col-
orizing" that blends a black-and-white and
color version of the image).

"Light in the Dark" Portfolio –
Sample workflow #2

The timing could not have been better. Just
shortly after we got a first very nice result
from HDR images (see workflow #1), we had a
unique photo workshop on Alcatraz. Now we
are certain that we would have missed many
Alcatraz shots without using HDRI. This time,
we again used three shots but at a wider range,
-2, 0, +2 EV.

Already the previews of the three RAW files
show that these three shots were good enough
to capture the scene contrast. How's that? The
underexposed shot (-2 EVs) shows no clip-
ping in the highlights and the overexposed (+2
EVs) does not show any blocked shadows.

The procedure was exactly the same as in our
fist example.

The main challenge with this and other color
images is to define the color temperature.
There is no right way to do it because we want
to show the warmth of the light but also not
be over the top. In the end, we most often like
more muted colors best.

This photo also shows some ghosting.

Moved by the air, the transparent tape
moved slightly during the different shots. We
think in this case it's not a problem, and it
may even add a nice touch to the image. We
just wanted to mention this and warn readers
that ghosting is lurking everywhere.

We shot a full portfolio on Alcatraz but
would have found the workshop worth it for
this shot alone. Since then, multiple expo-
sures are a fixed element in our photographic
tool set.

▲ Three Alcatraz shot in 2 EV intervals.

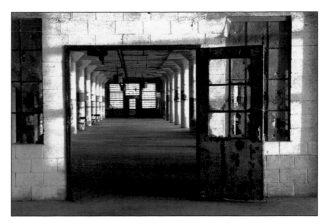

▲ HDR image displayed in linear space in Photomatix

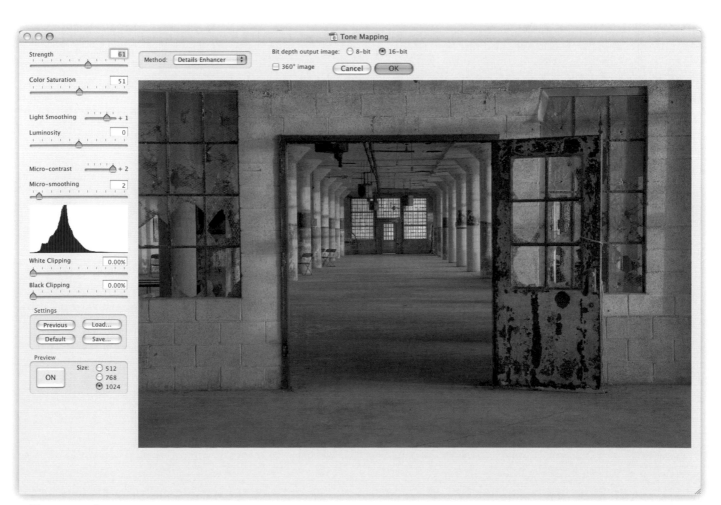

▲ Tone mapping

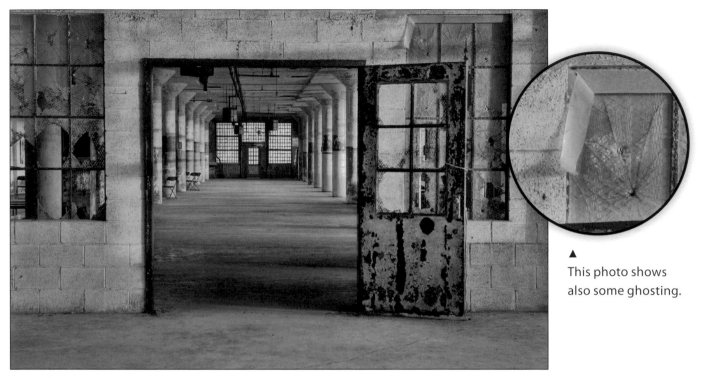

▲ This photo shows also some ghosting.

▲ Final image

▲ 5 shot exposure bracket

"Light in the Dark" Portfolio – Sample workflow #3

In November 2006, we conducted our fourth annual "Fine Art Photography Summit" in Page, Arizona. Page is most famous for its slot canyons: Lower and Upper Antelope Canyon. Down in the canyon, you have no direct light. There are two light sources:

· Direct sunlight bounces off the red rocks, and while losing intensity, it gets more and more reddish
· Light from the blue sky (also called air light) supplies other areas in the canyon with a very blue light

In this case, what your camera records is closer to the truth than what you can capture with your eyes. This means that the final images have kinds of made-up colors while still

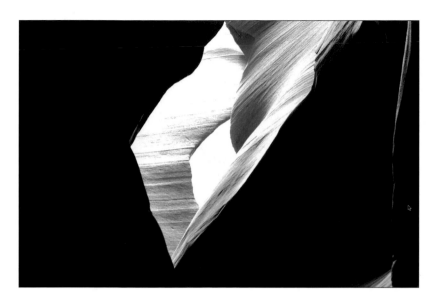

◄

HDR file in Photomatix

▼ Tone mapping

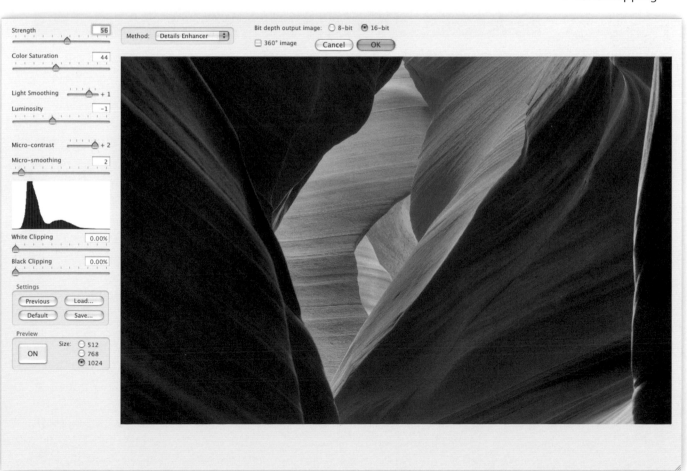

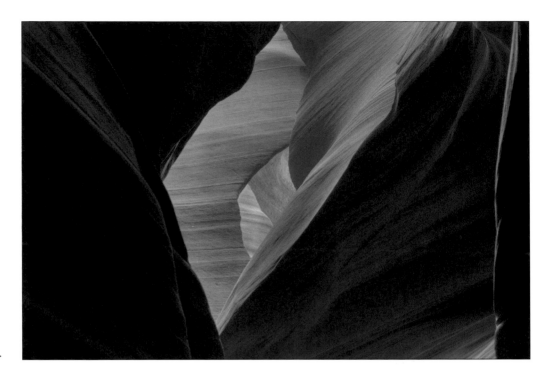

Final image ▶

capturing real color (real, more in a technical sense than to our eyes). Our eyes (and brain) try to neutralize these colors in the canyon.

This time the contrast is so high that using five exposures seems better than just using three.

As you can see, the most underexposed shot (#2) barely gets away with not showing any clipping (but is clearly good enough). On the other end, the most overexposed photo (#5) is the only one that does not show blocked shadows. Again, we think we captured the essential contrast with these five shots (three would not have been sufficient).

These five shots again get combined with HDR with Photomatix.

This time, we worked with selective white balance in LightZone to enhance the effect by bouncing sunlight and air light. We made some area of the image warmer in terms of white balance and other areas cooler.

**"Light in the Dark" Portfolio –
Sample workflow #4**
Recently we wanted to see how well cascades would work using HDRI techniques. The classic solution is to use longer exposures (we like about 1/5 to 1/15 of a second for high-speed cascades. But of course it depends upon your artistic goals; that is, how you would like to present the cascades. In most cases, it can be said that completely freezing the moving water does not add to the picture.

So we started photographing cascades with multiple exposures.

We experimented with bracketing of about (-1, 0, +1 EV).

Note: All shots were done in the shadows. Still, you will be surprised by the dynamic range of that scene.

Remember that you also have bracketed single shots. The first thing to do is to check whether the single shots can be used by them-

◄

3 exposures, 1 EV apart.

▼ Tone mapping

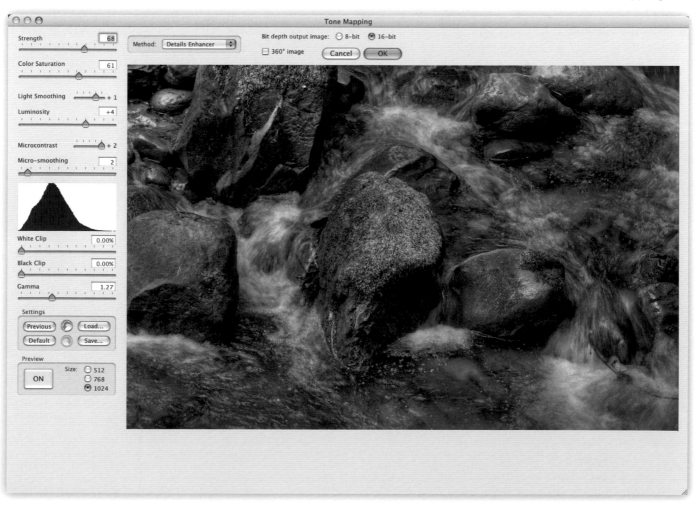

▲ Photomatix output

▲ Final image

selves. Bracketing was always a proven technique to get the best possible exposures. Now you can use this technique and get shots for HDRI at the same time.

We combined the three exposures in Photomatix (version 2.4) to an HDR image and then tonemapped the HDR file in Photomatix.

Again our goal is to keep the file soft. The final tuning is done this time in Photoshop CS3. Here is the version right out of Photomatix.

We brought this low-contrast image to life using the following steps:

- Additional local contrast enhancing with Akvis Enhancer
- Sharpening with DOP EasyS Plus
- Some extra contrast and saturation tuning

Here is the version we finally came up with.

It makes some sense to use HDRI even for moving objects like water and clouds. Otherwise, moving objects will cause a lot of trouble.

Summary

HDRI is still a new technique, but there are many photos that can be improved using multiple exposures and tone mapping. We expect in the future cameras that help capture higher dynamic range in a single shot and improved implementations to remove ghosting. We personally hope for many more ways to perform tone mapping, as well as ways that offer better control. HDRI is clearly here to stay, so we should all start experimenting with it now.

4.4. Creative Tonemapping Techniques

BY DIETER BETHKE

I live in the city named Kiel, in the north of Germany. My main assignment is consulting and sharing my knowledge in the photographic and printing community. We have a lot of water, ships, and landscape around my home base and I like to travel, mainly to northern and major European cities. To me, they are most impressive in the nighttime. So I focused on trying to create exceptional photographs around the themes of transportation, landscape, architecture, and night shots. Consequently, I got to know about capturing HDR images and spent a long time experimenting with this exciting new way to record and present high-contrast scenes.

In order to present stunning prints or on-screen presentations of my HDR images, I have to compress their dynamic range down to a level the planned output device is capable of. This process is called tone mapping, and it will be necessary as long as images have to be printed on common photographic substrates, inside newspapers and magazines at least. At first glance, it sounds like a lot of complicated work and it may seem as if we're degrading the quality of images. But how is quality of an image measured? Is it measured solely by its technical attributes? Definitely not. An image is more than "correctly" reproduced colors and shapes. It's an apparent interpretation, created and controlled by the photographer. To my personal deep conviction, the step of tone-mapping a completely captured scene in HDR image formats is the key to create a unique, never-before-seen image, capable of promoting the photographer's signature style.

Tone mapping offers great potential for creative arrangements, and it gives me the ability to express myself and my impression of a certain scene using methods beyond those that photographers have been used to for quite a long time now. To my knowledge, Ansel Adams's zone system was an assimilable approach to give power to the photographer and to break free from technical limitations.

At first glance it may look a bit confusing. But in the following examples, I will introduce you, step by step, to the use of all these sliders and check boxes. I will give helpful comments about my decisions to use them the way I do so you will be able to abstract your own conclusions for future projects. I will use the following examples to show you how I overcame typical problems and made creative use of tone mapping:

- **Architecture shots** (main issue: inside/outside view) • Case: "Sea Cloud II – The Lounge"
- **Night shots** (main issue: high contrast / low contrast in one shot) • Case: "Svenska Handelsbanken at night – Stockholm"
- **Panoramic landscape shots** (main issue: backlight) • Case: "Queen Mary 2 in the dockyard – Hamburg"
- **Dramatized shots** (main issue: create an eye-catcher) • Case: "The Stockroom"
- **Painterly looking images** (main issue: create an artistic experience) • Case: "HaBeMa"

My examples, shown on the following pages, are based on well-prepared HDR images. They were mainly shot in RAW format, with at least three—often more—exposures at 2 EV stop spacing, and then assembled to HDR using Photomatix Pro's timesaving batch-processing facility.

Let's start simply, explaining the basics a bit. The following introduction into a usual HDR/tone-mapping workflow consists of two main

▲

Case: "Sea Cloud II – The Lounge"

parts: straightforward tone mapping and some final steps within a common image editing software. Here we go.

Architecture – interior views

"Sea Cloud II – The Lounge" is part of a feasibility study about cubic panorama photography, intended to be used for online presentations on shipping companies' websites. When shooting panoramas, the photographer is often confronted with a common problem for interior shots: presenting the view through one or more windows while keeping the complete interior with all details visible and pleasing. In this case, I shot a single frame image to prove the concept of HDR/tone mapping mastering the challenge of a high dynamic range scene. If it works for this single frame, it will work for a complete 360 degree panorama. Also, the tone-mapped single-frame image could be used inside a printed catalog, for example. Actual dynamic

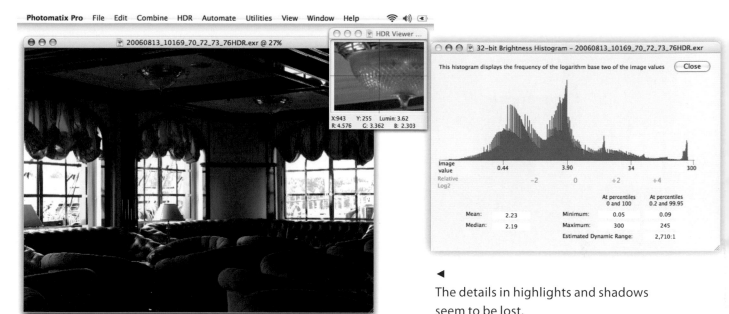

◄
The details in highlights and shadows
seem to be lost.

range was captured by five exposures in RAW
format with 2 EV spacing in between. This
means that a dynamic range of about 12 f-
stops is captured. I converted the five RAW
files using Adobe Lightroom's zero'd settings
and exported them into five 16-bit TIF files
with ProPhoto gamut. Photomatix Pro gener-
ated an HDR image out of these five TIF files
and saved it as OpenEXR.

Part 1: Straightforward tone mapping of an HDR image

I opened Photomatix Pro and loaded the HDR
image, which was saved as OpenEXR before.
As you can see, displaying the dynamic range
of about 2710:1 overburdens a common mon-
itor's capability (that of the print, anyway).
The details in highlights and shadows seem to
be lost.

But a little inspection with the HDR Viewer
tool (Cmd+V) reveals the opulence of captured
details.

In this section, it will be my task to set the
parameters in the tone-mapping method
called Details Enhancer to create a pleasing
and photographically ambitious low dynamic
range representation showing all the interest-
ing details in highlights and shadows simulta-
neously. The resulting tone-mapping output is
LDR but will show a high-contrast scene that
is printable on paper or usable for presenta-
tion on a common screen.

Let's start interactive tone mapping... with
default values.

❶ Though default values are a reasonable
point at which to start, they are not optimal
values for each and every kind of image. Gen-
erally, scenes of the natural environment
or well-known interiors benefit from lower
Strength values, around 30 to 50. The same is
true for landscape scenes. Even lower values
may be appropriate. Values above 60 tend to
give a hyperrealistic look, like a 3D game. But

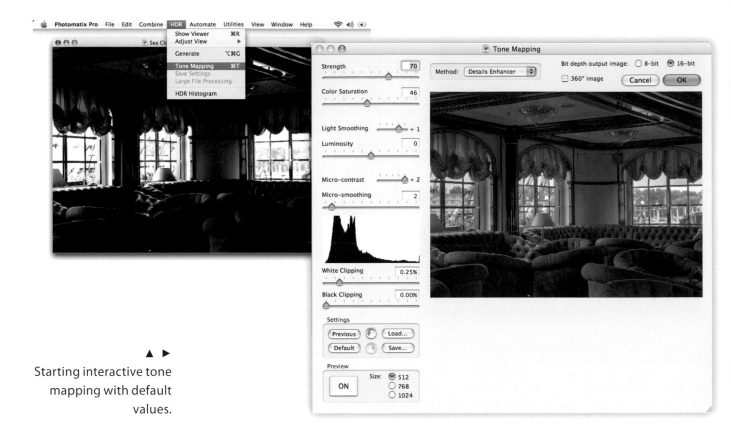

▲ ▶

Starting interactive tone
mapping with default
values.

that does not necessarily mean I would be
afraid to use higher values for Strength when
appropriate. You will see this later on in an-
other case. For this case, I decreased Strength
to 40 to get a more natural-looking amount of
contrast in the resulting image.

❷ Light Smoothing influences the amount
of smoothing applied to the luminance
variations. Have a look at the consecutively
stringed chair-backs. They are dropping shad-
ows onto each other, making this two-dimen-
sional image look three-dimensional, and I
want to emphasize this. Therefore, I reduce
Light Smoothing too because the depth of this
scene gets supported by emphasizing the con-
trast in gradients between lights and shadows.

❸ The colors of the chairs and curtains look a
little bit washed out. Raising the Color Satu-
ration value gives more vivid colors. Lower-
ing the color saturation creates more muted
colors, which might be appropriate with more
technical scenes. A value of about 60 fits well
for this lounge scene, in my opinion. I like the
warm and colorful look of these comfy lounge
chairs hit by rays of friendly sunbeams.

❹ Luminosity controls the compression of
the tonal range in general. Moving this slider
to the left most of the time gives a more natu-
ral look. Moving the slider to the right boosts
visibility of details in the shadows and bright-
ens the image. I decide to set it to +3 because

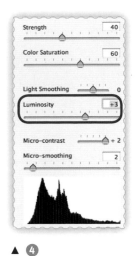

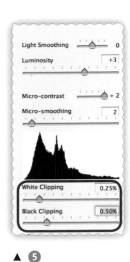

▲ ❶ ▲ ❷ ▲ ❸ ▲ ❹ ▲ ❺

I want to emphasize the light of the beautiful morning in this well-lit scene a bit.

❺ White Clipping and Black Clipping directly control how much image values at the upper and lower end of the histogram are mapped to pure white or pure black in the resulting image. They are similar to the black point and white point sliders in Photoshop's Levels dialog. In this case. adjusting Black Clipping to 0.50% kicks in a reasonable amount of global contrast, enhancing structures and shadows to a preferred level. And keeping White Clipping at 0.25% preserves the specular highlights of the reflection in the polished wooden ceiling.

❻ Because I want to process this tone-mapped image further, I choose to output it as a 16-bit TIF. Doing so gives more leeway for useful manipulation in image-editing software afterward by keeping as much valuable information inside the uncompressed or lossless compressed TIF file format as possible. Up to this point, I optimized the parameters accord-

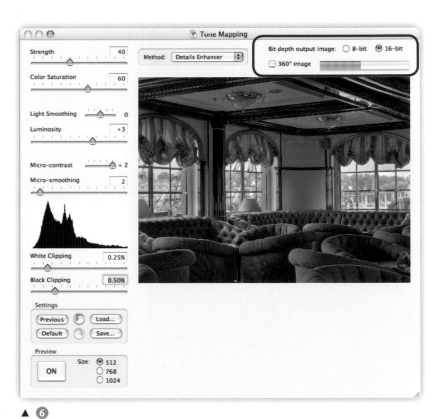

▲ ❻

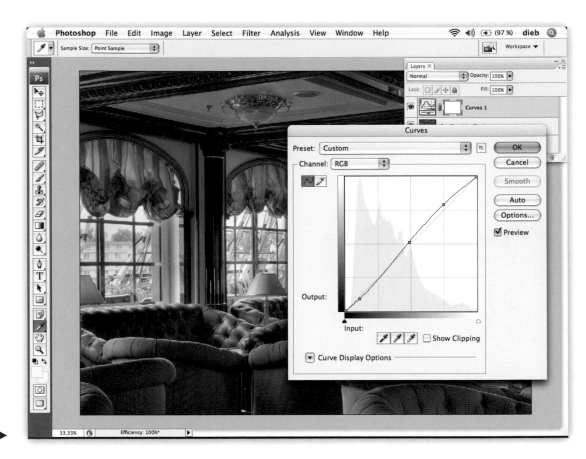

1 ▶

ing to the preview image. To start the tone-mapping process I have to hit the OK button. Processing the original high-resolution image in the background of the tone-mapping window takes some seconds.

7 As mentioned in the preceding step, I save the tone-mapped result as a 16-bit TIF and will hand it over to my favorite image editing software capable of 16-bit images.

Part 2: Finalizing the tone-mapped image with image editing software

To me, this means opening the saved 16-bit TIF file in Adobe Photoshop and applying some final image enhancements—no wild stuff, just some common basic tasks to prepare the image for presentation.

1 I apply a soft S-curve to increase the global contrast visually. To do this in a nondestructive way, I just apply a curves layer on top of the tone-mapped result.

2 As I am already satisfied with the framing and the appearance of the image, I just have to duplicate this view and apply some appropriate sharpening to finally prepare the image for presentation.

3 Presentation on-screen almost always demands that the image be converted to sRGB...

▲ **2**

◀ **3**

4reducing the bit depth to 8-bit mode and saving as JPG.

Following this first case, you are now familiar with the basic steps for creating an HDR/tone-mapping presentation. The workflow consists of two main parts: tone mapping and finalizing the image. I introduced you to the major parameters of Photomatix's Details Enhancer and the crucial finalizing tasks in Photoshop.

In the following cases, I will focus more on their respective special aspects, repeating some things but not everything (trying not to bore you to death) and sometimes digging a bit deeper into other aspects.

Let's move on to the next case, revealing some insights into the challenges of night shots and helpful composition in Photoshop.

◀ **4**

▲

Case: "Svenska
Handelsbanken at
night – Stockholm"

Night shots (…in the summer, in the city…)

Shooting a night scene almost always involves dealing with high contrast. Light sources and deep shadows inside the frame are responsible for maximum contrast, though they cover only small areas inside the scene. On the other hand, most parts of a night scene are dimly lit, showing only medium contrast and tending to hide interesting details. Also, night shots require long exposure times, which introduce sensor noise to the source images. Fortunately, I can overcome these obstacles nowadays

with an advanced shooting and processing workflow. It consists mainly of capturing an HDR image and tonemapping it, using a tone mapper that offers widely adjustable enhancement and preserves local contrast. The following HDR image was created out of five shots, but this time using 1 EV f-stop spacing in between them because merging a higher number of shots helps to smooth out noise. While I overexposed the shadows, I did not underexpose the lights perfectly because I will clip away the highlights in this case anyway.

◄

This is what you see, if you open the OpenEXR file in Photomatix Pro again.

▼ **1**

I merged them with Photomatix Pro's HDR generator and saved to an OpenEXR file. Let's have a look. This is what you see, if you open the OpenEXR file in Photomatix Pro again.

Part 1: Tone mapping with Details Enhancer
The first part of my advanced night shot processing workflow is using the parameterizable tone mapper Details Enhancer in Photomatix Pro again. Unless I'm loading formerly saved presets, I click the Default button first when I am going to tonemap a new kind of image.

1 I start parameterizing the Photomatix tone mapping by leaving the Strength at the default (70), which serves well as starting point for a night scene. It will be adjusted later on.

2 The scene looks too bright for a night shot. So, taking into account the lower luminosity of a night scene, I lower the Luminosity value to -9 .

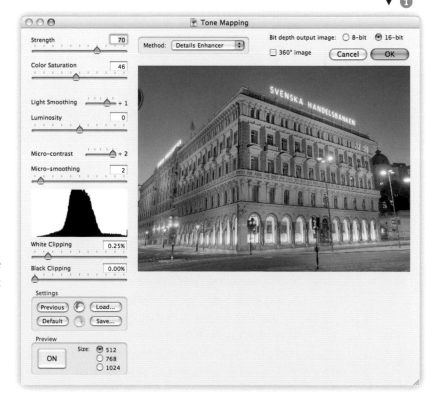

▲ ❷

▲ ❸

▲ ❹

▲ ❺

▲ ❻

❸ Color Saturation raised to 90 creates a powerful blue northern midsummer night sky and brings back the color of the illumination of the building.

❹ Light Smoothing set to +2 gives me nice luminosity gradients in the sky and the building.

❺ Lowering Micro-Contrast to 0 keeps midtones and shadows a little bit more open, which I prefer. This one and the step before are highly dependent upon personal taste.

❻ Finally, adjusting Strength up to 85 gives a well-balanced contrast all over the image.

❼ The next step is to check noise level with the Zoom tool (click on the image to get 100% view) and adjust Micro-Smoothing to a value that will take care of optimum balance between low noise and preservation of fine details. I used to check at least two positions in the image. In this case, I decide to take a close look at the sky and raise Micro-Smoothing until eventually the noise disappears. Then

I check a part of the image that shows the veneer and contains fine details and lower Micro-Smoothing until no degradation in detail is noticeable. Finally, for Micro-Smoothing I choose the value in between the setting used for lowest visible noise and the one keeping the finest detail. With this image, 5 is fine.

❽ To bring back the common characteristics of a night shot (high apparent contrast), I like to use the White and Black Clipping sliders. White Clipping provides specular highlights and gives good control over intentionally burned-out light sources, while Black Clipping mainly raises apparent contrast and blocks out some noise in the deep shadows. I decided to use 0.35% for White Clipping and 0.60% for Black Clipping to accentuate the look of a night scene but not lose too much information at both ends of the histogram.

❾ Saving settings as an XMP file is always a good idea so you can make use of the same settings later. Maybe you will want to write a tutorial like this one or simply to run a batch

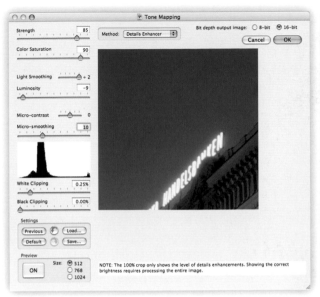
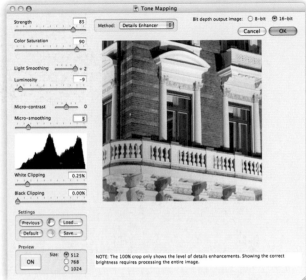

▲ **7**

◄ **8** **10** ►

of similar scenes through the batch-process-
ing facility in Photomatix Pro, for instance.

10 Again, the final step of the tone-mapping
part is saving the image as a 16-bit TIF and
handing it over.

To go on with image editing, I open the tone-
mapped result in Adobe Photoshop.

There are still some open issues to cover: ▲

Part 2: Composing in Photoshop

In the second part of my advanced night shot processing workflow, I have to deal with common issues of 8/16-bit LDR images because the tone mapping boiled down the HDR image into a normal LDR image from the file's and data format's point of view. Though I can see a lot of apparent high contrast and details in light and shadows, this gives me the advantage of using my favorite image editing tool to work on the last odds and ends. I prefer to work in 16-bit precision, so the adjustments necessary will do no visible harm to the appearance of the image.

As you can easily see, there are still some issues to cover:

A. Still a little bit of low apparent global contrast

B. Light trails from the rear lights of passing cars and from traffic lights in the lower-left corner of the frame. These artifacts are results of the different exposures, especially the longer ones.

C. Perspective distortion and crop

In the following steps, I will solve issues A and C using common Photoshop techniques, but B needs special treatment.

The solution to A: To gain global contrast, I just apply a curves layer, making use of a soft S-curve.

The solution to B: To get rid of the visible artifacts in the lower-left corner of the tone-mapped result, I have to create an additional layer inside Photoshop containing a spare image capable of replacing the disturbed areas. Usually, to create such a spare image, I like to create an exposure blending out of the set of original exposures by using, for example, H&S Adjust in Photomatix Pro, excluding the one or more exposures that introduce the unwanted artifacts. Then I put this spare image as a layer on top of the tone-mapped image inside Photoshop and use the layer masking feature to show only the parts needed to repair the disturbed areas of the tone-mapped image. This technique I used for the "Fridays" image, you will see later on in the showcase following the tutorials. In this special case of the shot of the Svenska Handelsbanken at night, there were too many cars driving through the frame and the traffic lights kept changing when I was capturing the LDR shots. Unfortunately, I failed to recognize these problems on location. Otherwise, I would have repeated the shots several times and selected the exposures that fit my needs best later on at home, discarding the scrap. But I missed the chance to take multiple sets, and so it was impossible to create the exposure blending mentioned above from a set of well-selected exposures. Fortunately, the second longest exposure of my one and only captured set is not showing the interference artifacts and matches as closely as possible the luminance level of the tone-mapped

▲
The solution to A.

The solution to B.
▼

▲

The solution to C.

result. So I decided to use this single exposure as an additional layer and masked the unneeded parts of it. To paint a layer's mask, I use a relatively big, soft-edged airbrush at 50% opacity (or a pressure-sensitive stencil on a professional pen tablet).

The solution to C: In order to straighten out the building and crop to a well-proportioned clipping, I first duplicate the layered image (reducing down to one layer) and then use the Transform→ Perspective and Distort tool.

Finally, the image gets scaled and sharpened appropriately for the planned kind of presentation. As a rule of thumb, sharpening for print deserves higher values than sharpening for screen presentation.

In this case, you see an advanced combination of HDR/tone mapping and layered composition of an exposure blending in Photoshop to handle image artifacts. With this night shot case and the former one, you are well prepared for typical tone mapping and presentation tasks. In the next case, I will comment on a more advanced and specific subject: enhancing panoramic photography.

Panoramic images – even more impressive with HDR/tone mapping

If you are going to shoot a panoramic image, it's hard to avoid getting the sun or any other direct light source into the frame, resulting in a very high contrast. On the other hand, back light can give dramatic and very interesting

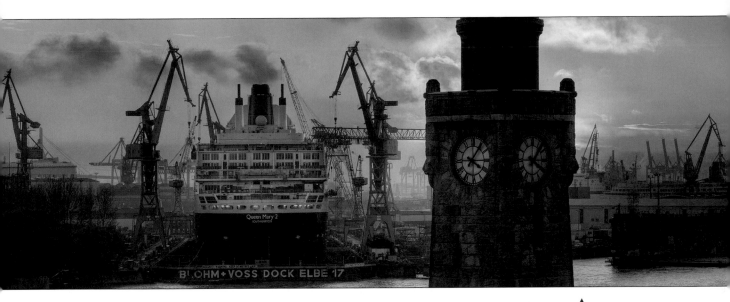

▲
Case: "Queen Mary
2 in the dockyard –
Hamburg"

shots. You just have to deal with the challenge in an appropriate way.

On one of those special November evenings, when the Queen Mary 2 was being renovated in the dockyard of Blohm+Voss in Hamburg, I assembled my tripod at a position that would give me the right viewing angle and decided to wait until the sun set exactly behind the tower. While waiting for the right moment, I took some test shots and optimized the shooting workflow and exposure settings. I also spent some time talking with some photographers taking images at the same time at this location. Sounds a little bit like going fishing!? And yes, it was a pleasure to take the exposures I needed and enjoy this darkening orange evening sky over the impressive industrial scenery. With this warm feeling and vital impression in my mind, I went home and could not wait to process the recorded exposures. And I wanted to create a panoramic image, offering the impressive experience of this situation to others. Finally, the tone-mapping workflow proved it was the right kind of tool, giving me the necessary latitude and influence.

Most of the time when people look at the result for the first time, they say, "Wow, that looks tremendous. So many details in there, and this impressionistic look. But you surely did a lot of work retouching the color of the sky and composing the tower into it using several layers and masks, right?" And that's usually the point when I start talking about HDR imaging and explain taking several exposures... Well, you have already read about the basic techniques, so I don't need to go into details again. I will say that I took six overlapping frames to stitch this panoramic image, each consisting of three exposures separated by 2 EV. And no advanced Photoshop layers composition was necessary to get this final result.

The most challenging obstacle within this project had been the cranes. It took six minutes to take the shots I finally used, and the cranes kept moving constantly. In my first tone-mapped version of this image, I had to retouch them in Photoshop to cover the ghosted areas. But while writing this, I created a new, second version using Photomatix Pro's brand-new ghost removal feature within HDR

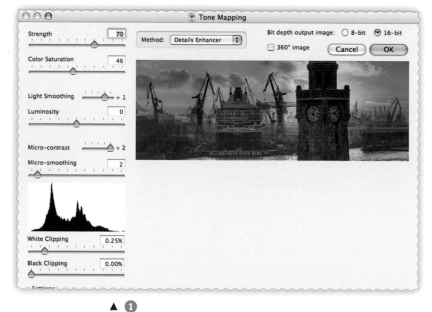

▲ ①

Part 1: Tone mapping

❶ As usual, I start by opening the HDR file in Photomatix Pro and start tonemapping with default values.

❷ To intensify the colors, especially the orange sky, I increase Color Saturation to 65. Usually I keep it lower for landscape photography, but this one should get a strong and impressionistic appearance.

❸ Raising Luminosity slightly to +3 emphasizes the glow around the tower a bit and opens up the shadows.

❹ The digital camera used for this project tends to introduce noise, so I have to engage micro-smoothing to smooth out noise but not too much detail. Using the 100% crop view, I check different settings and determine a value of 5 will do the job.

❺ Finally, I adjust White and Black Clipping and start the tone-mapping process to create a 16-bit result and save it as a TIF. Further processing will be done in Photoshop.

Part 2: Final steps in Photoshop

❶ As in the previous case, I apply a soft S-shaped tone curve to increase global contrast and brighten the midtones slightly.

❷ With a big soft-edged brush, I apply some selective dodging to the brighter parts of the ship's **superstructure** and the clock face. The shadows at the stern, bushes, and quay walls get burned the same way. I do this very gently with a maximum of 5% exposure and several strokes in order not to overdo but to pronounce the points of interest. Using the Clone Stamp and Healing Brush tools, I removed

generation. This ghost removal function is a great improvement, alleviating a lot of precious time spent on retouching. This means I can afford to spend more time on more creative image enhancement tasks, like dodging and burning selective areas. But let's start at the stage of tone mapping first.

▲ ❷ ▲ ❸ ▲ ❹ ▲ ❺

some spots in the sky, maybe generated by fly-ing birds.

In this part, you have seen how to handle tone mapping of a panoramic HDR photograph captured as multiple frames at twilight and emphasize selective parts of the image by manual dodging and burning. At this point, I would like to offer you the opportunity to compare how the image would have looked with only one exposure directly out of the cam versus the improvement achieved by HDR/tonemapping workflow. I put them side by side so you can decide for yourself whether the result is worth the effort.

Though I enhanced complexity and expression throughout the first cases—especially this case—they present a natural-looking result of HDR/tone mapping. At least this was my intention. In the next tutorials, my examples will get more expressive and artistic. Please have a look.

▲ ❷

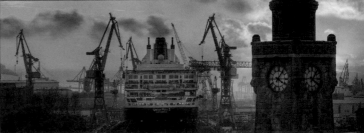

▲ Out-of-cam image ▲ Tone-mapped HDR image

► Case:
"The Stockroom"

Photography between hyperrealistic painting and comic strips

The folks at a German magazine about image editing topics asked me to create an eye-catcher for their article about HDR imaging, showing the creative power of tone-mapped images. We agreed that an everyday scene presented in a totally uncommon look would do the job. The photographed scene should offer a lot of detail and "contrasty" lighting.

Within the essential steps in postprocessing, I have to add to the image more details, saturated colors, harder edges, and, last but not least, a higher local contrast without loosing details in highlights and shadows. Again, similar to "Sea Cloud II – The Lounge", the arrangement of objects inside this scene, casting shadows onto each other, creates the virtual

depth of the image. So emphasizing shadows will emphasize the impression of depth and make it look more 3D, while saturated colors, hard edges, and high contrast will remind the observer of a comic strip. Together with the underlying photography of real-world scenery, it creates an eye-catching image that I call something in between hyperrealistic painting and comic style. I am aware that some parts of the audience will deprecate this style, and I am not recommending that anyone do this all the time. But please take into account that there is no such thing as wrong or right in the arts. What's important is whether you are satisfied with what you are creating. And it you are lucky, you will find more people that like what you are doing than those who dislike it.

▲

I found this type of scene inside a small stockroom and took my shots using a wide-angle lens.

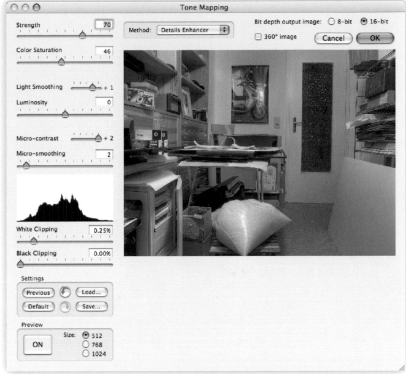

►

Starting the tonemapping.

Part 1: Tonemapping the high-saturated color version

That said, let's have a look at the postprocessing. The tone-mapping part in this case conzists of a twofold approach: First create the colored version, making it the main part of the resulting image, and then create a lights/shadows map.

❶ Starting with default settings, the first step to create the colored main part is to raise the Strength value from 70 to 100. I want to get the maximum possible effect this time.

❷ Raising Color Saturation to 75 creates the intended saturated colors. An extra portion of the details is preserved by lowering Micro-Smoothing to 0. Lowering Light Smoothing to -1 gives more accentuated lights and shadows.

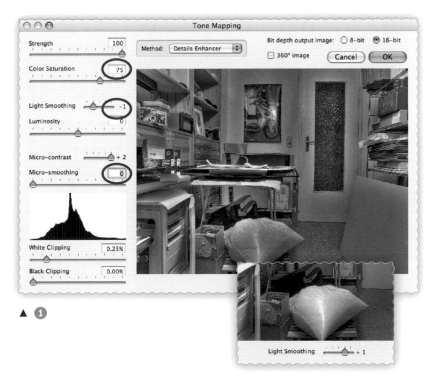

▲ ❶

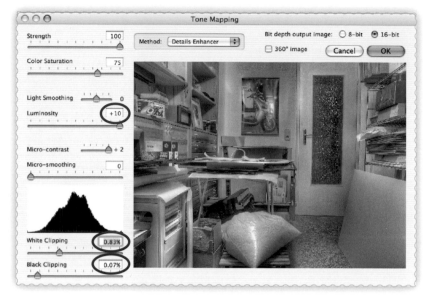

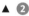 ▲ **2**

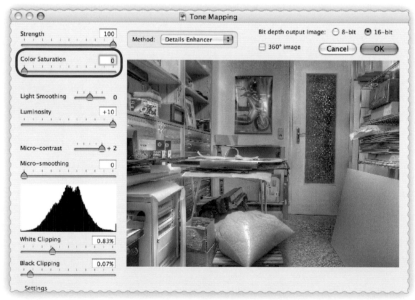 ▲ **1**

3 By using the maximum value for Luminosity (+10), I open up the shadows and intensify colors and local contrast. Though the image gets blurred, it's not a problem as it will be fixed by the additional lights/shadows map I will create later on. Looking at the impact this step has, I reset Light Smoothing to 0 in order not to overdo at this point. Adjusting the settings for White and Black Clipping to achieve a reasonable amount of global contrast is the final task for this first part of the postprocessing. After hitting the OK button, I save this colored tone-mapping result as stockroom_01.tif. It will become the background layer in the finalizing Photoshop composition of this project.

Part 2: Creating the lights/shadows map using tone mapping with different parameters
This map will become an additional layer later on in Photoshop, enhancing the edges, highlights, and shadows.

1 In order to create a black-and-white representation out of the colored version, I have to lower Color Saturation to 0 first.

2 In this step, I want to get deeper shadows and accentuate the lights. Therefore, I lower Luminosity and Light Smoothing to the minimum (-10 and -2).

3 Prior to saving the final stage of this lights and shadows map as a TIF, I add a little more "punch" to it by raising Black and White Clipping to the maximum. Now the areas of deep shadows and highlights are well defined. This will come in handy when the project is finished in Photoshop, which is the next part.

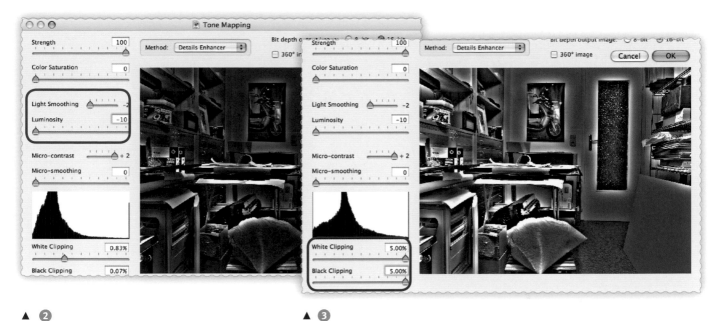

▲ ②

▲ ③

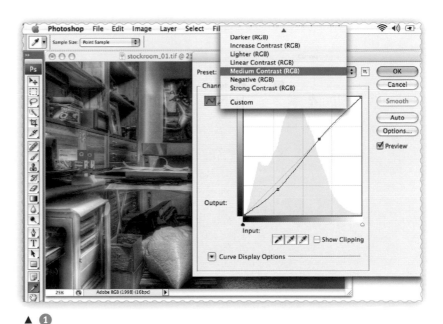

Part 3: Composing in Photoshop

① Opening the saved stockroom_01.tif in Photoshop and applying a curves layer gains overall contrast.

② At this stage, I observe that the camera's white balance was a bit off when shooting, but it's no big deal to correct it now using the same curves layer by activating and pointing the midtone eyedropper to a neutral midtone or light gray area inside the image. I like to do it by using an adjustment layer.

③ Now I will load the prepared lights/shadows map file (stockroom_02.tif) and put it as a layer on top of the colored layer (Shift+click the layer's icon and drag and drop it onto the open stockroom_01.tif).

④ Selecting Hard Light as the layer mode and adjusting the opacity of the top layer to 45% adds the intended final definition of hard

▲ ①

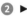

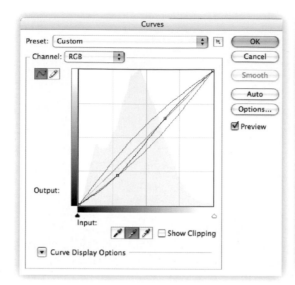

2 ▶

▲ 3

edges and accentuated lights and shadows, covering the blur of the colored version.

5 As this is the final state, I want to save the composition as a PSD file, including all layers. This means I will have an unaltered version at hand for later—not-yet-known—usage.

Please remember always to include the information about the working color space you used by embedding the color profile.

That's it. As you have seen, to create the above image, I mainly used a twofold HDR/ tone-mapping process and combined it with

▲ **4**

blended layers in Photoshop. The result is an accentuated and detailed image with graphical look. In contrast, the next case will show how to abstract details and apply a painterly look.

Painterly style

When we think about an artist painting a landscape scenery in oil or watercolor, for instance, he has to reproduce his impression of the original high-dynamic-range scene onto low-dynamic media, namely, the canvas covered by painted colors. His eyes are capturing the high-dynamic-range scene while his brain is able to convert the observed light and colors into directives that tell his hands how to mix the primary colors and where to place the brush to paint them onto the substrate. To me this sounds like a natural kind of tone mapping, and therefore, I am not surprised when I get results that remind me of a traditional painting when I use tone mapping on an HDR image in a certain way. One of the first things I tried with tone-mapped results was to make

them look even more like a painting, including printing them on canvas using fine art printing methods.

To create images that look like a painting (you probably guessed it already), I use the two-step processing of tone mapping within Photomatix Pro and then finalize it in Photoshop. In the tone-mapping part, I will create the basic implementation of painterly-looking light distribution and colors, so the final steps in Photoshop will consist mainly of retouching where necessary and imitating typical painting strokes.

Part 1: Tonemapping with high saturation, low-light smoothing and high strength

❶ I load the HDR image and start tonemapping with the default settings. This time I keep Strength at 70 to get a fair amount of dynamic compression. This lays the foundation for the painterly look. The colors of the original shot taken on a misty November morning are muted. Increasing Color Saturation to 70

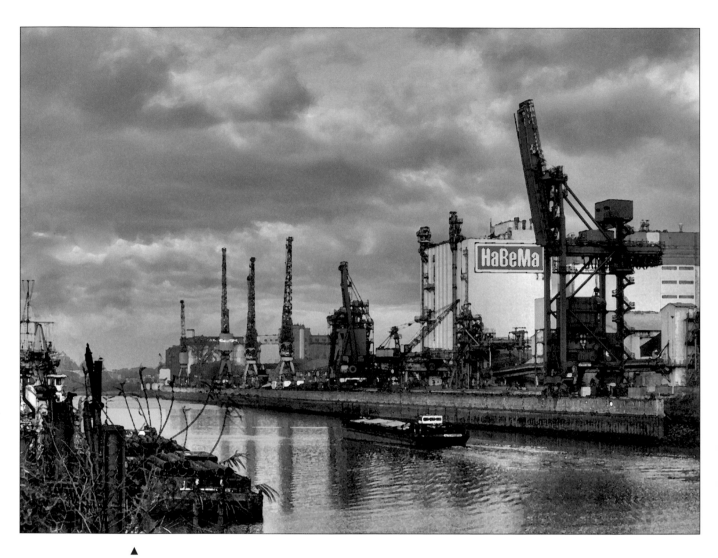

▲

Case: "HaBeMa"

facilitates more vivid colors, while lowering Light Smoothing to 0 pronounces the diversion of light and adds more eagerness to the scene. For a smoother look and a higher level of abstraction, I raise Micro-Smoothing to 10. Details will be eliminated by the artistic brush later on anyway.

② In the last step prior to saving the files as a 16-bit TIF, I adjust White and Black Clipping to gain more overall contrast. The basic tasks a painter would have done painting this scene—

namely, abstraction of details and dramatizing lights and shadows—are already done at this point. Finalizing in Photoshop will only correct some unavoidable distractions, like the pole in front and the branches at the left edge, and apply some artistic brush strokes.

Part 2: Finishing in Photoshop
① Using Photoshop's Clone Stamp, Healing Brush and Patch tools, I retouch and eliminate the distracting pole and the branches at the left edge. I prefer to do such destructive edit-

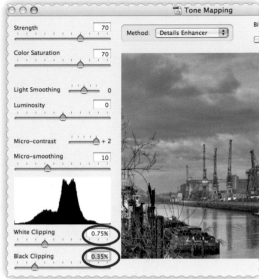

 1

▲ 2

▲ 1

▲ ❷

ing on a cloned layer in order to keep the master layer as backup. You never know.

❷ In order to apply some artistic brush strokes from the filter gallery, I have to duplicate the retouched version and reduce it to one layer. The Dry Brush and Watercolor filters demand 8-bit mode.

❸ After boiling down to one layer and 8-bit mode, I start the filter gallery and select Dry Brush as the first approach. By simple trial and error, I compare different settings and finally dial in 1/8/1 as satisfying parameters.

❹ As second option, I give the Watercolor filter a try with the settings 12/0/1 and compare the result to the Dry Brush result. It's definitely a matter of taste, and in this case I prefer the watercolor look. Printed as a fine art print on watercolor paper, this will look just great. This last step is only a quick overview about finishing a tone-mapped image with artistic brushes because the focus of the chapter is tone mapping. Usually, several layers with different levels of detail and layer masking will be used to refine the process and apply different levels of abstraction to different parts of

the image. Or I would make use of software simulating natural painting strokes with a stylus and a pen tablet .

Within this last example, I use individual parameterized tone mapping for basic abstraction and Photoshop's artistic filters to finish. Using an artistic filter out of Photoshop's filter gallery does not necessarily make you an artist, but I think my last example shows clearly the impact and potential of combining simulated natural media painting and tone mapping. Through HDR capturing and tone mapping, photographic artists are now able to achieve the same results as painters by using abstractive levels or being as precise as possible in reproducing the real view. As you have seen, creating a satisfying image by tone-mapping a high-contrast scene is not a "push one button" task.

Some photographers at the intermediate and beginners levels might think it is adequate to use an automatic tone mapper or the default values of parameterizable ones. However, I suggest that you invest some time looking at the parameters and playing around with them. Make your own experiences and discoveries. Different kinds of images deserve differ-

▲ 3

▼ 4

ent settings, and tone mapping is a subjective process. Why should we waste the potential gain in photographic quality and creativity a good parameterizable tone mapper with a reasonable graphical user interface is offering us? Please remember, there is no objective right or wrong in photography and other arts, but the photographer is solely responsible for the subjective results. And speaking for myself, I wouldn't want to pass this responsibility on to a fully automatic tone-mapping algorithm. So I highly recommend making the effort of an individual approach.

Hopefully you enjoyed my walk through some of the creative possibilities HDR/tone

mapping offers to us, and maybe you became inspired, at least a bit. All in all, you have a working toolbox at hand now and may arrange it according to your own style and workflow. To me, it is always a satisfying moment when professionals or seasoned photographers take a look at some of my images and tell me, "This cannot be done with one shot. How did you do it?" On the following pages, you will find a selection of images created using the same techniques as explained in the preceding sections. Thanks for reading—now relax and enjoy.

To see more of Dieter's work check out his website www.hdrfoto.de/hdribook/

 # Chapter 5: HDR Image Processing

This chapter is not about tone mapping. Or better said, it's about not to tonemap the HDR image **yet**. We will have a look at image editing in floating-point space.

"Being 'undigital' with digital images"—that was the title of one of the very first papers on HDRI, written in 1995 by the visionaries Mann and Picard. And that is what it's all about. Working directly in floating-point space is bringing image editing back home to a world where you think in f-stops, gradient ND filters, and adding light or taking it away, without ever being worried about digitally degrading your image into pixel mush. Believe me, once you have tasted the full sweetness of HDRI, you won't ever want to go back.

5.1. Taking Advantage of the Full Dynamic Range

The techniques I am about to show are all derived from digital compositing. Just a couple of years ago, ridiculously expensive movie production suites were the only systems capable of working in floating-point precision. That, and the fact that they lift all the weight of 32 bits in real time, was their major selling point. Nowadays, every off-the-shelf compositing package has the same capabilities, albeit not the speed. So these techniques work in After Effects, Fusion, Combustion, you name it.

However, I'll demonstrate them in Photoshop. Why? Because I can. The new layer and painting capabilities in CS3 Extended allow me to do so. You've already seen how selective exposure adjustment works. I called it the human tone-mapping operator. Well, that was just a fraction of where this can go.

5.1.1. Blocking Light: Day for Night
This is a good one—feel free to work along starting with the Egyptian.exr from the DVD. We're going to apply some movie magic to this image, just as professional matte painters do on a daily basis. We will change the image into a night shot.

Sunlight to moonlight
❶ We start out the very same way it would be done if we were working with a camera: We put a blue filter in front of the lens. In digital terms, that would be a new solid layer with a dark blue color.

The color is chosen according to what I feel the darkest shadows should look like.

❷ Next, we set the blending mode of the layer to Multiply. That makes this layer the direct equivalent of a filter in front of the lens. It blocks out light, in this case a lot of it.

A very brutal filter it is, indeed. But don't panic, it's all still in there. We just have to adjust the exposure of Photoshop's virtual camera, just as we would do with a real photo

▼ **Before**

① ▶
A blue solid
layer is the
foundation.

▲ ②
Blending mode Multiply turns the blue solid
into a photographic lens filter.

▲ ③
Adjusting the virtual exposure permanently.

camera when we shoot through a physical fil-
ter in front of the lens.

③ In this case, we want that to be a persistent
global change, so we do it in the 32-bit Pre-

view Options dialog from the View menu. We
could do the hard adjustment from the Image
menu as well and burn the new exposure to
the HDR values, but since we will be finishing
this piece in Photoshop, that 32-bit preview

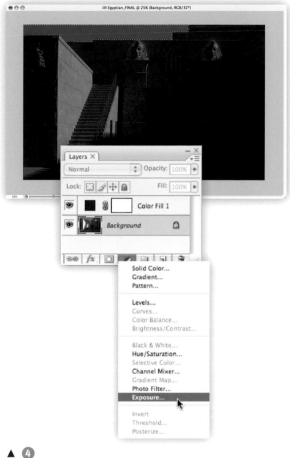

▲ ❹

Fixing the sky.

▲ ❺

This blue solid layer is doing all the work.

exposure is good enough—as long as we can keep our quick exposure slider in the center position because that slider will reset when the file is closed.

Great. Now the sunlight is moonlight. The sky is just a bit too bright for a night shot.

❹ To fix the sky, we have to select it first. For some reason the Magic Wand doesn't work in 32-bit mode, but the Quick Selection tool does. So we use that and draw some strokes across the blue. Then we add an Exposure adjustment layer with the widget on the bottom of the Layers palette. It will come up preloaded with

our selection mask. Now we can pull down the exposure selectively on the sky.

❺ That is our basic high-dynamic-range composite. If you toggle the blue solid layer on and off, you can really see how effective it is. A PSD file of the current state is also on the DVD, in case you would like to dissect it.

For our next step, it is very important that there **is** so much difference between these two. Our original doesn't have much DR to begin with—it has easily fit within the monitor range. But now we've boosted everything up, beyond the white point even, and we've

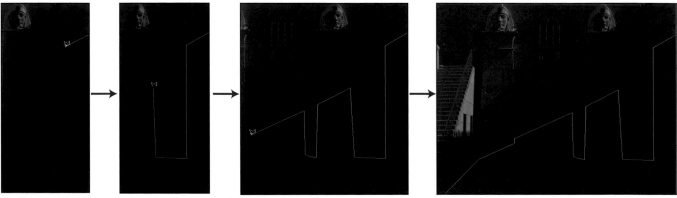

▲ **①** : Sketching a rough selection with the polygon tool.

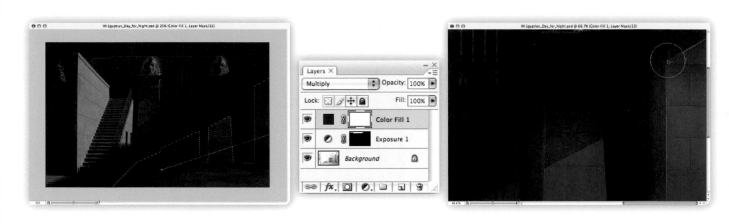

▲ **②**

A gradient in the layer mask lets the original image shine through.

▲ **③**

Adding some spill light and fitting the mask with the Smudge tool.

had the solid layer bring it down again. In the figurative sense, we were winding up the dynamic range here.

It's all about the mood

① The fun is just about to start, because now we're going to add a little mood to it. In particular, I imagine an off-frame torch that would spill some warm light into the scene. Let's say it is somewhere behind the arc to the right. So we use the polygon selection tool to roughly

sketch out where the light would be hitting the walls.

② Make sure to have the alpha mask of our "nighty" solid layer selected and select the Gradient tool from the toolbar. Set it to circular gradient mode and drag out a large radius from our imaginary light off-screen.

That makes our darkening filter partly transparent and allows the original image to shine through. Pretty cool, huh?

 4

Repeat the workflow on the lantern.

5 ▶

Adding a touch of interactive light.

3 The shadow line is a little too hard now; in reality, there would be some indirect light spilling into the shadows. So we have to put the spilled light in. Drop the selection, pick a large soft paint brush and paint a touch more transparency into the mask—very gently, with a flow setting of 10% or less.

Also, you can use the Smudge tool to massage our mask so it better fits the background. That's done with little strokes at a straight angle to the shadow lines, gently combing it over piece by piece. This has the additional benefit of softening the line; you can purposely soften it more by zigzagging across.

4 OK, that corner is done. Let's apply the same method to the little lamp on the other side. Sketch a rough selection with the Polygonal Lasso, and use it to paint some more transparency in our "nighty" solid layer.

5 The final step is to add a touch of interactive light to that wall behind. Same thing again—restrict the painting area to a selection and paint within that alpha mask using a soft brush.

Done.

Smooth sailing

Admittedly, a similar technique might have worked in 16-bit mode as well. But it wouldn't be as astonishingly simple and straightforward. We would need separate layers for the moonlight portions and warm light portions and all kinds of other trickery just to make it look natural again. Go ahead. Try to change the mode to 16-bit. I just did, and I can tell

▼ **After**

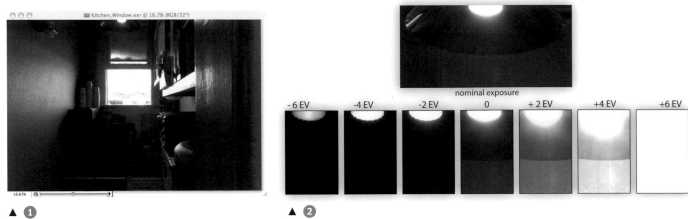

▲ ❶

Grab Kitchen_Window.exr from the DVD.

▲ ❷

Slide through the exposures and observe the lamp.

you it looks nasty! I refuse to print that here; you've gotta see it for yourself. And I gave up trying to repair it because either the shadows wash out or the moonlit wall turns flat, or the entire image becomes a mushy splotch.

Notice how such things were not even a concern at all in this tutorial. Believe me, it gives you great peace of mind to have the extended range available at all times and never to have to worry about clipping or banding or precision issues. It's also very convenient to think in terms of light being filtered and boosted instead of just assuming the pixels to be dry paint on a canvas.

5.1.2. Understanding the Color Picker

In the last tutorial, I skipped over one step very quickly in the hope it would go unnoticed. I'm talking about the HDR Color Picker and how exactly the chosen color relates to what you see on-screen. Considering the fact that we are working in a wider dynamic range than our monitor can display, there's not an easy answer.

❶ Let me explain that once again in a hands-on tutorial. The subject shall be our all-time favorite kitchen window, so please come along and pull it up from the DVD!

❷ First of all, let's have a closer look at the ceiling lamp that's just touching the top margin of the frame. Zoom in on the lamp and slide through the exposures. Watch how the pixels change their colors from orange to red to yellow until they finally blow out into white.

I know—it's tempting to assume we couldn't precisely pin down the true color of a pixel. But that is not the case. In fact, the opposite is true. We can pick colors better than ever!

Remember, what we are looking at is just a roughly tone-mapped representation of the image. We are looking through "8-bit gamma goggles". Our HDR color values are transformed for display in the very same way a camera would take a JPEG snapshot. And if a real camera would take the +4 EV image, we would be well aware that the yellow halo is not the true color in that spot. When the Color Picker returns yellow, it is actually lying to us.

It's just a very bright orange, too bright to fit in 8 bits.

The same applies here, but with the difference that we can actually tell the true color underneath. We are not locked into the yellow false coloration. But we have to adjust the exposure for the spot we want to look at, and only then we can see the true color. You have to realize that this is an opportunity, not a disadvantage.

Try to think of it like this: Our HDR image is pure light. What we see on-screen is a snapshot, taken with a virtual camera. The light itself surely has a definite color and intensity. But its appearance in the snapshot depends upon our exposure settings. It's like virtual photography.

Examining light

With that in mind, let's see how Photoshop's Color Picker works in HDR mode. It looks unusual at first, but it makes perfect sense once you get accustomed to the idea that HDR values describe light.

❶ The lower half shows the true light color underneath the pipette. Notice the Intensity slider just above the color field; this is our light intensity. Both values together describe the light that is in our HDR image. Now take closer look at the band of color swatches on top. The large center swatch shows how that light looks on-screen at the current exposure. Ergo, that is the on-screen color currently underneath the pipette. The additional color swatches are previews of how the same HDR values appear on-screen at different viewing exposures.

❷ You should really pull that image up to try it for yourself, just to get a feeling for it! Drag

▲ ❶
The Color Picker looks different in 32-bit mode.

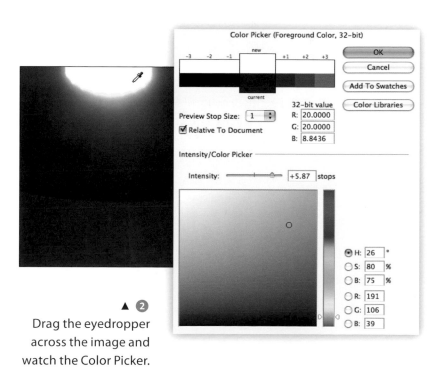

▲ ❷
Drag the eyedropper across the image and watch the Color Picker.

▲ ❸

The same colors are sampled at a different viewing exposure..

that eyedropper across the image while holding the mouse button and watch that Color Picker change in real time. You will notice that the true HDR color component stays pretty consistent. But the Intensity slider changes significantly when you hover over the light bulb, and so do the preview swatches.

❸ Also, try changing the viewing exposure. You'll notice how the color preview swatches are linked to the display exposure but the HDR color sample stays consistent. It's still an orange with +5.87 stops intensity, no matter how we look at it.

Remember this: Everything you see in an HDR image is pure light, not paint on a canvas. Therefore, you pick a light color, not a paint color.

5.1.3. Painting with Light

OK, this is where it's getting really cool! When you think the idea all the way through, you will realize that painting in HDRI mode means we are painting with light.

❶ Let's do that! We will now digitally turn on the fire alarm. In the Color Picker, drag the hue slider a tiny bit more downward so we have a bit more red in there. It's supposed to be alarming! Set the intensity not too high yet—3 stops are fine for now.

❷ Grab the regular paint brush tool, and pick a large soft brush. Make sure to set the Flow setting super low so we can paint a bit more gently here. There's no point in pouring it out all at once.

▲ ❶

Picking a bright red color.

❸ And now paint some strokes across the lamp. Isn't that just awesome? We get a natural blooming effect, right out of that simple

◀ ❷
Grab a large soft brush.

◀ ❸
Painting some strokes across the lamp.

◀ ❹
Adding an extra bit of bloom.

▲ ❺
Adding a flarewith fading strokes.

brush. Notice how the falloff is precisely what we saw in the Color Picker's preview swatches. The true light color is the same across, but it's getting hot in the center because we paint 3 stops higher than what we look at.

❹ Let's finesse it some more. Increase the brush size and gently kiss in that extra bit of bloom so it feels more illuminated.

❺ Then we have to tweak the brush a little. Go to the Brush settings, and set Size and

▲ ⑥ : Painting in the overbright lightbulb.

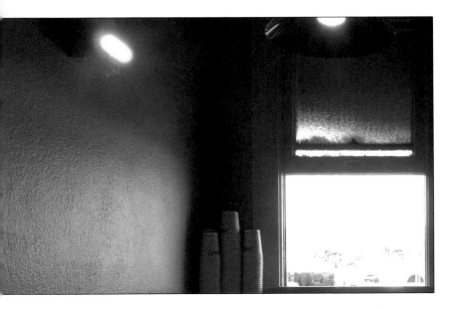

▲

Final.

Change the brush to a smaller, slightly harder tip and increase the paint intensity in the Color Picker. Then just lay down a nice clean neon stroke.

The last finishing touch is adding some bounce light to the wall and window frame. You know—large soft brush, kissing it in gently. I think you get the idea. Painting with light is really easy because the intensity overdrive effect is doing the work for us here. Understanding the Color Picker is the first step. And as soon as you get the logic behind HDR images being made of pure scene light, you will hit the ground running. There are tons of other applications, from neon signs over streaking car headlights to muzzle flashes. I'm sure you will spot an opportunity when it comes your way.

Flow to Fade mode. Then drag out small strokes from the center of our lamp. Try to match the flare of the ceiling lamp.

Looking at both lamps at the same time, something is missing in our fake. The glow is just about right, but the center isn't hot enough yet.

⑥ What we need is a lightbulb. Let's make it one of these fancy power-saving lamps.

This example was a bit simplified, though. Real pros paint on a dedicated layer and leave the original underneath untouched. One additional advantage is that you can play with blending modes afterward. In this case, Linear(Add) would be a good candidate, just so we wouldn't cover up the original lamp underneath.

push Black point in

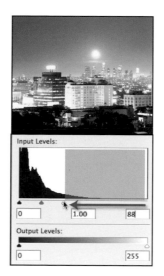

push White point in

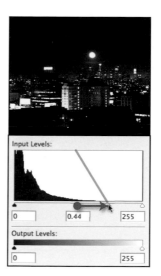

Gamma right: Contrast up

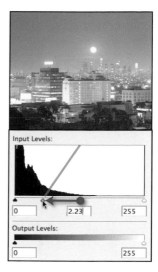

Gamma left: Contrast down

▲ **❶**:
The effect of the first row of controls, the Input Levels.

5.1.4. Color Grading with Levels

Levels is one of the most underrated controls. At first glance, it looks really simple, but as soon as you dive in a bit deeper, it unfolds into a tremendous color tool, especially when it works in floating-point precision.

Basic Levels lesson

Just to whirl it up a bit, let's use a brand-new example picture. That's downtown L.A. by night, featuring an insanely big moon. There's no better way to learn than to try it for yourself, so grab BigMoon.exr from the DVD and bring up the Levels control. And again, pros don't burn the Levels adjustment into the background; they add it as adjustment layer.

So basically, directly underneath the histogram we have five knobs in total. Let's just quickly recap what they do. In the first row there is the black input point, white input point, and good old buddy gamma (figure **❶**).

Black and white input points clamp out parts of the histogram. What remains will stretch out to become the new, adjusted histogram. Imagine that histogram to be made of jelly. You push it, and it will wobble back in place. When you pull a slider into the histogram, the part you're pointing at will stretch out to where the slider was before. Now, the black input point is kind of evil; it still clamps in 32-bit. Better stay away from that. But the white point is cool; when the histogram wobbles back, all the values marked in red will just be pushed beyond the brightness of the monitor. The effect is equal to pulling up the exposure. The gamma slider only works between these two points. Same system—you wind it up by skewing in one direction, and the histogram reacts by wobbling back. You select a tone that will become the new middle tone.

OK, we got that. By the way, note how extreme these settings are and there is still no visible banding anywhere. You know it—this is the incredible precision we are working in. It becomes even more apparent when we look at the effect of the lower sliders, the Output Levels, as illustrated in figure **❷** .

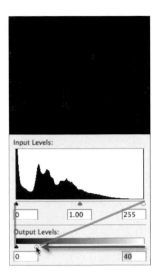

LDR : white output level LDR : fatality HDR : plenty of headroom HDR : full circle, in and out.

▲ ❷ The effect of the lower set of sliders, the Output Levels.

The two left images show how the lower sliders always worked on LDR images. The output white sets the target, where the tones selected by the input white point will be shifted. It's like setting up the cake tin where the jelly histogram will wobble into. Pulling them both down to the same value will suppress any further counter-wobbling and do nothing but shave off the tonal values. That's what the second image shows.

While this control was mostly useless in LDR, it can really play its cards on an HDR image. The two images on the right demonstrate this very impressively. Same adjustment, worlds apart. It still does what it's supposed to: setting the target for what was the upper boundary before. But there are so many more values beyond that, outside the visible histogram, and they are all coming in and filling it back up. So Output Levels is our friend now—it only pulls down the exposure instead of clipping.

Figure ❸ above is a crib sheet of the controls we can use in 32 bit Levels and what their effect is. Ignore the numerical values, if you want—they are really just a leftover from the 8-bit days of Photoshop. Most other programs label HDR levels as zero to one (0.000—1.000). What's important is that input white and output white are really the same Exposure slider, just working in opposite directions. If there were more space to move the top slider to the right, we wouldn't need the one below at all.

Channel by channel

So far we didn't do anything we couldn't achieve with an exposure adjustment. Nothing special. The interesting part comes in when we tweak individual channels with the Levels tool. One word of warning: We will seriously mess with these channels, including the top and low end that we currently can't see. So you cannot tonemap that with any fancy local operator anymore. There won't be much to

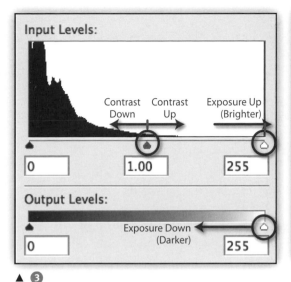

▲ ③

Overview of the Levels controls us-
able in 32-bit mode.

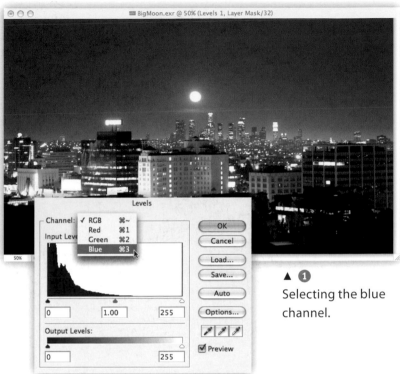

▲ ①

Selecting the blue
channel.

gain anyway; we're trying to use that extra in-
formation up now. Basically, we're tone map-
ping manually again.

① So here is our starting point again, and we
switch Levels to the blue channel.

② My train of thought goes like this: The
overall look is too yellow for me, so I want to
bring up the blue channel. Blue is the opposite
of yellow. I don't mind having yellow in the
highlights, though. Moon and city lights are
fine, so the highlight blue should stay pinned.
Ergo, the goal is to lower the contrast of the
blue channel. According to my crib sheet, that
would be done by moving the gamma slider to
the left. I grab a good portion of the shadow
tones so they can slingshot up to become the
new midtones.

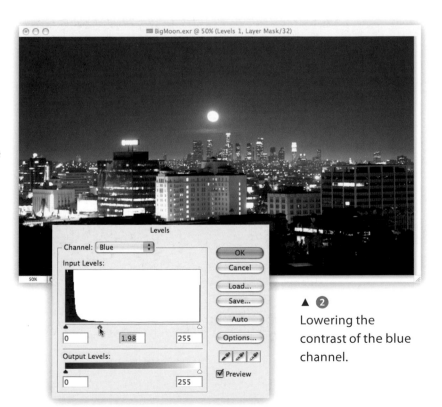

▲ ②

Lowering the
contrast of the blue
channel.

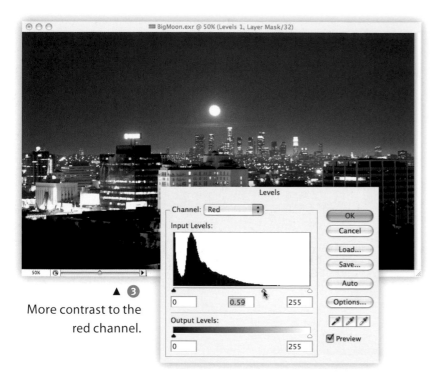

▲ ③
More contrast to the
red channel.

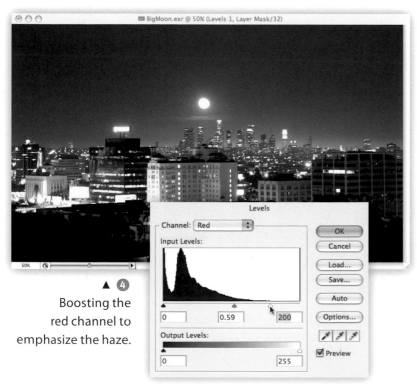

▲ ④
Boosting the
red channel to
emphasize the haze.

③ Purple wasn't what I was going for. Apparently, there is too much red mixed in there. Second look: Where exactly is too much red? In the shadow and middle portion! Highlights are just fine, so I go for the gamma slider again. This time, though, I grab some of these higher values on the right so they get hauled off below the midpoint.

④ Now I start digging this red haze layer that just appeared across downtown. Let's see if we can shave it out a bit more. This is clearly in the highlight portion, and I want to boost up the reds. So, the input white point is the one that needs to be tweaked now.

That's pretty much it.

Honestly, there is not really that much thought involved all of the time. It helps with the broad strokes, but often it's just fooling around, playing with what's there and exploring where it can go. You saw how input and output white cancel out each other—that means you're safe whatever you do. Of course, that depends upon how clean that HDR image was made in the first place. Mine starts breaking up into banding in the sky because I didn't shoot enough short exposures here. So in this case, I have to bring the overall exposure back up a notch, just to get it to the sweet spot.

5.2. Effect Filters the More Effective Way

Several filters have proven to be much more effective when they are fed with HDR imagery. Compositing programs have a longer history in that area because here the filters are needed to introduce all the photographic imperfections to CG imagery. These are precisely the same imperfections that photographers are trying to suppress: grain, lens distortion, motion blur, glare, and bloom.

5.2.1. Motion Blur

Real motion blur happens when the scene changes or the camera moves while the shutter is open. Light sources especially are sometimes bright enough to punch through and saturate the image even at a fraction of the exposure time. In an extreme case, this causes long streaks as in the fire-dancer snapshot.

The digital fake of this optical effect is done with a directional Gaussian blur. Popular blurs are linear, radial, crash-zoom, and along a custom path. Whatever the direction, in each case the effect is made by simply smearing each pixel along a motion vector. Usually that works pretty well—until there is a light source in the image. In that case, these lights are instantly smudged in with the much darker neighboring pixels, and the result is an unnaturally washed-out image.

The sole presence of super-bright values in an HDR image makes these filters much more effective. And I am not even talking about specifically crafted filter plug-ins. Let's take Photoshop's good old Radial Blur, for example. This filter is so ancient that the user interface doesn't even allow me to set the blur center in the image itself, let alone outside the image

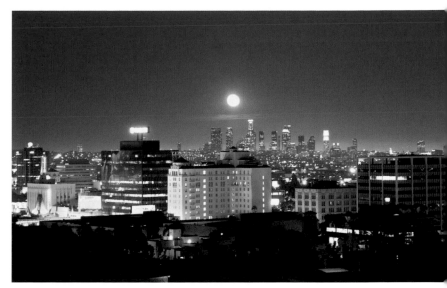

▲ Final.

▲

Firedancer showing some extreme photographic motion blur.

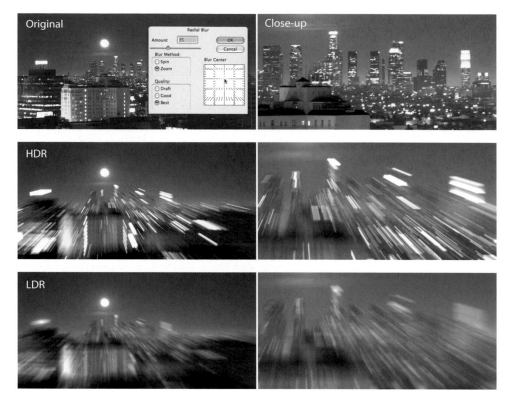

▶

Even Photoshop's good old Radial Blur works so much more realistically on HDR material.

area. Instead, I will try to aim at the moon inside that tiny square field.

Same filter, worlds apart. The lights in the HDR image are simply loaded with so much intensity that they have a much tougher stand against the background. They easily punch through the blur and stay vivid. My moon is zapping laser rays, hurray!

Admittedly, this was kind of a cheesy example. But the point is that faking motion blur digitally was flawed from day one. The LDR result is pretty much useless, whereas HDR material delivers what we would expect. It is God's gift to visual effects artists that their tools finally do what they're supposed to.

Here is an example in Digital Fusion, proving that really just that extra bit of information is responsible for better quality. Even a simple Transform node, the standard tool

for moving layers, gets an incredible boost in quality.

One word of explanation for readers who are less familiar with a nodal compositing system: The lower part shows a logical flow of all operations happening here. It starts with a loader on the left, loading a pretty dark HDR image. The second node pulls up the gain (exposure) so we can actually see something. From that point, the flow splits in two branches. The first one goes straight up into a Transform node and the result is shown in window A. The second branch goes through a Change Depth node, where the HDRI is simply converted to 8-bit followed by an identical Transform, which is shown in the window B.

Both Transform nodes move that image on a path, indicated in red. I just moved it over one frame here and then added some in-between

◀

Digital Fusion:
Motion Blur along a
path in 32-bit depth
(A) and 8-bit (B).

keyframes to shape a neat curve. Now I only have to tell the Transforms to calculate motion blur. They do that with subframe accuracy and actually move that image along the path from one frame to the other.

Once again, the difference is astonishing. When it moves the HDR image, we automatically get glowing lines along the path, a result that simply matches the photographic phenomena that we're trying to simulate better.

By the way, this screen shot is three years old; the new Fusion5 looks much sleeker. Still, only a few programs match this flexibility even today. Subframe accuracy, free mixing of different color depths, a 16-bit floating-point mode that entirely runs off the GPU—Fusion has always been a pretty snazzy workhorse.

5.2.2. Glow and Bleeding

In each camera's manual, you will find a warning that you shouldn't shoot directly into the sun. And that's for a good reason, because the extreme brightness causes the highlights to bleed out. What's happening here is that the surpass intensity spreads out in the film plate and eventually covers up darker parts of the image. CCDs used to bleed primarily into vertical lines; higher grade cameras now have a compensation for that. However, it's not just related to the sensor; it actually happens when the light travels through the lens. Bleeding is an inherent property of every optical system, including our eyes. Excessive light always spills over.

▲

Bleeding:
Excessive light spills over in any optical system.

A similar effect on a smaller scale is the glow that can be seen on neon lights, car headlights, or any kind of light source. Mostly this is a welcome addition to the mood; it's hard to imagine any night shot without these glows. It triggers something in our brain that says, "Pretty bright lights", because we see it the same way with our eyes. The important thing to notice is how the glow is adopting the color of the light. In fact, that is often the only hint at the light color because the center might even be clipped to plain white. Still, we think instantly, "Blue light", and not "Blue glow around a light of unknown color". Our eyes just know.

Obviously this is a phenomenon that will have to be added to CG imagery. And since it happens at the lens/camera level, there is no

real point in rendering it along with the 3D scene. It's a classic postprocessing effect.

Photoshop doesn't know an explicit Glow filter, so let's check this out in After Effects 7.

I just assume you're somewhat familiar with the After Effects interface (figure ❶). And if not, it's pretty self-explanatory: The timeline works just the same way as Photoshop's Layers palette, where you're stacking up layers from bottom to top. And the Project panel on the left is where all footage is collected that will or might get used in a composition. Crucial here is the small Color Depth Toggle field on the bottom of the Project panel. As soon as you switch it with an Alt-Click to 32 bit, a quick exposure slider magically appears below the big Composition viewport. It works like the quick exposure slider in Photoshop, just

◀

Glows are adopting
the colors of their
light sources.

◀ **1**

After Effects has
some special HDR
gadgets in 32-bit
mode.

▲ ❷

Changing the exposure reveals the glass colors originally blown out in the rendering.

with a little nicer design and a numerical EV readout.

You might have noticed that I have rendered these little bulb buddies already blown out (figure ❷ , next page). Well, I was a little careless there and built the scene according to real-world luminance rather than just for a particularly good exposure. These bulbs might have to light up something else in the scene. And frankly, I didn't care—because it's all kept in that HDR image anyway. If I stop it down by 3 EV, all the glass color comes back (figure ❷). Looks like they're switched off now. But I want them to shine!

I just drag and drop the Glow from the Effects palette on the Composition viewport and start playing with the settings (figure ❸ , next page). The Glow is additive and makes everything even brighter. So I bring it all back down

with the HDR Compander effect; a simple tone mapper.

If the image had been saved in 8- or 16-bit, that obviously wouldn't work at all. We can easily see how this would look by changing the color depth in the Project panel. What's blown out in the first place will just glow white. And, of course, the convenience of adjusting the exposure is gone (figure ❹).

In a regular LDR workflow, I would have to take much more care in rendering the image without any clipping in the first place. That's fine, as long as there are no other objects in the scene. This would put me back into cheating mode. I would have to render the bulb heads separately to suppress the glow on the other stuff. Having the proper intensity latitude all within one file is certainly making my life easier here.

In a nutshell: Enormous opportunities open up when you keep editing in 32-bit floating-point precision. It allows you to be careless about banding and clipping, even in intermediate steps. You can just concentrate on messing around; the underlying data is flexible enough to adjust. Processing steps that simulate analog tasks are finally working as expected in HDR space. You don't just edit on-screen pixels; you edit the light that was captured. There is no doubt that this is the future of image processing.

▲ ③

Glow and HDR Compander effect really made my day.

◄ ④

The effect falls apart in LDR.

Chapter 6: Shooting Panoramic HDR Images

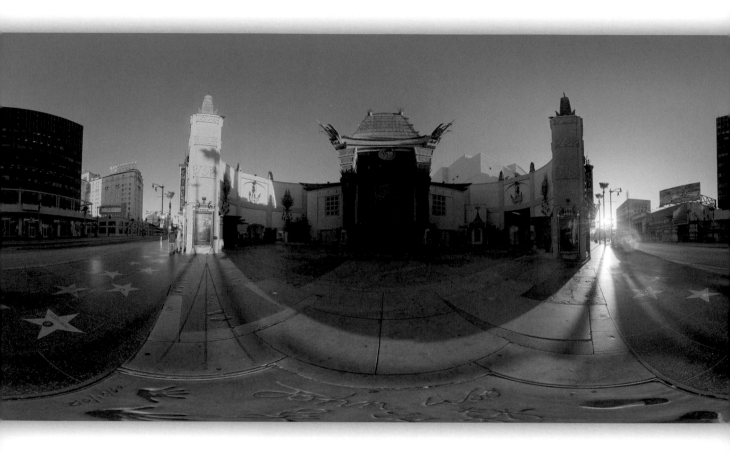

This chapter is all about creating HDR environments. It represents a symbiosis as well as the pinnacle of both fields: HDR photography and panorama photography. So, it's pretty much the hardest thing you can possibly do with a camera.

Panography, as panorama photography is often called, builds on a tradition that traces back to the beginnings of photography. Actually, it dates even further back if you count those large-scale paintings from ancient China, Greece, and the great Venetian masters. People just love panoramas and the immersive effect of a surround view; they always did. In the digital age, it has a well-established place in the holy realms of virtual reality (VR) technology. Research in this field has never stalled, and in combination with HDRI, it is active like never before.

Aside from looking cool, panoramic images are extremely useful for 3D rendering. But even if in a purely photographic sense, they used to be notoriously difficult to expose for. Because the environment as a whole is being captured, you are most likely to have super-bright areas as well as extremely dark shadows somewhere in the image. That's why panographers benefit in particular from an HDR workflow.

Large parts of this chapter are contributed by Bernhard Vogl. Together, we will present to you a variety of shooting methods, all of which have a different ratio of manual effort and hardware requirements. Provided you have the budget for specialty equipment, you can get great results quickly and easily. If you're willing to put in more effort and time, the result can be just as good or even better but with much less expenditure.

6.1. Pano Lingo

Shooting panoramas is quite a bit different from regular photography. Before we dive right in, we have to assure that some terms and definitions are well established.

6.1.1. Field of View

When a normal photographer talks about the "focal length" of his lens, he assumes that his conversation partner also uses the same image circle (film type, sensor size) for his imagination. In typical conversations, you will hear phrases like "shot with an 17mm" and everyone knows: This was a very wide-angle lens.

With digital cameras, even hobbyists slowly become aware that **focal length** alone is a term without definition. Most of them circumvent this problem by multiplying the focal length with a "crop factor," which is still based on 35mm film and standard lenses. You will learn in the following sections that this is not a good idea.

Panorama photographers have left this one-way street and now work with the term **field of view**, abbreviated as **FOV**. Imagine yourself in one corner of a triangle; the FOV will define how much you can see without moving your head. Still, this is an ambiguous definition, so we have to add a direction: horizontal, vertical, and sometimes the diagonal FOV from corner to corner.

A full spherical image will display a horizontal FOV (hFOV) of 360 degrees and a vertical FOV (vFOV) of 180 degrees. This is the maximum FOV ever needed in real-world situations and covers all you can see around you.

But what does the term **spherical** mean?

6.1.2. Image Projections

The basic problem of a surround view is that by definition it has no borders. It's more like a sphere that wraps all around the viewpoint. But a 2D image does have borders and is always a flat rectangle. So we have to unfold the surrounding sphere, just like carefully peeling an orange. That's called a panoramic projection. There are different ways to do that, and

each one is a compromise of some sort. It has to be, because we're representing a 3D space with a 2D image. The names of projection types are standard terms in a panographer's vocabulary, yet they exist in different dialects that you should know about.

Spherical map / latitude-longitude / equirectangular : This is the most common way of unwrapping the imaginary surrounding sphere. Note that all three names stand for exactly the same format. It can be easily recognized by the typical 2:1 aspect, and it corresponds to the transformation from a globe into a simple world map. The geographical latitude and longitude coordinates are taken directly as XY pixel coordinates. The horizon line of such a panorama equals the equator. It goes exactly across the center of the image and is mapped without any distortion.

The poles, on the other hand, correspond to the zenith and nadir points. In a brutal act of extreme distortion, they get smeared all across the image. These special points form the first and last pixel line. This is important to keep in mind when editing such an image. Messing with the upper and lower borders will produce significant errors because they converge into a point.

Architectural lines that go vertically are kept straight. Good points of reference are building corners, poles, and street lamps. But horizontal architectural lines are always bent, similar to a fisheye distortion. That's because the projection grid is tapering together more and more toward the zenith and nadir points. What looks like a vertical band of even squares on the map is turned into a pie-shaped slice on the projection sphere.

When you're manipulating an equirectangular panorama, you have to pay special atten-

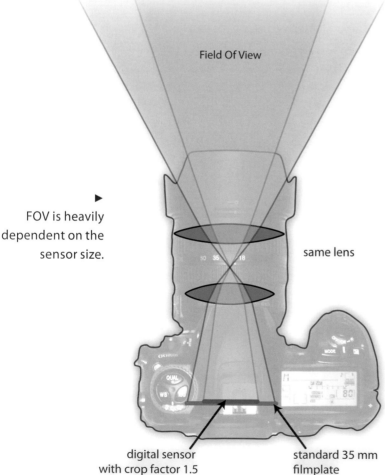

Field Of View

▶
FOV is heavily dependent on the sensor size.

same lens

digital sensor with crop factor 1.5

standard 35 mm filmplate

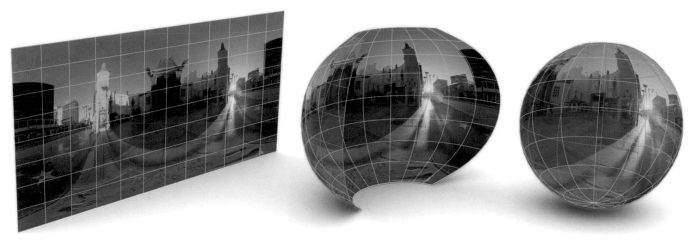

▲ A spherical map is wrapped around the view like a world map.

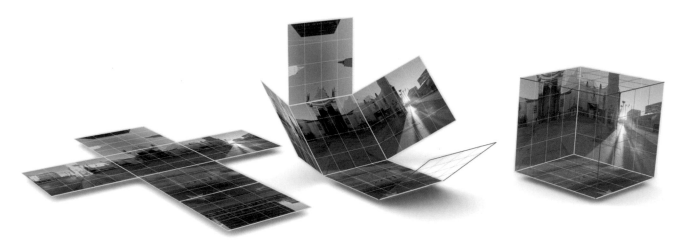

▲ A cubic map folds together like a toy box.

tion to the seam line. Left and right borders have to fit together perfectly. This can be assured by rolling the image horizontally, which corresponds to a rotation of the globe along the vertical axis.

Cubic map / horizontal cross / vertical cross:
Instead of a surrounding sphere, we can use a cube as well. If our viewpoint sits dead center, there is practically no visual difference between a cube and a sphere. The only thing that

counts is that for each viewing angle, we have the proper image patch.

This projection type is very efficient for VR display purposes. Computations are inexpensive because it needs only six polygons, which conveniently match the plain XYZ directions in virtual space. Mathematically, a virtual object could not be described any simpler. Hence, the cubic map is the native format used by QuickTime VR, as well as most computer games. Modern graphics cards even have a

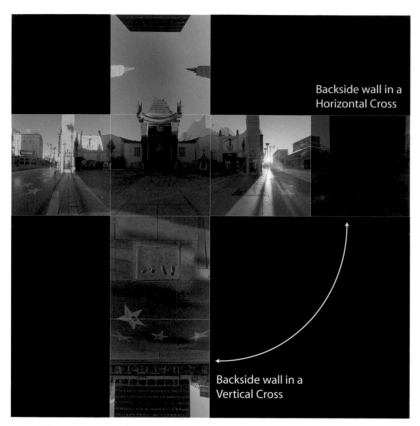

Backside wall in a
Horizontal Cross

Backside wall in a
Vertical Cross

▲ Different variants
depend on the
backwards cube wall.

The big advantage of this projection is that it has no fancy distortion. Each side of the cube is nicely flat and equals a simple view in that direction. In fact, it is exactly like a square crop of a photograph taken with a high-quality 13.3mm prime lens, delivering 90 degrees horizontal and vertical field of view. Straight architectural lines are kept straight, and the pixel density is consistent across the whole surface of the cube. This makes the individual cube faces a formidable canvas to edit and do touch-ups in. But you have to consider that the perspective jumps rapidly on the seams. Also, many squares are connected even though they are spaced apart in the image. In order to maintain the continuity across the seams, all image edits should be kept inside each square. Special attention is required when applying global image filters, like blurs or sharpening filters.

The downside is that the cross uses only half of the available image space. Even though on disk the black areas can be stomped to just a few bytes with any kind of lossless compression, it still doubles the amount of memory required for opening the image. That can make a huge difference because panoramas are notoriously huge pictures already. Therefore, some more varieties have emerged, where all cube faces are saved as separate files with a special naming convention or simply placed side by side in a long strip. Here the order and direction of the faces are different in each program, so this is really a specially tailored kind of cubic map that is not a good exchange format at all.

Angular map/lightprobe: This projection has been specifically designed for lighting 3D objects with HDR images. It was mentioned first by Paul Debevec, a pioneer who basically

special hardware acceleration for rendering arbitrary views from a cubic map.

There are many different flavors of this projection. It can be six individual images, all images in one long strip, or they can be sorted into horizontal or vertical cross. As final output, this really is just a question of what the viewer software expects. However, when used as an intermediate format for editing and touch-ups, the preferred format is the horizontal cross. It is identical to the vertical cross except for the placement of the backwards cube wall. Painting in an upside-down image is quite inconvenient, whereas in the horizontal cross, we have all four side views laid out nicely side by side.

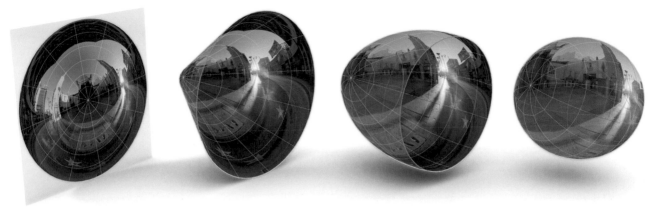

▲ Angluar maps are first extended into a cone and then shrink-wrapped to the surrounding sphere.

Backside of a correct angular map, circumference merges in a point.

Even a slight blur violates the image geometry and causes streaking.

▲

The extreme geometric distortion makes manipulatons a royal pain and prohibits any image filters.

invented the field of "image-based lighting." Note that actually every full panoramic HDR image is in fact a light probe, no matter what projection type. However, Debevec's legendary SIGGRAPH course "Rendering with Natural Light" in 1998 put this projection type on the map, and ever since then it is commonly referred to as lightprobe image.

The image geometry is similar to a fisheye lens, but with a field of view of 360 degrees and even angular distribution. Think of it as an ultra-mega-extreme fisheye that would be physically impossible to build.

In the center point we have the forward direction. Up, down, left, and right are set on a circle that is half the radius of the entire image. This is what a 180-degree fisheye would deliver. From there, our map keeps going outward in even angular steps until it reaches the backwards view, which is smeared all across

the outer radius of the map. The extreme distortion makes it very hard to read for a human, and since virtually every straight line appears bent, this projection is unsuitable for any retouching work.

The advantage of this format is its continuity. There is no seam line. Except for a single point directly behind the camera, the entire environment is pictured seamlessly. This minimizes the risk of seeing an image seam when we pan our virtual camera around because then we would have to rely on the rendering software to interpolate correctly across the seam. However, when looking backwards, we do have a problem. Every mistake in the image, no matter how small it is, will be displayed as an ugly streaky artifact. That's because all pixels close to the outer circumference get distorted into a very longish shape. So the backside of a bad angular map usually looks like the valve of a balloon, with those typical stretch marks around it.

Fun projections: Obviously, there are plenty of other ways to peel an orange. They are called stereographic, hyperbolic, or something similar. Some deliver quite unusual perspectives and distortions. They are not really useful for anything in particular except that they look pretty. But then again, pretty images is what this book is all about!

Comparison table: OK, let's wrap up the useful projection types. We have collected all the most important attributes in a comparison table, as a convenient quick reference.

	Spherical Map Latitude-Longitude Equirectangular	Cubic Map	Angular Map Lightprobe
Aspect Ratio	2:1	4:3	1:1
Distortion	Low on the horizon high on the poles	Low	Extreme
Breaks in Image Continuity	Two poles, one seam	Eight seams	One pole
Use of Space	100%	50%	78%
Suggested Image Editing Steps	Large-scale filters, careful retouch work	Extended edits possible in individual cube faces	None

6.1.3. Yaw, Pitch, and Roll

You will stumble upon those phrases when stitching your panorama. The scientists call them Euler coordinates. They are nothing but words used to describe rotating the image/camera around the various axes:

- Yaw: Shifts image along the horizon; camera moves like your head if you swing it from left to right.
- Pitch: Rotates image up/downward, like nodding your head.
- Roll: Tilt your head sideways, like a jet flying in a corkscrew pattern.

6.2. One-Shot Technique

This is the easiest way you can think of, a pure hardware solution. All it takes is pushing the big red button and the camera system takes a panorama.

Traditionally, this is done with a slit-scan technique. While the camera rotates, it slides a long negative strip underneath a vertical slit-shaped aperture. It literally scans the entire surrounding in one continuous exposure.

Modern day rotation cameras work digitally, of course. And boy, have they advanced! No more wooden boxes with knobby handles here. The latest Roundshot model shoots 470-megapixel panoramas in 2 seconds (www.round-shot.ch), and the Eyescan series from KST has

Classic One-Shot Cameras
(left to right):
Gluboscope,
Roundshot,
Voyageur II,
Lookaround
▼

▲

SpheroCam HDR

sures for each scanline. But that's entirely automatic; the controlling software takes care of that. The software spins the head for you, with a speed dependent on the chosen resolution and the exposure times necessary. At night it spins slower. Everything is precalibrated for you. The software corrects for lens distortion and puts those pixel lines together in a panorama. All that happens automatically; you just have to press the release button. Or, as in this case, the OK button in the host software.

If that is still too much work for you, there is a special fool-proof version—the entire software runs on a computer hidden in a watertight suitcase and the OK button is on the outside and blinks green. Even a policeman could operate this camera. In fact, this specialty version is **designed** for crime scene investigation. FBI and police forces all over the world simply love the possibility to pan around in an HDR panorama and look for new evidence in the deep shadows under the bed. Just like in that TV show. (Technically, the boxed suitcase version has just recently been discontinued, because investigators didn't know where to put down the suitcase without destroying evidence. Now the controlling laptop is mounted on the tripod.)

By now you might have guessed that all that doesn't come cheap. You can order your own SpheroCam HDR for $60,000 directly from the German maker SpheronVR. It comes in a complete package with laptop, tripod, and suitcase. It's also available from a variety of equipment rental services for a street price of $1,000/day or $3,000/week.

Wherever there is a market, there is also a competitor. In this case, it is the Panoscan MK-3, which is priced at around $40,000. The resolution is quite similar, but it does not include custom remote software. Instead, it

just recently broken through the gigapixel barrier (www.kst-dresden.de).

A very special beast is the SpheroCam HDR: It can take full spherical panoramas with a dynamic range of 26 EV in a maximum size of 10,600 x 5,300 pixels!

Just like digital medium format cameras, it needs to be remotely operated from a host computer. But for a different reason, because in reality, the Spherocam is a complex system assembled from proprietary and off-the-shelf hardware and exclusive custom software..

The centerpiece is an electronic panorama head that spins the camera with a Nikon fisheye slowly all around. Behind the lens is a single column of CCDs, representing our modern slit-scan technology. And before you ask, no, it is not some kind of miracle CCD from the future: Of course it shoots multiple expo-

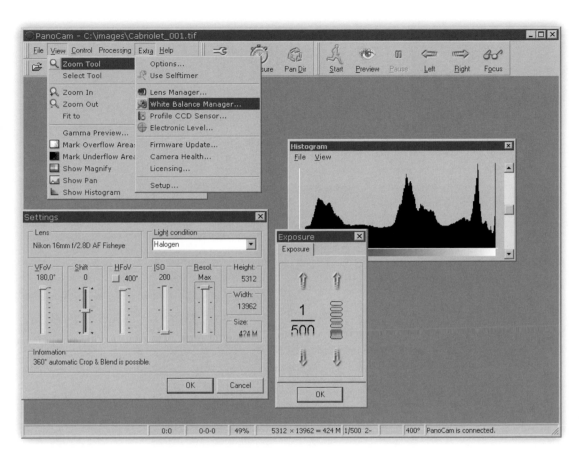

◄
Propietary host
software driving the
Spherocam HDR.

needs to be driven by the BetterLight View-finder software. The simple reason is that this camera really is a "modded" version of a digital BetterLight scanning back mounted on a motorized tripod head. This scanning back is known to many professional 4x5 photographers as one of the best-in-class, primarily for the Kodak CCD column and its highly acclaimed low-light behavior and low noise level. The Panoscan MK-3 does not combine the scanned pixel rows on-the-fly but rather takes three turns to make three LDR panoramas at different exposures. From that point it is up to you to merge them into an HDR image. So essentially, the Panoscan system is more comparable to the LDR version of the SpheroCam, which you can get for the same price.

6.3. Mirror Ball

On the opposite end of the scale, there is the mirror ball technique. It doesn't require you to take a loan, but the quality is very limited. It's sufficient, however, to be used in image-based lighting, and when it's done right it may also be good enough for smaller VR panoramas. In any case, it is very accessible, done quickly, and has been used in visual effects production for years.

The basic idea is this: There is a hard limit to how far you can push up the field of view in an optical lens system. Around 180 degrees is the maximum. It is physically impossible to catch the light rays from behind the camera, no matter how sophisticated the lenses are. Not so

▲ **Mirrorlenses** (left to right): Birdeye, Fullview, Surroundphoto, Omnieye, BeHere, ParaShot

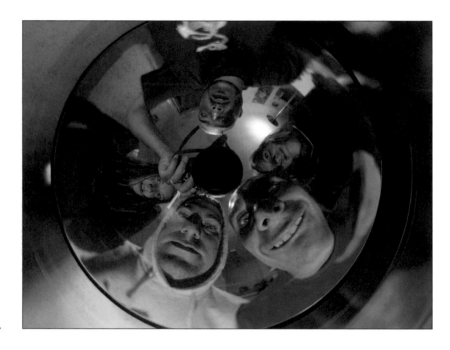

► Fun with a Birdeye.

with mirrors. If you don't shoot the environment directly, but the reflection of an environment instead, the FOV is only determined by the shape of the mirror.

6.3.1. Looking at Mirrors

It's not a new approach. Since the seventies, all kinds of differently shaped mirror lenses have been built. They can be curved inward or outward, in one continuous surface, or broken down in facets. Most systems are built in a compact design, just like a regular lens. Some are even more compact, so they can fit the needs of the surveillance industry. Whenever you see those tinted half domes hanging from a ceiling in a shopping mall, you can bet that there is one of those mirror lenses behind. These cameras actually do show the entire room at once, not just what they are secretly pointed at.

For panoramic photography, the convex mirror systems, where the mirror bulges up to the lens, have taken the lead. They usually come with their own software that has a hard-coded conversion into a standard panorama format built in.

A common problem with all those systems is that the mirror is so close to the camera, there

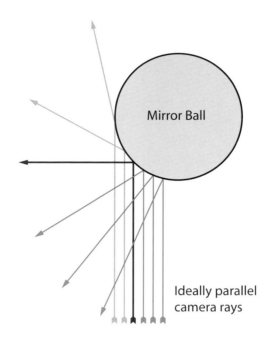

Ideally parallel
camera rays

is a large reflection of the photographer in the center. It makes it also very hard to focus because at that distance you need a macro lens, and even then you can focus on either the center bulge or the rim of the mirror. Such lenses can make some cool party pictures, but for serious applications, they are pretty useless.

The photo on the left was shot with an original Birdeye, nowadays more of a collector's item than a real lens. Modern mirror lenses still sell for $1,000, but the truth is that you can get better results with a regular mirror ball.

But that's not really 360 degrees, is it? Yes, it is. With a fully spherical ball, you can shoot almost the entire surrounding with a single bracketed exposure sequence.

When looking at a mirror ball from the front, you will notice that the outer rim is at an extremely flat angle in relation to you. This is where the camera rays barely change direction when they bounce off the surface. You would think they shoot to the side at a 90-degree angle, but it isn't like that. Geometry teaches us that incoming angle equals outgoing angle. So, the spot where these camera rays shoot 90 degrees to the side is actually somewhere two-thirds from the center to the rim. In the figure, it's drawn in red. Everything outward from that point goes to the area behind the ball, so on the very outer rim surface, the reflection is showing what you see right next to it.

There is a blind spot directly behind the sphere, and of course the photographer and camera are right in the center. That's why you get a better-quality panorama when shooting that ball from several sides.

Got balls? Two different angles are enough when the ball is a perfectly round sphere, like a pinball or a polished steel bearing from a hardware store. Some prefer these Chinese meditation balls that come as a pair in a box and have a little bell inside. There might also be chrome-coated juggling balls still available at your friendly neighborhood juggler supplies store. Basically, anything round and shiny will do. Use your imagination. I have seen HDR environments shot with a soup ladle and they looked just fine. When shopping for a ball that's made of metal, watch out for polishing marks and scratches on the surface.

Probably the cheapest and easiest one to get is a gazing ball. You find them in a garden center or home improvement market, usually between the garden gnomes and plastic flamingos. They are made of blown glass, so take your time to select one that has the least amount of dents. If you find a good one, it will have a much smoother surface than a metal

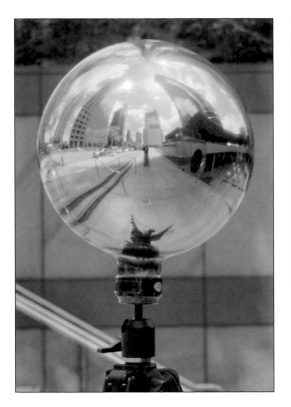

◄
Gazing balls are
cheap and easy to
mount.

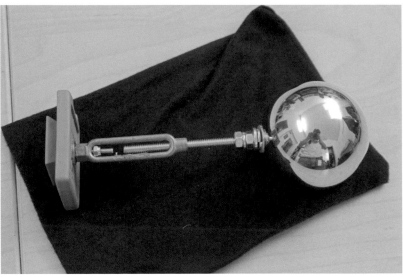

▲
Keith Bruns' rock solid chrome ball mount.

ball, free from polishing marks and micro scratches. Another cool thing about those gazing balls is that they already have a neck extension on the bottom, which makes it easy to MacGyver them on a regular tripod ball head.

However, you need to be quite careful handling a glass ball. And because the mirror coating is on the inside, there is an annoying secondary reflection visible on the glass surface. It's most visible on the outer rim, where the flat viewing angle causes a Fresnel effect. But don't worry, if you shoot it from three instead of two angles, you can paint out the major irregularities later. Shooting a mirror ball is more an adventure than a true science anyway, and considering the 20 bucks invested, it's always worth a try.

Ball on a stick: First of all, you need to mount your new mirror ball on a separate tripod. Time to get a bit inventive. You want to permanently attach the ball to a mounting plate, not the tripod itself. A cheap tripod is good enough since it will just stand there untouched throughout the whole shooting process. Watch out that there are no levers or knobs sticking out of the tripod head, or just remove them. You don't want them to show up in the reflection.

If you have a glass gazing sphere, you can just use plenty of duct tape to attach it to a circular mounting disk for ball heads. See the picture above for an example.

Smaller chrome balls should be mounted a couple of inches above the tripod so the tripod reflection is smaller. If you have the craftsman skills of Keith Bruns, you can do amazing

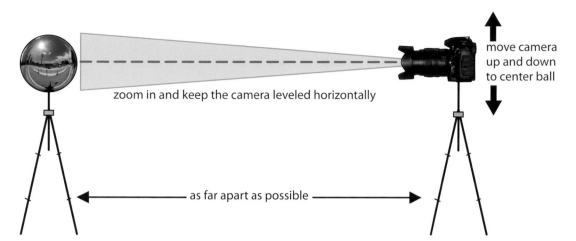

zoom in and keep the camera leveled horizontally

move camera up and down to center ball

as far apart as possible

◄ **2**
Stick to these setup rules and you can't go wrong..

stuff with a threaded rod, a drywall hanger, lock washers, and a couple of nuts. He drills a hole into the ball and uses the drywall hanger to anchor the entire rig from the inside. The result is a rock solid construction that lasts forever. Check out his results at www.unparent.com!

6.3.2. Shooting Your Ball Properly

On to the actual shoot.

1 Set up the sphere in the intended center spot of your panorama. When you plan on lighting a CG object with it, you should place the ball right in the spot where the CG object is supposed to be. Remember, the ball is the virtual lens that your panorama is taken with.

2 Zoom in as far as you can and go backward until the ball is just filling the frame. That serves two purposes: First, your own reflection will be smaller, so it will be easier to remove it afterwards. Second, you will get a nice flat view on the ball. Only when the camera rays are close to parallel can the reflection be unwrapped successfully to a panorama. Theoretically, the ideal would be that you are

infinitely far away and shooting with a telephoto lens with infinitely large focal distance. In the real world, a 10-inch ball shot through a 200mm lens on a 1.5 crop camera allows a good distance of about 20 feet. Smaller rooms might require a smaller ball.

The camera is mounted on its own tripod and leveled out exactly horizontally. A spirit level is absolutely necessary here, either built into the tripod or attached to the flash shoe. Move the camera up and down to frame the ball in the center; don't adjust the tilt angle! This is important for keeping the center points of the ball and the lens in the same horizontal plane. Remember, together they form an optical system. You want the reflection of the horizon be perfectly straight, and this is only ensured by shooting the ball perfectly straight on.

3 Now you're ready to shoot your first series of exposure brackets, either by manually changing the shutter speed, using autobracketing, or with a tethered capture setup. Fix white balance, ISO value, aperture, and focus—you know the deal. Browse back to section 3.2 for more details on this.

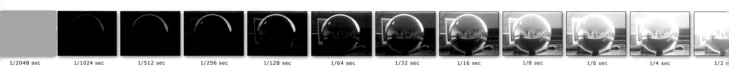

| 1/2048 sec | 1/1024 sec | 1/512 sec | 1/256 sec | 1/128 sec | 1/64 sec | 1/32 sec | 1/16 sec | 1/8 sec | 1/6 sec | 1/4 sec | 1/2 s |

▲ **③** : Shoot your brackets.

④ Great. Now don't touch the ball; instead, move the camera around it. The second set will be a side view, approximately 90 degrees away from the initial position. If seen from a top view, you would be moving from the 12 o'clock position to 3 o'clock, or 9 o'clock, wherever there is enough room. Take care to maintain the distance from the ball and keep the zoom level. Just move back until the ball appears to be the same size it was in the first set in your viewfinder. If the ground is uneven, you will need to readjust the tripod height to center the ball. Once again, watch the spirit level to keep the camera perfectly horizontal.

⑤ Now shoot the second set through the same exposures you used for the first one.

This is technically enough to stitch it all up into one panorama. If you want to be on the safe side, you can shoot a third set another 90 degrees apart. This will give you a little bit more meat for retouching and will be your safety net if the first set didn't work out. Don't worry if you didn't hit the 90-degree angle **exactly**; we can easily take care of that. The 90 degrees is just a ballpark figure that gives the best result out of two viewpoints. If it means you would be blocking a light, or casting a shadow on the sphere, you're free to wander around a bit. There is no reason you couldn't get a working panorama out of three shots 120 degrees apart, either.

The standard postprocedure is now as follows:
- Merge to HDR
- Crop the ball
- Unwrap
- Stitching and retouching

Merge to HDR: The first thing we want to do is merge all the exposures from each position to HDR images. If you read section 3.2 on HDR generation, you know what to do now. Use any HDR generator that pleases you. Just make sure to use a consistent camera curve; otherwise, the colors won't match up when we stitch them together. Pick either the generic gamma or your own precalibrated curve and everything will be fine.

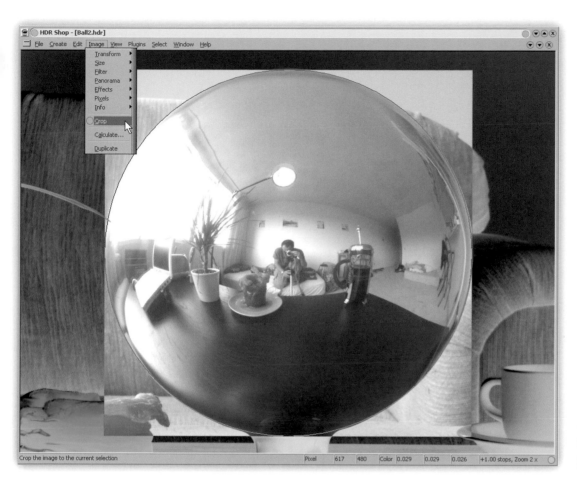

◀ **1**
Cropping in HDR
Shop

In this example, I just used my previously calibrated Photosphere and saved the images as Radiance HDRs for maximum compatibility. Did it right on the spot on my iBook. Easy.

6.3.3. Unwrapping Your Balls

Back in the convenience of the Windows environment, load the resulting HDR images into HDR Shop.

1 They need to be cropped first. For this particular purpose, HDR Shop offers a special selection tool that draws a circle inside the rectangular cropping frame. So the first thing to do is to activate this in the menu: Select→

Draw Options→ Circle. Now we need to fit that circle exactly to the edge of the ball. Take your time to do that carefully because close to the rim the image information is packed very densely. A successful unwrap can only be done when the sphere is just touching the frame on all four borders. So use the zoom feature (Ctrl +/-) and adjust the viewing exposure (+/-) to see the edge clearly in blown-out areas.

Once you've got the framing right, go to the menu and select Image→ Crop.

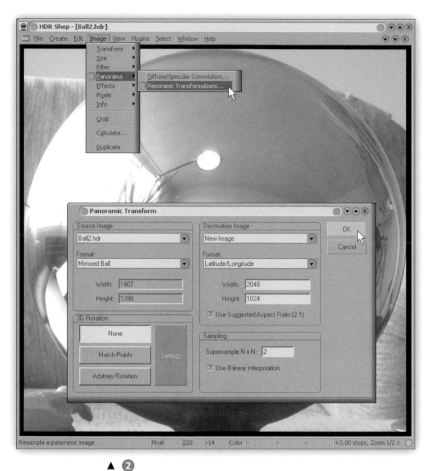

▲ **2**

Unwrapping
with HDR Shop's
Panoramic
Transformation.

Problem areas: Now it becomes quite apparent how unevenly the density of the image information is distributed across the surface of a mirror ball. In the center of the panorama, each pixel roughly equals a pixel from the original. But the closer we get to the border, the more details are being extracted from pixels that are packed tighter and tighter. Notice the extreme pinching distortion on the outer borders! Looks like the blue coffee cup on the right-hand side is accelerating to warp speed. This is the spot that was originally hidden behind the sphere. Our unwrapping algorithm has smeared the pixels from the selection circumference inward because it has no other choice. The real information content in this spot is zero.

Unfortunately, the sweet spot with the best unwrap quality shows the photographer. That's why it is so important to shoot the ball from a maximum distance. Even when we recover that spot with information from the second set, we have to replace it with a patch of lower quality.

By the way, cropping and unwrapping can also be done in Photomatix. However, Photomatix's crop selection tool is a bit more cumbersome, and the Unwrap Mirrorball function only does this one transformation.

We will go on fixing the image in Photoshop, so if you really hate switching applications in one workflow, you can do all of the previous steps in Photoshop, too. But note that PS won't show you the handy cropping circle either. And for unwrapping, you will have to buy the plug-in Flexify 2 from Flaming Pear, which might well be the best 35 bucks ever spent, considering that Flexify 2 will take care of all your panoramic remapping needs in full HDR and with a nifty live preview. .

2 Now the image is prepared for unwrapping. That's done by selecting Image→ Panorama→ Panoramic Transformations. A dialog pops up in which we need to specify some parameters. Our source format is Mirror Ball, and the target shall be Latitude-Longitude. To get the most of our image resolution, we don't want any parts to be scaled down at this point. As a rule of thumb, this is achieved by matching up the vertical resolution of the target to our source.

The result is already a fully spherical 360-by-180-degree panorama.

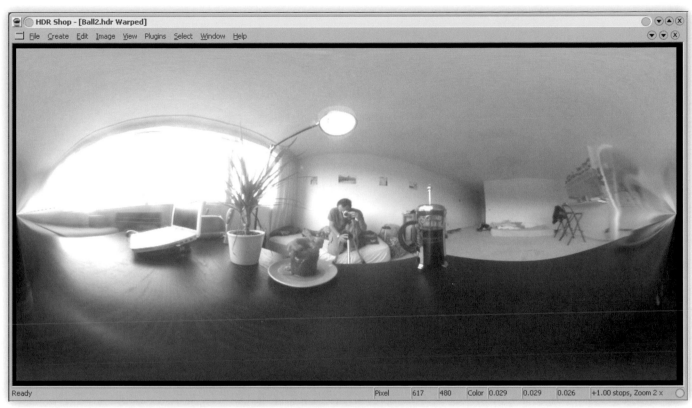

▲ Unwrapping your balls – The result.

◄ Problem areas.

Useful image information: Good ☐ Acceptable ■ Poor

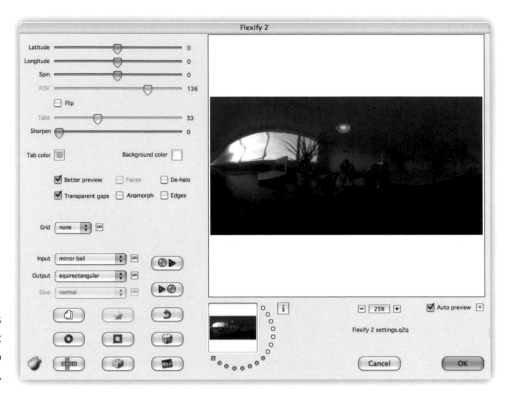

▶ Flexify 2 brings panoramic transformations into Photoshop.

6.3.4. Stitching Manually in Photoshop

Now that Photoshop CS3 finally has layers, we will put them to good use for stitching it all up into a final panorama. If you want to follow this tutorial, pop in the DVD and load the image Combine_Start.psd now.

You'll see that I have stacked up all three unwrapped views in layers. Now, this particular image is as problematic as it can be—the ball was way too big for that small room, so we have a lot of perspective shift in each image. Distortion caused by dents on the ball surface is quite extreme. And to make things even worse, I was very sloppy shooting those images and didn't shoot the same range of exposures for each. Worst-case scenario all over the place.

But fear not, there's nothing we can't fix in CS3!

Aligning the layers

❶ a. Hide all layers except the background.
b. Select the background layer.
c. Call Filter→Other→Offset from the menu.
d. Now shift the image about one third over. We want to see the ugly pinching spot as well as the pretty photographer's reflection. This shall be our base alignment for retouching.

❷ Now activate the second layer and set its opacity to 50%.

❸ a. Use the Offset filter again and slide the second layer until it matches the first one.
b. Cool. Set opacity back up now; alignment is all we needed it for.
c. Do the same thing for the third layer, even though we might not necessarily need it.
d. Now you can switch through them all to get a feel for the good and the bad areas.

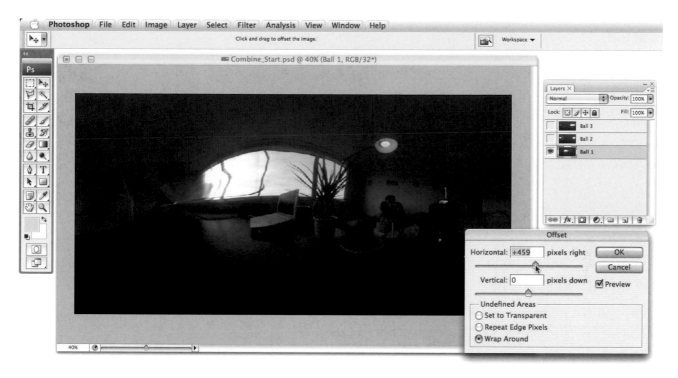

▲ ❶ : Preparing the base alignment to see the pinching spot.

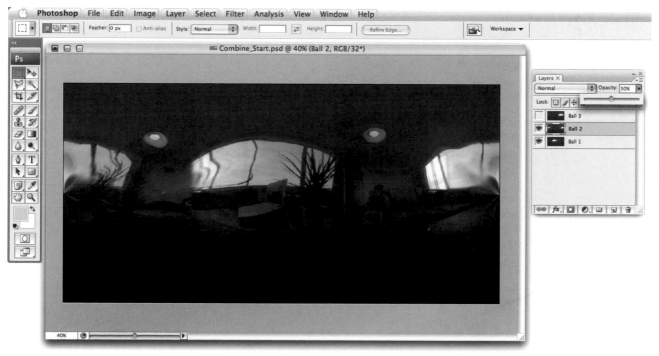

▲ ❷ : Next layer is semitransparent.

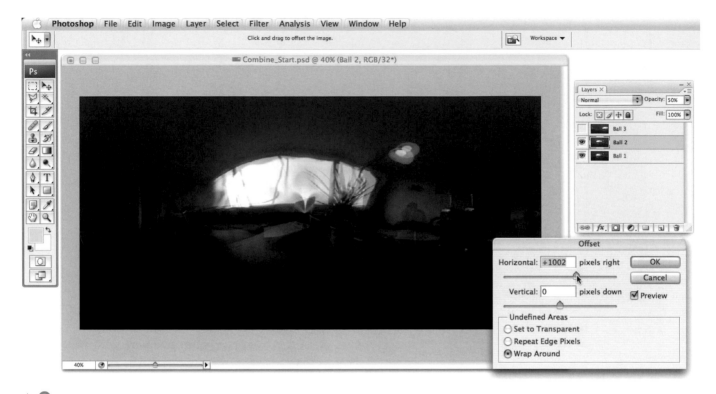

▲ ③
Visually matching up both layers.

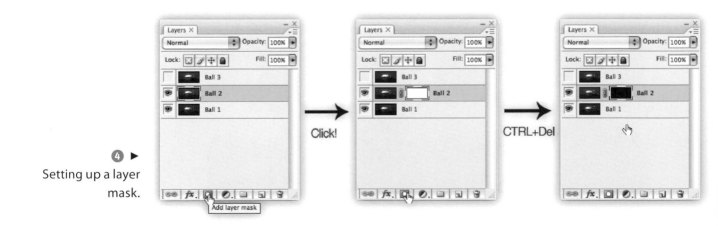

④ ▶
Setting up a layer
mask.

▲ **⑤ :** Rubbing out the photographer.

Combine the good parts

Or in this case, the parts that have the least amount of badness to them. We start out with getting rid of the photographer.

④ a. Create an alpha mask for that second layer. Just click the little icon on the bottom of the Layers palette.
b. Fill that alpha with black. Quickly done by hitting Ctrl+Delete.

⑤ a. Now you're ready for some rub-through action!
b. With the alpha still selected, change to the paintbrush tool and select a fairly large brush. Soft Round 100 pixels will do.
c. The foreground color should be white, background black.
d. Zoom in on the photographer's reflection and rub it away!

⑥ a. At this point it becomes quite obvious that the second layer is a bit brighter. Well, that was me screwing up the exposures at the shoot. Nothing to worry about.
b. Select the actual image layer and choose Image→Adjustments→Exposure.
c. Usually those glitches happen in somewhat even EV intervals. In this case, it takes an exposure correction of -0.5 EV to fix it permanently.

⑦ a. Now it's time to fine-tune that alpha map with a smaller brush. Painting with black brings back the corner of that candle, for example.
b. However, some artifacts are left: the shadow on the wall and the tripod legs. Unfortunately, we cannot steal these areas from the other images, so we dust off the good old Clone brush now. Alt+click on a good source spot, and then just paint on at the target spot.

▲ **7** : Cleanup work with the clone stamp tool.

▲ Before ▲ After

All right, here we are. Gone is the photographer. Let's see a quick before and after.

Sweet. Now, that might read like a lot of work, but it really took just 15 minutes. We had to pull out all the tricks here, and it goes much faster when the layers actually line up; that is, if I just would have listened to my own shooting advice. However, this is the workflow that will 100 percent lead to the desired result, no matter how badly you screw up. It is as nondestructive as it can be. You can paint these alpha masks over and over without changing any image content. Black rubs out, white rubs in. You can readjust the exposure as often as you want because there are no quantization errors or clamping in HDR land.

We're halfway there. The big ugly pinching spot is left. In order to have the same kind of flexibility when we go on, we'll need to bake down the changes we did so far.

◀ **8**
Bake it down to keep yourself from messing it up again.

▲ **9**
Repeat workflow with the pinching spot.

Bake it down

8 a. Drag the second layer onto the New Layer icon on the bottom of the Layers palette.

b. Shift+select the two lower layers.

c. Choose Layer→ Merge Layers.

d. Now just fill that alpha channel of the copy with black again, and we have everything laid out as fresh material for the second round of touch-up action.

Getting rid of the pinching hole

What's left now is just an application of the same workflow again.

9 a. Do a first-pass rub-through by painting into the alpha with a large soft brush.

b. Watch out for details hidden beyond the highlights. Toggle the viewing exposure with that little slider window widget. Remember, an HDR image is more than meets the eye! You know the rest:

a. Fine-tuning of the alpha map with a smaller brush.

b. Some clone stamp fun.

c. Starting to pull some detail from the third layer, which has been unused so far.

d. Noticing after the first couple of strokes that the third layer's exposure is way off.

e. Hitting up Image→ Adjustments→ Exposure to fix that.

f. Some more clone stamp fun and alpha massaging.

All in all, it took me another 30 minutes. Picky as I am, and sluggish as my mouse arm moves, you'll probably be done faster.

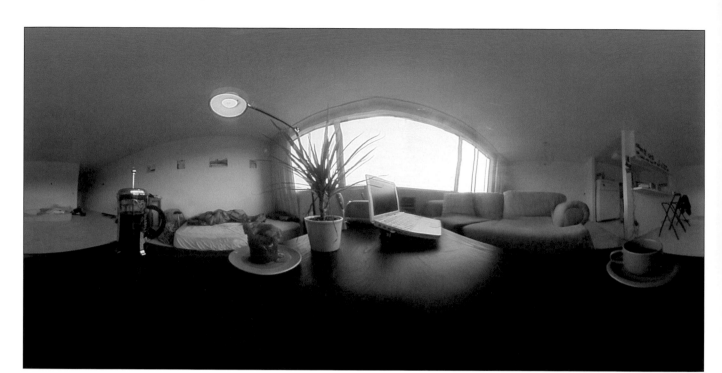

▲ **Final HDR panorama**
100% hand crafted.

Wrapping it all up

10 Four things are left to do:

a. Choose Layer menu→ Flatten All Layers.

b. Choose Filter → Other → Offset to set the final output direction, just so the interesting part is in the center and the seam goes across something boring.

c. Choose Image → Rotate Canvas → Flip Canvas Horizontal. That's because we have been working with a mirror image all the time. Instantly, you will recognize why it always looked so odd, especially when you have bill-boards in the image.

d. Save the final and do the Happy Dance!

6.4. Segmental Capture

This is the world of flexible image acquisition. Within this section we will discuss methods of capturing panoramic images with virtually every piece of equipment you can imagine. We will also compare practicability and ease of use, and you will learn to avoid some common pitfalls during image assembly.

Segmental capture does what the name implies: You divide your surrounding into a certain amount of segments that are photo-graphed and then stitched together in a sepa-rate step.

6.4.1. Basic Premises

To be able to process these segments, we have to follow three basic rules: sectors must over-lap, turn around the nodal point, and shoot consistent exposures.

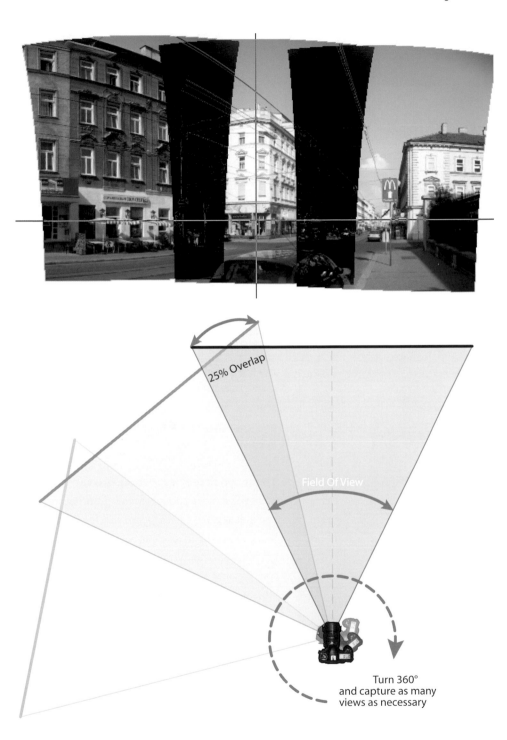

Sectors must overlap! After shooting, you have to stitch the adjacent images together. Without overlap, you can't precisely position the images. A good amount is 25 percent giving you enough room to correct even small mistakes.

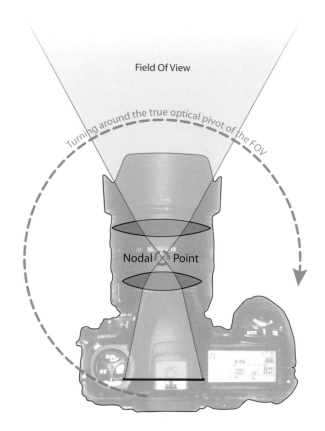

Field Of View

Turning around the true optical pivot of the FOV

Nodal ⊗ Point

Turn around the nodal point! While shooting, you must rotate the lens utilizing the nodal point. Technically, the better term would be the **no-parallax point**. This is the only usable rotation axis where foreground and background won't change their relative position in the photographed sectors.

A classic example of two lenses that don't meet the nodal point are the human eyes. Look at your surroundings and alternately close one of your eyes. You will notice that foreground and background change their position to each other. This is very important for stereographic viewing, but for panoramas we need to see every detail in our surrounding exactly the same way for each sector we are photographing.

Unfortunately, standard tripod mounts are roughly at image-sensor level, while the nodal point is in or even in front of the lens. This is the reason we will use special panoramic heads.

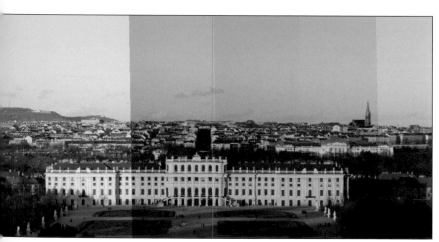

Shoot consistent exposures! All sectors must have the same exposures. Without using the same exposure settings, we will face the problem of varying image characteristics. Especially critical is the dynamic range covered in each one. If you plan to shoot HDR panoramas for later use with image-based lighting, it has to be consistent.

6.4.2. Getting the Right Gear

Camera: Any camera with manual exposure capabilities would do, although it is a good idea to use a decent SLR camera. You need easy access to manual white balance and exposure shift. The dial for exposure shift should be accessible through a primary dial on the camera.

Please note that we are talking about exposure shift. Shifting the aperture of the lens will change its optical characteristics. Furthermore, the camera should have a burst mode, enabling it to save images without delay.

Tripod: I assume you already own a tripod. That one should do.

If you want to have a small "footprint" in your panorama (that's the area that will be covered by your tripod when looking down in the panorama), you should consider a ball head instead of a big three-way head.

Lens: Choosing the right lens is a compromise between final resolution and speed. Resolution and therefore image quality will rise the longer your lens is. But you should consider the amount of data you're collecting by shooting HDR.

Let's make some rough calculations: A 17mm wide angle would need about 10 horizontal and 3 vertical shots to cover a full sphere. This makes 30 shots for a standard LDR panorama. Multiply this by the number of brackets you need to cover the full dynamic range of your scene. We'll assume 10 brackets for a typical outdoor scene, so we end up with 300(!) images to shoot—1 gigabyte of JPEG data just for one panorama!

On the other side, all the data collected will actually show up in the final image. Only the sky is the limit here.

Standard wide-angle lenses cannot get you very far in the FOV they can capture. They make a lot of sense for partial panoramas in very high resolution, but for full spherical panoramas you should consider getting a fisheye.

▲
Nikon's sky camera from the sixties.

Fisheye lenses: In the 1960s, Nikon sold a special camera, called the Fisheye camera or Sky camera. It was a device built to enable meteorologists to take images of the full sky dome in one shot. The images were captured using medium-format film, and the device was sold as an all-in-one package including the camera body, winder, and a case. The lens in the package was a 16.3mm f8 fisheye, developed by Nikon back in 1938.

Two years later, Nikon released the first interchangeable fisheye lens, a monster weighting more than 1 kilogram, extending so far into the camera that it was only mountable on an SLR with the camera's mirror locked up.

By 1969 and 1970, Nikon released several modernized fisheye lenses, the Nikkor 6mm f2,8 and the Auto Nikkor 8mm f2,8. These were still monstrous lenses that overruled decent telephoto lenses in size and weight and at a price others would spend for a brand-new luxury car.

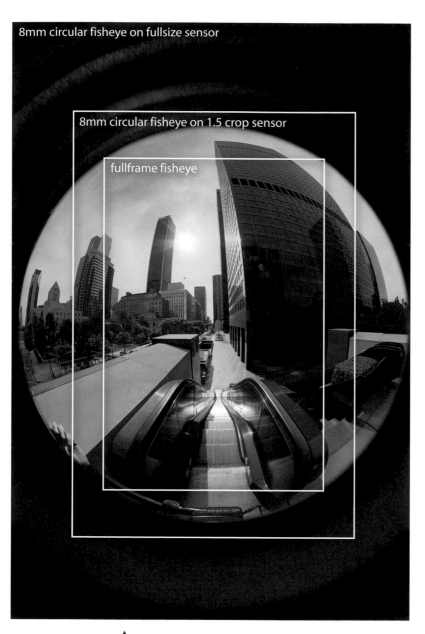

8mm circular fisheye on fullsize sensor

8mm circular fisheye on 1.5 crop sensor

fullframe fisheye

▲

Image crop with common fisheye/sensor configurations

another shot in the opposite direction and you're done.

Luckily, times have changed, so you don't need to use such heavy equipment anymore. Besides Nikon, there are several other companies selling fisheye lenses now—most of them with a smaller FOV than 180 degrees.

Here is a list of some common fisheye lenses that are used by panorama photographers:

- **Nikkor 8mm f2,8**: Excellent lens with low-light falloff but discontinued.
- **Sigma 8mm f4 & Sigma 8mm f3,5**: Cost-efficient lens, average optical performance but available for a wide range of cameras.
- **Peleng 8mm f3.5**: Uses old T2 universal mount. The best you can get for your money but expect above-average lens flares and internal reflections.
- **Nikkor 10.5mm f2.8**: Full-frame fisheye for digital cameras, covering 180 degrees only on the outer edges of the image.

Panoramic heads: A panoramic head represents your central configuration detail for technically correct panoramas. It will affect the way you capture the segments and it should closely match your camera and lens configuration.

You can roughly distinguish between three groups of heads.

Universal spherical heads allow you to adjust every axis and camera displacement. Such heads are especially useful if you plan to shoot with several lens types. Universal heads are a good starting point, and they will serve you as long as you are willing to spend some time for setup on location.

A typical head is the top-of-the line Manfrotto 303 SPH, as seen on the left. It's built industrial style: very heavy and bulky and survives even the roughest treatment.

So, why would someone want to use such heavy and expensive equipment? It's all about the field of view you can capture with one single shot. An 8mm circular fisheye for 35mm SLRs can capture a FOV of 180 degrees – that's exactly half of your surroundings! Add

▲ Fisheye lense
Sigma 8mm fisheye

▲ Universal spherical head
Manfrotto 303 SPH

▲ Fisheye head
Agnos's MrotatorC series

▲ High-precision head

A mentionable alternative is the Novoflex VR Pro. Both heads have in common that they are built up from standard pieces with some specific parts specifically designed for panographic needs. This also allows you to reorder missing or broken parts—a bonus you shouldn't underestimate because spare parts for specifically built heads may become very expensive. Nodal Ninja is another good one, albeit less robust and heavy. But it's also lighter on your budget.

Fisheye heads are built only for fisheye lenses, typically even for one particular lens. They are very small and restrict the usable FOV as little as possible. Some of them even position the camera in a special way, allowing as few shots as possible.

See Agnos's MrotatorC series for an example of such specialized heads. The special tilted mount of the camera is built for an 8mm fisheye on a typical DSLR with a crop factor of 1.5. It allows you to shoot a full spherical panorama with only three shots, unlike the usual four shots with a 90-degree tilted camera.

High-precision heads, the most familiar head of this group, are built for 360 precision. The basic idea behind this head is that using the exact same rotation angle for shooting the sectors would allow you to stitch images without the need for control points. Instead, you can use a predefined template that is applied to your image set.

If you plan to create many panoramas, investing in a high-precision head can be a good idea. They're also a good idea if you plan to shoot "featureless" panoramas—with images that do not allow automatic control point creation (e.g., images with a high amount of sky, white walls, or similar).

If you're either lazy or plan to shoot from a position where the camera is out of reach, you should consider a robotic head. Marc Cairies, Dr. Clauss, and Panoscan offer solutions that will position your camera and release the shutter without any manual intervention at all. Of course, a true hardcore panobuff would just build a motorhead himself. How about that for a fun weekend project?

► Homebrew motorhead ala Vogl,

PHOTO BY WOLFGANG STICH

► Touch base at the center.

6.4.3. Finding the Nodal Point

OK, so you got yourself a nice panohead and a wide-angle lens. Maybe even a fisheye. And now we have to put it all together, but in a way that the panohead will rotate the camera around the nodal point of the lens.

First axis: First we have to ensure that the center of the lens is exactly above the pivot of the head.

A quick and dirty method with a full spherical head is to tilt the camera downward and then check if the viewfinder's center aligns with the rotation axis. Camera sensors tend to be mounted with a slight misalignment, though, so this method is not really recommended.

A more precise method is shown on the left: Utilizing a bigger and longer lens, you can tilt the camera down until the lens touches the adapter. Seen from the front, the tangent of

▲ The gap test
Rotate the camera left to right to see if the gap opens or closes.

▲
Adjust the camera accordingly.

the lens's outer circle must touch the base exactly above the rotation axis.

Second axis: Now we will need two vertical lines, one very near the camera, another one far away. A good setup is to have two doors in a row or a door and a window. It's up to your imagination to use whatever you want.

Place the tripod in a way that you can see both verticals nearly lining up. Only a small gap should be left. This gap must not change while the camera is rotated.

Take a picture with the camera rotated to the left and one rotated to the right. Both shots must include the gap we are observing. In the following example, it is the black line between the front and rear door.

Now check the appearance of this gap.

If it opens, the lens is rotated behind the nodal point. Adjust the camera forward. If it closes, the lens is rotated ahead the nodal point. Adjust the camera backward.

If the gap doesn't change between both shots, you have found the correct nodal point for your lens and focal length. Congratulations!

It's a good idea to mark these settings on the panohead with a Sharpie or some duct tape.

Fisheye lenses and the nodal point: As usual, there is a special issue when adjusting the nodal point of fisheye lenses: their nodal point is dependent on the angle of rotation. So if you set up your fisheye, you have to do this by moving the camera the same angle you're planning to shoot with later.

However, on the Sigma 8mm and Nikon 10.5mm lenses, the nodal point sits right on that golden ring. Call it a happy coincidence, or wisdom of the lens makers who apparently are aware of the preferred shooting angles with their fisheyes. Most precious, that golden ring is.

▲
Nikon 10.5mm fisheye

Almost there. But before we can start shooting, we need a plan.

6.4.4. Finding the Right Rotation Angles

If you are a beginner in panoramic photography, you may have wondered why so many people use their camera in portrait mode. The reason is simple: It is easier to stitch! As we mentioned earlier, the sky is the limit. I mean, literally, the sky is limiting the resolution we can get out of a series of shots.

Look at the image above and you will notice why: To stitch the images together, you need distinct image features to know where to set the control points in two adjacent sectors. Blue sky and even clouds aren't distinct enough to reliably place control points. To still be able to use as much sky as possible, you

want to use the camera in portrait mode, adding some extra viewable vertical degrees.

How many sectors do we need?: The official back-of-an-envelope formula goes like this (in portrait mode):

$$\text{shots needed} = 1.3 \times \frac{\text{hFOV of your panorama}}{\text{hFOV of your lens}}$$

Example: The hFOV of your lens in portrait mode is 60 degrees, you plan to shoot a 360-degree panorama, so your rough estimation would be 1.3 * 360 / 60 = 7.8. Add some spare overlap and you need a shot every 45 degrees or whatever click stop your panorama head offers in the proximity.

Repeat the same for the vFOV of your panorama.

Example: Full spherical panorama with 180 degrees vertical, lens vFOV (portrait mode) is 90 degrees. 1.3 * 180 / 90 = 2.6. (You didn't use your calculator now, did you?)

Now we have our estimated number of shots needed for the panorama. Next we should consider how to place these sectors in our scenery when shooting.

The routine rule of thumb: Don't part anything!: This applies to (the smaller) objects in your scenery as well as bright lights. If you shoot inside a room, try to capture all windows and lights in a way that they don't cross the image boundary. If this is not possible, try to place your seam in the middle of the bright region.

To make things more complicated, it is crucial to place light sources in the middle of your image. Although you can't completely avoid it, chances are higher that your lens's optical flaws (like lens flares) will be held as low as possible.

▲

Placing the sun in the center

Equipment Checklist		
Camera		
Memory cards		
Batteries		Make sure they are loaded.
Portable storage		If available.
Lens		
Tripod		
Panorama head		
Useful additions:		
Screwdriver/Leatherman		Very useful if a screw becomes loose.
Duct tape (silver preferred)		To fasten the focus ring, tighten the tripod, make small repairs… Use the silver type; transparent and black duct tape tends to be left on delicate equipment parts.
Neutral density (ND) filters		Needed if you shoot HDR light probes in direct sunlight.

Sometimes it helps to—again—increase the number of sectors to shoot. This way, you can pick the best parts of each image to assemble a panorama that's as flawless as possible.

6.4.5. The Shoot

Now that you know all the terms and technical details, we can start shooting our first panorama. Due to the nature of segmental shooting, this will not be a "cooking recipe" but more of an introduction into the art of panorama shooting.

As long as you're not familiar with the process of panorama creation, I recommend using a simple checklist for setting up your camera and shooting the necessary brackets.

Later—just like a "real jock"—you may leave this checklist at home and concentrate on the shooting itself.

Camera Settings: Basically everything that was said in section 3.2.1. applies here as well: no image enhancements, fixed ISO, and fixed focus. We're going to shoot a hell of a lot of images, so JPEGs make much more sense than RAW here. You wouldn't gain much dynamic range with it anyway, and it would only end up in a file-handling nightmare.

Depending on the range you are planning to capture, the workflow splits here in MDR and HDR capture.

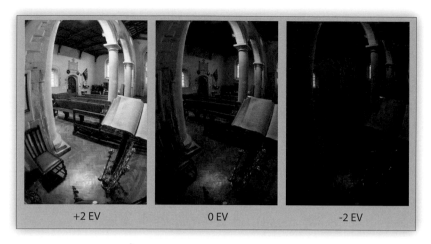

+2 EV 0 EV -2 EV

▲

A typical MDR (medium dynamic range) capture.

HDR workflow: To get the perfect HDRI for usage in 3D applications, you don't want any highlights to be clipped at all. Otherwise, you'd loose valuable light information that would give your renders that extra kick. The one exception is the disk of the sun. It's way too bright; don't even bother trying. We'll use a regular 3D light source for the sun anyway, just for flexibility.

- Set the camera to predefined "sunny" white balance. "Sunny" has the widest gamut of all predefined settings, so it is even advisable for indoor mixed-light situations.
- Now we have to measure the boundaries between which our exposure will range. A spot meter is very useful for this task.
- Measure the brightest spot. If you only have in-camera spot metering, remember that the field of view certainly will not fully cover bright spots of light. You'd be amazed how bright the center of a lightbulb is, even though it might be smaller than a pixel on your camera display. Better add some extra EV steps to your measured brightest value to be sure to include all the lights.
- You may experience problems using a time short enough to capture your brightest light. This is the time to use one or more ND filters. It is a good idea to make a note about this decision, as it won't show up in your EXIF data.
- Now, also measure your darkest spot and calculate the needed EV steps from dark to bright for your scenery. Depending on your EV spacing, you should now have an exposure time table like this: 1/15 – 1/60 – 1/250 – 1/1000 – 1/4000

Even when you're used to shooting HDR panoramas, it is still a good idea to use a slip of paper to write down the minimum and maximum exposure values you intend to shoot.

MDR workflow.: This is the minimalist approach, where the intention is to get a nicely tone-mapped LDR panorama. You want to go easy and use autobracketing, as limited as it might be.

- Switch the camera to automatic mode and set up white balance.
- Assuming that we are interested in capturing some extra highlights, we will shift our available bracketing range for the brightest shot being our "normal" exposure.

Let's have a look at a typical -2/0/+2 EV MDR scene to explain this approach.

As you can see, the brightest shot already includes everything we want to see in the shadows. This is the exposure the camera will measure for this scene. On the other hand, the bright window is still blown out two stops below. We need another -2 EV stopped down to capture this extra detail.

So, what we do is let the camera measure the correct exposure—just the same way every other photographer would do—and afterward we will shift this exposure 2 EV steps down.

Capturing HDR panoramas takes a long time, and you are definitely not the first one who will be disturbed while concentrating on the shoot.

Your notes may look something like this.

Now shoot as fast you can!: It is crucial to capture all EV steppings of each sector before the scenery changes too much. There may be people walking around, and even the sky is an issue with the wind moving the clouds. Software can eliminate such movements to a certain degree, but the algorithms can't do wonders.

Fast shooting is an easy task using in-camera bracketing functions. For full HDR panoramas, you should practice at home to develop the best method for your camera.

If you get lost while shooting, begin from the last step you are sure to have finished. It can be very disappointing to discover at home you have missed one photo, resulting in a useless HDR panorama.

Here are some tricks for shooting full spherical panoramas with fisheye lenses:

- By omitting the "tripod area" in your panorama, clearly can cover all remaining surroundings with fewer shots!
- With circular fisheye lenses, you should tilt the camera slightly upward. This will cover the zenith area of the panorama better and make stitching easier.
- With full-frame fisheye lenses (e.g., Nikkor 10.5mm on 1.5 crop DSLR camera), shoot the "horizontal row" by tilting the camera slightly downward. This will cover the complete floor except the tripod and you will need only one additional zenith shot to cover all you require for your full spherical panorama.

Min. exposure	1/15	Stepping		2 EV	
Max. exposure	1/4000	Sector (check each when done)			
f-stop	F 5.6	1	2	3	4
ND filters used	no	5	6	...	

The nadir point is especially hard to cover since this is where your tripod is. However, with autobracketing in good lighting conditions, you do have a chance. The trick is to pick up the entire rig, carefully rotating the camera as best you can around the nodal point, and then rest the tripod on your shoulder. Now you have to take a deep breath and shoot one exposure bracket handheld. Yes, it's very sketchy, and it doesn't always turn out well. But at least you tried and gave everyone around you a good laugh.

6.4.6. Putting It All Together

There is a huge variety of panorama stitching software, and each and every one claims to be the easiest and best. I'll tell you what: The best one has been around for almost 10 years, but it was undercover most of that time. That's because it was so good it got sued by the competition. And it doesn't even have a graphical user interface.

I'm talking about PanoTools.

A crowd of enthusiasts keeps developing this program as open source since the original creator, Prof. Helmut Dersch, has withdrawn. Nowadays, all panorama stitchers that matter are based in some way on PanoTools. Some are commercial, some are shareware, some are freeware. But the key is that they are all compatible with each other through the original PanoTools project format. We will focus on

two of the best-known ones: Hugin and PTGui Pro. Both of them can stitch HDR images.

What way to go? Several workflows are now possible to get from our exposure brackets to an HDR panorama:

1. The old-school way:
Stitch LDR panos with whatever stitcher, and merge them to HDRI.
- Pro: Most of the work done with LDR images, hassle free and fast.
- Con: Slightly misaligned source images most certainly result in blurred HDR panoramas.

2. The careful way:
First merge HDRIs, and then stitch those with Hugin or PTGui.
- Pro: High panorama quality.
- Con: High computing power needed, slow.

3. The special way:
Batch HDR creation of sector brackets, tone mapping, LDR stitching.
- Pro: High quality, fast.
- Con: Will not work for all lighting situations.

4. The modern way:
Full HDR workflow, straight from brackets to HDRI. Works with PTGui Pro and Autopano Pro, soon also Hugin and Realviz Stitcher Unlimited.
- Pro: Everything is Pro here.
- Con: Nope. May be too easy.

Before the arrival of HDR-capable panoramic software, there were ongoing discussions about the "right" way of stitching HDRIs. Nowadays, most workflow types are needed only for special cases—for example, when you want to save the hundred bucks for pro-grade software or when you have your own preferences for pano stitchers or HDR mergers.

Get organized!
❶ For easy processing, I recommend creating a subfolder for each panorama you are planning to stitch. Copy all images belonging to your panorama to this folder.

Do a rough visual check to make sure all bracketed shots are here—no more, no less. Don't rely on database-driven systems like Aperture or Lightroom. Make it a real physical folder, and use a basic thumbnail viewer like XNView. Even Windows Explorer or Mac Finder will do. Use thumbnails and arrange the window size in a way that you can easily see if all brackets are complete.

Keep in mind that subsequent processing steps build up on their predecessors. Any fault you overlook will end up in more work down the line.

We will have a closer look at workflow numbers 3 and 4 now. You're more than invited to come right along; all source files are on the DVD.

6.4.7. Modern Workflow: Direct HDR Stitching with PTGui Pro

Before we start, an important reminder: All LDR images must have the camera's EXIF data embedded, or at least all relevant exposure data. This is needed by PTGui to distinguish the source images that belong to one sector. If you feel the urge to review or change this data, you can use Friedemann Schmidt's Exifer (PC, www.exifer.de) or Reveal (Mac, http://albumshaper.sourceforge.net).

▲ ❷
Loading all images
into PTGui.

◄ ❶
Sorting all source images into
a folder with XNView.

Aligning the images

❷ First load all images into PTGui's Project
Assistant. I prefer doing this by dragging and
dropping them from the file list to the PTGui
window.

If the images don't show the correct ori-
entation, rotate them to be upright. Also, if
you work in simple mode, click the Advanced
button. Double-check if your lens is identified
correctly.

❸ After you start the alignment via the but-
ton Align Images, PTGui will analyze the EXIF
data and try to group corresponding bracket
series. A message will appear with the out-
come and ask you for a decision.
This message reveals an interesting feature
that is very useful if you plan to shoot light
probes where some images are so dark that it

▲ ❸
Pretty smart of PTGui to ask at this point.

is impossible to align them correctly. All im-
ages of a certain sector are glued together so
that no optimization will change their relative
position. This is the recommended way if you
have shot very carefully without touching the
camera. Alignment via control points is never
as accurate as careful shooting.

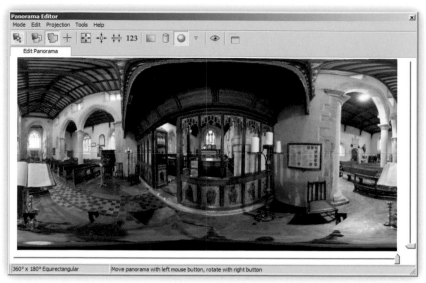

▲ ❹
Checking a preview in the Panorama Editor.

❺ ►
Defining verticals in the Control Points tab.

❹ Let's pull up the Panorama Editor window (Ctrl+E) and have a look at a preview!

Looks good to me. Apparently there's a pretty powerful algorithm at work here. Assuming you have used a leveled panohead, the results should be good enough for stitching the final output. If your panorama comes up just like that, you can safely skip ahead now.

Sometimes, however, you may encounter distortions in your panorama. It may look wavy or simply broken. In this case, you have to dig deeper into the GUI by checking, correcting, or adding control points.

What are those mysterious control points?
A computer can't work in a visual way like humans do. So it will need some mathematical clues on how to position and transform the input images to create a good-looking panorama.

In automatic mode, you don't have to care about these clues. All PanoTools-related software packages already include specialized software that will calculate distinct image features in every input image and automatically connect the matching ones. But sometimes these algorithms fail and you have to fix it with some manual intervention.

Fixing vertical lines
One indication that the automatic alignment failed is when vertical lines do not appear vertically straight. For equirectangular panos, this only applies to verticals near the horizon. Due to the image distortion, it's OK when they slightly shear apart on the top and the bottom.

This one is easy: Define some vertical control points!

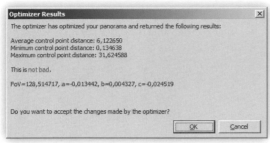

▲ **6**

Re-optimizing the panorama.

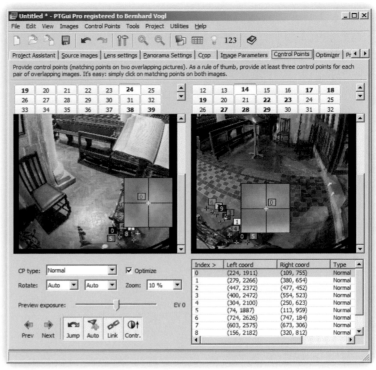

▲ **7**

Fixing mismatched control points.

5 For this, we have to select the Control Points tab. Here the viewport is split in two. That's because every control point refers to two images. In our special case, those happen to be the same. So we select the same image in the left and right window.

Mark the lower end of a vertical line in the left and the upper end in the right window. You will notice that a quick click will set a new point, but holding the mouse button for a second will bring up a small loupe with a crosshair. This is very handy for fine adjustments because whenever you move a point underneath that loupe, the mouse sensitivity will scale to the original image resolution.

To make the verticals self-stabilizing, you have to mark either another vertical in the same image or several other verticals in other sectors of the panorama.

6 None of these control-point changes have any effect on the image until you re-optimize the panorama. This can be done via the Optimizer tab. It is advisable to disable all lens parameters and yaw rotation for all images except one (the "anchor") image. After optimization, the results are displayed in a dialog window.

The verticals should be aligned now. Though, as you can see in this dialog, the image align-

ment itself is not perfect yet. Some of these control points are too far apart in the stitched final, causing an uneven pull on the others. That may lead to a broken-looking panorama, where edges and corners from adjacent sectors just barely miss each other.

In that case, we will have to keep on fixing.

Fixing mismatched control points

Here is an easy way to find those troublemakers.

7 Choose Tools→ Control Point Table (or press Ctrl+B). A new window will come up, showing a chart of all control points in the panorama. Sort them descending by distance. You can now double-click the line with the worst control point. The main window will

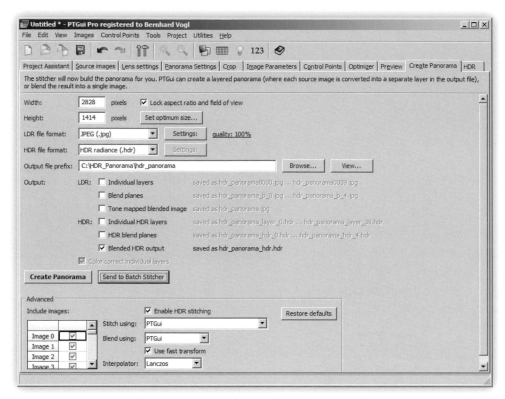

8 ▶
Rendering the final panorama.

jump to the Control Points tab and put the focus on the suspect.

You could now correct this control point by hand. But if you still have enough points remaining, it's barely worth the hassle. Just kill it by using the delete icon in the Control Points window.

In this example, it's pretty obvious that this point is just wrong because it doesn't even remotely correspond to the same object. Regular image patterns like this tiled floor can easily confuse automatic control-point generators.

After each change, go to the Optimizer tab and re-optimize your panorama. You can do that in simple and advanced mode. If you're not sure, choose simple. If you know what you're doing and you are sure that you have eliminated all false control points, you can choose Advanced

and optimize all parameters except Hshear, Vshear and Yaw for your anchor image.

Wavy horizons are most probably a combination of the preceding two problems. In this case, set some vertical control points, check if there are mismatching control points, and ensure that you include the optimization of FOV in the Optimizer tab. Control point creation is the central part of stitching a panorama. If you want a perfect stitch, plan on spending some time there because it will influence the quality of the output most of all.

Finishing the panorama

8 Go to the Create Panorama tab and check Enable HDR Stitching. There are plenty of options here, but don't worry! We only need to set these two:

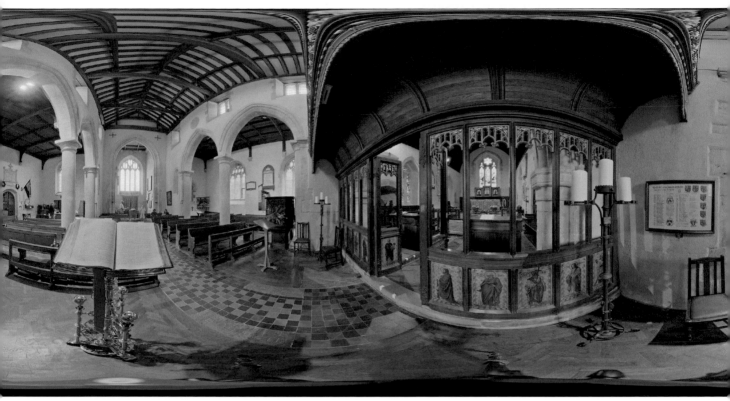

▲ **Final panorama**
tonemapped in Picturenaut

- HDR File Format: At the moment, the most supported image format is the Radiance HDR format. It can be read by virtually any software that is HDR-capable.
- Output: Blended HDR Output will give you the final HDR panorama in one file.

All other options can be ignored, and we can unleash the demon with the Send to Batch Stitcher button. The final processing is now happening in a background task.

You're done already. Your computer is not; it will have to chew on it for a while.

Workflow alternatives: If you want to use a different tool for HDR merging, you can do that as well. This is what the Blend Planes op-

▲

Rendering one pano per EV.

tion on the Create Panorama tab is for. In our example, this will generate five differently exposed panoramas, prealigned and ready for postprocessing. A panoramic bracketing sequence—isn't that great? Make sure to set LDR File Format to fit your postprocessing needs.

▲

PT Gui's integrated tone mapper.

6.4.8. Classic Workflow Type with Hugin

Honestly, this classic workflow isn't needed anymore.

I decided to include it here as a legacy technique that you can fall back on when necessary. It also reveals some secret trickery that will hopefully give you some ideas for solving any kind of problematic stitching situation. Besides that, Hugin is free and PTGui Pro is not.

We will start the same way we did in the modern HDR workflow: Arrange all images in a thumbnail viewer so that you can easily double-check your exposure brackets. If everything is cool, we will make HDR images first and then tonemap them.

As you see, PTGui Pro has come a long way. Never before has it been that easy to create HDR panoramas. And it builds on a long tradition to provide you with a complete toolset to solve even the worst stitching situations. In fact, it goes even further by offering a built-in tone mapper.

It's a simple and straightforward TMO that can process the panorama during the final stitching on-the-fly or can be used as a standalone tool from the Utilities menu. If you read Chapters 4 and 5, you're probably aware of all HDR processing and tone-mapping options, so I would recommend keeping them open and stitch your master as an HDR image. However, it's a nice shortcut to get an LDR proof copy right away.

Batch HDR merging: : Open Photomatix, select Batch Processing from the Automate menu, and navigate to the folder with the source images. Note that we may have to manually enter the number of brackets. Photomatix assumes three by default, but we have five in our example.

We will also create tone-mapped LDR images. We will need them for automatic control point creation, and if you don't care about a full HDR workflow, you may be able to continue further processing with these tone-mapped images.

Click the Run button and get yourself a cup of coffee. This might take awhile.

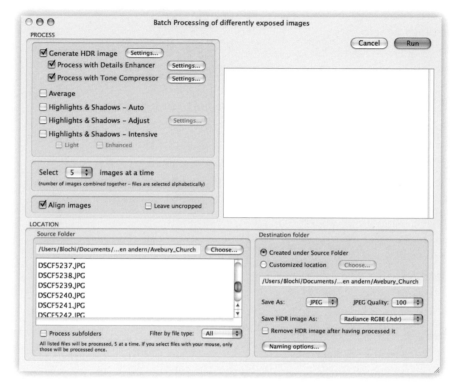

◄ Photomatix
Batch processing the LDR sequences
into HDR images.

When it's done, you will find a new subfolder called PhotomatixResults. It holds the HDR images as well as the tone-mapped LDRs. Examine each image closely for misalignments and ghosts. If something went wrong, redo that sector using HDR➔Generate from the menu. Try various generation options until you have the best possible result.

Batch tone mapping with Picturenaut: Photomatix is not the only software that can apply tone mapping to a stack of images. There are several others available, notably FDR Tools and Picturenaut, that have additional command-line tools. We can create a nice drag-and-drop workflow around those command-line helpers.

Let's have an exemplary look at Picturenaut to see how we can wrap the TMO inside a batch file. This method also works with every

other software that can be called from the command line and accepts command-line parameters.

Create a batch file—e.g., tonemap.bat. Wrap a loop around the main binary that shifts input parameters. The batch file will then look like this:

```
:loop
C:\Programs\picturenaut\hdri2ldri.exe %1
        %~dpn1_ldr.jpg
shift
if "%1" == ""goto end
goto loop
:end
```

All you have to do now is to drag all your HDR files on your tonemap.bat icon. Note, however, that this will only work for a limited number of HDR files at once (limited to 255 characters for one call).

Stitching the tone-mapped images with Hugin: Load Hugin and drag your tone-mapped LDRs into the main window, just as in PTGui.

For automatic-control-point creation, Hugin uses a helper software called Autopano. While this software will do a good job on normal rectilinear lenses, results for fisheye images will be somewhat disappointing. There is a little trick, though.

Open the Hugin preferences. You will find a tab called Autopano. Look for the section called Autopano (not the –SIFT one) and add another parameter at the end of the Arguments line: /ransac_dist:200. This will widen the search area where matching control points are expected. Don't hesitate to experiment with that value a little. It mostly depends on the scaled-down image size of your source images, defined by the parameter /size: (default: 1024).

Autopano is launched with the Create Ctrl Points button in the Images tab. A command-line window will pop up and you can see it do its thing. Afterward, Hugin will tell you that it has found several new control points and draws them in. Compared to PTGui, Hugin needs a bit more babysitting, though. Make sure to check the control points, tweak them, and add some more if we have too few. Ideally, they should be distributed pretty evenly across each seam. They should not cluster around a small area.

Now we proceed just as in the last section:
- Define some verticals to level and straighten the pano.
- Run the optimizer, first pass with positions, FOV, and barrel distortion (y,p,r,v,b) only.
- Inspect the result in the preview window.
- Call up the control point list, sort by control-point distance.
- Delete the worst of those buggers, or tweak them into a better match.
- Re-optimize.

Repeat those steps and keep refining the control point allocation until the optimizer gives you an average distance of less than 3 and a maximum distance not higher than 10. Usually, you should be done after three passes. On the last optimization, you can also try including the sensor shift—most sensors have a slight misalignment.

What we have now is a tone-mapped LDR representation of your panorama.

Maybe this is already what you wanted. In that case, you can stop here. All the cool kids keep going and create an HDR panorama, though.

Misdealing the cards: Save the project. We will now use it to stitch our HDR images. This is done with an ugly trick: Move the tone-mapped LDR images to another directory. Reloading the project will now force Hugin to ask for a helping hand to locate the missing images (figure ❶).

At this point, we boldly point to our HDR images (figure ❷) and voilà, we're back in the game with HDR!

Loading the HDR images will take awhile because a basic type of display tone mapping will happen. You can set the preferred display TMO in the preferences. These images, of course, will not be used to stitch the final panorama.

You may do some further panorama optimizations if you like, but basically we're done. All we have to do now is call the stitcher. Some minor pitfalls, though: The stitching engine has to be Nona and the output image format must be TIFF (figure ❸).

Click Stitch Now! and go for another cup of coffee. Expect your computer to eat up a decent amount of resources if you chose to create a high-resolution version.

Some miscellaneous hints

- You can also create the project file in PTGui or any other PanoTools-related software. Hugin will load it just fine. There is one exception, though, that you should be aware of: Cropping information does not transfer smoothly from PTGui to Hugin. This is because PTGui uses a "cutting" and Hugin uses a "masking" crop style. As long as you don't re-optimize your panorama in Hugin, you don't have to care about it. But if you want to, be aware that the position of the control points is affected by this different crop style and optimization will spoil your entire panorama. You will have to do the cropping in Hugin.

- Hugin can manage different lens groups within one panorama. That can come in handy when you shoot the panorama with a fisheye and the nadir with a normal lens after removing the tripod. That's not even restricted to physical lens types; it also includes equirectangular images. That means you can even insert a nadir patch into a previously generated panorama.
- It's a good idea to save the lens file from an exceptionally well-stitched panorama. This will give you a much better starting point for the future than relying on the EXIF data.
- To speed up processing the final, you should use the latest version of Enblend (the external blending software), and enable Cropped TIFFs in the preferences. Temporary files generated during the stitch process will now be much, much smaller. However, Photoshop cannot deal with these TIFFs, so you can't manually blend them anymore.

Hugin's panorama render settings.

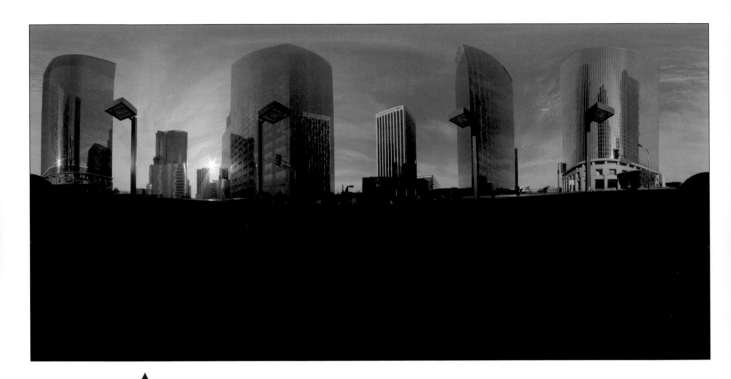

▲

A skydome is just a half panorama, from the horizon up. Typically, it looks like this.

6.5. Skydomes

What's that good for?

Well, the majority of natural daylight is usually coming from above. If the HDR image is intended to be used only for image-based lighting, we eventually don't even need a fully immersive panorama.

In architectural visualization, for example, it is a common practice to place a skydome around the scene. It looks like a big hemisphere, extending upward from the horizon. The CG model of the building is standing on a ground plane that covers up the lower half of the frame all the way to infinity. So we wouldn't see this part of the panorama anyway, and its light would be blocked by the CG ground plane. The same applies to many other situations in visual effects, cartoon animation, fine arts—wherever the scene is large and completely filled up with stuff.

Skydomes are not sufficient when only a CG element is to be inserted into a live-action background. Lighting on a film set always features components coming from below the horizon line, even if that is just the light bouncing off the ground. Those subtle but important nuances would be left out entirely. The second case where skydomes often fail are highly reflective CG objects. Think of cars, cell phones, or the silver surfer. Wherever a proper reflection is required to get the look right, a full spherical panorama should be preferred. And last but not least, our particular skydome technique is not suitable for making nice backdrops or matte paintings because there isn't enough resolution to gain here.

So, whether a skydome is sufficient or not is a case-by-case decision, dependent on the project itself. Despite all these limitations, skydomes have one huge advantage: They are fast, easy, and straightforward to generate.

▲ **Spirit level**
handy and cool looking.

◀

Watch your head!

Shooting fast like no other: You need a fisheye lens. The only catch is that the fisheye needs to be fully circular, meaning the entire 180-degree circle must be visible in-frame. That's a tough call on the camera too, because most DSLRs will crop that circle off. A qualifying setup would be a full-size sensor camera like the Canon 5D with a Sigma 8mm lens.

And now you just point that camera straight up. Since one shot is all we do, we have to aim very precisely. A handy accessory is a small spirit level that slides on the flash shoe.

A panoramic head isn't necessarily required because we don't have to stitch a thing. But it helps in keeping the weight of the camera centered over the tripod; otherwise, you loose quite a bit of stability. Also, not every ordinary tripod head will actually allow you to shoot straight up—that's just a highly unconventional angle.

Watch your head! It can be tricky shooting with such a wide angle. If you don't crouch

fully underneath the lens, you will be in the picture. Imagine the lens floating on an invisible water level and you have to dive under.

Dewarp and be done: Merge those exposures to HDR and save in Radiance format. Then bring it over to HDR Shop and crop the image down to the 180-degree circle, just as we did with the mirror ball.

Now call the Panoramic Transformations dialog from the Image menu. The magic setting is Mirror Ball Closeup for the source because this one actually means Fisheye. The distortion is identical. Call it a lucky geometrical coincidence, an excessive typo in the interface design, or just a clever way to fly under the radar of the iPix patent police. I'm sure the programmers had a good reason to relabel Fisheye distortion into Mirror Ball Closeup.

Also, we have to specify a 3D rotation. Click the Arbitrary Rotation button and punch in

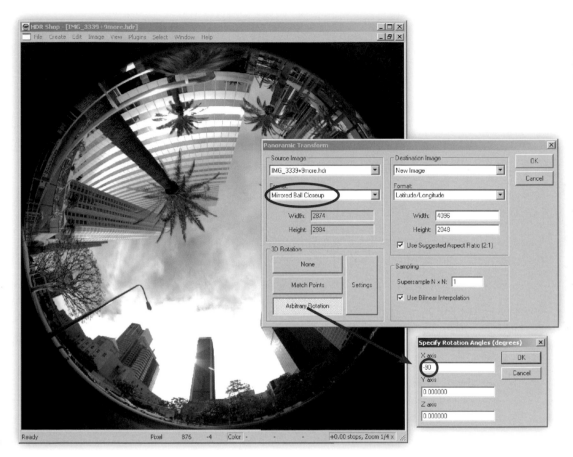

► 1-step unwrapping
in HDR Shop.

-90 on the X axis, which means we shot the image straight up.

That's it. The skydome is done. No stitching, no blending, no hassle. Including file transfers and HDR merging, that might have 10 mouse clicks, most of them on OK buttons. Can you feel the positive vibe?

As you see, the Sigma 8mm even gives us a little bit more than 180-degree field of view. We could stretch that image vertically just a little bit so the borderline is even below the center.

Rescuing a hurried shoot: This is supposed to be a speedy technique. Eventually, you don't even have the time to level out your camera

precisely to 90 degrees upward. In that case, you might want to use Hugin for unwrapping, just because it will give you the chance to fine tune the angle interactively.

This is how it goes:

❶ After merging, you drop the HDR image onto Hugin and it will ask you for the lens info. Make sure to point out that you used a circular fisheye.

❷ Then you crop that circle right in here, with Hugins circular cropping tool. Just draw the diameter across. The option "Always center Crop on d,e" should be unchecked if your fish-

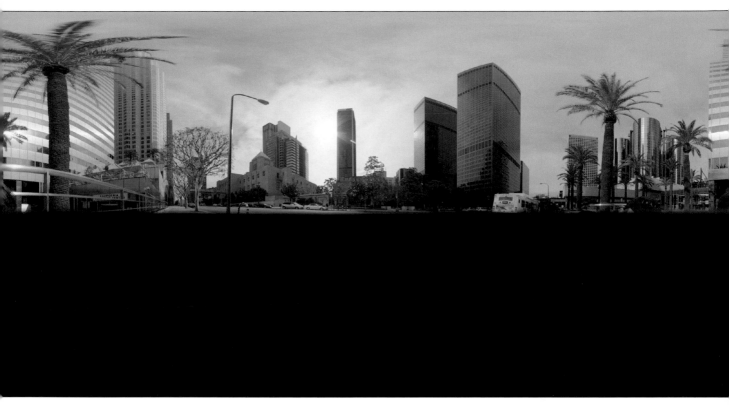

▲ Final skydome.

eye isn't precisely sitting in the center of the sensor. Most lenses aren't.

❸ Set initial Pitch to 90 degrees in the Image tab and open the preview window.

❹ Here we have a large crosshair, indicating the horizon and vertical centerline. The spot you click in the image will hop to that center. And with a right click somewhere, you twist the image around that center. If you stay close to the horizon, you can nudge it in very fine degrees and incrementally straighten everything out.

❺ To stretch the image below the horizon, increase the FOV in the Lens tab.

▲ ❶

Make sure to set the lens type right.

❻ Finally, you run the stitcher, but without any blending options enabled. It will spit out a TIFF Float file that you have to convert yourself to a more economical Radiance file or OpenEXR.

❷ ►
Hugin's curcular cropping tool.

The general workflow in Hugin is not as quick and dirty as in HDR Shop, but it's much more versatile. In between these two would be using the Flexify 2 Photoshop plug-in. Here you have a preview as well, and you can adjust the angular orientation conveniently with sliders. But they work only in full-degree steps. And there's no way to change the FOV right away. You're best off not screwing up the shoot in the first place and then just hurling it through HDR Shop.

▲ **❹** : Visually aligning the horizon.

	One Shot	Mirror Ball	Segmental Capture		Skydome
			Wide Angle	Fisheye	
Equipment needed	• SpheroCam HDR or Panoscan MK-3	• Mirror ball • two tripods	• Panohead • one tripod	• Fisheye lens • Panohead • one tripod	• Fisheye lens • one tripod
Total cost min/max (assuming you already have a camera)	$40,000 to $60,000	$100 to $200	$200 to $600	$400 to $1,200	$400 to $600
Number of sectors necessary	1	2 to 3	12 to 30	2 to 7	1
Geometric and photographic accuracy of the final result	●●●	●○○	●●●	●●●	●●○
Maximum resolution	10,600 x 5,300	Roughly equals camera res	Infinite, up to gigapixels	Circular Fisheye: camera res Full-frame F-Eye: 3 x camera res	camera res / 2
Shooting time required	Medium, 5 to 10 min	High, 10 to 15 min	Very high, 15 to 30 min	Medium, 5 to 10 min	Low, 2 min
Postprocessing time required	-	Medium, 30 min	Very high, 3 to 6 hours	High, 1 to 2 hours	Low, 5 min

6.6. Comparison

Let's wrap up this chapter with the all-too-popular score chart!

Which technique is the one is for you?

A **skydome** is created quickly and easily, so it should definitely be preferred when the requirements of the project don't call for a fully immersive panorama.

The **mirror ball** technique is very attractive for beginners and the casual user because it has the lowest cost and needs just a very reasonable effort for stitching and post.

Segmental capture with a **fisheye** offers a good balance of speed and optical accuracy, thus it is the recommended way for professional VR and on-set photographers.

Segmental capture with regular **wide-angle** lenses is useful for matte paintings and oversized prints because the resolution is literally open ended.

Purchasing or renting one of the specialized **one-shot** systems is the best option when ease of use and instant results are the major decision points and money is not an issue.

Chapter 7: Application in CGI

In the eighties, the term **computer-generated photo-realism** came up for the first time. It meant a believable picture of virtual objects; things that don't really exist in the material world. They are just made of geometric and mathematical descriptions, which are designed in a 3D application or scanned in. Rendering algorithms form the virtual counterpart of a camera and allow taking a snapshot of this data.

Calling it "computer generated" is a bit misleading because in the end, it is still a human who models the virtual objects and operates cameras and lights. It's still "artist-generated" imagery, the only difference being that all assets and tools are housed inside a computer. And whether those virtual snapshots are believable enough to evoke the illusion that we would be looking at a photograph of a real-world object depends on the artist.

7.1. Principles of Computer-Generated Imaging

Much has changed since the eighties when this was a visionary concept. As algorithms became more sophisticated, 3D programs have grown into the most complex applications on earth. These days they easily outnumber a 747 cockpit in the amount of buttons and controls. It's very easy to get lost, and that's why it is absolutely necessary for an artist to understand the principles of the algorithms behind these tools.

Modern times: CGI is simply great. Doing it is a hell of a lot fun, and for the photographic media in general, it is a huge relief. Finally, film and photos are released from the chains of the material world, and the bounds of what is presentable are extended out into the realms of imagination. CGI has injected a creative potential here that used to be reserved for painting and literature. Mystic fairy tale creatures, imaginary landscapes, and purely fictional storytelling have rejoined the fine arts because they are finally available in the predominant media of our times.

Nowadays, CGI is used on a daily basis to extend film sets, advertise products that haven't been made yet, and perform dangerous stunts via virtual stunt doubles. Directors and writers are fully aware of all the possibilities, and they surely enjoy the new freedom. They trust the artists to create anything they can imagine, and they simply expect seamless integration with live-action footage. Photo-realism is the standard, not the exception anymore. That even counts for episodic television, where a new show has to deliver as much as 20 special-effects shots every week. You'd be amazed at

▲
2004 episodic TV show on a teenager community in a beach house

▲
... except there never was a beach house. Done all digitally by EdenFX.

how much you see on TV that is actually not even real.

The bar is set high on the big screen, and even in feature-film production the trend is moving toward demanding perfect quality in less and less amount of time. Now here is an

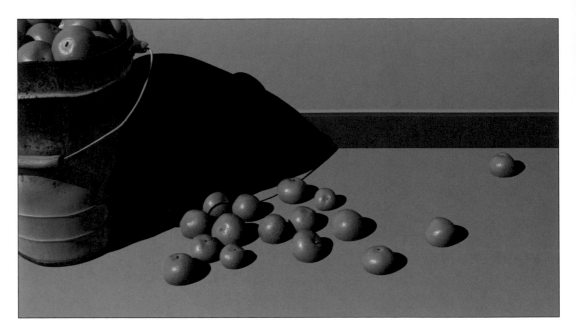

important fact about the time necessary for creating a visual effect: It's divided up into the time required for rendering (machine time) and the time required by an artist to create the scene and set everything up. Machine time is an asset that is easier and cheaper to extend, whereas artist time is not an endless resource. At least it shouldn't be seen that way, and companies that do see it that way are having a harder time finding good artists. The trick is to balance those two factors by utilizing advanced techniques for the creation process and rendering.

So, let's talk about rendering techniques with an eye on these two restraints: machine time and artist time. You'll see that there is a fundamental difference between classic rendering and physically based rendering.

7.1.1. Classing Photorealistic Rendering

In classic rendering, it doesn't matter how exactly the image is done, as long as the final result looks photo-realistic. Typical rendering methods in this class are **scanline** rendering and **raytracing**. They are both based on simplified shading models like Phong and Blinn, and the general term used to describe the lighting model is **direct illumination**.

As diverse as the implementation might look, they are all built on the same foundation: Light sources are defined separately from geometry, and they can have properties that would be impossible in a physical world. For example, point lights are defined one-dimensional items, which means they are simplified to an infinitely small point in space without any physical size whatsoever. Also, the way light spreads out in 3D space is often characterized with a linear intensity falloff in contrast to the physically correct inverse square law known since Newton. Another popular light definition is parallel light, shin-

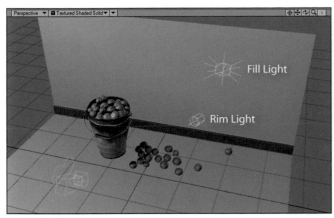

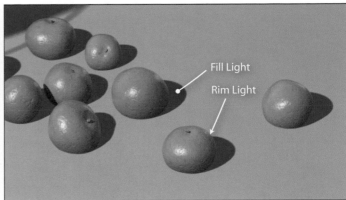

▲ ❷ : Fill and Rim lights are common standard additions.

ing from an infinite distance at the scene with constant intensity all over. Or take ambient light, which supposedly comes from nowhere and brightens up all surfaces equally. All these definitions are abstract models, with the purpose of simplifying the calculations and reducing the machine time necessary.

Faking it all together

❶ Here is a simple example scene. Initially, it doesn't look anything near photo-realistic.

❷ It takes a lot of time and effort to create a believable lighting situation by hand. The first step is usually to fuzz up the shadows and add a colored fill light. Then we have to take into account light bouncing off the wall, reflecting back onto the oranges. So we place a rim light that doesn't affect diffuse shading and doesn't cast shadows at all. It only generates a specular highlight. These two lights are pretty much standard procedure.

What's harder to do is the subtle effect of blocked light in crouches and corners. A popular trick is to distribute negative lights in strategic areas.

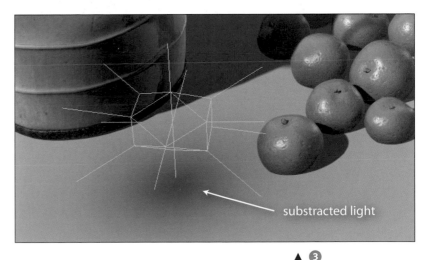

substracted light

▲ ❸
Negative lights eat light away.

Negative lights

❸ I know - you're probably wondering what the heck a negative light is. Well, if you set the intensity of a light to a negative value, it will subtract light from the scene instead of adding it.

Essentially, it is an independent soft shadow that can be simply placed anywhere. For that to work properly, shadows and specular have to be turned off and it should have a small falloff radius that keeps it local. Eventually, its influence also has to be restricted to particular objects.

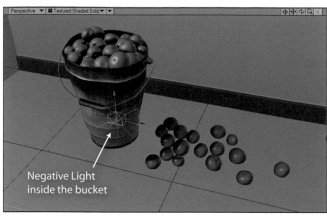

▲ ❸ : Strategically placed negative light.

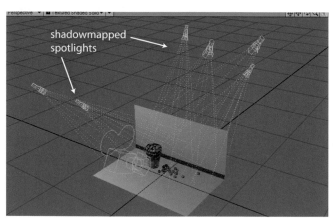

▲ ❹ : Shadow-mapped spotlights.

Shadow mapping

❹ You could also make soft shadows by using several shadow-mapped spotlights. Shadow maps are generated before the actual rendering and can be artificially smoothed out with a blur factor. When you shine a bunch of them from different angles, these shadows blend into each other and become even smoother.

Textures and ramps

❺ But it still doesn't look real. It's missing the bounce light that reflects off the red trim. Some of that should be thrown back onto the

ground and casting a reddish sheen right next to that corner. So we have to pull another stunt. Lighting trick number 3 is to paint that effect into the texture of that object. That could be done in a paint program or directly within the 3D application by using gradients (a.k.a. ramps).

A gradient has a center and a falloff. In this case, the falloff is set to a simple Z direction. By placing the centerpoint right in that corner, this is where the maximum coloration will happen. After one meter, my gradient becomes transparent and the coloration falls off.

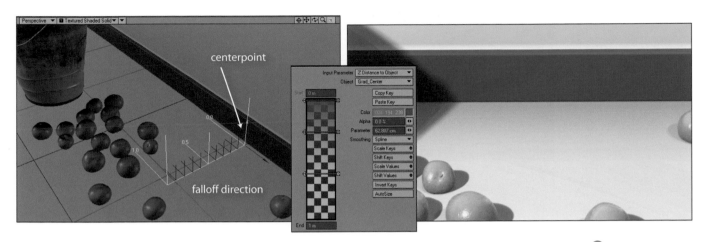

▲ **5**
Textures and ramps.

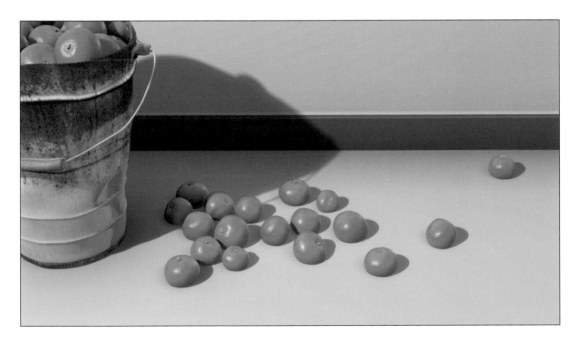

◄ **6**
Final with manual
lighting setup.

6 After a couple more gradients and negative lights the scene looks like image **6** .

That took me about 3 hours to set up, but it rendered in 3 minutes. More experienced lighting artists are faster. But it's hard. All the subtle nuances that are just inherent in real-world lighting have to be interpreted by the artist and manually created in some way. It's

tedious work—and not everybody's piece of cake.

All 3D packages that are commonly used in production are initially based on this principle. Their user interfaces are always built around their particular render engine, and all those thousands of buttons and sliders are there for the user to find just the right settings to make

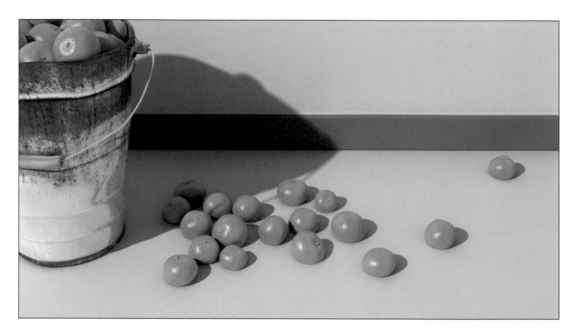

7 ▶
Rendering with
radiosity.

the cheat work. Photo-realism is possible with
all of these programs, provided you know
your render engine in and out and have the
experience to use the most abstract light defi-
nitions to your favor. It also requires a strong
painter's eye; you have to be aware of all the
subtle effects that a regular person might
not even notice. But people would notice for
sure when that "certain something" is miss-
ing, even though they couldn't describe what
exactly it is.

However, this approach has two major ad-
vantages: It renders incredibly fast, usually
close to real-time. So you have all the feedback
you need. And you have total control over the
result. Similar to painting, you simply do what
looks right to you, not what is physically cor-
rect.

7.1.2. Physically Based Rendering
On the other hand, we can simulate light be-
havior strictly according to the laws of physics.

For image **7** , it took me just the flip of a
button to turn on **global illumination**. GI is
the collective name for a variety of physically
accurate rendering methods.

Radiosity: One example that is already con-
sidered a classic approach is radiosity. Here
the entire scene is divided in small patches,
varying in size depending on corners and
roundness of the geometry. Then the received,
absorbed, and scattered amount of light is
computed for each patch. That's done by
shooting a number of rays into each direc-
tion. Essentially, it will render a small fisheye
image—the median brightness and color of
this crude fisheye rendering determine the
received amount of light.

Now we just have to look at the material
settings to see which colors of the light are
absorbed and to what extent. We'll subtract
the absorbed light from the received. What's
left is the scattered light, which is the optical

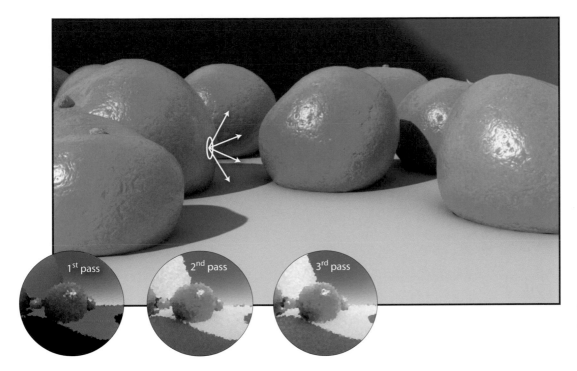

1st pass 2nd pass 3rd pass

◄

Radiosity repeatedly fires a number of rays to determine the indirect illumination

property responsible for the appearance of the patch in question. This step gets repeated, but this time the scattered light from the pass before is taken into account. Essentially, each patch can see the current appearance of the others in the small fisheye renderings. That means that each of these iterative passes delivers one additional level of bounce light. It usually takes about two to three bounces until a fairly comprehensive model of light distribution is formed—the radiosity lighting solution.

It's a pretty slow process. Sophisticated stochastic formulas, using what is known as the **Monte Carlo** method, are used to predict the optimum patch size and placement. The name itself hints at the fact that this is mostly a guessing game; in technical programmers' terms it is called Russian roulette. And since

the name is so cool, this type of GI is often referred to as Monte Carlo radiosity.

Photon tracing: Another approach to global illumination is photon tracing. Here the light is split up in defined quantities of photons and we follow their path as they bounce around between the objects again and again. With each collision, some of these photons get stuck to the geometry. The others keep bouncing until eventually all photons are used up or a predetermined number of bounces is reached. This is done as a separate calculation before the actual rendering, and the final distribution of all photons is collected in a photon map.

The principal advantage over Monte Carlo radiosity is that Photon tracing doesn't slow down as much with each additional bounce because the photons get used up more and more. So for calculating the fifth and sixth

► Photon tracing lets light particles bounce around like Ping-Pong balls.

bounce, there is only a handful left. When these photons travel through glass, they can change the path according to the refraction index, so we get beautiful caustic effects for free. On the flip side, photon tracers have harder-to-work-on large scenes and tight corners. It's like throwing a handful of Ping-Pong balls into your apartment—chances are quite low that they will land inside the coffee cup across the room. In order to increase the odds of reaching that far, you'd need to throw high amounts of Ping-Pong balls (or trace a lot of photons).

The most popular photon tracer is probably mental ray; other popular render engines incorporating this principle are Brazil, Finalrender, and VRay. Some GI algorithms even consider light as a wave, and instead of limiting the calculations to RGB components, they calculate the physically correct wavelengths all across the spectrum. Maxwell and Indigo, for example, are engines capable of such spectral rendering.

The basic premise of them all: One important basic principle is common to all global illumination renderers: The strict distinction between objects and light sources is abolished. Lights are just luminous objects themselves, and when an object is illuminated brightly enough, it starts to act as a light source on the rest of the scene again.

Ten years ago these kinds of simulations could only be found in specialty software for spectral analysis, lighting design, and architectural planning. For purely artistic purposes and commercial animation work, these calculations were way too elaborate and the software much too specialized. Even though pioneering programs like Lightscape and Radiance were able to render that way, they needed hours or days for one image and they had to be operated via command-line scripting.

Today that's a whole different story. All traditional 3D applications offer a global illumination mode now. Several simplifications to the algorithms make it work in a production

◄ Bright objects automatically illuminate the scene.

▲ Reflection is the physically correct way to render specular highlights.

schedule. In some cases, the simulation was built on top of the classic render engine—for example, in LightWave or Cinema 4D. That makes GI appear as fully integrated, and it is operated by the same controls that were originally designed for the classic engine. In other programs that where built in a modular architecture to begin with, the render engine can be swapped out entirely. Maya, 3ds MAX and Softimage are such modular programs, and they've all got mental ray implanted. After such a surgery, the user gets presented with an all-new set of controls and the old settings for the classic engine disappear or become invalid.

Handling the simulation: To many artists, the GI mode appeared as yet another new feature. With such seamless integration, it's easy to forget that GI resembles an entirely different way of rendering that doesn't affect only lights, but material definitions as well.

One common misconception is the role of specular material parameters. They used to be the way to define glossy materials, but they have absolutely no influence in a radiosity simulation. That's because they were a cheat to begin with. In the real world, highlights are the reflection of light sources. But since classic raytracing cannot follow a reflection ray to a one-dimensional point in space, a reflected light cannot be computed that way. Specular is just a hack to get by this limitation, allowing precise control over the brightness and spread of an artificially painted-on highlight.

In a simulation environment, however, objects and lights are all one thing. Lights do have three dimensions now; they have a shape and they can be reflected. Reflectance is a much better-suited material property to model highlights simply because reflection is the real-world physical phenomenon causing highlights. Whether such highlights show up as a sharp sparkle or a smooth sheen was traditionally defined with a glossiness or

IBL ▶
All the lighting comes from the panoramic HDR image.

IBL ▶
Swapping the HDR image changes the entire lighting.

highlight spread parameter. These parameters are invalid again, they only apply to the old painted-on specular hit. Instead, we set the roughness of the surface accordingly or use reflection blurring—just as in the real world.

7.1.3. Image-Based Lighting (IBL)

You might have guessed it by now: When traditional lights are substituted with luminous objects, there is a huge potential to make use of HDR imagery. Remember, HDR images are **made** to conserve real-world light, accurate in intensity scale, as well as color. Surrounding a 3D scene with an HDR environment literally casts natural light into the virtual world.

Now, this is kind of a paradigm shift. Lighting the old-school way took some seriously talented and experienced artist just to get it to look photo-realistic. Shooting and applying an HDR environment is more of a technical achievement. It's a craft that everybody can learn, right? But does that mean there is no more need for skilled artists? Where is the fun in making a scene look great by applying some obscure set of HDR data? Where is the creative challenge? And most importantly, where are the levers to pull if you actually **are** talented and you want to take control over the look and feel of the final result?

Well, consider this: Traditional lighting is a craft as well. It's not just artistic talent. Tons of books out there teach it in step-by-step tutorials. It's just that with HDR lighting, photo-realism is the starting point instead of the goal at the end of the tunnel. So you can spend more time working creatively on the intended look. Traditional methods can get totally mixed in, so all the old tricks remain

valid. And it also throws up a new challenge: optimizing a scene so it can be rendered within a reasonable time. The truth is, while basic HDR lighting is set up with a few clicks, render times for global illumination can go through the roof. Creative tweaking needs feedback just so you can try things and take the scene though a couple of variations. And we're back to the topic of finding a good balance of machine time and artist time.

However, let's not rush it. Let's first take a look at the straightforward technical craft and then find out where the playground is and how to bend the rules to our favor.

7.2. Brute Force Simulation: A Feasibility Study

This technique was pioneered in 1998 by Paul Debevec and Greg Malik. In their SIGGRAPH presentation "Rendering with Natural Light," they demonstrated quite impressively the basic principle by pumping up the Radiance render engine with a lot of custom code. Five years later, in 2003, we asked the questions "How far has IBL trickled down to commercially available software packages? Can it be used in production without writing a single line of code? Is it ready for prime time yet?"

So, let's find out!

Our case study takes a look at the most basic approach to IBL. By basic, we mean that the pure untreated HDR image is the only light being used—no artificial lights whatsoever. No optimizations, no cheating, no tweaking! Just brute force global illumination.

This scene might not look too exciting by itself, but it represents some interesting challenges. We have strong backlight from a large window showing up in reflections and high-

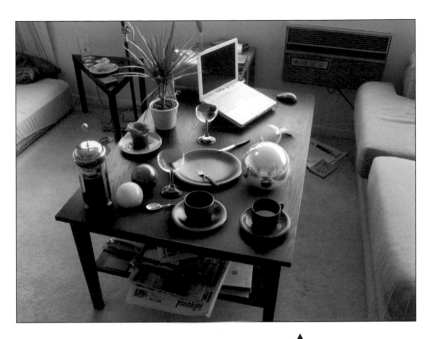

▲

My apartment is the test ground for a brute force radiosity rendering study.

◄

Map of the objects that aren't really there.

lights. So we really need to take care of reflective material properties, formerly known as specular components.

The basic ingredients: The starting point is a background photograph with the empty table.

I placed my trusty mirror ball in the center of the table and shot an HDR environment. If you read section 6.3, you know exactly how this image was done.

▲ Background photo.

▲ HDR environment.

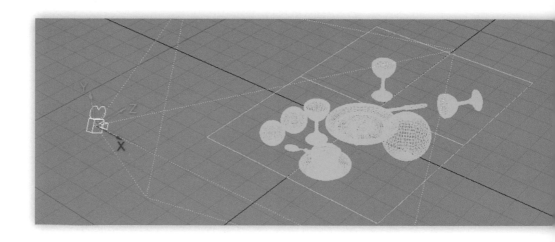

►
Some simple 3d objects.

Then I modeled some simple objects to populate the table.

Note that the coordinate system is anchored right in the spot where the mirror ball was placed. That's the 0,0,0 coordinate—the center of our 3D universe—from where the sampled lighting stems. The farther we move an object away from this point, the less accurate our HDR environment will be.

Where does the environment go? Good question. You could map it on some ball geometry. But that would be highly inefficient; we would be wasting one global illumination bounce just

on that ball. To simplify things, each renderer has a special slot for that HDR image, called environment material, texture environment, or something like that. In each case, that will simulate a ball of infinite size surrounding the scene.

Eyeballing the camera: Now it's time to match the camera perspective. It makes our life a whole lot easier to start off with the same zoom setting as the real camera. For that we need two numbers: the film size and focal length.

EXIF Filebrowser

Camera Settings

Lens Focal Length | 7.4 mm

Aperture Height | 0.189"

Zoom Factor: 3.06 FOV: 47.09° × 36.19°

Max Aperture Value 3.0
Metering Mode Pattern
Light Source Unknown
Flash Did not fire.
Focal Length 7.4 mm
FlashPix Version 0100
EXIF Color Space sRGB
Pixel X Dimension 2048
Pixel Y Dimension 1536

EXIF

Super 8 motion picture
16 mm motion picture
35 mm motion picture
Super 35 1.78:1 (3 perf)
Super 35 1.78:1 (4 perf)
65 mm Super Panavision motion picture
65 mm Imax motion picture
Size 110 (pocket camera)
Size 135 (35 mm SLR)
Size 120 (60 x 45 mm rollfilm camera)
Size 120 (90 x 60 mm rollfilm camera)
1/3" CCD video camera
1/2" CCD video camera
2/3" CCD video camera

Film Size Presets

◀ ❶
Camera Settings.

❶ Film size defines the crop factor, and it's easy to find in the camera's manual. And since this background is a shot with a digital still camera, we're fortunate enough to know the focal length from the EXIF data. If that would be a real-world effects shot, we would now rely on the notes that our buddy the VFX supervisor took on set. That's one of his many important responsibilities: taking notes on lens information for each shot. If he were busy chatting with that makeup girl again, we would need to have a serious talk later but for now we just stick to our best guess.

❷ Once we have the zoom level right, our 3D camera automatically has the same field of view as the real one. Now it's quite easy to match. A perspective grid is a helpful reference, and even better is some rough geometry that indicates the significant perspective lines. In this example, we just move and rotate the camera around until the virtual tabletop sits right on top of the real table.

Camera View

▲ ❷ : Matching perspective.

▲ ❸ : Close-up of the virtual objects inserted.

❸ This is supposed to be a case study, not an artistic masterpiece. So the objects were mainly chosen for technical reasons. We have a big mirror sphere, which allows quick evaluation of brightness, orientation, and mapping type of the HDR environment. This is a common trick and highly recommended because it makes it so much easier to set up a scene with HDRI. Usually, you'd just make it invisible for the final rendering.

Also, we have two material test balls on the left, representing a perfectly smooth and a slightly dull object. The wine glasses are there to find out if the renderer handles transparency and refraction right. Because those are usually computed via raytracing, this is questioning how well the radiosity and classic render engine go hand in hand. And just to be mean, we put a fake coffee cup right next to the real one. Nothing could be harder because even if the coffee cup looks photo-realistic by itself, it still has to stand the comparison with the reference. Now, that is a nice little challenge!

Volunteers wanted: To test that scene in a wide variety of 3D packages, this study was then conducted online. Christian Bauer provided a testing ground on www.CGTechniques.com, where we initiated the "HDRI challenge" as open forum. The scene was converted into all kinds of standard formats and provided for free download, together with the background and HDR environment image. Then we invited artists from all over the CG community to get their hands dirty and put their tools and talent to the test.

The response was overwhelming. Within the first month 200 volunteers participated by posting their results.

It turned out that the basic idea works in all of the leading packages: Maya, 3ds MAX, Softimage XSI, LightWave, Cinema 4D. A direct comparison of render times wasn't really feasible since every image was rendered on a different machine and the quality settings between packages are simply not comparable.

What we really learned from this: Much more interesting were the discussions on setup techniques that started in the forums—for the first time between users of different software packages. It turned out that a lot of optimization tricks apply equally to all programs. Some other render tweaks could not be transferred so easily. Apparently, the software makers also watched this HDRI challenge, and so it just happened that the next update of several render engines delivered some of the missing features.

In retrospect, this project could not have been a bigger success. Intercommunication was the key element, and by now it can safely be said that all renderers can deal with HDRI equally well, and they all stumble into similar problems that need to be addressed.

Brazil/3dMAX
Image by Saeed Kalhor

Cinema4D
Image by Christopher Bahry

Mentalray/XSI
Image by ZePilot

Lightwave
Image by Christian Bloch

Mentalray/Maya
Image by Terry Riyasat

V-Ray/3dMAX
Image by Wouter Wynen

▲ Some selected entries for the HDRI challenge.

If you want to give it a shot yourself, pop in the DVD, load up the scene file, and dissect it yourself! The cool thing is that once the scene light has been set, you can drop anything on that tabletop and it will look just right!

▲ A herd of two-legged camels invading my apartment.

7.3. Advanced Setup Techniques

You might have noticed that all the former screen shots and example renderings were skipping the most important part: How the HDRI setup was done in detail. So far I have only proven that it works. Now we're going to look at how it works efficiently.

Now, what I am not going to do is show you screen shots of buttons to push in Maya/3ds MAX/XSI... rest assured that they are there somewhere; you will have to consult the manual to look them up. I will show you the methodology so you know what to look for. Myself, I'm using LightWave, but the techniques apply everywhere.

7.3.1. Keeping It Straight
One particular question seems to be popping up over and over again.

Why do my HDRI renderings turn out so dark? The issue is that you are looking at a naked linear image.

For illustration purpose, let's place the XYZ RGB dragon scan from the Stanford 3D Scanning Repository in front of the Grauman's Chinese Theatre.

There is absolutely nothing wrong with image ❶ . It simply hasn't been tonemapped yet. That might sound like a broken record, because you have read precisely the same thing over and over again in Chapters 3 and 4. In the simplest form, we just apply a 2.2 gamma and we're fine (see ❷).

That was the quick and dirty fix. However, it's not always that easy. Once you start using texture maps, they will flatten out and lose all contrast (see ❸).

So we have to dig a bit deeper.

The root of the problem: We're looking at a fundamental color management issue here.

Remember that HDR images are linear by nature, but 8-bit textures are not. All 8-bit imagery has a gamma value burned in, which has the effect of distorting the intensity levels toward the bright end. In section 1.4, the difference is pointed out in detail. What it boils down to is that HDR and LDR textures don't mix well. It's not the fault of HDRI; it's our old textures that have always been wrong.

Wow. What a bold statement. How come we never noticed?

It went unnoticed because in traditional rendering, we are used to cheating anyway, and this is just one of a million false assumptions we start off with. This was not the worst one.

But when it comes to physically based rendering, it does make a big difference. GI simulations are done strictly in linear space

▲ **1** : Straight linear rendering.

▲ **2** : Post-gamma adjustment.

▲ **3** : Rendering with texture maps and post-gamma adjustment.

because that is what reality is like. An HDR image fits right in. When the image is done rendering, you have a physically correct model of the lighting conditions. It's all linear like the real world, linear like a RAW file. To see it on a monitor, we have to add the gamma encoding or, even better, tone-map it properly. It's exactly the problem that the first half of this book talks about. When you simulate reality, you have the same troubles real-world

photographers have. Or better said, you have the same opportunities.

Now, let's just assume a gamma is all that is added to take a rendering from linear to screen space. What happens to an 8-bit texture that was used in the scene? Exactly—it gets another gamma boost. It was the only part in the equation that already had the gamma in it, and now it will be doubled up. The texture becomes flat and loses contrast. But

▲ ❹ : Linear rendering with LDR textures left in gamma space.

if we don't add the gamma to the output image, the HDR images will be left in linear space (see ❹). The 8-bit texture might be fine, but everything else is wrong.

Can you see the problem? We have to consolidate all our input images to be either linear or in gamma space. Otherwise it will look wrong either way. At this point, the road splits into two possible workflows: **a linear workflow and a cheater's workflow**.

Linear workflow: gamma out of LDR images!
We convert all texture images to linear space. This is the **right** way!

Basically, it's the same preparation that was necessary for merging an HDR image from LDR input images. In a perfect world, you would know the response curve/color profile/LUT of the image source and would find a way to apply that in your 3D package. Unfortunately, we don't live in a perfect world. None of the 3D apps take color management that

seriously. Currently, all we can do is apply the inverse of whatever gamma is in an image, and we have to rely on our best guess what that would be. Mostly, 2.2 is in the ballpark, so applying a gamma correction of 1/2.2 = 0.455 would roughly linearize it.

How much work that is depends:
- 3dMAX automates this task by enabling Gamma Correction in the preferences. In modo, this is already set up by default.
- Adding a gamma node in the Hypershade (Maya)/Rendertree (XSI)/Nodal Editor (LW) is the most precise way since the texture has already been taken into the domain of the floating-point engine.
- Adding the gamma correction in the Image Editor (LW) is less accurate because it will only work within the original bit depth of the image. There will be some degrading happening, especially to the darks. However, it is more convenient than making all surfaces nodal.

▲ Linear workflow
All input images are consolidated in linear space first.

▲ Linear workflow
A post gamma is applied to the final rendering, and everything is perfectly in sync.

- The worst case scenario is to convert each texture externally to 32-bit and save it as EXR. Photoshop and Picturenaut will automatically strip the gamma that was set in the color profile; in HDR Shop, you will have to guess again. This option is not very advisable anyway because it will quickly exhaust texture memory.

 Now we can go ahead and render, and everything is perfectly synced up in linear space. The final image will still be linear—a proper HDR image. Now we can safely put the gamma back in, and we're done.

Sounds complicated, but this is precisely how it's done in high-end VFX production. Working in linear space has even been a topic long before the advent of HDRI. It fits the natural behavior of light like a glove, and it is the main secret for getting better shadow details and more natural shading. I strongly recommend doing a Google search for "linear workflow" and then reading up on exactly how it works in your application. There are several helper scripts floating around that automate the tedious conversion tasks.

▲ Cheaters workflow
All input images are assumed to be in gamma space, and the rendered out is left as is.

However, it's still a lot of hassle. If there are 100 textures used in a scene, you strip that gamma off a hundred times. At the same time, there is no more eyeballing allowed; you will have to use true physically correct settings for everything. What used to be 50 percent gray before now has to be set to 18 percent, the real-world value.

And you won't see your final image before the post-gamma has been applied. This is a major roadblock for people who prefer to work in a "What you see is what you get" fashion. OpenGL will be pretty much useless (unless you're using modo), instead you'll have to set the 2.2 gamma boost in the frame buffer settings of your render engine and preview render everything.

One step further: Applying that post-gamma directly in your 3D software isn't always the best idea either. It might be suitable for saving it down to an 8-bit image. But since we want to keep all the floating-point precision as is, we're much better off saving it as EXR and leaving it in linear space all the way through the compositing stage. Then you can take your time for a bad-ass color correction, slide the exposure up and down, get photo-realistic motion blur, and do all the funky stuff that working in 32-bit FP allows you to. You know the deal.

Cheater's workflow: gamma into HDR images! There is a convenience in having the textures already come with a gamma. It fits the old-school way of doing CG, where everything is done by rule of thumb and you simply cheat

your way through. Using HDR images for lighting requires a little cheating as well.

You just have to be aware that it will not be the straight physically correct rendering anymore. Instead, you bring only some aspects from that into the world of the classic eyeballing approach. You do something absolutely obscene: You add the gamma to the HDR image! By doing so, you bring all input images into gamma space. All lighting and shadow effects from the rendering process will still be happening in linear space, and in the end you have a weird hybrid.

Technically, it's all wrong, but at least it will be **consistently** wrong. During each step, you see what you get. Interactive preview renderers will show you when it is too wrong and you can tweak it manually. To compensate for shadows getting too dark, you add some extra fill light or ambient light, for example.

Since this is a hack to begin with, there is no fixed gamma value that you apply to each HDR image. You merely have to work it out yourself: just high enough that it visually doesn't have too much contrast, but low enough that it still pumps enough light into your scene.

Because gamma is a two-sided sword: It pivots around the white point (or what appears to be the white point on-screen). That means it will not only pull up the midtones, it will also push down the overbright areas. But we need these über-white values; they are what make up the vivid lighting of HDRI. So a good gamma value is somewhere between 1.4 and 1.6. If that still looks too dark, you may go up to 1.8, but anything above 2 flattens it out entirely. Instead, you'd better give it an overall intensity boost to keep the lights up where they belong. And that will commonly cause

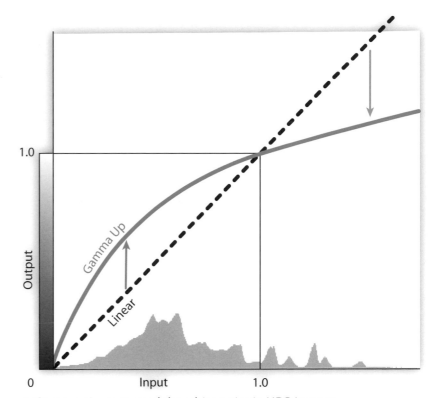

▲ Gamma pivots around the white point in HDR images.

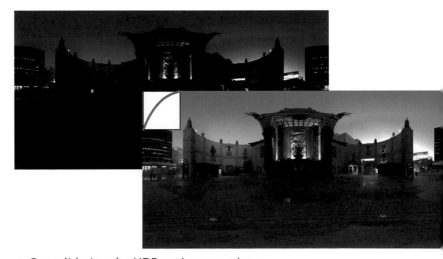

▲ Consolidating the HDR environment into gamma space means playing with gamma, exposure and saturation.

The Beauty pass
90 percent there already, but not quite photoreal yet.

the saturation to go up as well, so this is another thing to be countercorrected.

In short, you would simply adjust Gamma, Exposure, and Saturation to your taste.

Yes, it is just like tone mapping, except you're tweaking the lighting for the effect it has on your scene, not for the HDRI to look pretty.

And how would we do that? Well, there are the same options again. In LightWave that would be the Image Editor, and in Maya and XSI you would add a Gamma node to the environment material. If there is no other way, there is still the possibility of burning these adjustments right into the file with Photoshop. That is the weakest alternative because it will screw up the HDR image for everything else.

Nevertheless, some commercial HDR image collections come pretreated with a gamma. You can easily tell when you open one up in Picturenaut and it looks all washed out.

7.3.2. Compositing Is Your Friend

Were the previous sections too tech-savvy for you? Is your head spinning from gamma in and out and twice around the corner, just to get back to where we were? Mine certainly is.

By the end of the day, we just want to paint pretty pictures. CGI shouldn't be like rocket science. It's not all about the perfect simulation of reality. All we care about is getting the subtle effects of global illumination. In fact, when you look at it with an artistic mindset, you might want to bend the rules of physics and take control over every single aspect.

Artists are also very impatient. Changing a number and waiting for a full new render to finish simply kills the creative flow. Whatever you do in 2D will always be faster than 3D.

Keep your render buffers! Each renderer is able to spit out more than just the final rendering. In fact, there is an enormous amount of internal render buffers available: Plain RGB color, diffuse shading, shadows, reflections—

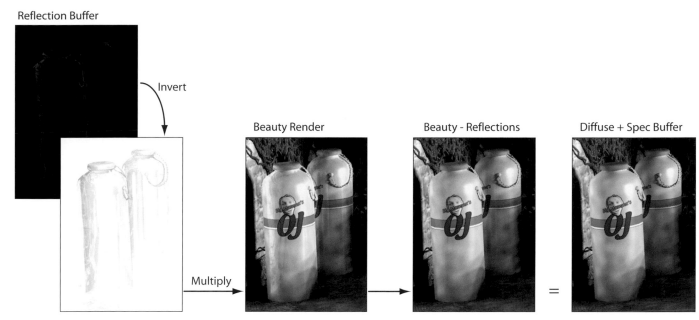

Reflection Buffer

Invert

Multiply

Beauty Render

Beauty - Reflections

Diffuse + Spec Buffer

=

▲ ❷ : **Backwards compositing**
Using the Reflection buffer to substract reflections
from the Beauty pass.

the list goes on forever. Photographers would give an arm and a leg for that kind of magical camera. If you'd want to micro-manage, you could export them all and rebuild the final output from scratch. In fact, that's what most books teach you on this topic. You'll get 100 percent flexibility in post when you break it all out and then puzzle it back together. But it also can become quite tedious.

That's why in regular production it often makes sense to get it close to the final look right away. This will be your "Beauty" pass.

By the way, there are about 30 textures in that scene, and I was already too lazy to set it up in a linear workflow. It's definitely in the ballpark, but not quite photo-realistic yet. The idea now is to use render buffers to beef it up. Not wasting any time to break it out and rebuild it, but rather to go forward from here. You might wonder, aren't we losing flexibil-

ity then? Well, yes, but not as much as you'd think.

Compositing in 32-bit precision is changing the rules.

Tweaking reflections: Take the Reflection pass, for example. Obviously we can use it to boost reflections by adding it on top of the Beauty pass. But we can also go the other way and tone them down. The trick is to invert the Reflection pass and multiply it from the Beauty pass. It's effectively the opposite of a boost; it subtracts what has been previously added by the render engine (see figure ❷).

For comparison, I have put in the classic forward composite next to it. It boils down to the same result. So, why would that backward approach be better now?

Well then, let me show you the juice (figure ❸).

Beauty Render

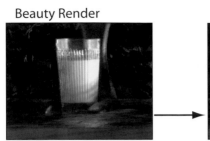

Beauty - Reflections

Diffuse + Spec Buffer

 ▶

▲ **Ambient Occlusion pass** pure geometric poetry.

Apparently, I would have to render the glass separately again to get that forward composite working. And then I also would need what's behind the glass... Bear in mind that this is not the most complicated scene in the world. The more stuff you have in there, the more you have to rebuild. But I don't want to end up with 20+ layers just to tone down reflections. Don't need that. Rendering passes were supposed to make my life easier, not complicate it. That's why it is often a good idea to take the ready-made output as starting point and work backwards from there. You'd basically want your passes to be a safety net, handy to fix certain aspects only.

Ambient occlusion—a pass like a poem: Let me confess now: I've fallen madly in love with ambient occlusion. It's simply the most beautiful pass of them all. AO makes everything look so innocent and untouched. Makes me wanna cry.

At first glance, it looks just like radiosity. But it's not. It's much simpler. Ambient occlusion is based purely on geometry. The tighter a corner, the darker it gets filled in. Materials, lights, reflectance properties, none of those matter. No colors bleed into their surroundings, no light is bouncing around. Only nooks and edges. That's all it is.

Eventually, that's all we need. Simple is good because it renders fast and is very predictable. And it makes even the cheapest traditional rendering look great. It can be multiplied or burned in, on top of everything or just underneath a key light pass. You can even use it for simulating a first order bounce by using it as the alpha mask for a high-contrast, blurred-color pass. Just play with it, and you'll find a million applications.

Ambient occlusion is always worth a shot. Even though my Beauty pass with two-bounce radiosity is much more physically correct, kissing in a slight AO with "Soft Light" blending mode does something nice to it. Makes it somewhat more vivid, more crisp.

Beauty with Ambient Occlusion

▲ ❹
Kissing in some ambient occlusion with Soft Light blending mode.

▲ **Depth buffer**
ramps near to far as black to white.

with Depth of Field

▲ ❺
Depth of field effect based on depth buffer.

Deeper and deeper: The Depth buffer, or Z channel as it's also called, benefits a lot from 32-bit output as well. Otherwise, you'd have only 256 depth planes.

But in full precision, you can virtually isolate anything from anything, derive a selection mask, clip something out, or put something in between two objects. Of course, you can also generate a very precisely placed depth of of field effect like in figure ❺ .

Most CG renderings benefit from a little depth of field. It doesn't take much—sometimes just a 1- to 2-pixel blur at the maximum

defocus spot. But it eliminates the superclean look that real photographic lenses rarely deliver. It's also a great artistic tool because you can point the viewer's eye to the important part of the image.

Other than that, our depth pass can also help to put some atmosphere in here. It's perfect for faking volumetric effects because it gives us a 2D template of the 3D scene. Just multiplying it to a supercheap fractal noise magically transforms the noise into hazy light beams (see ❻). Rendering true volumetric

×

+

=

Fractal noise, stretched & blurred Depth pass, blurred Before After

▲ **6**

Using fractal noise and depth buffer to fake some hazy light beams.

lights would take ages, but this technique is real time.

Without going too deep into the compositing side again, here is some general advice for working with render passes:

- Make up your mind which passes you might need.
- Run a test render, browse through your options, and try to get a rough road map of the composite together.
- Keep it simple. Work backwards from your Beauty when possible, and build up when necessary.
- Try to render all your passes in one swoop. They should be additional outputs, piggy-backed to the Beauty pass render. Ideally, they are embedded channels in an EXR.
- If you have to break out a pass as a separate render, consider rendering in half resolution. Ambient occlusion is a good candidate for that.

Finishing touches: Let me just quickly finish off this still life. Waht you see in figure **7** is pretty much standard procedure now.

The point is, no matter how physically correct a renderer works, you can't neglect the "photo" part of photo-realism. You might render something that looks real, but for photo-realism you still have to put in all the little things that a photographer tries to avoid. They are important visual clues that whisper to a viewer that this would be a photograph. It's good to be subtle here, and it's OK when you can barely make out the difference from step to step. But when comparing start with finish, it becomes very obvious that something magical has happened here.

What has all this to do with image-based lighting? Nothing. Just thought you might like to know... I just can't show this chapter to the photographers because they would get too envious of us 3D folks for having all these great render passes to play with.

| Before, with Vignetting added in the currently off-screen corners. | Colorgrading with Levels, see chapter 5.1.4. for details | Soft Glow added, large scale and low opacity. Secondary small glow. | Grain added, in blue channel bigger, more, and softer |

▲ ⑦ : Finishing touches.

Before
After

View from one patch

... as seen by radiosity with 100 rays: or or or

▲ **1**

Radiosity with 100 sampling rays.

7.3.3. Sample Wisely: Split the Light!
Back to the topics of lighting and rendering. Here is another question that appears pretty consistently once a month in every CG board.

Why are my HDRI renderings so noisy?
1 Keep in mind that all GI algorithms have to trace rays. Monte Carlo radiosity fires **x** amount of rays from each surface patch in random directions. Now, when we have an HDR image with a lot of sharp details, each of those random rays will hit something entirely different. And this will be all different again when the next patch starts shooting rays. They will simply not match anymore.

2 Increasing the number of ray samples would be one solution. There will be less of a chance that important areas are missed. But it's not precisely the best option because then our image will render forever.

In this example, going from 100 to 500 samples bumps up render time from 7 to 35 minutes. That was with LightWave on my rusty PowerBook; your actual mileage may vary. But the proportion will be similar. Double the samples and you double the time it takes.

3 A much better solution is to scale down the HDRI and put a blur on it. This will make sure that even a small number of samples will hit very similar spots. In the end, we are only interested in the average of all those samples

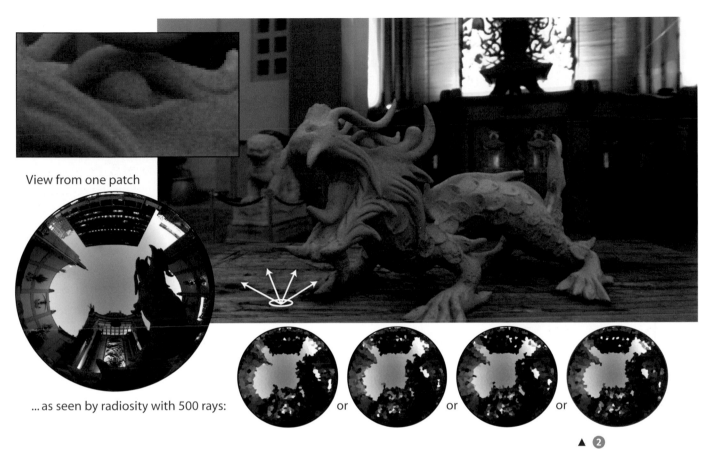

View from one patch

... as seen by radiosity with 500 rays: or or or

▲ ②
Radiosity with 500
sampling rays.

2048 x 1024

Scaled down & blurred

360 x 180

◄ ③
Preparing the HDRI
properly.

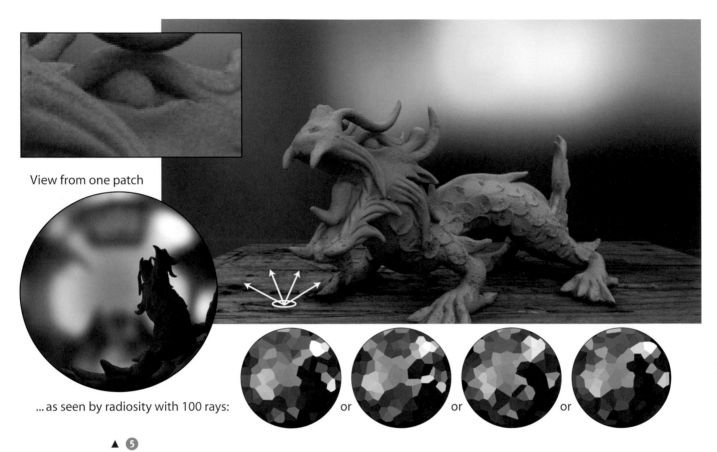

View from one patch

... as seen by radiosity with 100 rays: or or or

▲ **5**

Radiosity with 100 sampling rays, but lit with a blurred HDR image.

anyway since that is all we need to figure out how much light can reach that patch. So don't be cautious here—when I'm talking about scaling and blurring the image, I really mean it!

4 A common technique is to blur the map right within the 3D application, sometimes even by overdriving the Mip-Mapping value, which is actually meant for anti-aliasing. Well, let me tell you that this is quite a wasteful habit because you still have a big HDR image sitting in memory that doesn't do you any good. Also, you need a much bigger blur to cover the same percentage in the image, and the worst is that this expensive blur is getting

recalculated over and over again. Blur it once, scale it right, and be done with it!

5 Isn't that cool? Still 7 minutes, and even less noise. Now we're cooking! The reason is obvious: Whatever random rays are being fired, they hit almost the same colors on the HDR image.

By the way, photon tracing does not suffer from noise as much as Monte Carlo. But the situation is similar: As these particles bounce around, they hit random spots on the HDR map. Some renderer engines are just better in smoothing out the errors. In the next frame, these will be all different errors and your animation will be flickering—a very undesirable effect unless you render a silent movie.

▲ Jamie Clark's Mustang + my lowres blurry HDRI

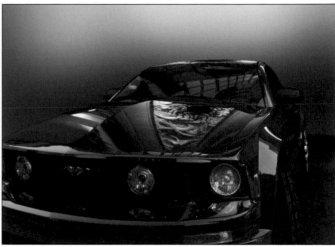

▲ Original sharp HDRI used as reflection map.

Reflections: They have become a problem now.

Let's swap out the dragon for a shiny car and have a look. This is not a scan. It was completely hand-modeled by Jamie Clark and kindly donated for this tutorial. A lot of photographers seem to render car scans or stock models lately. Well, just have a look at the wireframe screen shots on the next pages and you will see why scans can never compare to a carefully handcrafted CG model.

In reflections, we don't want to see a blurred environment; reflections are supposed to stay crisp and clean. Yet we still want to keep sampling rates low.

The trick is simple: We use the high-resolution HDR image as a reflection map. That way we catch two birds with one stone: We keep the same speed because reflection maps render practically in real time. They're very simple. And we save one level of raytracing recursion. Eventually, we might even get away with not using raytraced reflections at all.

Essentially, we are splitting the HDR image into two light components: diffuse and specular lighting. Diffuse is responsible for nice

shadows on the ground, and specular makes catchy highlights.

Background: With all that trickery, we have forgotten one thing: The background looks all blurry now. Some like it that way; it kind of puts the CG model in focus. But with that shallow depth of field most models look like, well, just models. It kills the scale of the scene.

It doesn't cost us much to render the same view without the car but with the original panorama in the background. Actually, I did that already and front-projected this image onto the ground. You might have noticed the strange brown spot on the ground texture that suddenly cuts off. This is actually part of the theatre entrance door. From the side it looks like figure ❶ .

It takes a bit of fiddling with the ground material to blend it with the background. Since the ground is affected by the lighting as well, it will get a bit brighter. Mixing diffuse and luminous surface settings can usually lead you to a good match. In a very saturated lighting, there might even be a little color overlay necessary,

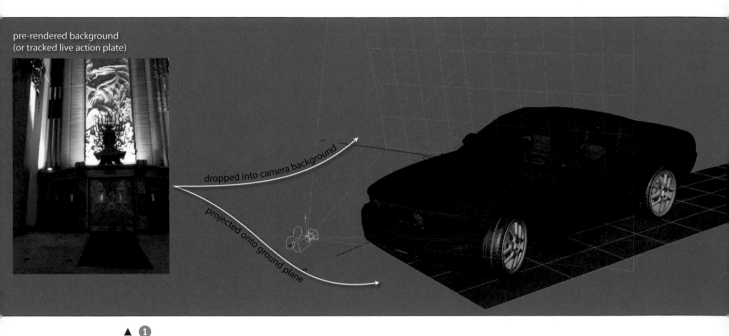

pre-rendered background
(or tracked live action plate)

dropped into camera background

projected onto ground plane

▲ **1**

Basic in-camera
compositing via
front projection.

countertinting the lighting with the comple-
mentary color.

Camera projection is yet another one of
those cheap hacks that help in slapping stuff
together quickly. Strictly taken, I should have
rendered the car separately from the ground
plane. In that case, the ground render would
need an invisible car in there, just to throw
a shadow. Then I could multiply the shadow
over the background and put the car on top.
But somehow I prefer this projection tech-
nique whenever possible. It's much simpler
and takes only one radiosity rendering instead
of two. Once it's all put back into one piece,
nobody can tell anyway (see **2**).

In this case I got away with just a little depth
of field. What sucks is that it wasn't a creative
decision. There's just not enough resolution,
even in the bigger HDR image. I was forced to
blur it out to hide these fist-sized pixels as in
figure **3** .

Bigger backgrounds: So the third ingredient
would be a super-high-res panorama image,
mapped on a simple background ball. Ideally,
the resolution would be high enough that it
delivers a crisp backdrop wherever we point
the camera.

How high?

Well, it's the same math as when we're
shooting a panorama. Because we are. Let's
say our CG camera shoots with 45-degree
horizontal FOV, which equals a 24mm lens on
a full-size 35mm film back. So our background
panorama would need to be 360 degrees / 45
degrees = 8 times the intended render resolu-
tion. For full HDTV, that means we'd need a
15.360-pixel-wide image. In other words, in-
sanely big.

OK, let's compromise. If we go with an
8.000-pixel-wide pano, we have about half the
resolution for HD. Still kind of acceptable. But
even that is already pushing the limits. Make
that an HDR image and it will eat up 366 MB
memory. Precious space that you don't have

◄ ❷
Final rendering merged with the pre-rendered background image.

▲ ❸
Even the bigger HDR image doesn't have enough resolution.

when working with a scene of decent size. So here are the options: Either crop the background panorama to what you're really going to see in-frame and map that on a partial ball. Or save 75 percent memory just by tonemapping it down to 8-bit. Actually, you could stitch this huge panorama in 8-bit right away, cutting down the time you have to look at boring progress bars.

How to handle a ball: Silly, I know. It's quite obvious that it should be excluded from all lighting effects, that it should neither cast nor receive any shadows. It shouldn't even be seen by reflection or radiosity rays. It's only there for the camera.

Looking at a sphere from the inside can be a bit strange. What's not so obvious is that you have to invert the mapping direction. Regular spherical mapping types are made for balls

Background Pano / 8000 x 4000 / LDR

▶

The complete rig
now consists of
these three images.

Reflection Map / 2048 x 1024 / HDR

Environment Map / 360 x 180 / HDR ———————

▶

Regular spherical
mapping appears
mirrored on the
inside.

seen from the outside, so the image will appear mirrored from the inside. Text will be written backwards, and objects in a panorama will swap positions. In LightWave, you have to set the Width Wrap Amount value to -1 to fix that, and other programs have something similar for sure.

The position of the ball matters a lot as well.

When background ball and camera are in the same position, the projection will be right. It will look just like in a Quicktime VR. Move the ball forward, and you get a fisheye-lens effect. Place the ball in the world center and you get some arbitrary distortion. Yeah, that's right—the world center is not the naturally correct position for that ball. The camera position is, as illustrated in ❶ .

The quick solution is to scale the ball way up. This minimizes the effect because our camera will always be in the center. That's why the en-

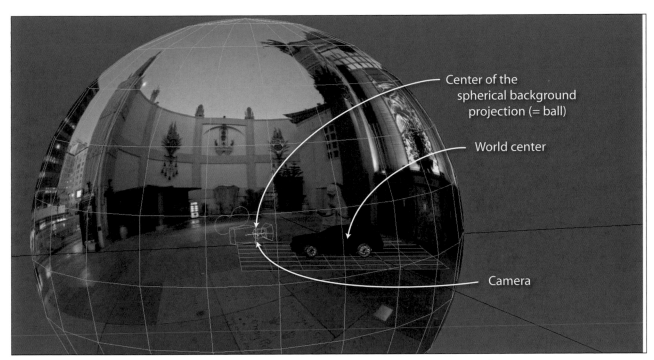

Center of the
spherical background
projection (= ball)

World center

Camera

▲ ❶ : Correct center of the background ball is the camera position.

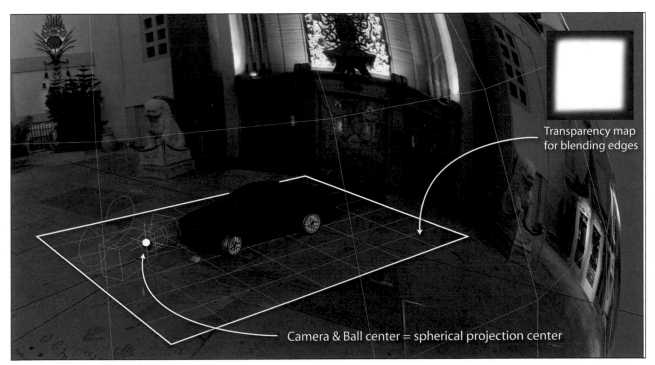

Transparency map
for blending edges

Camera & Ball center = spherical projection center

▲ ❷ : Direct spherical projection of the panorama onto a flat ground.

▲

Final rendering with high-res background, medium-sized reflection map, and low-res environment map.

vironment material simulates a ball of infinite size.

However, knowing about this effect reveals an interesting opportunity: We can spherically project our panorama on any kind of geometry. As long as the projection center is at the camera, it will visually all line up. For example, we could skip prerendering the background now (see ❷).

Looking at the sun: There are several problems involved with HDR images with the sun in them.

- The sun is really really hard to capture. Really hard. Chances are that the circle of the sun is blown out, even in the HDR image. It's not so much of a problem that it doesn't have the right intensity, but the color will be wrong.
- If you made the effort to capture the sun, it will just be too bright. Just a single sampling ray hitting that sunspot will tip the balance of all sampled rays. So you have a hit-or-miss situation, which leads to the worst noise you've ever seen in a rendering.
- You want control over the shadow.

When you think about it, the sun is the prime example of a direct-illumination source. There's no point in brute-forcing it through a global illumination algorithm. In a regular outdoor scene, the sun is your key light. So you want to control every aspect of it.

7.4. Smart IBL

You might say that I make it all too compli-
cated.

Splitting the light into diffuse and specular
HDR images, putting them all in the right slot,
even creating an extra background ball. And
then going in and hitting all the right flags
to make it work. Isn't that just an overkill of
setup for a relatively simple task? Who has the
nerves to do all that?

Introducing the one-button solution: Well,
then, let me make it easier for you again. Let
me introduce you to a unique suite of plug-ins
that does all that and more. It was created in a
joint effort by Christian Bauer, Volker Heister-
berg, Chris Huf, and myself.

We are calling it the "smart image-based
lighting" system, or **sIBL** for short.

The idea is to put all these three images in a
folder and link them together with a descrip-
tion file. From that point on they are siblings.

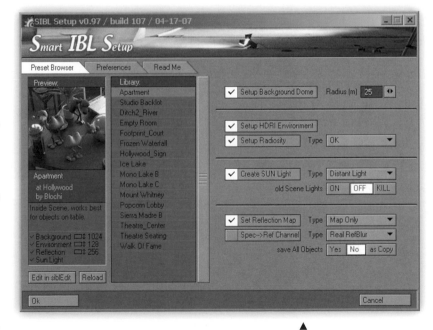

▲
sIBL loader plugin
for LightWave,
automating the
entire setup
procedure.

Together they form a complete lighting set.
We also throw in sunlight that matches in
color, direction, and intensity. The description
file is the key because here we keep all the rel-
evant setup information. Each image is tagged

Preview:

Walk Of Fame

at Mans Chinese
by Blochi

First rays of sunlight, very bright

✓ Background □‡ 4000
✓ Environment □‡ 180
✓ Reflection □‡ 1024
✓ Sun Light

Preview:

Ice Lake

at California
by Blochi

very cold indirect light, just before dawn

✓ Background □‡ 4000
✓ Environment □‡ 180
✓ Reflection □‡ 800

Preview:

Popcorn Lobby

at Mans Chinese
by Blochi

Entrance Lobby, red ambient and shiny popcorn counter

✓ Background □‡ 4000
✓ Environment □‡ 180
✓ Reflection □‡ 1024

with projection type, size, orientation, and recommended gamma for the cheater's work-flow. You actually don't have to care about the individual images anymore.

All you have to do is choose the sIBL set you want to load. We even included short notes and a thumbnail image so you can make an educated choice.

Just pick a set and everything falls into place. Admittedly, it might not be your final lighting setup, but it's darn close. You'll have a perfect starting point. If you have your own background plate, you'll probably further tweak the HDR images to get a better color match.

But often it's just a matter of rotating and moving the background ball until you find a nice composition. Wherever you turn the ball, the sunlight will follow. In fact, even the environment image and the reflection map are synced to that ball with some expression magic.

The example images on the left are the direct render outputs without any postpro-cessing. All these lighting situations are just the flip of a button apart. And each one is rendered in 14 minutes, which is pretty good for rendering clean Monte Carlo on my ridicu-lously slow machine. That's because sIBL is a preoptimized setup. There is certainly room for more render engine optimizations, but those are scene dependent, so you will have to figure them out yourself.

Since a smart IBL rig is done so quickly, it is a great tool to see how a work-in-progress model looks under different lighting styles. It's somewhat like a rapid prototyping ap-proach. You might have guessed already that I've also used this tool to set up other example scenes in this book. The Mustang and the Backyard OJ Factory both got sIBL'ed. It's one

◀ sIBL loader for 3ds Max

◀ sIBL loader for Maya

of those plug-ins that get you hooked, and eventually you forget how much work goes into setting it up by hand.

A universal pipeline tool: And here comes the amazing part. It works the same in Maya and 3ds Max, via the sIBL-Loader by Christian Bauer and Volker Heisterberg.

All these scripts share identical presets. It's an entirely open system; nothing is propri-etary. No database, no fancy file formats. The premise is that it can be ported easily to any 3D platform. Cinema4D and XSI are coming up next; they're already in the works.

Name ▲	Size
▼ 📁 Ditch_River	13.3 MB
Ditch2–Rive_Thumb.jpg	4 KB
Ditch2–River_2k.hdr	6 MB
Ditch2–River_Env.hdr	144 KB
Ditch2–River_TMap.jpg	7.1 MB
Ditch2–River.ibl	4 KB
▼ 📁 Footprint_Court	9.2 MB
Footprint_Court_2k.hdr	5.9 MB
Footprint_…8k_TMap.jpg	3.2 MB
Footprint_Court_Env.hdr	148 KB
Footprint_…t_Thumb.jpg	8 KB
Footprint_Court.ibl	4 KB
▶ 📁 Frozen_Waterfall	17.3 MB
▶ 📁 Hollywood_Sign	11.9 MB
▶ 📁 Ice_Lake	17.9 MB
▶ 📁 Mono_Lake_B	13.3 MB
▶ 📁 Mono_Lake_C	13.2 MB
▶ 📁 Mount_Whitney	14.8 MB
▶ 📁 Popcorn_Lobby	11.9 MB
▶ 📁 Sierra_Madre_B	14.5 MB
▶ 📁 Theatre_Center	11.5 MB
▶ 📁 Theatre_Seating	14.7 MB
▶ 📁 Walk_Of_Fame	9.4 MB

▶ All presets are stored in a centralized sIBL Collection folder.

A pivotal point of the system is the **sIBL Collection**. This is just a plain old folder with one subfolder for each set. It can be anywhere, even on a network location. As long as this sIBL-Collection path is accessible to the Loader scripts, everything is fine.

When you drop a new sIBL set in there, it will be instantly visible to all the Loader scripts because they scan through that collection on each start, looking for the IBL (.ibl) description files.

Essentially, it is like a little content management system. Imagine this: A lighting TD is done with stitching HDR images and preparing all the ingredients as sIBL set. A couple of test renders are completed and they look good. Then that folder is moved from the local collection into the shared one and all the artists have it at their fingertips right away. That includes the character artists working in Maya, the LightWavers doing the backgrounds, and the Max'ler who makes all the cool particle effects. Everybody is happy, and everybody renders with the same lighting.

Creating and editing sIBL sets: You think that was cool? Then check this out.

The icing on the cake is the sIBL-Editor by Chris Huf. It's a stand-alone application for preparing the HDR images properly and wrapping them all up with the right tags into an sIBL set. If you ask me, Chris went way beyond the call of duty with this. This thing has more features than most other programs dealing with HDR images. And it looks pretty slick, too. It's divided in three parts, one for each task: managing, editing, and creation.

Shown in ❶ is the browser, where you can inspect your collection and do simple management tasks.

❷ Double-clicking in the browser takes you to the main editor. It's your worksheet, where you can swap out individual images and edit all the setup information that is stored in the IBL file. You also get a more detailed analysis of the images, and you can pick the sun position, color, and intensity.

Everything is interactive here. The display reacts in real time when you set exposure, gamma, and image shift. The latter is intended for defining the north position but without touching the images themselves. It can also be handy for lining up images that were stitched separately, maybe even remixed from different sets.

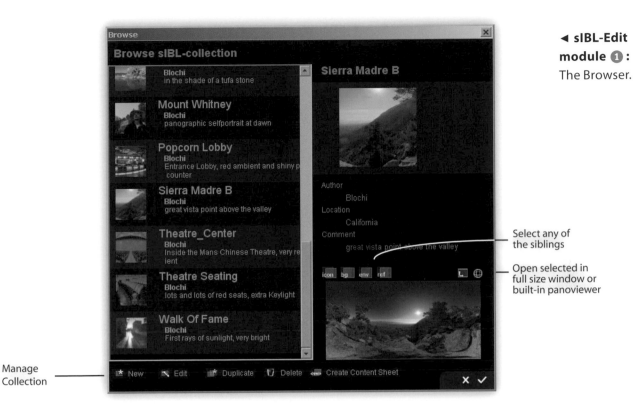

◄ sIBL-Edit
module ❶ :
The Browser.

Select any of
the siblings

Open selected in
full size window or
built-in panoviewer

Manage
Collection

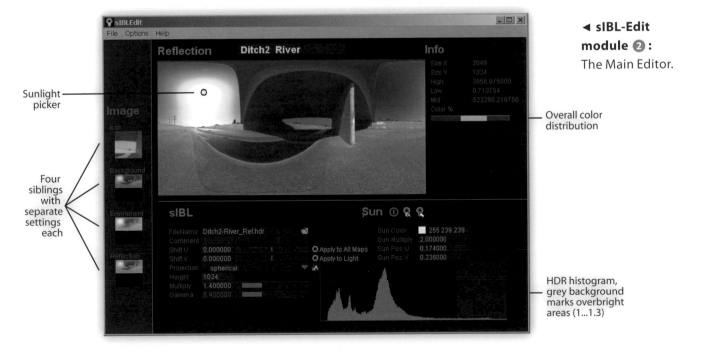

◄ sIBL-Edit
module ❷ :
The Main Editor.

Sunlight
picker

Four
siblings
with
separate
settings
each

Overall color
distribution

HDR histogram,
grey background
marks overbright
areas (1...1.3)

▶
sIBL-Edit module ❸ : The Creator.

switch between images ————

uncheck to exclude current ————

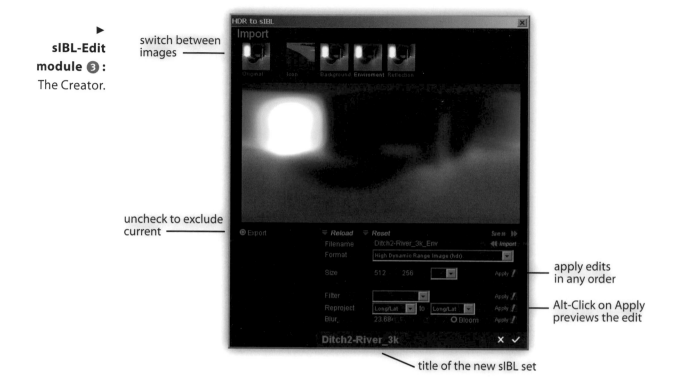

apply edits in any order

Alt-Click on Apply previews the edit

title of the new sIBL set

▲ ❹
Diffuse Convolution in HDR Shop.

❸ The third window is the creator. To make a brand-new sIBL set, you can just drag and drop your master HDR or EXR onto the program icon and it will initially break it out automatically. That means it will resize the re-

flection map, tonemap the background image, blur the environment image, and even crop an icon—all by itself. Of course, all these edits can be tweaked manually as well. That's done in a conversion toolbox style.

That blur is even better suited for this purpose than any other. It correctly wraps around the panoramic seam, and it will also take the spherical distortion into account by incrementally blurring wider on the top and the bottom. It's an approximation, of course. But it's fast as hell because it uses the iterative box blur technique. The only spherically correct blur around would be the Diffuse Convolution function in HDR Shop. But that one takes forever, even on a 360-by-180 image (see ❹).

Oh, and while we're at it: All HDR Shop plug-ins integrate seamlessly; they just appear in the Filter drop-down menu. So you can fire Banty's Diffuse Filter right from here, just like

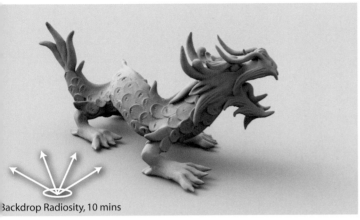

Backdrop Radiosity, 10 mins

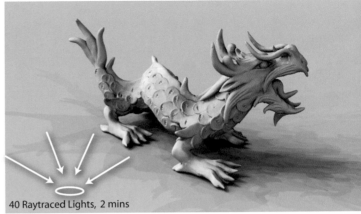

40 Raytraced Lights, 2 mins

▲

Comparing Radiosity and Lightdome rendering techniques.

in Picturenaut. And there is even a complete set of panoramic remapping functions included. So you can literally take an HDR image from mirror ball to production ready with a few clicks.

And did I mention that the sIBL system is released as freeware? We highly encourage you to use it, share it, port it, and support it. It comes with this book, precharged with a starters collection. And by the time you're reading this, there might even be more sIBL collections online. Or wait—no, it's shareware! We demand that you share your best self-shot, self-created sIBL set with the rest of the CG community. Come to our forum at www.smart-tIBL.com and get connected!

7.5. More Creative Applications

All the approaches we have talked about so far rely on physically based rendering. The light from the HDR images is pumped into the scene directly, and global illumination does the work. But can we also use it in classic rendering? Have it look as cool without waiting for radiosity to finish its crazy calculation?

Of course we can.

7.5.1. Squeezing Out Light Sources

A common shortcut is to convert an HDR image into a rig of regular light sources. This technique is a bridge to the traditional way of faking soft shadows and moody ambient light, as it was described in the very beginning of this chapter.

It sounds like a hack, but it really isn't. See, when we blur that environment image, we do nothing but give these radiosity rays a bit less randomness. They still do shoot in random directions, but they hit more uniform areas.

But we can also flip that concept all around and first look up the best rays. Then we just fixate them in standard direct lights and render without GI. The random element is out the door entirely, and that means no sampling noise or flickering—just a bunch of standard lights and superquick render times.

That's the basic idea. Obviously, this technique has its own kind of artifacts. Now we have a whole bunch of overlapping shadows instead of smooth gradual radiosity shadows. I'll show you some tricks to deal with that situation later; for now let's look at our options for creating such a light rig.

▲ LightGen running in Picturenaut.

▲ Banty's Median Cut in Picturenaut: better and faster.

LightGen: The first program that could generate such a rig was LightGen, an HDR Shop plug-in from Jon Cohen. You feed it an HDR image and it will spit out a text file with light information. It's a pretty slow algorithm, so you have to scale the image down to 128x64 pixels first. As with any HDR Shop plug-ins, it runs in Picturenaut as well, actually even better because you get to see the console output that would normally just pop away.

Importer scripts that build the actual light rig from LightGen's output text file are available for pretty much all 3D programs. They often have no interface; they just dump the lights into your scene. It works, but it's a pretty unintuitive workflow. When test rendering doesn't turn out as you want it, you have to start over in LightGen and generate a new text file.

The second flaw of LightGen is that it isn't very smart. Lights of varying intensity will be distributed pretty evenly across the image. But that's not cool. What we are really interested in are the light rays that actually contribute to the lighting. Who cares about the dark spots in an HDR image; much more important is that our samples pick up the bright lights.

Better lights: What we need is a method called importance sampling. Put more lights where they make sense. Dismiss dark areas. Two algorithms are capable of doing such a smart light extraction: **Median Cut** by Debevec gives a very fast approximation, and **Voronoi Tesselation** by Kellig & Keller is more accurate, albeit much slower again.

The screenshot on the left shows how Franceso Banterle's implementation of the median cut algorithm looks:

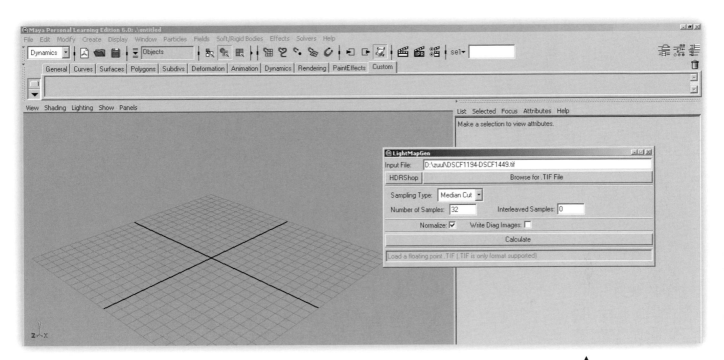

The dot pattern already shows how much better the light distribution is compared to the LightGen result. The dots cluster around bright spots, sampling more of the light and less of the shadows. It's also fast enough to work on the original image resolution. If you look closely at the options, you'll see that Banterle's Median Cut supports direct output for 3ds MAX, Maya, and Radiance. It's part of Banty's Toolkit, which comes with Picturenaut on the DVD with this book.

Another implementation, which even includes both algorithms, can be found in a utility called LightMapGen by Jeremy Pronk. Natively it runs in a command line and generates a setup file, which you'll then import into Maya. There is, however, also a front-end GUI for Maya that makes this process feel more like an integrated workflow.

LightMapGen is freely available on www.happiestdays.com.

LightBitch: Although these tools can do the job, I was never quite satisfied with the general workflow. It simply doesn't follow the WYSIWYG paradigm because it is divided into these two steps: generate and import. Making lights blindly in an external software is messing with my flow.

❶ So I created my own adaption for Light-Wave. It started out as an integrated Light-Wave GUI for Pronk's LightMapGen. Then I wanted it to visualize the rig **before** the actual lights are generated. And as the work progressed, it turned into something else entirely.

▲
Jeremy Pronk's Light-MapGen integrated in Maya.

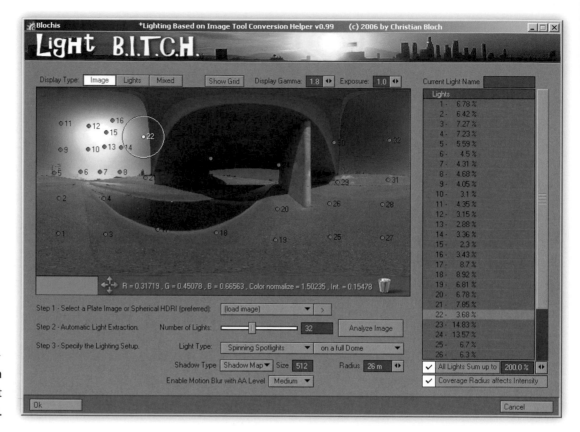

1 ▶
My LightBitch
fully interactive light
editor for LightWave.

The twist is that you can touch these light samples. Simply by dragging them around, you can resample from the HDR image and optimize the distribution by hand. Add new samples just by clicking in the image, and delete samples with drag and drop on the trashcan. Everything is interactive; even the luminosity of all lights is listed and normalized in real time. While you are dragging, all the numbers dance according to their current balancing.

2 And so it has become a lighting toolbox that has all kinds of little helpers at your fingertips. You can overlay a grid that indicates the 3D orientation on the map. Or you can enable these coverage circles and see how well the image is represented by these lights.

It turns out that an artist knows very well what colors he wants to have represented in the light rig. The algorithmic solution is there to give a lighting artist a helping hand, not replace him. That's where LightBitch shines. It puts the artist back in control.

3 For example, when I feel the sun is underrepresented, I can just add a new sample. The same for the small blue patch on the other side of the bridge—that one was eliminated entirely. So I just make some room by nudging the others aside and sample some new lights.

This coverage radius can be scaled with the right mouse button. And it solves a double purpose: For one, it is an intensity multiplier. The larger the coverage of a light, the more its intensity is weighted against the others. And

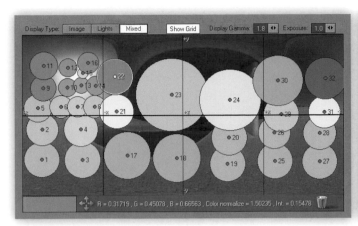

▲ ❷

Grid overlay and light coverage circles.

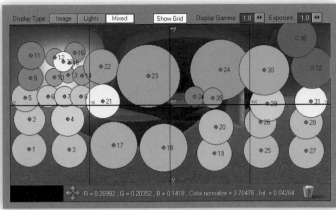

▲ ❸

Manually tweaking the lighting solution.

second, it is used as the radius for a spinning light setup.

Ye good old spinning light trick: LightBitch can serve several kinds of rigs, but the most sophisticated one is this.

❹ Each light is parented to a null object that spins two rounds per frame. So the lights run in circles, very fast. For screen shot ❹, I have scaled the timeline just so you can better see these motion paths.

When that is rendered with a time-sliced motion blur, it smears the light along that circle. It basically multiplies the lights, depending on how many subframe passes are calculated. For example, a five-pass motion blur makes these 32 lights appear as if there were 160.

The lightbulb icon on top of the dome is the main switch; scaling it will brighten or darken all lights.

And this is what the rendered image looks like.

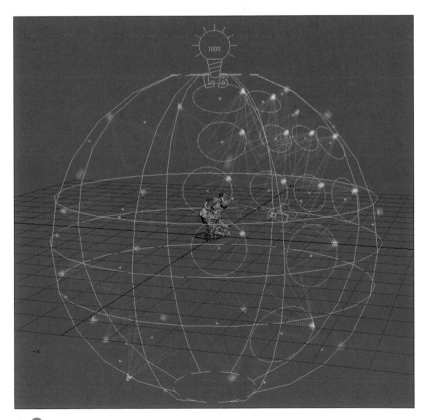

▲ ❹

Spinning light rig generated by LightBitch.

▲ **5**

Troll and his new hat rendered with a LightBitch rig.

5 The rendered image looks virtually identical to the Monte Carlo render, but it took only 7 minutes instead of 14. And remember, that was already an optimized sIBL setup. The gain compared to brute force radiosity is even higher.

6 Let's see how that compares in a slightly more scientific test scene. Back to the plain gray dragon scan! Initially, the rig was generated with 64 lights, and 40 of them remained after deleting everything below the ground plane. All images rendered with nine motion blur passes.

So spinning these lights makes a huge difference. It doesn't cost us anything because most scenes are rendered with motion blur anyway. And the second noticeable point is that shadow mapping is twice as fast while softening the blending areas.

It might not look precisely like radiosity, but it's a pretty good estimate. In any case, it renders much faster and is totally noise resistant.

What else is cool about these light domes?
- You're not locked into the HDR image. Light colors and intensities can be fully tweaked as with any regular light—because they **are** regular lights.

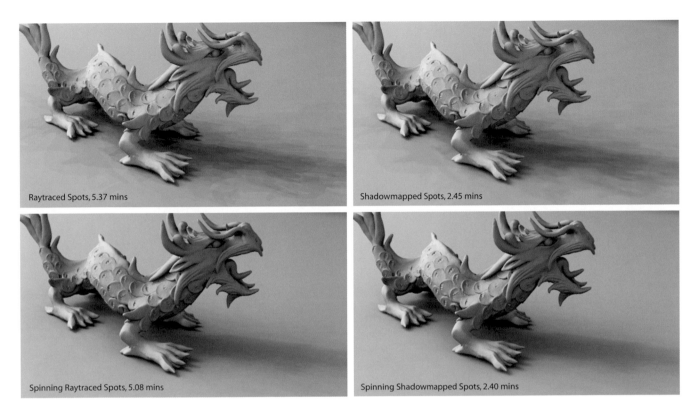

Raytraced Spots, 5.37 mins

Shadowmapped Spots, 2.45 mins

Spinning Raytraced Spots, 5.08 mins

Spinning Shadowmapped Spots, 2.40 mins

▲ ⑥

XYZRGB dragon scan rendered with different LightBitch rigs.

- Advanced effects like subsurface scattering and caustics get a particular speed boost compared to radiosity-based IBL.
- Ambient occlusion is a good companion to a light-dome rig because it eliminates the shadow-blending artifacts. You'd use the light rig only to add ambient light and AO for taking it away. Both combine their strengths and cancel out each other's weaknesses.
- You can change the positioning of the lights and give your light probe a proper 3D dimensionality.
- LightBitch is also self-aware. When launched a second time, it will ask you what to do. So you can quickly iterate through a bunch of different light rigs.

- When you get in more than one rig from different light probes, you can remodel the spatial lighting distribution in a larger set. And of course, you'll find this fine plug-in on the DVD for free. Why? Because I like you.

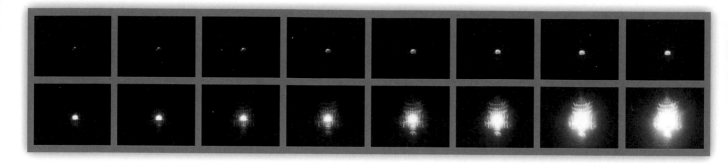

▲
Exposure sequence
of a bike headlight.

7.5.2. HDR Cookies

Here comes another secret technique that uses HDRI without radiosity!

It's about capturing the light characteristics of a real lamp and applying it to a 3D spotlight. That way we get more realistic light behavior, even with traditional rendering techniques. And this is how it works.

Grabbing a light: First we have to capture a real light and turn it into an HDR image.

❶ No lab necessary here. All it takes is a large translucent canvas. That can be a backdrop screen on T-stands from a photo supply store or just a bed sheet stretched across a door frame. Put a lamp behind and aim it straight at the screen. It should be close enough to picture the entire cone angle on the canvas. Depending on the type of light, this distance is somewhere between 2 and 7 inches. Then, just place your camera on the other side of the screen, dim all other lights, and shoot an HDR image.

The idea is to have the same optical view as the lamp itself. Ideally, you'd set up a fisheye lens at the same distance, but on the opposite side. However, chances are that 2 inches is just getting you into trouble with focus and lens flares. So better shoot with a regular lens.

❷ In the end it doesn't matter what lens you use because you can easily get the fisheye distortion in with Hugin. Very very easily, actually. Essentially, it's the opposite of de-fishing for stitching purposes. We just set the lens parameter to Normal and then remap projection to Full Frame (fisheye). Both get assigned the same field of view, somewhere between 120 and 140. Just play with it a bit and you'll see that higher numbers bulge the image more, and keeping them both the same will make sure we keep the crop. A little eyeballing is certainly appropriate here.

Almost done. Hitting Stitch will now just remap it into a TIFF Float file that we have to convert to Radiance HDR in Photoshop. While I'm there, I take the chance to blur out the linen structure of the bed sheet. Yeah, how very professional of me.

Pimp my light! Now we're ready to roll. Let's put our cookie to the test.

In real-world lighting, a cookie is a little piece of cutout cardboard that is stuck in front of a light. The purpose is to cast some kind of fake shadow onto a movie set—like having the shadow of a tree but without needing an actual tree.

translucent screen

light fisheye lens theoretically ideal regular lens works better

▲ **1** : Shooting setup

▲ **2** : Correcting the lens distortion in Hugin.

▲ ❸ : 3d scene setup in LightWave.

Our HDR cookie is a bit different. It has color, like a slide projection. But even more interestingly, it has extreme intensities. When we stick it on a 3D spotlight, it acts as an amplifier. All the image values between 0 and 1 (visible black and white) take light away, modeling a natural light falloff. But beyond 1, it keeps going brighter, which is just awesome.

❸ Let's have a look. The test scene of the day is stripped down to the minimum: one floor, one wall, one intimidated celebrity lamp, and one single spotlight.

❹ Initially, it doesn't look exciting at all, although the supposedly magical "Linear Workflow" is even used in this scene. There are no texture maps in this scene that I would have to worry about. That means a simple post-gamma adjustment of 1.8 is all it takes to get the linear workflow working.

The good news is that the scene rendered in 50 seconds.

❺ Nothing gets touched except that the bike headlight cookie is plugged into the spotlight.

Now it has taken 53 seconds, so that added 3 seconds. That's certainly a low price to pay for such a leap in quality. All of a sudden we have a fine mood in here. And just by swapping the light cookie, we can flip the mood entirely (❻ and ❼).

Technically, that idea is not new at all. Architects and lighting designers for some time have rendered with IES light datasets, which contain accurate angular measurements of real light sources taken under lab conditions by the light manufacturers themselves. Lately those IES lights are supported in standard 3D apps as well. HDR cookies are not as physically correct as IES lights, but for an artist, they are much more useful. You can make a million variations out of each one just by changing colors, crops, and blurs, or even by painting stuff in. It's just an image, not some weirdo dataset that you don't have access to.

▲ ❹ : Initial rendering with a standard spotlight.

▲ ❺ : The bike headlight as HDR cookie makes all the difference.

▲ 6 : USB worm light.

▲ 7 : Desk lamp.

In a nutshell: HDR images can help tremendously in physically based as well as in traditional rendering methods. However, it is not quite the holy grail of plug and play as the hype has been promising us. The sIBL team and I did our share to help out with some of the tedious setup work, but there is still the need for creative tweaking and an artistic eye.

The key is not to take it all too literally. Don't be a slave to physical correctness. It only has to **look** real; it doesn't have to **be** real. HDRI is one of the paths leading that way, but it's not a template that you have to obey. If you know how to use and abuse HDR images to your advantage, it turns into a powerful tool that delivers more effect with less effort.

Last page

What a ride.

When I started this project, my buddies asked me, "A whole book on HDRI? More like a brochure, right? What in the world could you write in an entire book on that?" And now we're on page 300-something, and I still have the odd feeling that some topics came up short.

And when you look at it, we did cover a lot of ground: from shooting tips to tone-mapping tutorials, from getting your head twisted with all the technical backgrounds of HDRI to lighting a CG troll with just the flip of a button. True, many of the techniques described here are not scientifically correct, but they are working hacks that get the job done. Keep this book on your desk because there is no way that you will remember everything. Even I have to look things up here every once in a while, and there is no shame in that.

My hope is that photographers and CG artists could both benefit from this book. I would love to see these two communities get together, share ideas, and learn from each other. Both have some new toys now: Picturenaut and sIBL, two freeware tools that were born from community effort and that are going to live now in a shared community.

The book ends here, but the saga continues on www.hdrlabs.com. This is the new permanent home of our new tools, along with a forum for all of you. Figure out new techniques and tell everyone! Show your results and share experiences! Of course, you can also talk about this book; I would love to hear your opinion. If you want to know what the heck I was thinking when I wrote a certain chapter. just come by and ask.

I hope you had as much fun reading this book as I had writing it. And if you picked up something new on the way, even better.

See you at the forum.

CHRISTIAN BLOCH

Thanks: First of all, I would like to thank Uwe Steinmüller, Dieter Bethke, and Bernhard Vogl for their great contributions and the ongoing idea exchange. You made this book into something special, a truly comprehensive guide that deserves the title "Handbook". Also, many thanks to Greg Ward for the great foreword, the invaluable technical advice, and laying the groundwork for HDRI in the first place. My publisher, Gerhard Rossbach, for believing in this project, and all the fine folks at Rocky Nook, exclam, and dpunkt for working so hard to make it happen. Almute Kraus for making this book really shine through such a polished layout. John Gross and Mark Miller for running EdenFX with so much respect for your VFX artists and for giving me the time to do this. You certainly are the primary sponsors of this book. All my fellow artists at Eden for picking up my workload in the time I was gone and for teaching me everything I know. John Teska, Dave Morton, Sean Scott, Fred Pienkos, Eddie Robison, Steven Rogers, John Karner, Eric Hance, Casey Benn, Jim May, Chris Zapara, Pierre Drolet, Rob Bonchune—it has always been a pleasure and a privilege to work with such a top-gun team. Jamie Clark for the fabulous Mustang model and XYZ RGB for the dragon scan, and the Stanford Computer Graphics Laboratory for making it publicly available. Gerardo Estrada for getting me up to speed on the linear work-flow and the thorough plug-in tests. Chris Huf and Marc Mehl for creating these insanely great applications Picturenaut and sIBL-Edit, and for all the vivid chats and discussions on HDRI. Christian Bauer for his long-term engagement in sIBL and the HDR challenge—couldn't have done all that without you. And Volker Heisterberg for joining the club with getting sIBL into Maya. Courtney Pearson, Audrey Campbell, and Peter Dobson from the Mann Theatres, as well as the friendly staff at the Grauman's Chinese for making it possible to shoot this great location and use it here. Sven Dreesbach, Tore Schmidt, Alex Cherry, Jan Walter, Olcun Tan and Sara Winkle for making living in this strange town bearable. Denis Thürer, Matze Gropp, Ronny Götter, and all the rest of the gang for keeping it real and not letting me down. Mom and dad for everything. My lovely Maria for sticking with me during the sheer endless time it took me to write all that up.

But most importantly, I thank **you** for picking up this book.

Covers Lightroom 1.2

Juergen Gulbins · Uwe Steinmueller
Managing Your Photographic Workflow with
Photoshop Lightroom

Juergen Gulbins · Uwe Steinmueller
Managing Your Photographic Workflow with Photoshop Lightroom

With Adobe Photoshop Lightroom (and Apple's new competitive program, Aperture), a new generation of software tools has arrived that have been designed from the ground up specifically for digital photographic post-processing.

This book guides the new user through Photoshop Lightroom 1.2, which has more power under the hood, and a little more complexity than one would expect from its fairly straightforward user interface. With easy to follow, step-by-step instructions and full-color illustrations,

the authors demonstrate how to use Photoshop Lightroom to build an efficient photographic workflow; from importing and organizing images; through the development and editing phases; all the way to building presentations for the web and in slideshows; and finally, to the ultimate product—the fine art print on paper.

October 2007, 216 pages
ISBN 978-1-933952-20-8, $29.95

Rocky Nook, Inc.
26 West Mission St Ste 3
Santa Barbara, CA 93101-2432

Phone 1-805-687-8727
Toll-free 1-866-687-1118
Fax 1-805-687-2204

E-mail contact@rockynook.com
www.rockynook.com

Brad Hinkel · Steve Laskevitch
Photoshop CS3 Photographer's Handbook
An Easy Workflow

Photographers often feel intimidated when starting out with Photoshop; the sheer number of tools and options can be overwhelming for the beginner. In *Photoshop CS3 Photographer's Handbook*, you will find a straightforward guide that provides a simple, yet effective workflow for editing photographs in the newest generation of Photoshop. Designed to get you quickly working in Photoshop, the essential information needed for image editing is included. More advanced Photoshop techniques are covered in step-by-step projects that will guide

you to new levels of image manipulation and creativity.

Use the *Photoshop CS3 Photographer's Handbook* to:
- Get a solid foundation towards understanding Photoshop CS3
- Learn a practical workflow for editing images
- Learn techniques for image editing with simple step-by-step instructions

June 2007, 208 pages
ISBN 978-1-933952-11-6, $35.95

Rocky Nook, Inc.
26 West Mission St Ste 3
Santa Barbara, CA 93101-2432

Phone 1-805-687-8727
Toll-free 1-866-687-1118
Fax 1-805-687-2204

E-mail contact@rockynook.com
www.rockynook.com

rockynook

> "You can't depend on your eyes if your imagination is out of focus."
>
> MARK TWAIN

Uwe Steinmueller · Juergen Gulbins
Fine Art Printing for Photographers
Exhibition Quality Prints with Inkjet Printers

Today's digital cameras produce image data files making large-format output possible at high resolution. As printing technology moves forward at an equally fast pace, the new inkjet printers are now capable of printing with great precision at a very fine resolution, providing an amazing tonal range and significantly superior image permanence. Moreover, these printers are now affordable to the serious photographer. In the hands of knowledgeable and experienced photographers, they can help create prints comparable to the highest quality darkroom prints on photographic paper.

This book provides the necessary foundation for fine art printing: the understanding of color management, profiling, paper, and inks. It demonstrates how to set up the printing workflow as it guides the reader step-by-step through the process of converting an image file to an outstanding fine art print.

October 2006, 246 pages
ISBN 1-933952-00-8, $44.95

Rocky Nook, Inc.
26 West Mission St Ste 3
Santa Barbara, CA 93101-2432

Phone 1-805-687-8727
Toll-free 1-866-687-1118
Fax 1-805-687-2204

E-mail contact@rockynook.com
www.rockynook.com

rockynook

Alain Briot
Mastering
Landscape Photography

The Luminous-Landscape Essays

rockynook

Alain Briot
Mastering Landscape Photography
'The Luminous Landscape Essays'

Mastering Landscape Photography consists of thirteen essays on landscape photography by master photographer Alain Briot. Topics include practical, technical, and aesthetic aspects of photography to help photographers build and refine their skills. This book starts with the technical aspects of photography; how to see, compose, find the right light, and select the best lens for a specific shot. It continues by focusing on the artistic aspects of photography with chapters on how to select your best work, how to create a portfolio, and finally concludes with two chapters on how to be an artist in business. Alain Briot is one of today's leading contemporary landscape photographers. He received his education in France and currently works mostly in the southwestern part of the United States. Alain Briot is a columnist on the highly respected Luminous Landscape website.

November 2006, 256 pages
ISBN 1-933952-06-7, Price: $39.95

Rocky Nook, Inc.
26 West Mission St Ste 3
Santa Barbara, CA 93101-2432

Phone 1-805-687-8727
Toll-free 1-866-687-1118
Fax 1-805-687-2204

E-mail contact@rockynook.com
www.rockynook.com

rockynook

Sascha Steinhoff
Scanning Negatives and Slides
Digitizing Your Photographic Archives

Many photographers have either moved into digital photography exclusively or use both analog and digital media in their work. In either case, there is sure to be an archive of slides and negatives that cannot be directly integrated into the new digital workflow, nor can it be archived in a digital format. Increasingly, photographers are trying to bridge this gap with the use of high-performance film scanners. The subject of this book is how to achieve the best possible digital image from a negative or a slide, and how to build a workflow to make this process efficient, repeatable, and reliable. The author uses Nikon film scanners, but all steps can easily be accomplished while using a different scanner. The most common software tools for scanning (SilverFast, VueScan, NikonScan) are not only covered extensively in the book, but are also provided on a CD, which also contains other useful tools for image editing, as well as numerous sample scans.

Dec 2006, approx. 300 pages, Includes CD
ISBN 1-933952-01-6, $44.95

Rocky Nook, Inc.
26 West Mission St Ste 3
Santa Barbara, CA 93101-2432

Phone 1-805-687-8727
Toll-free 1-866-687-1118
Fax 1-805-687-2204

E-mail contact@rockynook.com
www.rockynook.com